SHAKESPEARE

Eminent Lives, a series of brief biographies by distinguished authors on canonical figures, joins a long tradition in this lively form, from Plutarch's *Lives* to Vasari's *Lives of the Painters*, Dr. Johnson's *Lives of the Poets* to Lytton Strachey's *Eminent Victorians*. Pairing great subjects with writers known for their strong sensibilities and sharp, lively points of view, the Eminent Lives are ideal introductions designed to appeal to the general reader, the student, and the scholar. "To preserve a becoming brevity which excludes everything that is redundant and nothing that is significant," wrote Strachey: "That, surely, is the first duty of the biographer."

ALSO BY BILL BRYSON

Shakespeare

The World as Stage

Bill Bryson

 ATLAS BOOKS

HARPER

An Imprint of HarperCollins*Publishers*
www.harpercollins.com

EMINENT LIVES

HarperCollins books may be purchased for educational, business, or
sales promotional use. For information, please write: Special Markets
Department, HarperCollins Publishers, 10 East 53rd Street,
New York, NY 10022.

FIRST EDITION

Designed by William Ruoto

Library of Congress Cataloging-in-Publication Data

Bryson, Bill.
Shakespeare : the world as stage / Bill Bryson. — 1st ed.
p. cm. — (Eminent lives)
ISBN: 978-0-06-074022-1
ISBN-10: 0-06-074022-1
Includes bibliographical references.
1. Shakespeare, William, 1564–1616. 2.
Dramatists, English—Early modern, 1500–1700—Biography. I. Title.
PR2895.B79 2007
822.3'3—dc22
[B] 2007021647

07 08 09 10 11 ID/RRD 10 9 8 7 6 5 4 3 2 1

Acknowledgments

I<small>N ADDITION TO THE</small> kindly and patient interviewees cited in the text, I am grateful to the following for their generous assistance: Mario Aleppo, Anna Bulow, Charles Elliott, Will Francis, Emma French, Peter Furtado, Carol Heaton, Gerald Howard, Jonathan Levi, Jacqui Shepard, Paulette Thompson, and Ed Weisman. I am especially indebted to Professor Stanley Wells and Dr. Paul Edmondson of the Shakespeare Birthplace Trust in Stratford-upon-Avon for generously reviewing the manuscript and suggesting many corrections and prudent qualifications, though of course any errors that remain are mine alone. Special thanks also to James Atlas for his enthusiastic encouragement throughout, and to the astute and kindly copy editors Robert Lacey and Sue Llewellyn. As always, and above all, my greatest debt and most heartfelt thanks go to my dear wife, Cynthia.

To Finley and Molly and in memory of Maisie

Chapter One

In Search of William Shakespeare

B EFORE HE CAME INTO a lot of money in 1839, Rich-
ard Plantagenet Temple Nugent Brydges Chandos Gren-
ville, second Duke of Buckingham and Chandos, led a largely
uneventful life.

He sired an illegitimate child in Italy, spoke occasionally
in the Houses of Parliament against the repeal of the Corn
Laws, and developed an early interest in plumbing (his house at
Stowe, in Buckinghamshire, had nine of the first flush toilets
in England), but otherwise was distinguished by nothing more
than his glorious prospects and many names. But after inherit-
ing his titles and one of England's great estates, he astonished
his associates, and no doubt himself, by managing to lose every
penny of his inheritance in just nine years through a series of
spectacularly unsound investments.

Bankrupt and humiliated, in the summer of 1848 he fled
to France, leaving Stowe and its contents to his creditors. The

auction that followed became one of the great social events of the age. Such was the richness of Stowe's furnishings that it took a team of auctioneers from the London firm of Christie and Manson forty days to get through it all.

Among the lesser-noted disposals was a dark oval portrait, twenty-two inches high by eighteen wide, purchased by the Earl of Ellesmere for 355 guineas and known ever since as the Chandos portrait. The painting had been much retouched and was so blackened with time that a great deal of detail was (and still is) lost. It shows a balding but not unhandsome man of about forty who sports a trim beard. In his left ear he wears a gold earring. His expression is confident, serenely rakish. This is not a man, you sense, to whom you would lightly entrust a wife or grown daughter.

Although nothing is known about the origin of the painting or where it was for much of the time before it came into the Chandos family in 1747, it has been said for a long time to be of William Shakespeare. Certainly it *looks* like William Shakespeare—but then really it ought to, since it is one of the three likenesses of Shakespeare from which all other such likenesses are taken.

In 1856, shortly before his death, Lord Ellesmere gave the painting to the new National Portrait Gallery in London as its founding work. As the gallery's first acquisition, it has a certain sentimental prestige, but almost at once its authenticity was doubted. Many critics at the time thought the subject was too dark-skinned and foreign looking—too Italian or Jewish—to be an English poet, much less a very great one. Some, to quote

the late Samuel Schoenbaum, were disturbed by his "wanton" air and "lubricious" lips. (One suggested, perhaps a touch hopefully, that he was portrayed in stage makeup, probably in the role of Shylock.)

"Well, the painting is from the right period—we can certainly say that much," Dr. Tarnya Cooper, curator of sixteenth-century portraits at the gallery, told me one day when I set off to find out what we could know and reasonably assume about the most venerated figure of the English language. "The collar is of a type that was popular between about 1590 and 1610, just when Shakespeare was having his greatest success and thus most likely to sit for a portrait. We can also tell that the subject was a bit bohemian, which would seem consistent with a theatrical career, and that he was at least fairly well to do, as Shakespeare would have been in this period."

I asked how she could tell these things.

"Well, the earring tells us he was bohemian," she explained. "An earring on a man meant the same then as it does now—that the wearer was a little more fashionably racy than the average person. Drake and Raleigh were both painted with earrings. It was their way of announcing that they were of an adventurous disposition. Men who could afford to wore a lot of jewelry back then, mostly sewn into their clothes. So the subject here is either fairly discreet, or not hugely wealthy. I would guess probably the latter. On the other hand, we can tell that he was prosperous—or wished us to think he was prosperous—because he is dressed all in black."

She smiled at my look of puzzlement. "It takes a lot of dye

to make a fabric really black. Much cheaper to produce clothes that were fawn or beige or some other lighter color. So black clothes in the sixteenth century were nearly always a sign of prosperity."

She considered the painting appraisingly. "It's not a *bad* painting, but not a terribly good one either," she went on. "It was painted by someone who knew how to prime a canvas, so he'd had some training, but it is quite workaday and not well lighted. The main thing is that if it is Shakespeare, it is the only portrait known that might have been done from life, so this would be what William Shakespeare really looked like—if it is William Shakespeare."

And what are the chances that it is?

"Without documentation of its provenance we'll never know, and it's unlikely now, after such a passage of time, that such documentation will ever turn up."

And if not Shakespeare, who is it?

She smiled. "We've no idea."

If the Chandos portrait is not genuine, then we are left with two other possible likenesses to help us decide what William Shakespeare looked like. The first is the copperplate engraving that appeared as the frontispiece of the collected works of Shakespeare in 1623—the famous First Folio.

The Droeshout engraving, as it is known (after its artist, Martin Droeshout), is an arrestingly—we might almost say magnificently—mediocre piece of work. Nearly everything about it is flawed. One eye is bigger than the other. The mouth

is curiously mispositioned. The hair is longer on one side of the subject's head than the other, and the head itself is out of proportion to the body and seems to float off the shoulders, like a balloon. Worst of all, the subject looks diffident, apologetic, almost frightened—nothing like the gallant and confident figure that speaks to us from the plays.

Droeshout (or Drossaert or Drussoit, as he was sometimes known in his own time) is nearly always described as being from a family of Flemish artists, though in fact the Droeshouts had been in England for sixty years and three generations by the time Martin came along. Peter W. M. Blayney, the leading authority on the First Folio, has suggested that Droeshout, who was in his early twenties and not very experienced when he executed the work, may have won the commission not because he was an accomplished artist but because he owned the right piece of equipment: a rolling press of the type needed for copperplate engravings. Few artists had such a device in the 1620s.

Despite its many shortcomings, the engraving comes with a poetic endorsement from Ben Jonson, who says of it in his memorial to Shakespeare in the First Folio:

> *O, could he but have drawne his wit*
> *As well in brasse, as he hath hit*
> *His face, the Print would then surpasse*
> *All that was ever writ in brasse.*

It has been suggested, with some plausibility, that Jonson may not actually have seen the Droeshout engraving before

penning his generous lines. What is certain is that the Droeshout portrait was not done from life: Shakespeare had been dead for seven years by the time of the First Folio.

That leaves us with just one other possible likeness: the painted, life-size statue that forms the centerpiece of a wall monument to Shakespeare at Holy Trinity Church in Stratford-upon-Avon, where he is buried. Like the Droeshout, it is an indifferent piece of work artistically, but it does have the merit of having been seen and presumably passed as satisfactory by people who knew Shakespeare. It was executed by a mason named Gheerart Janssen, and installed in the chancel of the church by 1623—the same year as Droeshout's portrait. Janssen lived and worked near the Globe Theatre in Southwark in London and thus may well have seen Shakespeare in life—though one rather hopes not, as the Shakespeare he portrays is a puffy-faced, self-satisfied figure, with (as Mark Twain memorably put it) the "deep, deep, subtle, subtle expression of a bladder."

We don't know exactly what the effigy looked like originally because in 1749 the colors of its paintwork were "refreshed" by some anonymous but well-meaning soul. Twenty-four years later the Shakespeare scholar Edmond Malone, visiting the church, was horrified to find the bust painted and ordered the churchwardens to have it whitewashed, returning it to what he wrongly assumed was its original state. By the time it was repainted again years later, no one had any idea of what colors to apply. The matter is of consequence because the paint gives the portrait not just color but definition, as much of the detail is not

carved on but painted. Under whitewash it must have looked rather like those featureless mannequins once commonly used to display hats in shopwindows.

So we are in the curious position with William Shakespeare of having three likenesses from which all others are derived: two that aren't very good by artists working years after his death and one that is rather more compelling as a portrait but that may well be of someone else altogether. The paradoxical consequence is that we all recognize a likeness of Shakespeare the instant we see one, and yet we don't really know what he looked like. It is like this with nearly every aspect of his life and character: He is at once the best known and least known of figures.

More than two hundred years ago, in a sentiment much repeated ever since, the historian George Steevens observed that all we know of William Shakespeare is contained within a few scanty facts: that he was born in Stratford-upon-Avon, produced a family there, went to London, became an actor and writer, returned to Stratford, made a will, and died. That wasn't quite true then and it is even less so now, but it is not all that far from the truth either.

After four hundred years of dedicated hunting, researchers have found about a hundred documents relating to William Shakespeare and his immediate family—baptismal records, title deeds, tax certificates, marriage bonds, writs of attachment, court records (many court records—it was a litigious age), and so on. That's quite a good number as these things go,

but deeds and bonds and other records are inevitably bloodless. They tell us a great deal about the business of a person's life, but almost nothing about the emotions of it.

In consequence there remains an enormous amount that we don't know about William Shakespeare, much of it of a fundamental nature. We don't know, for one thing, exactly how many plays he wrote or in what order he wrote them. We can deduce something of what he read but don't know where he got the books or what he did with them when he had finished with them.

Although he left nearly a million words of text, we have just fourteen words in his own hand—his name signed six times and the words "by me" on his will. Not a single note or letter or page of manuscript survives. (Some authorities believe that a section of the play *Sir Thomas More*, which was never performed, is in Shakespeare's hand, but that is far from certain.) We have no written description of him penned in his own lifetime. The first textual portrait—"he was a handsome, well-shap't man: very good company, and of a very readie and pleasant smooth witt"—was written sixty-four years after his death by a man, John Aubrey, who was born ten years after that death.

Shakespeare seems to have been the mildest of fellows, and yet the earliest written account we have of him is an attack on his character by a fellow artist. He appears to many biographers to have spurned his wife—famously he left her only his second-best bed in his will, and that as an apparent afterthought—and yet no one wrote more highly, more devotedly, more beamingly, of love and the twining of kindred souls.

We are not sure how best to spell his name—but then neither, it appears, was he, for the name is never spelled the same way twice in the signatures that survive. (They read as "Willm Shaksp," "William Shakespe," "Wm Shakspe," "William Shakspere," "Willm Shakspere," and "William Shakspeare." Curiously one spelling he didn't use was the one now universally attached to his name.) Nor can we be entirely confident how he pronounced his name. Helge Kökeritz, author of the definitive *Shakespeare's Pronunciation*, thought it possible that Shakespeare said it with a short *a*, as in "shack." It may have been spoken one way in Stratford and another in London, or he may have been as variable with the pronunciation as he was with the spelling.

We don't know if he ever left England. We don't know who his principal companions were or how he amused himself. His sexuality is an irreconcilable mystery. On only a handful of days in his life can we say with absolute certainty where he was. We have no record at all of his whereabouts for the eight critical years when he left his wife and three young children in Stratford and became, with almost impossible swiftness, a successful playwright in London. By the time he is first mentioned in print as a playwright, in 1592, his life was already more than half over.

For the rest, he is a kind of literary equivalent of an electron—forever there and not there.

To understand why we know as little as we do of William Shakespeare's life, and what hope we have of knowing more, I went one day to the Public Record Office—now known as

the National Archives—at Kew, in West London. There I met David Thomas, a compact, cheerful, softspoken man with gray hair, the senior archivist. When I arrived, Thomas was hefting a large, ungainly bound mass of documents—an Exchequer memoranda roll from the Hilary (or winter) term of 1570—onto a long table in his office. A thousand pages of sheepskin parchment, loosely bound and with no two sheets quite matching, it was an unwieldy load requiring both arms to carry. "In some ways the records are extremely good," Thomas told me. "Sheepskin is a marvelously durable medium, though it has to be treated with some care. Whereas ink soaks into the fibers on paper, on sheepskin it stays on the surface, rather like chalk on a blackboard, and so can be rubbed away comparatively easily.

"Sixteenth-century paper was of good quality, too," he went on. "It was made of rags and was virtually acid free, so it has lasted very well."

To my untrained eye, however, the ink had faded to an illegible watery faintness, and the script was of a type that was effectively indecipherable. Moreover the writing on the sheets was not organized in any way that aided the searching eye. Paper and parchment were expensive, so no space was wasted. There were no gaps between paragraphs—indeed, no paragraphs. Where one entry ended, another immediately began, without numbers or headings to identify or separate one case from another. It would be hard to imagine less scannable text. To determine whether a particular volume contained a reference to any one person or event, you would have to read essentially every word—and that isn't always easy even for experts

like Thomas because handwriting at the time was extremely variable.

Elizabethans were as free with their handwriting as they were with their spelling. Handbooks of handwriting suggested up to twenty different—often very different—ways of shaping particular letters. Depending on one's taste, for instance, a letter d could look like a figure eight, a diamond with a tail, a circle with a curlicue, or any of fifteen other shapes. A's could look like h's, e's like o's, f's like s's and l's—in fact nearly every letter could look like nearly every other. Complicating matters further is the fact that court cases were recorded in a distinctive lingua franca known as court hand—"a peculiar clerical Latin that no Roman could read," Thomas told me, smiling. "It used English word order but incorporated an arcane vocabulary and idiosyncratic abbreviations. Even clerks struggled with it because when cases got really complicated or tricky, they would often switch to English for convenience."

Although Thomas knew he had the right page and had studied the document many times, it took him a good minute or more to find the line referring to "John Shappere alias Shakespere" of "Stratford upon Haven," accusing him of usury. The document is of considerable importance to Shakespeare scholars for it helps to explain why in 1576, when Will was twelve years old, his father abruptly retired from public life (about which more in due course), but it was only found in 1983 by a researcher named Wendy Goldsmith.

There are more than a hundred miles of records like this in the National Archives—nearly ten million documents al-

together—in London and in an old salt mine in Cheshire, not all of them from the relevant period, to be sure, but enough to keep the most dedicated researcher busy for decades.

The only certain way to find more would be to look through all the documents. In the early 1900s an odd American couple, Charles and Hulda Wallace, decided to do just that. Charles Wallace was an instructor in English at the University of Nebraska who just after the turn of the century, for reasons unknown, developed a sudden and lasting fixation with determining the details of Shakespeare's life. In 1906 he and Hulda made the first of several trips to London to sift through the records. Eventually they settled there permanently. Working for up to eighteen hours a day, mostly at the Public Record Office on Chancery Lane, as it then was, they pored over hundreds of thousands—Wallace claimed five million*—documents of all types: Exchequer memoranda rolls, property deeds, messuages, pipe rolls, plea rolls, conveyancings, and all the other dusty hoardings of legal life in sixteenth- and early seventeenth-century London.

Their conviction was that Shakespeare, as an active citizen, was bound to turn up in the public records from time to time. The theory was sound enough, but when you consider that there were hundreds of thousands of records, without in-

* This was probably stretching it. If the Wallaces averaged five minutes, say, on each document it would have taken them 416,666 hours to get through five million of them. Even working around the clock, that would represent 47.5 years of searching.

dexes or cross-references, each potentially involving any of two hundred thousand citizens; that Shakespeare's name, if it appeared at all, might be spelled in some eighty different ways, or be blotted or abbreviated beyond recognition; and that there was no reason to suppose that he had been involved in London in any of the things—arrest, marriage, legal disputes, and the like—that got one into the public records in the first place, the Wallaces' devotion was truly extraordinary.

So we may imagine a muffled cry of joy when in 1909 they came across a litigation roll from the Court of Requests in London comprising twenty-six assorted documents that together make up what is known as the Belott-Mountjoy (or Mountjoie) Case. All relate to a dispute in 1612 between Christopher Mountjoy, a refugee Huguenot wigmaker, and his son-in-law, Stephen Belott, over a marriage settlement. Essentially Belott felt that his father-in-law had not given him all that he had promised, and so he took the older man to court.

Shakespeare, it appears, was caught up in the affair because he had been a lodger in Mountjoy's house in Cripplegate in 1604 when the dispute arose. By the time he was called upon to give testimony eight years later, he claimed—not unreasonably—to be unable to remember anything of consequence about what had been agreed upon between his landlord and the landlord's son-in-law.

The case provided no fewer than twenty-four new mentions of Shakespeare and one precious additional signature— the sixth and so far last one found. Moreover it is also the best and most natural of his surviving signatures. This was the one

known occasion when Shakespeare had both space on the page for a normal autograph and a healthily steady hand with which to write it. Even so, as was his custom, he writes the name in an abbreviated form: "Wllm Shaksp." It also has a large blot on the end of the surname, probably because of the comparatively low quality of the paper. Though it is only a deposition, it is also the only document in existence containing a transcript of Shakespeare speaking in his own voice.

The Wallaces' find, reported the following year in the pages of the *University of Nebraska Studies* (and forever likely to remain, we may suppose, that journal's greatest scoop), was important for two other reasons. It tells us where Shakespeare was living at an important point in his career: in a house on the corner of Silver and Monkswell streets near Saint Aldermanbury in the City of London. And the date of Shakespeare's deposition, May 11, 1612, provides one of the remarkably few days in his life when we can say with complete certainty where he was.

The Belott-Mountjoy papers were only part of what the Wallaces found in their years of searching. It is from their work that we know the extent of Shakespeare's financial interests in the Globe and Blackfriars theaters, and of his purchase of a gatehouse at Blackfriars in 1613, just three years before his death. They found a lawsuit in which the daughter of John Heminges, one of Shakespeare's closest colleagues, sued her father over some family property in 1615. For Shakespeare scholars these are moments of monumental significance.

Unfortunately, as time passed Charles Wallace began to grow a little strange. He penned extravagant public tributes to

himself in the third person ("Prior to his researches," read one, "it was believed and taught for nearly 50 years that everything was known about Shakespeare that ever would be known. His remarkable discoveries have changed all this . . . and brought lasting honor to American scholarship") and developed paranoid convictions. He became convinced that other researchers were bribing the desk clerks at the Public Record Office to learn which files he had ordered. Eventually he believed that the British government was secretly employing large numbers of students to uncover Shakespeare records before he could get to them, and claimed as much in an American literary magazine, causing dismay and unhappiness on both sides of the Atlantic.

Short of funds and increasingly disowned by the academic community, he and Hulda gave up on Shakespeare and the English, and moved back to the United States. It was the height of the oil boom in Texas, and Wallace developed another unexpected conviction: He decided that he could recognize good oil land just by looking at it. Following a secret instinct, he sank all his remaining funds in a 160-acre farm in Wichita Falls, Texas. It proved to be one of the most productive oil fields ever found anywhere. He died in 1932, immensely rich and not very happy.

With so little to go on in the way of hard facts, students of Shakespeare's life are left with essentially three possibilities: to pick minutely over legal documents as the Wallaces did; to speculate ("every Shakespeare biography is 5 percent fact and

95 percent conjecture," one Shakespeare scholar told me, possibly in jest); or to persuade themselves that they know more than they actually do. Even the most careful biographers sometimes take a supposition—that Shakespeare was Catholic or happily married or fond of the countryside or kindly disposed toward animals—and convert it within a page or two to something like a certainty. The urge to switch from subjunctive to indicative is, to paraphrase Alastair Fowler, always a powerful one.

Others have simply surrendered themselves to their imaginations. One respected and normally levelheaded academic of the 1930s, the University of London's Caroline F. E. Spurgeon, became persuaded that it was possible to determine Shakespeare's appearance from a careful reading of his text, and confidently announced (in *Shakespeare's Imagery and What It Tells Us*) that he was "a compactly well-built man, probably on the slight side, extraordinarily well-coordinated, lithe and nimble of body, quick and accurate of eye, delighting in swift muscular movement. I suggest that he was probably fair-skinned and of a fresh colour, which in youth came and went easily, revealing his feelings and emotions."

Ivor Brown, a popular historian, meanwhile concluded from mentions of abscesses and other eruptions in Shakespeare's plays that Shakespeare sometime after 1600 had undergone "a severe attack of staphylococcic infection" and was thereafter "plagued with recurrent boils."

Other, literal-minded readers of Shakespeare's sonnets have been struck by two references to lameness, specifically in Sonnet 37:

As a decrepit father takes delight
To see his active child do deeds of youth,
So I, made lame by Fortune's dearest spite,
Take all my comfort of thy worth and truth.

And again in Sonnet 89:

Say that thou didst forsake me for some fault,
And I will comment upon that offense.
Speak of my lameness, and I straight will halt.

and concluded that he was crippled.

In fact it cannot be emphasized too strenuously that there is nothing—not a scrap, not a mote—that gives any certain insight into Shakespeare's feelings or beliefs as a private person. We can know only what came out of his work, never what went into it.

David Thomas is not in the least surprised that he is such a murky figure. "The documentation for William Shakespeare is exactly what you would expect of a person of his position from that time," he says. "It seems like a dearth only because we are so intensely interested in him. In fact we know more about Shakespeare than about almost any other dramatist of his age."

Huge gaps exist for nearly all figures from the period. Thomas Dekker was one of the leading playwrights of the day, but we know little of his life other than that he was born in London, wrote prolifically, and was often in debt. Ben Jonson

was more famous still, but many of the most salient details of his life—the year and place of his birth, the identities of his parents, the number of his children—remain unknown or uncertain. Of Inigo Jones, the great architect and theatrical designer, we have not one certain fact of any type for the first thirty years of his life other than that he most assuredly existed somewhere.

Facts are surprisingly delible things, and in four hundred years a lot of them simply fade away. One of the most popular plays of the age was *Arden of Faversham*, but no one now knows who wrote it. When an author's identity *is* known, that knowledge is often marvelously fortuitous. Thomas Kyd wrote the most successful play of its day, *The Spanish Tragedy*, but we know this only because of a passing reference to his authorship in a document written some twenty years after his death (and then lost for nearly two hundred years).

What we do have for Shakespeare are his plays—all of them but one or two—thanks in very large part to the efforts of his colleagues Henry Condell and John Heminges, who put together a more or less complete volume of his work after his death—the justly revered First Folio. It cannot be overemphasized how fortunate we are to have so many of Shakespeare's works, for the usual condition of sixteenth- and early seventeenth-century plays is to be lost. Few manuscripts from any playwrights survive, and even printed plays are far more often missing than not. Of the approximately three thousand plays thought to have been staged in London from about the time of Shakespeare's birth to the closure of the theaters by the

Puritans in a coup of joylessness in 1642, 80 percent are known only by title. Only 230 or so play texts still exist from Shakespeare's time, including the thirty-eight by Shakespeare himself—about 15 percent of the total, a gloriously staggering proportion.

It is because we have so much of Shakespeare's work that we can appreciate how little we know of him as a person. If we had only his comedies, we would think him a frothy soul. If we had just the sonnets, he would be a man of darkest passions. From a selection of his other works, we might think him variously courtly, cerebral, metaphysical, melancholic, Machiavellian, neurotic, lighthearted, loving, and much more. Shakespeare was of course all these things—as a writer. We hardly know what he was as a person.

Faced with a wealth of text but a poverty of context, scholars have focused obsessively on what they *can* know. They have counted every word he wrote, logged every dib and jot. They can tell us (and have done so) that Shakespeare's works contain 138,198 commas, 26,794 colons, and 15,785 question marks; that ears are spoken of 401 times in his plays; that *dunghill* is used 10 times and *dullard* twice; that his characters refer to love 2,259 times but to hate just 183 times; that he used *damned* 105 times and *bloody* 226 times, but *bloody-minded* only twice; that he wrote *hath* 2,069 times but *has* just 409 times; that all together he left us 884,647 words, made up of 31,959 speeches, spread over 118,406 lines.

They can tell us not only what Shakespeare wrote but what

he read. Geoffrey Bullough devoted a lifetime, nearly, to tracking down all possible sources for virtually everything mentioned in Shakespeare, producing eight volumes of devoted exposition revealing not only what Shakespeare knew but precisely how he knew it. Another scholar, Charlton Hinman, managed to identify individual compositors who worked on the typesetting of Shakespeare's plays. By comparing preferences of spelling—whether a given compositor used *go* or *goe*, *chok'd* or *choakte*, *lantern* or *lanthorn*, *set* or *sett* or *sette*, and so on—and comparing these in turn with idiosyncrasies of punctuation, capitalization, line justification, and the like, he and others have identified nine hands at work on the First Folio. It has been suggested, quite seriously, that thanks to Hinman's detective work we know more about who did what in Isaac Jaggard's London workshop than Jaggard did himself.

Shakespeare, it seems, is not so much a historical figure as an academic obsession. A glance through the indexes of the many scholarly journals devoted to him and his age reveals such dogged investigations as "Linguistic and Informational Entropy in Othello," "Ear Disease and Murder in Hamlet," "Poisson Distributions in Shakespeare's Sonnets," "Shakespeare and the Quebec Nation," "Was Hamlet a Man or a Woman?" and others of similarly inventive cast.

The amount of Shakespearean ink, grossly measured, is almost ludicrous. In the British Library catalog, enter "Shakespeare" as author and you get 13,858 options (as opposed to 455 for "Marlowe," for instance), and as subject you get 16,092 more. The Library of Congress in Washington, D.C., contains

about seven thousand works on Shakespeare—twenty years' worth of reading if read at the rate of one a day—and, as this volume slimly attests, the number keeps growing. *Shakespeare Quarterly*, the most exhaustive of bibliographers, logs about four thousand serious new works—books, monographs, other studies—every year.

To answer the obvious question, this book was written not so much because the world needs another book on Shakespeare as because this series does. The idea is a simple one: to see how much of Shakespeare we can know, really know, from the record.

Which is one reason, of course, it's so slender.

Chapter Two

The Early Years, 1564–1585

WILLIAM SHAKESPEARE WAS BORN into a world that was short of people and struggled to keep those it had. In 1564 England had a population of between three million and five million—much less than three hundred years earlier, when plague began to take a continuous, heavy toll. Now the number of living Britons was actually in retreat. The previous decade had seen a fall in population nationally of about 6 percent. In London as many as a quarter of the citizenry may have perished.

But plague was only the beginning of England's deathly woes. The embattled populace also faced constant danger from tuberculosis, measles, rickets, scurvy, two types of smallpox (confluent and hemorrhagic), scrofula, dysentery, and a vast, amorphous array of fluxes and fevers—tertian fever, quartian fever, puerperal fever, ship's fever, quotidian fever, spotted fever—as well as "frenzies," "foul evils," and other peculiar

maladies of vague and numerous type. These were, of course, no respecters of rank. Queen Elizabeth herself was nearly carried off by smallpox in 1562, two years before William Shakespeare was born.

Even comparatively minor conditions—a kidney stone, an infected wound, a difficult childbirth—could quickly turn lethal. Almost as dangerous as the ailments were the treatments meted out. Victims were purged with gusto and bled till they fainted—hardly the sort of handling that would help a weakened constitution. In such an age it was a rare child that knew all four of its grandparents.

Many of the exotic-sounding diseases of Shakespeare's time are known to us by other names (their ship's fever is our typhus, for instance), but some were mysteriously specific to the age. One such was the "English sweat," which had only recently abated after several murderous outbreaks. It was called "the scourge without dread" because it was so startlingly swift: Victims often sickened and died on the same day. Fortunately many survived, and gradually the population acquired a collective immunity that drove the disease to extinction by the 1550s. Leprosy, one of the great dreads of the Middle Ages, had likewise mercifully abated in recent years, never to return with vigor. But no sooner had these perils vanished than another virulent fever, called "the new sickness," swept through the country, killing tens of thousands in a series of outbreaks between 1556 and 1559. Worse, these coincided with calamitous, starving harvests in 1555 and 1556. It was a literally dreadful age.

Plague, however, remained the darkest scourge. Just under three months after William's birth, the burials section of the parish register of Holy Trinity Church in Stratford bears the ominous words *Hic incepit pestis* (Here begins plague), beside the name of a boy named Oliver Gunne. The outbreak of 1564 was a vicious one. At least two hundred people died in Stratford, about ten times the normal rate. Even in nonplague years 16 percent of infants perished in England; in this year nearly two-thirds did. (One neighbor of the Shakespeare's lost four children.) In a sense William Shakespeare's greatest achievement in life wasn't writing *Hamlet* or the sonnets but just surviving his first year.

We don't know quite when he was born. Much ingenuity has been expended on deducing from one or two certainties and some slender probabilities the date on which he came into the world. By tradition it is agreed to be April 23, Saint George's Day. This is the national day of England, and coincidentally also the date on which Shakespeare died fifty-two years later, giving it a certain irresistible symmetry, but the only actual fact we have concerning the period of his birth is that he was baptized on April 26. The convention of the time—a consequence of the high rates of mortality—was to baptize children swiftly, no later than the first Sunday or holy day following birth, unless there was a compelling reason to delay. If Shakespeare was born on April 23—a Sunday in 1564—then the obvious choice for christening would have been two days later on Saint Mark's Day, April 25. However, some people thought

Saint Mark's Day was unlucky and so, it is argued—perhaps just a touch hopefully—that the christening was postponed an additional day, to April 26.

We are lucky to know as much as we do. Shakespeare was born just at the time when records were first kept with some fidelity. Although all parishes in England had been ordered more than a quarter of a century earlier, in 1538, to maintain registers of births, deaths, and weddings, not all complied. (Many suspected that the state's sudden interest in information gathering was a prelude to some unwelcome new tax.) Stratford didn't begin keeping records until as late as 1558—in time to include Will, but not Anne Hathaway, his older-by-eight-years wife.

One consideration makes arguments about birth dates rather academic anyway. Shakespeare was born under the old Julian calendar, not the Gregorian, which wasn't created until 1582, when Shakespeare was already old enough to marry. In consequence, what was April 23 to Shakespeare would to us today be May 3. Because the Gregorian calendar was of foreign design and commemorated a pope (Gregory XIII), it was rejected in Britain until 1751, so for most of Shakespeare's life, and 135 years beyond, dates in Britain and the rest of Europe were considerably at variance—a matter that has bedeviled historians ever since.

The principal background event of the sixteenth century was England's change from a Catholic society to a Protestant one—though the course was hardly smooth. England swung from

Protestantism under Edward VI to Catholicism under Mary Tudor and back to Protestantism again under Elizabeth. With each change of regime, officials who were too obdurate or dilatory to flee faced painful reprisals, as when Thomas Cranmer, archbishop of Canterbury, and colleagues were burned at the stake in Oxford after the Catholic Mary came to the throne in 1553. The event was graphically commemorated in a book by John Foxe formally called *Actes and Monuments of These Latter and Perillous Days, Touching Matters of the Church* but familiarly known then and ever since as *Foxe's Book of Martyrs*—a book that would provide succor to anti-Catholic passions during the time of Shakespeare's life. It was also a great comfort to Elizabeth, as later editions carried an extra chapter on "The Miraculous Preservation of the Lady Elizabeth, now Queen of England," praising her brave guardianship of Protestantism during her half sister's misguided reign (though in fact Elizabeth was anything but bravely Protestant during Mary's reign).

Though it was an age of huge religious turmoil, and although many were martyred, on the whole the transition to a Protestant society proceeded reasonably smoothly, without civil war or wide-scale slaughter. In the forty-five years of Elizabeth's reign, fewer than two hundred Catholics were executed. This compares with eight thousand Protestant Huguenots killed in Paris alone during the Saint Bartholomew's Day massacre in 1572, and the unknown thousands who died elsewhere in France. That slaughter had a deeply traumatizing effect in England—Christopher Marlowe graphically depicted it in *The Massacre at Paris* and put slaughter scenes in two other

plays—and left two generations of Protestant Britons at once jittery for their skins and ferociously patriotic.

Elizabeth was thirty years old and had been queen for just over five years at the time of William Shakespeare's birth, and she would reign for thirty-nine more, though never easily. In Catholic eyes she was an outlaw and a bastard. She would be bitterly attacked by successive popes, who would first excommunicate her and then openly invite her assassination. Moreover for most of her reign a Catholic substitute was conspicuously standing by: her cousin Mary, Queen of Scots. Because of the dangers to Elizabeth's life, every precaution was taken to preserve her. She was not permitted to be alone out of doors and was closely guarded within. She was urged to be wary of any presents of clothing designed to be worn against her "body bare" for fear that they might be deviously contaminated with plague. Even the chair in which she normally sat was suspected at one point of having been dusted with infectious agents. When it was rumored that an Italian poisoner had joined her court, she had all her Italian servants dismissed. Eventually, trusting no one completely, she slept with an old sword beside her bed.

Even while Elizabeth survived, the issue of her succession remained a national preoccupation throughout her reign—and thus through a good part of William Shakespeare's life. As Frank Kermode has noted, a quarter of Shakespeare's plays would be built around questions of royal succession—though speculating about Elizabeth's successor was very much against the law. A Puritan parliamentarian named Peter Wentworth

languished for ten years in the Tower of London simply for having raised the matter in an essay.

Elizabeth was a fairly relaxed Protestant. She favored many customary Catholic rites (there would be no evensong in English churches now without her) and demanded little more than a token attachment to Anglicanism throughout much of her reign. The interest of the Crown was not so much to direct people's religious beliefs as simply to be assured of their fealty. It is telling that Catholic priests when caught illegally preaching were normally charged not with heresy but with treason. Elizabeth was happy enough to stay with Catholic families on her progresses around the country so long as their devotion to her as monarch was not in doubt. So *being* Catholic was not particularly an act of daring in Elizabethan England. Being publicly Catholic, propagandizing for Catholicism, was another matter, as we shall see.

Catholics who did not wish to attend Anglican services could pay a fine. These nonattenders were known as recusants (from a Latin word for "refusing") and there were a great many of them—an estimated fifty thousand in 1580. Fines for recusancy were only 12 pence until 1581, and in any case were only sporadically imposed, but then they were raised abruptly—and, for most people, crushingly—to £20 a month. Remarkably some two hundred citizens had both the wealth and the piety to sustain such penalties, which proved an unexpected source of revenue to the Crown, raising a very useful £45,000 just at the time of the Spanish Armada.

Most of the queen's subjects, however, were what were known as "church Papists" or "cold statute Protestants"—prepared to support Protestantism so long as required, but happy and perhaps even quietly eager to become Catholics again if circumstances altered.

Protestantism had its dangers, too. Puritans (a word coined with scornful intent in the year of Shakespeare's birth) and Separatists of various stripes also suffered persecution—not so much because of their beliefs or styles of worship as because of their habit of being willfully disobedient to authority and dangerously outspoken. When a prominent Puritan named (all too appropriately, it would seem) John Stubbs criticized the queen's mooted marriage to a French Catholic, the Duke of Alençon, his right hand was cut off.* Holding up his bloody stump and doffing his hat to the crowd, Stubbs shouted, "God save the Queen," fell over in a faint, and was carted off to prison for eighteen months.

In fact he got off comparatively lightly, for punishments could be truly severe. Many convicted felons still heard the chilling words: "You shall be led from hence to the place whence you came . . . and your body shall be opened, your heart

* It was an unlikely courtship. The queen was old enough to be his mother—she was nearly forty, he just eighteen—and the duke moreover was short and famously ugly. (His champions suggested hopefully that he could be made to look better if he grew a beard.) It was only the duke's death in 1584 that finally put an end to the possibility of marriage.

and bowels plucked out, and your privy members cut off and thrown into the fire before your eyes." Actually by Elizabeth's time it had become most unusual for felons to be disemboweled while they were still alive enough to know it. But exceptions were made. In 1586 Elizabeth ordered that Anthony Babington, a wealthy young Catholic who had plotted her assassination, should be made an example of. Babington was hauled down from the scaffold while still conscious and made to watch as his abdomen was sliced open and the contents allowed to spill out. It was by this time an act of such horrifying cruelty that it disgusted even the bloodthirsty crowd.

The monarch enjoyed extremely wide powers of punishment, and Elizabeth used them freely, banishing from court or even imprisoning courtiers who displeased her (by, for instance, marrying without her blessing), sometimes for quite long periods. In theory she enjoyed unlimited powers to detain, at her pleasure, any subject who failed to honor the fine and numerous distinctions that separated one level of society from another—and these were fine and numerous indeed. At the top of the social heap was the monarch, of course. Then came nobles, high clerics, and gentlemen, in that order. These were followed by citizens—which then signified wealthier merchants and the like: the bourgeoisie. Then came yeomen—that is, small farmers—and last came artisans and common laborers.

Sumptuary laws, as they were known, laid down precisely, if preposterously, who could wear what. A person with an income of £20 a year was permitted to don a satin doublet but not a satin gown, while someone worth £100 a year could wear all

the satin he wished, but could have velvet only in his doublets, but not in any outerwear, and then only so long as the velvet was not crimson or blue, colors reserved for knights of the Garter and *their* superiors. Silk netherstockings, meanwhile, were restricted to knights and their eldest sons, and to certain—but not all—envoys and royal attendants. Restrictions existed, too, on the amount of fabric one could use for a particular article of apparel and whether it might be worn pleated or straight and so on through lists of variables almost beyond counting.

The laws were enacted partly for the good of the national accounts, for the restrictions nearly always were directed at imported fabrics. For much the same reasons, there was for a time a Statute of Caps, aimed at helping domestic cap makers through a spell of depression, which required people to wear caps instead of hats. For obscure reasons Puritans resented the law and were often fined for flouting it. Most of the other sumptuary laws weren't actually much enforced, it would seem. The records show almost no prosecutions. Nonetheless they remained on the books until 1604.

Food was similarly regulated, with restrictions placed on how many courses one might eat, depending on status. A cardinal was permitted nine dishes at a meal while those earning less than £40 a year (which is to say most people) were allowed only two courses, plus soup. Happily, since Henry VIII's break with Rome, eating meat on Friday was no longer a hanging offense, though anyone caught eating meat during Lent could still be sent to prison for three months. Church authorities were permitted to sell exemptions to the Lenten rule and made a lot

of money doing so. It's a surprise that there was much demand, for in fact most varieties of light meat, including veal, chicken, and all other poultry, were helpfully categorized as fish.

Nearly every aspect of life was subject to some measure of legal restraint. At a local level, you could be fined for letting your ducks wander in the road, for misappropriating town gravel, for having a guest in your house without a permit from the local bailiff. Our very first encounter with the name Shakespeare is in relation to one such general transgression in 1552, twelve years before William was born, when his father, John, was fined 1 shilling for keeping a dung heap in Henley Street in Stratford. This was a matter not just of civic fussiness but of real concern because of the town's repeated plague outbreaks. A fine of a shilling was a painful penalty—probably equivalent to two days' earnings for Shakespeare.

Not much is known about John Shakespeare's early years. He was born about 1530 and grew up on a farm at nearby Snitterfield, but came to Stratford as a young man (sparing posterity having to think of his son as the Bard of Snitterfield) and became a glover and whittawer—someone who works white or soft leather. It was an eminently respectable trade.

Stratford was a reasonably consequential town. With a population of roughly two thousand at a time when only three cities in Britain had ten thousand inhabitants or more, it stood about eighty-five miles northwest of London—a four-day walk or two-day horseback ride—on one of the main woolpack routes between the capital and Wales. (Travel for nearly everyone was on foot or by horseback, or not at all. Coaches as a

means of public transport were invented in the year of Shakespeare's birth but weren't generally used by the masses until the following century.)

Shakespeare's father is often said (particularly by those who wish to portray William Shakespeare as too deprived of stimulus and education to have written the plays attributed to him) to have been illiterate. Illiteracy was the usual condition in sixteenth-century England, to be sure. According to one estimate at least 70 percent of men and 90 percent of women of the period couldn't even sign their names. But as one moved up the social scale, literacy rates rose appreciably. Among skilled craftsmen—a category that included John Shakespeare—some 60 percent could read, a clearly respectable proportion.

The conclusion of illiteracy with regard to Shakespeare's father is based on the knowledge that he signed his surviving papers with a mark. But lots of Elizabethans, particularly those who liked to think themselves busy men, did likewise even when they could read, rather as busy executives might today scribble their initials in the margins of memos. As Samuel Schoenbaum points out, Adrian Quiney, a Stratford contemporary of the Shakespeares, signed all his known Stratford documents with a cross and would certainly be considered illiterate except that we also happen to have an eloquent letter in his own hand written to William Shakespeare in 1598. It is worth bearing in mind that John Shakespeare rose through a series of positions of authority in which an inability to read would have been a tiresome, if not insuperable, handicap. Anyway, as should be

obvious, his ability to write or not could have had absolutely no bearing on the capabilities of his children.

Literate or not, John was a popular and respected fellow. In 1556 he took up the first of many municipal positions when he was elected borough ale taster. The job required him to make sure that measures and prices were correctly observed throughout the town—not only by innkeepers but also by butchers and bakers. Two years later he became a constable—a position that then, as now, argued for some physical strength and courage—and the next year became an "affeeror" (or "affurer"), someone who assessed fines for matters not handled by existing statutes. Then he became successively burgess, chamberlain, and alderman, which last entitled him to be addressed as "Master" rather than simply as "Goodman." Finally, in 1568, he was placed in the highest elective office in town, high bailiff—mayor in all but name. So William Shakespeare was born into a household of quite a lot of importance locally.

One of John's duties as high bailiff was to approve payment from town funds for performances by visiting troupes of actors. Stratford in the 1570s became a regular stop for touring players, and it is reasonable to suppose that an impressionable young Will saw many plays as he grew up and possibly received some encouragement or made some contact that smoothed his entrance into the London theater later. He would at the very least have seen actors with whom he who would eventually become closely associated.

For four hundred years this was about all that was known of John Shakespeare, but in the 1980s some discoveries at the

Public Record Office showed that there was another, rather more dubious side to his character.

"It appears that he hung out with some fairly shady fellows," says David Thomas. Four times in the 1570s, John was prosecuted (or threatened with prosecution—the records are sometimes a touch unclear) for trading in wool and for money-lending, both highly illegal activities. Usury in particular was considered a "vice most odious and detestable," in the stark phrasing of the law, and fines could be severe, but John seems to have engaged in it at a seriously committed level. In 1570 he was accused of making loans worth £220 (including interest) to a Walter Mussum. This was a very considerable sum—well over £100,000 in today's money—and Mussum appears not to have been a good risk; at his death his entire estate was worth only £114, much less than John Shakespeare had lent him.

The risk attached to such an undertaking was really quite breathtaking. Anyone found guilty of it would forfeit all the money lent, plus interest, and face a stiff fine and the possibility of imprisonment. The law applied—a little unfairly, it must be said—to any extension of credit. If someone took delivery of, say, wool from you with the understanding that he would repay you later, with a little interest for your trouble, that was considered usury, too. It was this form of usury of which John Shakespeare was probably guilty, for he also traded (or so it would seem) in large quantities of wool. In 1571, for instance, he was accused of acquiring 300 tods—8,400 pounds—of wool. That is a lot of wool and a lot of risk.

We cannot be certain how guilty he was. Informers, as

David Thomas points out, sometimes brought actions as a kind of nuisance ploy, hoping that the accused, even if innocent, would agree to an out-of-court settlement rather than face a costly and protracted trial in London, and one of John Shakespeare's accusers did have a record of bringing such malicious suits.

In any case something severely unfavorable seems to have happened in John's business life for in 1576, when William was twelve, he abruptly withdrew from public affairs and stopped attending meetings. He was listed at one point among nine Stratford residents who were thought to have missed church services "for fear of processe for debtte." His colleagues repeatedly reduced or excused levies that he was due to pay. They also kept his name on the membership for another ten years in the evident hope that he would make a recovery. He never did.

Shakespeare's mother, Mary Arden, provides us with a history that is rather more straightforward, if not tremendously vivid or enlightening. She came from a minor branch of a prominent family. Her father farmed, and the family was comfortable, but probably no more than that. She was the mother of eight children: four daughters, of whom only one lived to adulthood, and four sons, all of whom reached their majority but only one of whom, Will, married. Not a great deal is known about any of them apart from Will. Joan, born in 1558, married a local hatter named Hart and lived to be seventy-seven. Gilbert, born in 1566, became a successful haberdasher. Richard was born in 1574 and lived to be not quite forty, and that is all we know

of him. Edmund, the youngest, became an actor in London—how successfully and with which company are unknown—and died there at the age of twenty-seven. He is buried in Southwark Cathedral, the only one of the eight siblings not to rest at Holy Trinity in Stratford. Seven of the eight Shakespeare children appear to have been named after close relations or family friends. The exception was William, the inspiration for whose name has always been a small mystery, like nearly everything else about his life.

It is commonly supposed (and frequently written) that Shakespeare enjoyed a good education at the local grammar school, King's New School, situated in the Guild Hall in Church Street, and he probably did, though in fact we don't know, as the school records for the period were long ago lost. What is known is that the school was open to any local boy, however dim or deficient, so long as he could read and write—and William Shakespeare patently could do both. King's was of an unusually high standard and was generously supported by the town. The headmaster enjoyed an annual salary of twenty pounds—roughly twice what was paid in other towns and even more, it is often noted, than the headmaster at Eton got at the time. The three masters at the school in Shakespeare's day were all Oxford men—again a distinction.

Boys normally attended the school for seven or eight years, beginning at the age of seven. The schoolday was long and characterized by an extreme devotion to tedium. Pupils sat on hard wooden benches from six in the morning to five or six in the evening, with only two short pauses for refreshment, six days a

week. (The seventh day was probably given over largely to religious instruction.) For much of the year they can hardly have seen daylight. It is easy to understand the line in *As You Like It* about a boy "creeping like snail / Unwillingly to school."

Discipline was probably strict. A standard part of a teacher's training, as Stephen Greenblatt notes, was how to give a flogging. Yet compared with many private or boarding schools Stratford's grammar provided a cushioned existence. Boys at Westminster School in London had to sleep in a windowless grain storeroom, bereft of heat, and endure icy washes, meager food, and frequent whippings. (But then, these were conditions not unknown to many twentieth-century English schoolboys.) Their school day began at dawn as well but also incorporated an additional hour of lessons in the evening and private studies that kept some boys up late into the night.

Far from having "small Latin and less Greek," as Ben Jonson famously charged, Shakespeare had a great deal of Latin, for the life of a grammar-school boy was spent almost entirely in reading, writing, and reciting Latin, often in the most mind-numbingly repetitious manner. One of the principal texts of the day taught pupils 150 different ways of saying, "Thank you for your letter" in Latin. Through such exercises Shakespeare would have learned every possible rhetorical device and ploy—metaphor and anaphora, epistrophe and hyperbole, synecdoche, epanalepsis, and others equally arcane and taxing to memorize. According to Stanley Wells and Gary Taylor, in their introduction to the Oxford edition of the complete works, any grammar-school pupil of the day would have received a

more thorough grounding in Latin rhetoric and literature "than most present-day holders of a university degree in classics." But they wouldn't have received much else. Whatever mathematics, history, or geography Shakespeare knew, he almost certainly didn't learn it at grammar school.

Formal education stopped for Shakespeare probably when he was about fifteen. What became of him immediately after that is unknown—though many legends have rushed in to fill the vacuum. A particularly durable one is that he was caught poaching deer from the estate of Sir Thomas Lucy at Charlecote, just outside Stratford, and prudently elected to leave town in a hurry. The story and its attendant details are often repeated as fact even now. Roy Strong, in the scholarly *Tudor and Jacobean Portraits*, states that Shakespeare left Stratford in 1585 "to avoid prosecution for poaching at Charlecote" and that he was to be found in London the following year. In fact, we don't know when he left Stratford or arrived in London or whether he ever poached so much as an egg. It is, in any case, unlikely that he poached deer from Charlecote, as it didn't have a deer park until the following century.

The only certainty we possess for this early period of Shakespeare's adulthood is that in late November 1582, a clerk at Worcester recorded that William Shakespeare had applied for a license to marry. The bride, according to the ledger, was not Anne Hathaway but Anne Whateley of nearby Temple Grafton—a mystery that has led some biographers to suggest that Shakespeare courted two women to the point of matrimony at the same time and that he stood up Anne Whateley out of

duty to the pregnant Anne Hathaway. Anthony Burgess, in a slightly fevered moment, suggested that young Will, "sent on skin-buying errands to Temple Grafton," perhaps fell for "a comely daughter, sweet as May and shy as a fawn."

In fact Anne Whateley probably never existed. In four hundred years of searching, no other record of her has ever been found. The clerk at Worcester was not, it appears, the most meticulous of record keepers. Elsewhere in the ledgers, in the same hand, scholars have found "Barbar" recorded as "Baker," "Edgcock" confused with "Elcock," and "Darby" put in place of "Bradeley," so turning Hathaway into Whateley was by no means beyond his wayward capabilities. Moreover—for Shakespeare investigators really are tireless—the records also show that in another book on the same day the clerk noted a suit concerning a William Whateley, and it is presumed that the name somehow stuck in his mind. No one, however, has yet found a convincing explanation for how Temple Grafton came into the records when the real bride was from Shottery.

The marriage license itself is lost, but a separate document, the marriage bond, survives. On it Anne Hathaway is correctly identified. Shakespeare's name is rendered as "Shagspere"—the first of many arrestingly variable renderings. The marriage bond cost £40 and permitted the marriage to proceed with one reading of the banns instead of the normal three so that it might be conducted the sooner. The £40 was to indemnify the church authorities against any costly suits arising from the action—a claim of breach of promise, for instance. It was a truly whopping sum—something like £20,000 in today's

money—particularly when one's father is so indebted that he can barely leave his own house for fear of arrest and imprisonment. Clearly there was much urgency to get the couple wed.

What makes this slightly puzzling is that it was not unusual for a bride to be pregnant on her wedding day. Up to 40 percent of brides were in that state, according to one calculation, so why the extravagant haste here is a matter that can only be guessed at. It *was* unusual, however, for a young man to be married at eighteen, as Shakespeare was. Men tended to marry in their mid- to late twenties, women a little sooner. But these figures were extremely variable. Christopher Marlowe had a sister who married at twelve (and died at thirteen in childbirth). Until 1604 the age of consent was twelve for a girl, fourteen for a boy.

We know precious little about Shakespeare's wife and nothing at all about her temperament, intelligence, religious views, or other personal qualities. We are not even sure that Anne was her usual name. In her father's will she was referred to as Agnes (which at the time was pronounced with a silent *g*, making it "ANN-uss"). "Agnes" and "Anne" were often treated as interchangeable names. We know also that she was one of seven children and that she evidently came from prosperous stock: Though her childhood home is always referred to as Anne Hathaway's cottage, it was (and is) a handsome and substantial property, containing twelve rooms. Her gravestone describes her as being sixty-seven years old at the time of her death in 1623. It is from this alone that we conclude that she was considerably older than her husband. Apart from the gravestone, there is no evidence of her age on record.

We know also that she had three children with William Shakespeare—Susanna in May 1583 and the twins, Judith and Hamnet, in early February 1585—but all the rest is darkness. We know nothing about the couple's relationship—whether they bickered constantly or were eternally doting. We don't know if she ever accompanied him to London, saw any of his plays, or even took an interest in them. We have no indication of any warmth between them—but then we have no indication of warmth between William Shakespeare and any other human being. It is tempting to suppose that they had some sort of real bond for at least the first years of their marriage—they had children together on two occasions, after all—but it may actually be, for all we know, that they were very loving indeed and enjoyed a continuing (if presumably often long-distance) affection throughout their marriage. Two of the few certainties of Shakespeare's life are that his marriage lasted till his death and that he sent much of his wealth back to Stratford as soon as he was able, which may not be conclusive proof of attachment but hardly argues against it.

So, in any case, we have the position of a William Shakespeare who was poor, at the head of a growing family, and not yet twenty-one—not the most promising of situations for a young man with ambitions. Yet somehow from these most unpropitious circumstances he became a notable success in a competitive and challenging profession in a distant city in seemingly no time at all. How he did it is a perennial mystery.

One possibility is often mentioned. In 1587, when Shakespeare was twenty-three, an incident occurred among the

Queen's Men, one of the leading acting troupes, that may have provided an opening for Shakespeare. Specifically, while touring the provinces, the company was stopped at Thame, a riverside town in Oxfordshire, when a fight broke out between William Knell, one of the company's leading men, and another actor, John Towne. In the course of their fight, Towne stabbed Knell through the neck, mortally wounding him (though evidently in self-defense, as he was subsequently cleared of blame). Knell's death left the company an actor short and raised the possibility that they recruited or were joined by a stagestruck young William Shakespeare when they passed through Stratford. Unfortunately there is no documentary evidence to connect Shakespeare to the Queen's Men at any stage of his career, and we don't know whether the troupe visited Stratford before or after its fateful stop in Thame.

There is, however, an additional intriguing note in all this. Less than a year later Knell's youthful widow, Rebecca, who was only fifteen or sixteen, remarried. Her new partner was John Heminges, who would become one of Shakespeare's closest friends and associates and who would, with Henry Condell, put together the First Folio of Shakespeare's works after Shakespeare's death.

But a few intriguing notes are all that the record can offer. It is extraordinary to think that before he settled in London and became celebrated as a playwright, history provides just four recorded glimpses of Shakespeare—at his baptism, his wedding, and the two births of his children. There is also a passing reference to him in a lawsuit of 1588 filed by his father

in a property dispute, but that has nothing to say about where he was at that time or what he was doing.

Shakespeare's early life is really little more than a series of occasional sightings. So when we note that he was now about to embark on what are popularly known as his lost years, they are very lost indeed.

Chapter Three

The Lost Years, 1585–1592

F EW PLACES IN HISTORY can have been more deadly and desirable at the same time than London in the sixteenth century. Conditions that made life challenging elsewhere were particularly rife in London, where newly arrived sailors and other travelers continually refreshed the city's stock of infectious maladies.

Plague, virtually always present somewhere in the city, flared murderously every ten years or so. Those who could afford to left the cities at every outbreak. This in large part was the reason for the number of royal palaces just outside London—at Richmond, Greenwich, Hampton Court, and elsewhere. Public performances of all types—in fact all public gatherings except for churchgoing—were also banned within seven miles of London each time the death toll in the city reached forty, and that happened a great deal.

In nearly every year for at least 250 years, deaths outnum-

bered births in London. Only the steady influx of ambitious provincials and Protestant refugees from the Continent kept the population growing—and grow it did, from fifty thousand in 1500 to four times that number by century's end. (Such figures are of course estimates.) By the peak years of Elizabeth's reign, London was one of the great cities of Europe, exceeded in size only by Paris and Naples. In Britain no other place even came close to rivaling it. A single London district like Southwark had more people than Norwich, England's second city. But survival was ever a struggle. Nowhere in the metropolis did life expectancy exceed thirty-five years, and in some poorer districts it was barely twenty-five. The London that William Shakespeare first encountered was overwhelmingly a youthful place.

The bulk of the population was packed into 448 exceedingly cozy acres within the city walls around the Tower of London and Saint Paul's Cathedral. The walls survive today only in scattered fragments and relic names—notably those of its gateways: Bishopsgate, Cripplegate, Newgate, Aldgate, and so on—but the area they once physically bounded is still known as the City of London and remains administratively aloof from the much vaster, but crucially lowercased, city of London that surrounds it.

In Shakespeare's day the City was divided into a hundred or so parishes, many of them tiny, as all the proximate spires in the district attest even today (even when there are far fewer churches than in Shakespeare's time). The number varied slightly over time as parishes sometimes amalgamated, creat-

ing such mellifluous entities as "Saint Andrew Undershaft with All Hallows on the Wall" and "Saint Stephen Walbrook and Saint Benet Sheerhogg with Saint Laurence Pountney." It is a striking reflection of the importance of religion to the age that within such a snug ambit there existed scores of parish churches *and* a mighty cathedral, Saint Paul's, not to mention the nearby abbey at Westminster and the noble stone mount of Saint Mary Overie (now Southwark Cathedral) just across the river.

By modern standards the whole of greater London, including Southwark and Westminster, was small. It stretched only about two miles from north to south and three from east to west, and could be crossed on foot in not much more than an hour. But to an impressionable young provincial like William Shakespeare the clamor and clutter and endless jostle, the thought that any glimpsed face would in all likelihood never be seen again, must have made it seem illimitable. This was, after all, a city where a single theater held more people than his hometown.

In Shakespeare's day the walls were still largely intact, though often difficult to discern because so many buildings were propped against them. Beyond the walls the fields were rapidly filling in. In his great and stately *Survey of London*, published in 1598, when he was in his seventies, John Stow noted with dismay how many districts that had formerly looked out on open fields where people could "refresh their dull spirits in the sweet and wholesome air" now gave way to vast encampments of smoky hovels and workshops. (In a touching reminder of the timelessness of complaint, he also bemoaned the fact that

traffic in the city had grown impossible and that the young never walked.)*

London's growth was limited only by unsuitable conditions for building. Heavy clay soils to the north of the city made it nearly impossible to sink wells or provide adequate drainage, so the northern outskirts remained rural far longer. On the whole, however, growth was unrelenting. The authorities repeatedly issued edicts that new housing was not to be erected within three miles of City walls, under pain of demolition, but the fact that the edicts had so often to be renewed shows how little they were regarded. The one effect the laws *did* have was to discourage the erecting of buildings of quality outside the City walls, since they might at any moment be condemned. Instead London became increasingly ringed with slums.

Most of the districts that we think of now as integral parts of London—Chelsea, Hampstead, Hammersmith, and so on—were then quite separate, and in practical terms often quite distant, villages. Westminster, the seat of government, was a separate city, dominated by Westminster Abbey and Whitehall Palace, a twenty-three-acre complex of royal apartments, offices, storehouses, cockpits, tennis courts, tiltyards,

* A tailor by profession, Stow spent a lifetime and endured decades of poverty to put together his great history. He was seventy-three when it was published. His payment was £3 in cash and forty copies of his own book. When James I was asked to provide some charitable patronage for the old man, he merely sent him two letters giving him permission to beg. Stow actually did so, setting up alms bowls in the streets of the City, though without much effect.

and much else, bounded by several hundred acres of hunting grounds, which today survive in remnants as London's great central parks: Hyde Park and Kensington Gardens, Green Park, Saint James's Park, and Regent's Park.

With 1,500 rooms and a resident population of a thousand or so courtiers, servants, bureaucrats, and hangers-on, Westminster was the largest and busiest palace in Europe and headquarters for the English monarch and her government—though Elizabeth, like her father before her, used it only as a winter residence. Shakespeare would get to know at least part of the palace well, as player and playwright. Every bit of the historic palace is now gone except the Banqueting House, and Shakespeare never saw that, for the present building was built in 1619, after he died.

City life had a density and coziness that we can scarcely imagine now. Away from the few main thoroughfares, streets were much narrower than they are now, and houses, with their projecting upper floors, often all but touched. So neighbors were close indeed, and all the stench and effluvia that they produced tended to accumulate and linger. Refuse was a perennial problem. (Houndsditch, according to John Stow, got its name from the number of dogs thrown into it; even if fanciful the story is telling.) Rich and poor lived far more side by side than now. The playwright Robert Greene died in wretched squalor in a tenement in Dowgate, near London Bridge, only a few doors from the home of Sir Francis Drake, one of the wealthiest men in the land.

According to nearly all histories, the gates to the City were

locked at dusk, and no one was allowed in or out till dawn, though as dusk falls at midafternoon in a London winter there must have been some discretion in the law's application or there would have been, at the very least, crowds of stranded, and presumably aggrieved, playgoers on most days of the week. Movement was only fractionally less proscribed, at least in theory, inside the walls. A curfew took effect with darkness, at which time taverns were shut and citizens forbidden to be out, though the fact that the night constables and watchmen were nearly always portrayed in the theater as laughable dimwits (think of Dogberry in *Much Ado About Nothing*) suggests that they were not regarded with much fear.

The principal geographical feature of the city was the Thames. Unconstrained by artificial embankments, the river sprawled where it could. It was up to a thousand feet wide in places—much wider than it is today—and was the main artery for the movement of both goods and people, though the one span across it, London Bridge, stood as an unnerving impediment to through traffic. Because water accelerates as it flows through narrow openings, "shooting the bridge" was an exciting and risky adventure. A popular saying had it that London Bridge was made for wise men to pass over and fools to pass under. Despite all that was tipped into it, the river was remarkably full of life. Flounder, shrimp, bream, barbels, trout, dace, eels, and even occasionally swordfish, porpoises, and other exotica were among the catches hauled out by bemused or startled fishermen. On one memorable occasion, a whale nearly got caught between the arches of London Bridge.

The bridge was already venerable when Shakespeare first saw it. It had been built nearly four centuries earlier, in 1209, and would remain the only span across the river in London for nearly two centuries more. Standing a little east of today's London Bridge, it stretched more than nine hundred feet and was a little city in itself, with more than a hundred shops in scores of buildings of all shapes and sizes. The bridge was the noisiest place in the metropolis, but also the cleanest (or at least the best aired), and so became an outpost of wealthy merchants—a kind of sixteenth-century Bond Street. Because space was so valuable, some of the buildings were six stories high and projected as much as sixty-five feet over the river, supported by mighty struts and groaning buttresses. It even had its own precarious palace, Nonesuch House, built in the late 1570s, teetering at its southern end.

By long tradition at the Southwark end of the bridge the heads of serious criminals, especially traitors, were displayed on poles, each serving as a kind of odd and grisly bird feeder. (The headless bodies were hung above the entrance gates to the city, or distributed to other cities across the realm.) There were so many heads, indeed, that it was necessary to employ a Keeper of the Heads. Shakespeare, arriving in London, was possibly greeted by the heads of two of his own distant kinsmen, John Somerville and Edward Arden, who were executed in 1583 for a fumbling plot to kill the queen.

The other dominant structure in the city was old Saint Paul's Cathedral, which was even larger than the one we see today, though its profile was oddly stunted. A steeple that had

once pierced the sky to a height of five hundred feet had been lost to lightning just before Shakespeare was born and never replaced. The cathedral that Elizabethans knew would vanish in the Great Fire of 1666, a generation or so in the future, making way for the stately white Christopher Wren edifice we see today.

Saint Paul's stood in an immense open square, covering about twelve acres all together, which served, a bit unexpectedly, as both cemetery and market. It was filled on most days with the stalls of printers and stationers, a sight that must have been hypnotizing for a young man with an instinctive regard for words. Printed books had already existed, as luxuries, for a century, but this was the age in which they first became accessible to anyone with a little spare income. At last average people could acquire learning and sophistication on demand. More than seven thousand titles were published in London in Elizabeth's reign—a bounty of raw materials waiting to be absorbed, reworked, or otherwise exploited by a generation of playwrights experimenting with entirely new ways of entertaining the public. This was the world into which Shakespeare strode, primed and gifted. He must have thought he'd found very heaven.

Inside, the cathedral was an infinitely noisier and more public place than we find today. Carpenters, bookbinders, scriveners, lawyers, haulers, and others all plied their trades within its echoing vastness, even during services. Drunks and vagrants used it is as a place of repose; some relieved themselves in corners. Little boys played ball games in the aisles until chased away. Other people made small fires to keep warm. John

Evelyn could have been writing of Saint Paul's when he noted, a generation later, "I have been in a spacious church where I could not discern the minister for the smoke; nor hear him for the people's barking."

Many used the building as a shortcut, particularly when it rained. The desire to retire indoors was motivated by fashion as much as any sudden interest in comfort. Starch, a stylish new item just making its way into England from France, notoriously wilted in rain. Starch's possibilities for fashionable discomfort were already being translated into increasingly exotic ruffs, soon to be known as *piccadills* (or *peckadills*, *pickadailles*, *picardillos*, or any of about twenty other variants), from which ultimately would come the name "Piccadilly," and these grew "every day worser and worser" as one contemporary glumly noted.* Moreover, dyes were not yet colorfast, or even close to it, adding a further powerful incentive to stay dry.

Partly for this reason Sir Thomas Gresham had recently built the Royal Exchange, the most fabulous commercial building of its day. (Gresham is traditionally associated with Gresham's law—that bad money drives out good—which he may or may not actually have formulated.) Modeled on the Bourse in Antwerp, the Exchange contained 150 small shops, making it one

* The word *piccadill* was first recorded by the playwright Thomas Dekker in 1607 in *Northward Ho*. Eventually a house near the modern Trafalgar Square became informally but popularly known as Piccadilly Hall, possibly because its owner made his money selling piccadills. The street running west toward Hyde Park took its name from the hall, not the ruffs.

of the world's first shopping malls, but its primary purpose and virtue was that for the first time it allowed City merchants— some four thousand of them—to conduct their business indoors out of the rain. We may marvel that they waited so long to escape the English weather, but there we are.

Among other differences we would notice between then and now was much to do with dining and diet. The main meal was taken at midday and, among the better off, often featured foods that are uneaten now—crane, bustard, swan, and stork, for instance. Those who ate well ate at least as well as people today. A contemporary of Shakespeare's (and a friend of the family) named Elinor Fettiplace left to posterity a household management book from 1604—one of the first of its type to survive—that contains recipes for any number of dishes of delicacy and invention: mutton with claret and Seville orange juice, spinach tart, cheesecakes, custards, creamy meringues.* Other contemporary accounts—not least the plays of Shakespeare and his fellow writers—show an appreciation for dietary variety that many of us would be pressed to match today.

For poorer people, not surprisingly, diet was much simpler and more monotonous, consisting mainly of dark bread and

* Fettiplace's book is a gossipy, wide-ranging compendium of recipes, cleaning tips, and other domestic concerns gathered from relatives and friends. Among these friends was John Hall, Shakespeare's son-in-law. So it is entirely possible that she knew the playwright himself; she must certainly have known of him. But if she had any idea of his importance to posterity, or how grateful we would be for even the slightest word of his character and appetites, she failed to note it in her household accounts.

cheese, with a little occasional meat. Vegetables were eaten mostly by those who could afford nothing better. The potato was an exotic newcomer, still treated skeptically by many because its leaves looked similar to those of poisonous nightshade. Potatoes wouldn't become a popular food until the eighteenth century. Tea and coffee were yet unknown.

People of all classes loved their foods sweet. Many dishes were coated with sticky sweet glazes, and even wine was sometimes given a generous charge of sugar, as were fish, eggs, and meats of every type. Such was the popularity of sugar that people's teeth often turned black, and those who failed to attain the condition naturally sometimes blackened their teeth artificially to show that they had had their share of sugar, too. Rich women, including the queen, made themselves additionally beauteous by bleaching their skin with compounds of borax, sulfur, and lead—all at least mildly toxic, sometimes very much more so—for pale skin was a sign of supreme loveliness. (Which makes the "dark lady" of Shakespeare's sonnets an exotic being in the extreme.)

Beer was drunk copiously, even at breakfast and even by the pleasure-wary Puritans. (The ship that took the Puritan leader John Winthrop to New England carried him, ten thousand gallons of beer, and not much else.) A gallon a day was the traditional ration for monks, and we may assume that most others drank no less. For foreigners English ale was an acquired taste even then. As one continental visitor noted uneasily, it was "cloudy like horse's urine." The better off drank wine, generally by the pint.

Tobacco, introduced to London the year after Shakespeare's birth, was a luxury at first but soon gained such widespread popularity that by the end of the century there were no fewer than seven thousand tobacconists in the City. It was employed not only for pleasure but as a treatment for a broad range of complaints, including venereal disease, migraine, and even bad breath, and was seen as such a reliable prophylactic against plague that even small children were encouraged to use it. For a time pupils at Eton faced a beating if caught neglecting their tobacco.

Criminality was so widespread that its practitioners split into fields of specialization. Some became *coney catchers*, or swindlers (a coney was a rabbit reared for the table and thus unsuspectingly tame); others became *foists* (pickpockets), *nips*, or *nippers* (cutpurses), *hookers* (who snatched desirables through open windows with hooks), *abtams* (who feigned lunacy to provide a distraction), *whipjacks*, *fingerers*, *cross biters*, *cozeners*, *courtesy men*, and many more. Brawls were shockingly common. Even poets carried arms. An actor named Gabriel Spencer killed a man named James Freake in a duel, then in turn was killed by Ben Jonson two years later. Christopher Marlowe was involved in at least two fatal fights, one in which he helped a colleague kill a young innkeeper and another in which he was killed in a drunken scuffle in Deptford.

We don't know when Shakespeare first came to London. Ever a shadow even in his own biography, he disappears, all but utterly, from 1585 to 1592, the very years we would most like to know where he was and what he was up to, for it was in this

period that he left Stratford (and, presumably, wife and family) and established himself as an actor and playwright. There is not a more tempting void in literary history, nor more eager hands to fill it.

Among the first to try was John Aubrey, who reported in 1681, long after Shakespeare was dead, that he was a schoolmaster in the country, but no evidence has ever been presented to support the claim. Various other suggestions for the lost years have him traveling in Italy, passing his time as a soldier in Flanders, or going to sea—possibly, in the more romantic versions, sailing with Drake on the *Golden Hinde*. Generally none of this is based on anything other than a need to put him *somewhere* and a desire to explain some preoccupation or area of expertise that later became evident in his work.

It is often noted, for instance, that Shakespeare's plays are full of ocean metaphors ("take arms against a sea of troubles," "an ocean of salt tears," "wild sea of my conscience") and that every one of his plays has at least one reference to the sea in it somewhere. But the idea that this argues for a maritime spell in his life shrivels slightly when you realize that *sailor* appears just four times in his work and *seamen* only twice. Moreover, as Caroline Spurgeon long ago noted, Shakespeare's marine allusions mostly depict the sea as a hostile and forbidding environment, a place of storms and shipwrecks and unsettling depths—precisely the perspective one would expect from someone who wasn't comfortably acquainted with it. In any case there is an obvious danger in reading too much into word frequencies. Shakespeare refers to Italy in his work more often

than to Scotland (35 times to 28) and to France far more than
to England (369 references to 243), but we would hardly sup-
pose him French or Italian.

One possibility for how Shakespeare spent these missing
years, embraced with enthusiasm by some scholars, is that he
didn't come to London by any direct route, but rather went to
northern England, to Lancashire, as a recusant Catholic. The
idea was first put forward as long ago as 1937 but has gained
momentum in recent years. As it now stands it is a compli-
cated and ingenious theory based (as I believe its proponents
would freely enough concede) on a good deal of supposition.
The gist of it is that Shakespeare may have passed his time in
the north as a tutor and possibly as an actor (we must, after all,
get him ready for a theatrical career soon afterward), and that
the people responsible for this were Roman Catholics.

There is certainly no shortage of possible Catholic connec-
tions. Throughout Shakespeare's early years, some four hundred
English-born, French-trained Jesuit missionaries were slipped
into England to offer illicit religious services to Catholics, often
in large secret gatherings on Catholic estates. It was danger-
ous work. About a quarter of the missionaries were caught and
dreadfully executed, though others were simply rounded up
and sent back to France. Those who escaped capture, or were
brave enough to return and try again, often worked exceedingly
productively. Robert Parsons and Edmund Campion between
them were said to have converted (or reconverted) twenty thou-
sand people on a single tour.

In 1580, when William was sixteen, Campion passed

through Warwickshire on his way to the more safely Catholic north. He stayed with a distant relative of Shakespeare's, Sir William Catesby, whose son Robert would later be a ringleader of the Gunpowder Plot. One of the masters at Shakespeare's school during his time there (always assuming he *was* there) was John Cottom, who came from a prominent Catholic family in Lancashire and whose brother was a missionary priest closely associated with Campion. In 1582 this latter Cottom was caught, tortured, and put to death, along with Campion himself. Meanwhile his older brother, the schoolmaster, had left Stratford—whether in a hurry or not is unknown—and returned to Lancashire, where he declared his Catholicism openly.

The thought is that this Cottom may have taken Will with him. What adds appeal to the theory is that the following year a "William Shakeshafte" appears in the household accounts of Alexander Hoghton, a prominent Catholic living just ten miles from the Cottom family seat. Moreover Hoghton in his will commended this Shakeshafte to a fellow Catholic and landowner, Thomas Hesketh, as someone worth employing. In the same passage Hoghton also mentioned the disposition of his musical instruments and "play clothes," or costumes. "This sequence," notes the Shakespeare authority Robert Bearman, "suggests that this Shakeshafte was either a household musician or player or both."

According to one version of the theory, Shakespeare, on the strength of Hoghton's endorsement, moved to the Hesketh family seat, at Rufford, and there encountered traveling troupes of play-

ers, such as Lord Derby's Men, through which he made a connection that took him to London and a life in the theater. Interestingly one of Shakespeare's later business associates, a goldsmith named Thomas Savage, who served as a trustee for the leasehold on the Globe, was also from Rufford and related by marriage to the Hesketh family. So the coincidences are intriguing.

However, it must be said that one or two troubling considerations need to be accounted for in all this. First, there is the problem that William Shakeshafte received an unusually large annuity of two pounds in Hoghton's will—more than any other member of the household but one. That would be a generous gift indeed, bearing in mind that our William Shakespeare was just seventeen years old and could have been in Hoghton's employ for only a few months at the time of the latter's death. It seems more likely, on the face of it, that such a bequest would go to a longer-serving, and no doubt more elderly, employee, as a kind of pension.

There is also the curious matter of the name. "Shakeshafte" is clearly not an ingenious alias. Some scholars maintain that "Shakeshafte" was simply a northern variant of "Shakespeare," and that our Will wasn't trying to hide his name but merely to adapt it. This may be so but it suggests a further reason for uncertainty. "Shakeshafte" was not an uncommon name in Lancashire. In 1582 the records show seven Shakeshafte households in the area, of which at least three had members named William. So it requires a certain leap of faith to suppose with any confidence that this one was the young Will from Stratford. As Frank Kermode succinctly summed up the Catholic issue

(in the *New York Times Book Review*), "There seems to be no reason whatever to believe this except the pressure of a keen desire for it to be true."

In addition to all this there is the problem of allowing Shakespeare time enough for both a Lancashire adventure and a return to Stratford to woo and bed Anne Hathaway. Shakespeare's first child, Susanna, was baptized in May 1583, indicating conception the previous August—at just about the time he is supposed to have been in Lancashire. It is not impossible that William Shakespeare could have been a Catholic in Lancashire and a suitor to Anne Hathaway at more or less the same time—as well as a budding theatrical figure—but one may reasonably ask if that isn't supposing rather a lot.

It is impossible to say how religious Shakespeare was, or if he was at all. The evidence, predictably, is mixed. Samuel Schoenbaum was struck by how often certain biblical allusions appeared in Shakespeare's work; the story of Cain, for instance, appears twenty-five times in thirty-eight plays—quite a high proportion. But Otto Jespersen and Caroline Spurgeon thought Shakespeare almost wholly *un*interested in biblical themes, and noted that nowhere in his works did the words "Bible," "Trinity" or "Holy Ghost" appear—a conclusion endorsed in more recent times by the British historian Richard Jenkyns. "The more Elizabethan literature one reads," he has written, "the more striking is Shakespeare's paucity of religious reference." The British authority Stanley Wells, however, contends that Shakespeare's plays "are riddled with biblical allusions."

In short, and as always, a devoted reader can find support for nearly any position he or she wishes in Shakespeare. (Or as Shakespeare himself put it in a much misquoted line: "The devil can cite Scripture for his purpose.") As Professor Harry Levin of Harvard has noted, Shakespeare condemned suicide in plays like *Hamlet*, where it would conflict with sixteenth-century Christian dogma, but treated it as ennobling in his Roman and Egyptian plays, where it was appropriate (and safe) to suggest as much. From what little is known, and whatever their private thoughts may have been, it is certainly the case from their marriages, christenings, and so on that John Shakespeare and William gave every appearance of being dutiful, if not necessarily pious, Protestants.

David Thomas of the National Archives thinks it unlikely in any case that a definitive answer will ever emerge as to whether Shakespeare passed his lost period in Lancashire, as a Catholic or otherwise. "Unless he got married or had children there, or bought property or paid taxes—and people at his level at that time didn't pay taxes—or committed a crime or sued someone, he wouldn't appear in the record. As far as we know, he didn't do any of those things." Instead the only proof of Shakespeare's existence we have for the period is a passing reference to him on a legal document, which gives no indication of his occupation or whereabouts.

Tensions between Protestants and Catholics came to a head in 1586 when Mary, Queen of Scots, was implicated in a plot to overthrow the queen and Elizabeth agreed, reluctantly, that she

must be executed. Killing a fellow monarch, however threatening, was a grave act, and it provoked a response. In the spring of the following year, Spain dispatched a mighty navy to capture the English throne and replace Elizabeth.

The greatest fleet that "ever swam upon the sea," the Spanish Armada looked invincible. In battle formation it spread over seven miles of sea and carried ferocious firepower: 123,000 cannonballs and nearly three thousand cannons, plus every manner of musket and small arms, divided between thirty thousand men. The Spanish confidently expected the swiftest of triumphs—one literally for the glory of God. Once England fell, and with the English fleet in Spanish hands, the very real prospect arose of the whole of Protestant Europe being toppled.

Things didn't go to plan, to put it mildly. England's ships were nimbler and sat lower in the water, making them awkward targets. They could dart about doing damage here and there while the Spanish guns, standing on high decks, mostly fired above them. The English ships were better commanded, too (or so all English history books tell us). It is only fair to note that most vessels of the Spanish fleet were not battleships but overloaded troop carriers, making plump and lumbering targets. The English also enjoyed a crucial territorial edge: They could exploit their intimate knowledge of local tides and currents, and could dart back to the warm comfort of home ports for refreshment and repairs. Above all they had a decisive technological advantage: cast-iron cannons, an English invention that other nations had not yet perfected, which fired straighter and

were vastly sturdier than the Spanish bronze guns, which were poorly bored and inaccurate and had to be allowed to cool after every two or three rounds. Crews that failed to heed this—and in the heat of battle it was easy to lose track—often blew themselves up. In any case the Spanish barely trained their gun crews. Their strategy was to come alongside and board enemy ships, capturing them in hand-to-hand combat.

The rout was spectacular. It took the English just three weeks to pick the opponent's navy to pieces. In a single day the Spanish suffered eight thousand casualties. Dismayed and confused, the tattered fleet fled up the east coast of England and around Scotland into the Irish Sea, where fate dealt it further cruel blows in the form of lashing gales, which wrecked at least two dozen ships. A thousand Spanish bodies, it was recorded, washed up on Irish beaches. Those who struggled ashore were often slaughtered for their baubles. By the time the remnants of the Armada limped home, it had lost seventeen thousand men out of the thirty thousand who had set off. England lost no ships at all.

The defeat of the Spanish Armada changed the course of history. It induced a rush of patriotism in England that Shakespeare exploited in his history plays (nearly all written in the following decade), and it gave England the confidence and power to command the seas and build a global empire, beginning almost immediately with North America. Above all it secured Protestantism for England. Had the Armada prevailed, it would have brought with it the Spanish Inquisition, with goodness knows what consequences for Elizabethan Eng-

land—and the young man from Warwickshire who was just about to transform its theater.

There is an interesting postscript to this. A century and a half after John Shakespeare's death, workmen rooting around in the rafters of the Shakespeare family home on Henley Street in Stratford found a written testament—a "Last Will of the Soul," as it was called—declaring John's adherence to the Catholic faith. It was a formal declaration of a type known to have been smuggled into England by Edmund Campion.

Scholars have debated ever since whether the document itself was genuine, whether John Shakespeare's signature upon it was genuine, and what any of this might or might not imply about the religious beliefs of William Shakespeare. The first two of these questions are likely to remain forever unresolvable as the document was lost sometime after its discovery, and the third could never be other than a matter of conjecture anyway.

Chapter Four

In London

I N 1596, WHILE ATTENDING a performance at the new
Swan Theatre in London, a Dutch tourist named Johannes
de Witt did a very useful thing that no one, it seems, had ever
done before. He made a sketch—rather rough and with a not
wholly convincing grasp of perspective—depicting the Swan's
interior as viewed from a central seat in the upper galleries.
The sketch shows a large projecting stage, partly roofed, with
a tower behind containing a space known as the tiring (short
for "attiring") house—a term whose earliest recorded use is by
William Shakespeare in *A Midsummer Night's Dream*—where
the actors changed costumes and grabbed props. Above the
tiring area were galleries for musicians and audience, as well as
spaces that could be incorporated into performances, for bal-
cony scenes and the like. The whole bears a striking resem-
blance to the interior of the replica Globe Theatre we find on
London's Bankside today.

De Witt's little effort was subsequently lost, but luckily a friend of his had made a faithful copy in a notebook, and this eventually found its way into the archives of the library of the University of Utrecht in the Netherlands. There it sat unregarded for almost three hundred years. But in 1888 a German named Karl Gaedertz found the notebook and its rough sketch, and luckily—all but miraculously—recognized its significance, for the sketch represents the only known visual depiction of the interior of an Elizabethan playhouse in London. Without it we would know essentially nothing about the working layout of theaters of the time. Its uniqueness explains the similarity of the interior design of the new, replica Globe. It was all there was to go on.

Two decades after de Witt's visit, another Dutchman, an artist named Claes Jan Visscher, produced a famous engraved panorama of London, showing in the foreground the theaters of Bankside, the Globe among them. Roughly circular and with a thatched roof, this was very much Shakespeare's "wooden O" and has remained the default image of the theater ever since. However, in 1948, a scholar named I. A. Shapiro showed pretty well conclusively that Visscher had based his drawing on an earlier engraving, from 1572, before any of the theaters he depicted had actually been built. In fact, it appeared that Visscher had never actually been to London and so was hardly the most reliable of witnesses.

This left just one illustration from the era known to have been drawn from life and that was a view made by a Bohemian artist named Wenceslas Hollar sometime in the late 1630s or

early 1640s. Called the *Long View*, it is a lovely drawing— "perhaps the most beautiful and harmonious of all London panoramas," in Peter Ackroyd's estimation—but a slightly strange one in that it depicts a view from a position slightly above and behind the tower of Southwark Cathedral (then known as the Church of Saint Saviour and Saint Mary Overie), as if Hollar had been looking down on the cathedral from another building—a building that did not in fact exist.

So it is a view—entirely accurate as far as can be made out—that no human had ever seen. More to the point, it showed the second Globe, not the first, which had burned down in 1613, three years before Shakespeare died. The second Globe was a fine theater, and we are lucky to have Hollar's drawing of it, for it was pulled down soon afterward, but it was patently not the place where *Julius Caesar, Macbeth*, and a dozen or so other Shakespeare plays were (probably to almost certainly) first performed. In any case the Globe was only a very small part of the whole composition and was depicted as seen from a distance of nine hundred feet, so it offers very little detail.

And there you have the complete visual record we possess of theaters in Shakespeare's day and somewhat beyond: one rough sketch of the interior of a playhouse Shakespeare had no connection with, one doubtful panorama by someone who may never have seen London, and one depiction done years after Shakespeare left the scene showing a theater he never wrote for. The best that can be said of any of them is that they may bear some resemblance to the playhouses Shakespeare knew, but possibly not.

The written record for the period is not a great deal more enlightening. Most of what little we know about what it was like to attend the theater in Shakespeare's time comes from the letters and diaries of tourists, for whom the London sights were novel enough to be worth recording. Sometimes, however, it is a little hard to know quite what to make of these. In 1587 a visitor from the country wrote excitedly to his father about an unexpected event he had seen at a performance by the Admiral's Men: One actor had raised a musket to fire at another, but the musket ball "missed the fellow he aimed at and killed a child, and a woman great with child forthwith, and hit another man in the head very sore." It is astounding to suppose that actors were firing live muskets—which in the sixteenth century were really little more than exploding sticks—in the confined space of a theater, but, if so, one wonders where they were hoping the musket ball *would* lodge. The Admiral's Men failed to secure an invitation to take part in the Christmas revels at court the following month—something that would normally have been more or less automatic—so it would appear that they were in some sort of temporary disgrace.

We would know even less about the business and structure of Elizabethan theatrical life were it not for the diary and related papers of Philip Henslowe, proprietor of the Rose and Fortune theaters. Henslowe was a man of many parts, not all of them entirely commendable. He was an impresario, moneylender, property investor, timber merchant, dyer, starch manufacturer, and, in a very big way, brothel keeper, among much else. He was famous among writers for advancing them small

sums, then keeping them in a kind of measured penury, the better to coax plays from them. But for all his shortcomings, Henslowe redeemed himself to history by keeping meticulous records, of which those from the years 1592 to 1603 survive. His "diary," as it is usually called, wasn't really a diary so much as a catchall of preoccupations; it included a recipe for curing deafness, notes on casting spells, even advice on how best to pasture a horse. But it also incorporated invaluable details of the day-to-day running of a playhouse, including the names of plays his company performed and the actors employed, along with exhaustive lists of stage props and wardrobes (including a delightfully mysterious "robe for to go invisible").

Henslowe's papers also included a detailed contract for the building of the Fortune Theatre, at an agreed-on cost of £440, in 1600. Although the Fortune was not much like the Globe— it was somewhat larger, and square rather than round—and although the contract included no drawings, it provided specifications on the heights and depths of the galleries, the thickness of wood to be used in the floors, the composition of plaster in the walls, and other details that proved immeasurably beneficial in building the replica Globe on Bankside in 1997.

Theaters as dedicated spaces of entertainment were a new phenomenon in England in Shakespeare's lifetime. Previously players had performed in innyards or the halls of great homes or other spaces normally used for other purposes. London's first true playhouse appears to have been the Red Lion, built in 1567 in Whitechapel by an entrepreneur named John Brayne. Almost nothing is known about the Red Lion, including how

much success it enjoyed, but its life appears to have been short. Still, it must have shown some promise, for nine years after its construction Brayne was at it again, this time working in league with his brother-in-law, James Burbage, who was a carpenter by trade but an actor and impresario by nature. Their new theater—called the Theatre—opened in 1576 a few hundred yards to the north of the City walls near Finsbury Fields in Shoreditch. Soon afterward Burbage's longtime rival Henslowe opened the Curtain Theatre just up the road, and London was a truly theatrical place.

William Shakespeare could not have chosen a more propitious moment to come of age. By the time he arrived in London in (presumably) the late 1580s, theaters dotted the outskirts and would continue to rise throughout his career. All were compelled to reside in "liberties," areas mostly outside London's walls where City laws and regulations did not apply. It was a banishment they shared with brothels, prisons, gunpowder stores, unconsecrated graveyards, lunatic asylums (the notorious Bedlam stood close by the Theatre), and noisome enterprises like soapmaking, dyeing, and tanning—and these could be noisome indeed. Glue makers and soapmakers rendered copious volumes of bones and animal fat, filling the air with a cloying smell that could be all but worn, while tanners steeped their products in vats of dog feces to make them supple. No one reached a playhouse without encountering a good deal of odor.

The new theaters did not prosper equally. Within three years of its opening, the Curtain was being used for fencing

bouts, and all other London playhouses, with the single eventual exception of the Globe, relied on other entertainments, particularly animal baiting, to fortify their earnings. The pastime was not unique to England, but it was regarded as an English specialty. Queen Elizabeth often had visitors from abroad entertained with bearbaiting at Whitehall. In its classic form, a bear was put in a ring, sometimes tethered to a stake, and set upon by mastiffs, but bears were expensive investments, so other animals (such as bulls and horses) were commonly substituted. One variation was to put a chimpanzee on the back of a horse and let the dogs go for both together. The sight of a screeching ape clinging for dear life to a bucking horse while dogs leaped at it from below was considered about as rich an amusement as public life could offer. That an audience that could be moved to tears one day by a performance of *Doctor Faustus* could return the next to the same space and be just as entertained by the frantic deaths of helpless animals may say as much about the age as any single statement could.

It was also an age that gave rise to the Puritans, a people so averse to sensual pleasure that they would rather live in a distant wilderness in the New World than embrace tolerance. Puritans detested the theater and tended to blame every natural calamity, including a rare but startling earthquake in 1580, on the playhouses. They considered theaters, with their lascivious puns and unnatural cross-dressing, a natural haunt for prostitutes and shady characters, a breeding ground of infectious diseases, a distraction from worship, and a source of unhealthy sexual excitement. All the female parts were of course played by

boys—a convention that would last until the Restoration in the 1660s. In consequence the Puritans believed that the theaters were hotbeds of sodomy—still a capital offense in Shakespeare's lifetime*—and wanton liaisons of all sorts.

There may actually have been a little something to this, as popular tales of the day suggest. In one story a young wife pleads with her husband to be allowed to attend a popular play. Reluctantly the husband consents, but with the strict proviso that she be vigilant for thieves and keep her purse buried deep within her petticoats. Upon her return home, the wife bursts into tears and confesses that the purse has been stolen. The husband is naturally astounded. Did his wife not feel a hand probing beneath her dress? Oh, yes, she responds candidly, she had felt a neighbor's hand there—"but I did not think he had come for *that.*"

Fortunately for Shakespeare and for posterity, the queen brushed away all attempts to limit public amusements, including on Sundays. For one thing she liked them herself, but equally pertinent, her government enjoyed hearty revenues from licensing bowling alleys, theatrical productions, gaming houses (even though gambling was actually illegal in London), and the sale and manufacture of much that went on in them.

* Stephen Orgel makes the point that sodomy, though inveighed against in law, was tolerated in practice as long as it was discreet. Far more at risk of prosecution were incautious heterosexual females, because illicit births added inexcusably to the poor rolls.

But though plays were tolerated, they were strictly regulated. The Master of the Revels licensed all dramatic works (at a cost of 7 shillings per license) and made sure that companies performed in a manner that he considered respectful and orderly. Those who displeased him could in theory be jailed at his indefinite pleasure, and punishments were not unknown. In 1605, soon after the accession of James I, Ben Jonson and his collaborators on *Eastward Ho!* made some excellent but unwisely intemperate jokes about the sudden influx of rough and underwashed Scots to the royal court and were arrested and threatened with having their ears and noses lopped off. It was because of these dangers (and the Vagrancy Act of 1572, which specifically authorized the whipping of unlicensed vagabonds) that acting troupes attached themselves to aristocratic patrons. The patron afforded the actors some measure of protection, and they in turn carried his name across the land, lending him publicity and prestige. For a time patrons collected troupes of actors rather in the way rich people of a later age collected racehorses or yachts.

Plays were performed at about two o'clock in the afternoon. Handbills were distributed through the streets advertising what was on offer, and citizens were reminded that a play was soon to start by the appearance of a banner waving from the highest part of the structure in which a performance was to take place and a fanfare of trumpets that could be heard across much of the city. General admission for groundlings—those who stood in the open around the stage—was a penny. Those who wished to sit paid a penny more, and those who desired a cushion paid

another penny on top of that—all this at a time when a day's wage was 1 shilling (12 pence) or less a day. The money was dropped into a box, which was taken to a special room for safekeeping—the box office.

For those who could afford an additional treat, apples and pears (both apt to be used as missiles during moments of disappointment) and nuts, gingerbread, and bottles of ale were on offer, as was the newly fashionable commodity tobacco. A small pipeful cost 3 pence—considerably more than the price of admission. There were no toilets—or at least no official ones. Despite their large capacity, theaters were reasonably intimate. No one in the audience was more than fifty feet or so from the edge of the stage.

Theaters had little scenery and no curtains (even at the Curtain), no way to distinguish day from night, fog from sunshine, battlefield from boudoir, other than through words. So scenes had to be set with a few verbal strokes and the help of a compliant audience's imagination. As Wells and Taylor note, "Oberon and Prospero have only to declare themselves invisible to become so."

No one set scenes more brilliantly and economically than Shakespeare. Consider the opening lines of *Hamlet*:

> *Barnardo*: Who's there?
> *Francisco*: Nay, answer me. Stand, and unfold yourself.
> *Barnardo*: Long live the King!
> *Francisco*: Barnardo?
> *Barnardo*: He.

In five terse lines Shakespeare establishes that it is night-time and cold ("unfold yourself" means "draw back your cloak"), that the speakers are soldiers on guard, and that there is tension in the air. With just fifteen words—eleven of them monosyllables—he has the audience's full, rapt attention.

Costumes were elaborate and much valued but not always greatly assembled with historical veracity, it would seem. We know this because a man named Henry Peacham (or so it is assumed; his name is scribbled in the margin) made a sketch of a scene in *Titus Andronicus* during one of its performances. Where and when precisely this happened is not known, but the sketch shows a critical moment in the play when Tamora begs Titus to spare her sons and portrays with some care the postures and surprisingly motley costumes (some suitably ancient, others carelessly Tudor) of the performers. For audience and players alike, it appears, a hint of antiquity was sufficient. Realism came rather in the form of gore. Sheep's or pig's organs and a little sleight of hand made possible the lifting of hearts from bodies in murder scenes, and sheep's blood was splashed about for a literal touch of color on swords and flesh wounds. Artificial limbs were sometimes strewn over imagined fields of battle—"as bloody as may be," as one set of stage directions encouraged. Plays, even the solemn ones, traditionally ended with a jig as a kind of bonus entertainment.

It was a time of rapid evolution for theatrical techniques. As Stanley Wells has written: "Plays became longer, more ambitious, more spectacular, more complex in construction, wider

in emotional range, and better designed to show off the talents of their performers." Acting styles became less bombastic. A greater naturalism emerged in the course of Shakespeare's lifetime—much of which he helped to foster. Shakespeare and his contemporaries also enjoyed a good deal of latitude in subject and setting. Italian playwrights, following the classical Roman tradition, were required to set their plays around a town square. Shakespeare could place his action wherever he wished: on or in hillsides, forts, castles, battlefields, lonesome islands, enchanted dells, anywhere an imaginative audience could be persuaded to go.

Plays, at least as written, were of strikingly variable lengths. Even going at a fair clip and without intermissions, *Hamlet* would run for nearly four and a half hours. *Richard III, Coriolanus*, and *Troilus and Cressida* were only slightly shorter. Jonson's *Bartholomew Fair* would have taken no less than five hours to perform, unless judiciously cut, as it almost certainly was. (Shakespeare and Jonson were notoriously copious. Of the twenty-nine plays of three thousand lines or more that still exist from the period 1590–1616, twenty-two are by Jonson or Shakespeare.)

A particular challenge for audience and performers alike must surely have been the practice of putting male players in female parts. When we consider how many powerful and expressive female roles Shakespeare created—Cleopatra, Lady Macbeth, Ophelia, Juliet, Desdemona—the actors must have been gifted dissemblers indeed. Rosalind in *As You Like It* has about a quarter of all the lines in the play; Shakespeare clearly

had enormous confidence in some young actor. Yet, while we often know a good deal about performers in male roles from Shakespeare's day, we know almost nothing about the conduct of the female parts. Judith Cook, in *Women in Shakespeare*, says she could not find a single record of any role of a woman played by a specific boy actor. We don't even know much about boy actors in general terms, including how old they were. For many of a conservative nature, stage transvestism was a source of real anxiety. The fear was that spectators would be attracted to both the female character and the boy beneath, thus becoming doubly corrupted.

This disdain for female actors was a Northern European tradition. In Spain, France, and Italy, women were played by women—a fact that astonished British travelers, who seem often to have been genuinely surprised to find that women could play women as competently onstage as in life. Shakespeare got maximum effect from the gender confusion by constantly having his female characters—Rosalind in *As You Like It*, Viola in *Twelfth Night*—disguise themselves as boys, creating the satisfyingly dizzying situation of a boy playing a woman playing a boy.

The golden age of theater lasted only about the length of a good human lifetime, but what a wondrously prolific and successful period it was. Between the opening of the Red Lion in 1567 and the closing of all the theaters by the Puritans seventy-five years later, London's playhouses are thought to have attracted fifty million paying customers, something like ten times the entire country's population in Shakespeare's day.

To prosper, a theater in London needed to draw as many as two thousand spectators a day—about 1 percent of the city's population—two hundred or so times a year, and to do so repeatedly against stiff competition. To keep customers coming back, it was necessary to change the plays continually. Most companies performed at least five different plays in a week, sometimes six, and used such spare time as they could muster to learn and rehearse new ones.

A new play might be performed three times in its first month, then rested for a few months or abandoned altogether. Few plays managed as many as ten performances in a year. So quite quickly there arose an urgent demand for material. What is truly remarkable is how much quality the age produced in the circumstances. Few writers made much of a living at it, however. A good play might fetch £10, but as such plays were often collaborations involving as many as half a dozen authors, an individual share was modest (and with no royalties or other further payments). Thomas Dekker cranked out, singly or in collaboration, no fewer than thirty-two plays in three years, but never pocketed more than 12 shillings a week and spent much of his career imprisoned for debt. Even Ben Jonson, who passed most of his career in triumph and esteem, died in poverty.

Plays belonged, incidentally, to the company, not the playwright. A finished play was stamped with a license from the Master of the Revels giving permission for its staging, so it needed to be retained by the company. It is sometimes considered odd that no play manuscripts or prompt books were found

among Shakespeare's personal effects at his death. In fact it would have been odd if they had been.

For authors and actors alike, the theatrical world was an insanely busy place, and for someone like William Shakespeare, who was playwright, actor, part owner, and probably de facto director as well (there were no formal directors in his day), it must have been nearly hysterical at times. Companies might have as many as thirty plays in their active repertoire, so a leading actor could be required to memorize perhaps fifteen thousand lines in a season—about the same as memorizing every word in this book—as well as remember every dance and sword thrust and costume change. Even the most successful companies were unlikely to employ more than a dozen or so actors, so a great deal of doubling up was necessary. *Julius Caesar*, for instance, has forty named characters, as well as parts for unspecified numbers of "servants," "other plebeians," and "senators, soldiers, and attendants." Although many of these had few demanding lines, or none at all, it was still necessary in every case to be fully acquainted with the relevant props, cues, positions, entrances, and exits, and to appear on time correctly attired. That in itself must have been a challenge, for nearly all clothing then involved either complicated fastenings—two dozen or more obstinate fabric clasps on a standard doublet—or yards of lacing.

In such a hothouse, reliability was paramount. Henslowe's papers show that actors were subjected to rigorous contractual obligations, with graduated penalties for missing rehearsals, being drunk or tardy, failing to be "ready apparelled" at the

right moment, or—strikingly—for wearing any stage costumes outside the playhouse. Costumes were extremely valuable, so the fine was a decidedly whopping (and thus probably never imposed) £40. But even the most minor infractions, like tardiness, could cost an actor two days' pay.

Shakespeare appears to have remained an actor throughout his professional life (unlike Ben Jonson, who quit as soon as he could afford to), for he was listed as an actor on documents in 1592, 1598, 1603, and 1608—which is to say at every phase of his career. It can't have been easy to have been an actor as well as a playwright, but it would doubtless have allowed him (assuming he wished it) much greater control than had he simply surrendered a script to others, as most playwrights did. According to tradition, Shakespeare specialized in good but fairly undemanding roles in his own plays. The Ghost in *Hamlet* is the part to which he is most often linked. In fact, we don't know what parts he played, but that they were nontaxing roles seems a reasonable assumption given the demands on him not only as writer of the plays but also in all likelihood as the person most closely involved with their staging. But it may well be that he truly enjoyed acting and craved large parts when not distracted by scripting considerations. He was listed as a principal performer in Ben Jonson's *Every Man in His Humour* in 1598 and in *Sejanus His Fall* in 1603.

It is tempting, even logical, to guess that Shakespeare when he arrived in London gravitated to Shoreditch, just north of the City walls. This was the home of the Theatre and the Curtain both, and was where many playwrights and actors lived, drank,

caroused, occasionally fought, and no less occasionally died. It was in Shoreditch, very near the Theatre, in September 1589 that the rising, and ever hotheaded, young star Christopher Marlowe, fresh from the triumphs of *Tamburlaine the Great*, fell into a heated altercation with an innkeeper named William Bradley. Swords were drawn. Marlowe's friend Thomas Watson, a playwright himself, stepped into the fray and, in inevitably confused circumstances, stabbed Bradley in the chest. The blow was fatal. Both writers spent time in prison—Marlowe very briefly, Watson for five months—but were cleared on the grounds that Bradley had provoked his own demise and that they had acted in self-defense. We may reasonably suppose that the murder of Bradley was the talk of the district that evening, but whether Shakespeare was around to hear it or not we don't know. If not yet, he soon would be, for at some point shortly after this he became, in a big and fairly sudden way, a presence in the London theater.

We are not quite sure, however, when that point was. We are not even sure when we have our first glimpse of him at work. The ever-meticulous Henslowe has a note in his diary recording a performance of "harey VI" at the Rose in the first week of March 1592. Many take this to be Shakespeare's *Henry VI, Part 1*, which would be gratifying for Shakespeare fans because "harey VI" was a great triumph. It attracted box office receipts of £3 16 shillings and 8 pence on its debut—a very considerable sum—and was performed thirteen times more in the next four months, which is to say more than almost any other play of its day. But the success of the play, particularly upon its

debut, does rather raise a question: Would people really have turned out in droves to see the premiere of a play by a little-known author or was it perhaps a play, now lost, on the same subject by someone better established? One troubling point is that Shakespeare had no recorded connection with Henslowe's company as actor or playwright.

The first certain mention of Shakespeare as playwright comes, unexpectedly enough, in an unkind note in a thin and idiosyncratic pamphlet, when he was already the author of several plays—probably five, possibly more—though there is much uncertainty about which exactly these were.

The pamphlet's full, generously descriptive title is *Greene's Groat's-Worth* of *Wit, Bought with a Million of Repentance. Describing the folly of youth, the falsehood of make-shift flatterers, the misery of the negligent, and mischiefs of deceiving Courtesans. Written before his death and published at his dying request*, by Robert Greene, who did indeed fulfill the title's promise by dying while it was being prepared for publication. (Amazingly he managed in the same month to produce a second volume of deathbed thoughts called, rather irresistibly, *Greene's Vision, Written at the instant of his death*.)

Greene was a pamphleteer and poet and a leading light in a group of playwrights known to posterity as the University Wits. Mostly, however, he was a wastrel and cad. He married well but ran through his wife's money and abandoned her and their

* A groat was a small coin worth four pence.

child, and took up with a mistress of tarnished repute by whom he produced another child, grandly named Fortunatus, and with whom he lived in a tenement in Dowgate, near London Bridge. Here, after overindulging one evening on Rhenish wine and pickled herring (or so all histories report), Greene fell ill and began to die slowly and unattractively, ridden with lice and sipping whatever intoxicants his dwindling resources could muster. Somehow during this month of decline, he managed (almost certainly with a good deal of help) to produce his two collections of thoughts, based loosely on his own life and peppered with tart observations about other writers, before rasping out his last breath, on September 3, 1592. He was thirty-one or possibly thirty-two—a reasonable age for a dying Londoner.

Only two copies of *Greene's Groat's-Worth* survive, and there would not be much call for either were it not for a single arresting sentence tucked into one of its many discursive passages: "Yes, trust them not: for there is an upstart Crow, beautified with our feathers, that with his Tiger's heart wrapped in a Player's hide, supposes he is as well able to bombast out a blank verse as the best of you: and being an absolute *Johannes fac totum*, is in his own conceit the only Shake-scene in a country."

If the not-so-subtle reference to "Shake-scene" didn't identify the target at once, the reference to a "Tiger's heart wrapped in a Player's hide" almost certainly did, for it is a parody of a line in *Henry VI, Part 3*. It is clear from the context that Shakespeare had distinguished himself enough to awaken envy in a dying man but was still sufficiently fresh to be considered an upstart.

No one knows quite what Shakespeare did to antagonize the dying Greene. It may have been very personal, for all we know, but more probably it was just a case of professional jealousy. Greene evidently felt that Shakespeare's position as a player qualified him to speak lines but not to create them. Writing was clearly best left to university graduates, however dissolute. (Greene was the worst kind of snob—a university graduate from a humble background: His father was a saddler.) At any rate Shakespeare or someone speaking for him must have protested, for soon afterward Greene's editor and amanuensis, Henry Chettle, offered an apology of radiant humility and abjection, praising Shakespeare's honesty and good character, "his facetious grace in writing," and much else.

Chettle was much more grudging in apologizing to Christopher Marlowe, who was far worse maligned (though, as was usual in these tracts, not explicitly named), as Greene's slender volume accused him of atheism—a very grave charge for the time. Why Chettle was so much more respectful (or fearful) of Shakespeare than of the comparatively well-connected and always dangerous Marlowe is an interesting but unresolvable puzzle. At all events no one would ever attack Shakespeare in such a way again.

Just at the moment that Shakespeare enters the theatrical record, the record itself is suspended owing to a particularly severe outbreak of plague. Four days after the death of Robert Greene, London's theaters were officially ordered shut, and they would

remain so for just under two years, with only the briefest remissions. It was a period of great suffering. In London at least ten thousand people died in a single year. For theatrical companies it meant banishment from the capital and a dispiritingly itinerant existence on tour.

What Shakespeare did with himself at this time is not known. Ever elusive, he now disappears from recorded sight for two years more. As always there are many theories as to where he passed the plague years of 1592 and 1593. One is that he spent the time traveling in Italy, which would account for a rush of Italian plays upon his return—*The Taming of the Shrew, The Two Gentlemen of Verona, The Merchant of Venice, Romeo and Juliet*—though at least one of these was probably written already and none requires a trip to Italy to explain its existence. All that is certain is that in April 1593, just before his twenty-ninth birthday and little more than half a year after the theaters had shut, William Shakespeare produced a narrative poem called *Venus and Adonis* with a dedication so florid and unctuous that it can raise a sympathetic cringe even after four hundred years. The dedication says:

> Right Honourable, I know not how I shall offend in dedicating my unpolished lines to your lordship, nor how the world will censure me for choosing so strong a prop to support so weak a burden. Only, if your honour seem but pleased, I account myself highly praised, and vow to take advantage of all idle hours till I have honoured you with some graver labour. But if the first heir

of my invention prove deformed, I shall be sorry it had
so noble a godfather. . . .

The person at whom this gush was directed was not an aged
worthy, but a wan, slender, exceedingly effeminate youth of
nineteen, Henry Wriothesley (pronounced "rizzly"), third Earl
of Southampton and Baron of Titchfield. Southampton grew up
at the heart of the court. His father died when he was just seven,
and he was placed under the wardship of Lord Burghley, the
queen's lord treasurer—effectively her prime minister. Burghley
saw to his education and, when Southampton was just seventeen,
sought to have him marry his granddaughter, Lady Elizabeth de
Vere, who was in turn daughter of Edward de Vere, the seven-
teenth Earl of Oxford and longtime favorite among those who
think Shakespeare was not Shakespeare. Southampton declined
to proceed with the marriage, for which he had to pay a colossal
forfeit of £5,000 (something like £2.5 million in today's money).
He really didn't want to marry Burghley's granddaughter.

Southampton, it appears, enjoyed the intimate company of
men and women both. He had a mistress at court, one Eliz-
abeth Vernon, but equally while serving in Ireland as Lord-
General of Horse under his close friend the Earl of Essex, he
shared quarters with a fellow officer whom he would "hug in
his arms and play wantonly with," in the words of one scan-
dalized observer. He must have made an interesting soldier,
for his most striking quality was his exceeding effeminacy.
We know precisely how he looked—or at least wished to be
remembered—because Nicholas Hilliard, the celebrated por-

traitist, produced a miniature of him showing him with flowing auburn locks draped over his left shoulder, at a time when men did not normally wear their hair so long or arrange it with such smoldering allure.

Matters took a further interesting lurch in the spring of 2002 when another portrait of Southampton was identified at a stately home, Hatchlands Park in Surrey, showing him dressed as a woman (or an exceedingly camp man), a pose strikingly reminiscent of the beautiful youth with "a woman's face, with Nature's own hand painted" described with such tender admiration in Sonnet 20. The date attributed to the painting, 1590–1593, was just the time that Shakespeare was beseeching Southampton's patronage.

We've no idea how much or how little Southampton admired the poem dedicated to him, but the wider world loved it. It was the greatest publishing success of Shakespeare's career—far more successful in print than any of his plays—and was reprinted at least ten times in his lifetime (though only one first-edition copy survives, in the Bodleian Library in Oxford). Written in narrative form and sprawling over 1,194 lines, *Venus and Adonis* was rich and decidedly racy for its day, though actually quite tame compared with the work on which it was based, Ovid's *Metamorphoses*, which contains eighteen rapes and a great deal of pillage, among much else. Shakespeare threw out most of the violence but played on themes—love, lust, death, the transient frailty of beauty—that spoke to Elizabethan tastes and ensured the poem's popularity.

Some of it is a little rich for modern tastes—for instance:

And now she beats her heart, whereat it groans. . .
"Ay me!" she cries, and twenty times, "Woe, woe!"

But such lines struck a chord with Elizabethan readers and made the work an instant hit. The publisher was Richard Field, with whom Shakespeare had grown up in Stratford, but it did so well that a more successful publisher, John Harrison, bought out Field's interest. The following year Harrison published a follow-up poem by Shakespeare, *The Rape of Lucrece*, based on Ovid's *Fasti*. This poem, considerably longer at 1,855 lines and written in a seven-line stanza form known as rhyme royal, was primarily a paean to chastity and, like chastity itself, was not so popular.

Again there was an elaborate dedication to the foppish earl:

To the Right Honourable Henry Wriothesely, Earl of Southampton and Baron of Titchfield.

The love I dedicate to your Lordship is without end; whereof this pamphlet, without beginning, is but a superfluous moiety. The warrant I have of your honourable disposition, not the worth of my untutored lines, makes it assured of acceptance. What I have done is yours; what I have to do is yours; being part in all I have, devoted yours. Were my worth greater, my duty would sow greater; meantime, as it is, it is bound to your Lordship, to whom I wish long life still lengthened with all happiness.

Your Lordship's in all duty,
William Shakespeare

As these dedications are the only two occasions when
Shakespeare speaks directly to the world in his own voice,
scholars have naturally picked over them to see what might
reasonably be deduced from them. What many believe is that
the second dedication shows a greater confidence and familiar-
ity—and possibly affection—than the first. A. L. Rowse, for
one, could think of "no Elizabethan dedication that gives one
more the sense of intimacy" and that conclusion is echoed with
more or less equal vigor in many other assessments.

In fact we know nothing at all about the relationship, if
any, that existed between Shakespeare and Southampton.
But as Wells and Taylor put it in their edition of the complete
works, "the affection with which Shakespeare speaks of him
in the dedication to *Lucrece* suggests a strong personal con-
nection." The suspicion is that Southampton was the beautiful
youth with whom Shakespeare may have had a relationship, as
described in the sonnets—which may have been written about
the same time, though the sonnets would not be published for
fifteen years. But according to Martin Wiggins of the Uni-
versity of Birmingham, addressing work to a nobleman "was
commonly only a speculative bid for patronage." And Shake-
speare was just one of several poets—Thomas Nashe, Gervase
Markham, John Clapham, and Barnabe Barnes were others—
vying for Southampton's benediction during the same period
(his rivals' obsequious dedications, not incidentally, make

Shakespeare's entreaties look restrained, honest, and frankly dignified).

Southampton was not, in any case, in a position to bestow largesse in volume. Although he enjoyed an income of £3,000 a year (something like £1.5 million in today's money) upon reaching his majority, he also inherited vast expenses and was dissolute into the bargain. Moreover, under the terms of his inheritance, he had to pass a third of any earnings to his mother. Within a few years he was, to quote Wiggins again, "virtually bankrupt." All of which makes it unlikely that Southampton gave—or was ever in a position to give—Shakespeare £1,000, a story first related by Shakespeare's biographer Nicholas Rowe in the early 1700s and endorsed surprisingly often ever since: for instance, by the Shakespeare scholar Sidney Lee in the *Dictionary of National Biography.*

So by 1594 William Shakespeare was clearly on the way to success. He was the author of two exceedingly accomplished poems and he had the patronage of a leading aristocrat. But rather than capitalize on this promising beginning, he left the field of poetry and returned all but exclusively to the theater, a move that must have seemed at least mildly eccentric, if not actively willful, for playwriting was not an esteemed profession, and its practice, however accomplished, gained one little critical respect.

Yet this was precisely the world that Shakespeare now wholeheartedly embraced. He never dedicated anything else to Southampton or any other aristocrat, or sought anyone's pa-

tronage again. He wrote for publication only once more that we know of—with the poem *The Phoenix and the Turtle*, published in 1601. Nothing else bearing his name was published with his obvious consent in his lifetime, including the plays that he now turned to almost exclusively.

The theatrical scene that Shakespeare found was much altered from two years before. For one thing, it was without his greatest competitor, Christopher Marlowe, who had died the previous year. Marlowe was just two months older than Shakespeare. Though from a modest background himself—he was the son of a shoemaker from Canterbury—he had gone to Cambridge (on a scholarship), and so enjoyed an elevated status.

Goodness knows what he might have achieved, but in 1593 he fell into trouble in a very big way. In the spring of that year inflammatory anti-immigrant notices began to appear all over London bearing lines of verse inspired by popular dramas, including in one instance a vicious parody of Marlowe's *Tamburlaine*. The government by this time was so obsessed with internal security that it spent £12,000 a year—a fabulous sum—spying on its own citizens. This was an era when one really didn't wish to attract the critical attention of the authorities. Among those interrogated was Thomas Kyd, Marlowe's friend and former roommate and author of the immensely popular *Spanish Tragedy*. Under torture (or possibly just the threat of it) at Bridewell Prison, Kyd accused Marlowe of being "irreligious, intemperate, and of cruel heart," but above all of being a blasphemer and atheist. These were serious charges indeed.

Marlowe was brought before the Privy Council, questioned, and released on a bond that required him to stay within twelve miles of the royal court wherever it happened to be so that his case could be dealt with quickly when it pleased his accusers to turn to it. He faced, at the very least, having his ears cut off—that was if things went well—so it must have been a deeply uneasy time for him. As Marlowe's biographer David Riggs has written, "There were no acquittals in Tudor state courts."

It was against this background that Marlowe went drinking with three men of doubtful character at the house of a widow, Eleanor Bull, in Deptford in East London. There, according to a subsequent coroner's report, a dispute arose over the bill, and Marlowe—who truly was never far from violence—seized a dagger and tried to stab one Ingram Frizer with it. Frizer, in self-defense, turned the weapon back on Marlowe and stabbed him in the forehead above the right eye—a difficult place to strike a killing blow, one would have thought, but killing him outright. That is the official version, anyway. Some historians believe Marlowe was assassinated at the behest of the crown or its senior agents. Whatever the motivation, he was dead at twenty-nine.

At that age Shakespeare was writing comparative trifles—*Love's Labour's Lost*, *The Two Gentlemen of Verona*, and *The Comedy of Errors* are all probably among his works of this period. Marlowe by contrast had written ambitious and appreciable dramas: *The Jew of Malta*, *The Tragical History of Doctor Faustus*, and *Tamburlaine the Great*. "If Shakespeare too had

died in that year," Stanley Wells has written, "we should now regard Marlowe as the greater writer."

No doubt. But what if both had lived? Could either have sustained the competition? Shakespeare, it seems fair to say, had more promise for the long term. Marlowe possessed little gift for comedy and none at all, that we can see, for creating strong female roles—areas where Shakespeare shone. Above all it is impossible to imagine a person as quick to violence and as erratic in temperament as Christopher Marlowe reaching a wise and productive middle age. Shakespeare had a disposition built for the long haul.

Kyd died the next year, aged just thirty-six, never having recovered from his ordeal at Bridewell. Greene was dead already, of course, and Watson followed him soon after. Shakespeare would have no serious rivals until the emergence of Ben Jonson in 1598.

For theatrical troupes the plague years were an equally terminal moment. The endless trudge in search of provincial engagements proved too much for many companies, and one by one they disbanded—Hertford's, Sussex's, Derby's, and Pembroke's all fading away more or less at once. By 1594 only two troupes of note remained: the Admiral's Men under Edward Alleyn, and a new group, the Lord Chamberlain's Men (named for the head of the queen's household), led by Richard Burbage and comprising several talents absorbed from recently extinguished companies. Among these talents were John Heminges, who would become Shakespeare's close friend and (some thirty

years in the future) coeditor of the First Folio, and the celebrated comic Will Kemp, for whom Shakespeare would (it is reasonably presumed) write many of his most famous comedic roles, such as Dogberry in *Much Ado About Nothing*.

Shakespeare would spend the rest of his working life with this company. As Wells and Taylor note, "He is the only prominent playwright of his time to have had so stable a relationship with a single company." It was clearly a happy and well-run outfit, and its members were commendably—or at the very least comparatively—sober, diligent, and clean living.

Shakespeare seems to have been unusual among the troupe in not being a conspicuously devoted family man. Burbage was a loving husband and father of seven in Shoreditch. Heminges and Condell were likewise steady fellows, living as neighbors in the prosperous parish of Saint Mary Aldermanbury, where they were pillars of their church and prodigious procreators, producing no fewer than twenty-three children between them.

In short they led innocuous lives. They did not draw daggers or brawl in pubs. They behaved like businessmen. And six times a week they gathered together, dressed up in costumes and makeup, and gave the world some of the most sublime and unimprovable hours of pleasure it has ever known.

Chapter Five

The Plays

N EARLY EVERYONE AGREES THAT William Shakespeare's career as a playwright began in about 1590, but there is much less agreement on which plays began it. Depending on whose authority you favor, Shakespeare's debut written offering might be any of at least eight works: *The Comedy of Errors, The Two Gentleman of Verona, The Taming of the Shrew, Titus Andronicus, King John,* or the three parts of *Henry VI.*

The American authority Sylvan Barnet lists *The Comedy of Errors* as Shakespeare's first play with *Love's Labour's Lost* second, but more recently Stanley Wells and Gary Taylor, in the *Oxford Complete Works,* credit him with ten other plays—more than a quarter of his output—before either of those two comes along. Wells and Taylor place *The Two Gentlemen of Verona* at the head of their list—not on any documentary evidence, as they freely concede, but simply because it is notably unpolished (or has "an uncertainty of technique suggestive of

inexperience," as they rather more elegantly put it). The Arden Shakespeare, meanwhile, puts *The Taming of the Shrew* first, while the Riverside Shakespeare places the first part of *Henry VI* first. Hardly any two lists are the same.

For many plays all we can confidently adduce is a *terminus ad quem*—a date beyond which they could not have been written. Sometimes evidence of timing is seen in allusions to external events, as in *A Midsummer Night's Dream*, in which seemingly pointed references are made to unseasonable weather and bad harvests (and England had very bad harvests in 1594 and 1595), or in *Romeo and Juliet* when Nurse speaks of an earthquake of eleven years before (London had a brief but startling one in 1580), but such hints are rare and often doubtful anyway. Many other judgments are made on little more than style. Thus *The Comedy of Errors* and *Titus Andronicus* "convey an aroma of youth," in the words of Samuel Schoenbaum, while Barnet can, without blushing, suggest that *Romeo and Juliet* came before *Othello* simply because "one feels Othello is later."

Arguments would run far deeper were it not for the existence of a small, plump book by one Francis Meres called *Palladis Tamia: Wit's Treasury*. Published in 1598, it is a 700-page compendium of platitudes and philosophical musings, little of it original and even less of it of interest to history except for one immeasurably helpful passage first noticed by scholars some two hundred years after Shakespeare's death: "As Plautus and Seneca are accounted the best for comedy and tragedy among the Latins, so Shakespeare among the English is the most excellent in both kinds for the stage. For comedy, wit-

ness his *Gentlemen of Verona*, his *Errors*, his *Love Labour's Lost*, his *Love Labour's Won*, his *Midsummer Night's Dream*, and his *Merchant of Venice*; for tragedy, his *Richard the Second, Richard the Third, Henry the Fourth, King John, Titus Andronicus*, and his *Romeo and Juliet*."

This was rich stuff indeed. It provided the first published mention of four of Shakespeare's plays—*The Merchant of Venice, King John, The Two Gentlemen of Verona,* and *A Midsummer Night's Dream*—and additionally, in a separate passage, established that he had written at least some sonnets by this time, though they wouldn't be published as a collected work for a further eleven years.

Rather more puzzling is the mention of *Love's Labour's Won*, about which nothing else is known. For a long time it was assumed that this was an alternative name for some play that we already possess—in all likelihood *The Taming of the Shrew*, which is notably absent from Meres's list. Shakespeare's plays were occasionally known by other names: *Twelfth Night* was sometimes called *Malvolio,* and *Much Ado About Nothing* was sometimes *Benedick and Beatrice,* so the possibility of a second title was plausible.

In 1953 the mystery deepened when an antiquarian book dealer in London, while moving stock, chanced upon a fragment of a bookseller's inventory from 1603, which listed *Love's Labour's Won* and *The Taming of the Shrew* together—clearly suggesting that they weren't the same play after all, and giving further evidence that *Love's Labour Won* really was a separate play. If, as the inventory equally suggests, it existed in pub-

lished form, there may once have been as many as 1,500 copies in circulation, so there is every chance that the play may one day turn up somewhere (a prospect thought most unlikely for Shakespeare's other lost play, *Cardenio*, which appears to have existed only in manuscript). It is all a little puzzling. If *Love's Labour's Won* is a real and separate play, and was published, a natural question is why Heminges and Condell didn't include it in the First Folio. No one can say.

In whatever order the plays came, thanks to Meres we know that by 1598, when he had been at it for probably much less than a decade, Shakespeare had already proved himself a dab hand at comedy, history, and tragedy, and had done enough—much more than enough, in fact—to achieve a lasting reputation. His success was not, it must be said, without its shortcuts. Shakespeare didn't scruple to steal plots, dialogue, names, and titles—whatever suited his purpose. To paraphrase George Bernard Shaw, Shakespeare was a wonderful teller of stories so long as someone else had told them first.

But then this was a charge that could be laid against nearly all writers of the day. To Elizabethan playwrights plots and characters were common property. Marlowe took his *Doctor Faustus* from a German *Historia von D. Johann Fausten* (by way of an English translation) and *Dido Queen of Carthage* directly from the Virgil's *Aeneid*. Shakespeare's *Hamlet* was preceded by an earlier Hamlet play, unfortunately now lost and its author unknown (though some believe it was the hazy genius Thomas Kyd), leaving us to guess how much his version owed to the original. His *King Lear* was similarly inspired by an earlier *King*

Leir. His *Most Excellent and Lamentable Tragedy of Romeo and Juliet* (to give it its formal original title) was freely based on the poem *The Tragicall History of Romeus and Juliet* by a promising young talent named Arthur Brooke, who wrote it in 1562 and then unfortunately drowned. Brooke in turn had taken the story from an Italian named Matteo Bandello. *As You Like It* was borrowed quite transparently from a work called *Rosalynde*, by Thomas Lodge, and *The Winter's Tale* is likewise a reworking of *Pandosto*, a forgotten novel by Shakespeare's bitter critic Robert Greene. Only a few of Shakespeare's works—in particular the comedies *A Midsummer Night's Dream*, *Love's Labour's Lost*, and *The Tempest*—appear to have borrowed from no one.

What Shakespeare did, of course, was take pedestrian pieces of work and endow them with distinction and, very often, greatness. Before he reworked it *Othello* was insipid melodrama. In *Lear*'s earlier manifestation, the king was not mad and the story had a happy ending. *Twelfth Night* and *Much Ado About Nothing* were inconsequential tales in a collection of popular Italian fiction. Shakespeare's particular genius was to take an engaging notion and make it better yet. In *The Comedy of Errors*, he borrows a simple but effective plot device from Plautus—having twin brothers who have never met appear in the same town at the same time—but increases the comic potential exponentially by giving the brothers twin servants who are similarly underinformed.

Slightly more jarring to modern sensibilities was Shakespeare's habit of lifting passages of text almost verbatim from other sources and dropping them into his plays. *Julius Caesar*

and *Antony and Cleopatra* both contain considerable passages taken with only scant alteration from Sir Thomas North's magisterial translation of Plutarch, and *The Tempest* pays a similar uncredited tribute to a popular translation of Ovid. Marlowe's "Whoever loved that loved not at first sight?" from *Hero and Leander* reappears unchanged in Shakespeare's *As You Like It*, and a couplet from Marlowe's *Tamburlaine*—

> *Hola, ye pampered jades of Asia*
> *What, can ye draw but twenty miles a day?*

—finds its way into Henry IV, Part 2 as

> *And hollow pampered jades of Asia*
> *Which cannot go but thirty miles a day.*

Shakespeare at his worst borrowed "almost mechanically," in the words of Stanley Wells, who cites a passage in *Henry V* in which the youthful king (and, more important, the audience) is given a refresher course in French history that is taken more or less verbatim from Raphael Holinshed's *Chronicles*. *Coriolanus*, in the First Folio, contains two lines that make no sense until one goes back to Sir Thomas North's *Lives of the Noble Grecians and Romans* and finds the same lines *and* the line immediately preceding, which Shakespeare (or more probably a subsequent scribe or compositor) inadvertently left out. Again, however, such borrowing had ample precedent. Marlowe in his turn took several lines from Spenser's *The Faerie Queene* and

dropped them almost unchanged into *Tamburlaine*. *The Faerie Queene*, meanwhile, contains passages lifted whole (albeit in translation) from a work by the Italian poet Ludovico Ariosto.

In the rush to entertain masses of people repeatedly, the rules of presentation became exceedingly elastic. In classical drama plays were strictly either comedies or tragedies. Elizabethan playwrights refused to be bound by such rigidities and put comic scenes in the darkest tragedies—the porter answering a late knock in *Macbeth*, for instance. In so doing they invented comic relief. In classical drama only three performers were permitted to speak in a given scene, and no character was allowed to talk to himself or the audience—so there were no soliloquies and no asides. These are features without which Shakespeare could never have become Shakespeare. Above all, plays before Shakespeare's day were traditionally governed by what were known as "the unities"—the three principles of dramatic presentation derived from Aristotle's *Poetics*, which demanded that dramas should take place in one day, in one place, and have a single plot. Shakespeare was happy enough to observe this restriction when it suited him (as in *The Comedy of Errors*), but he could never have written *Hamlet* or *Macbeth* or any of his other greatest works if he had felt strictly bound by it.

Other theatrical conventions were unformed or just emerging. The division of plays into acts and scenes—something else strictly regulated in classical drama—was yet unsettled in England. Ben Jonson inserted a new scene and scene number each time an additional character stepped onstage, however briefly or inconsequentially, but others did not use scene divisions at

all. For the audience it mattered little, since action was continuous. The practice of pausing between acts didn't begin until plays moved indoors, late in Shakespeare's career, and it became necessary to break from time to time to trim the lights.

Almost the only "rule" in London theater that was still faithfully followed was the one we now call, for convenience, the law of reentry, which stated that a character couldn't exit from one scene and reappear immediately in the next. He had rather to go away for a while. Thus, in *Richard II*, John of Gaunt makes an abrupt and awkward departure purely to be able to take part in a vital scene that follows. Why this rule out of all the many was faithfully observed has never, as far as I can make out, been satisfactorily explained.

But even by the very relaxed standards of the day, Shakespeare was invigoratingly wayward. He could, as in *Julius Caesar*, kill off the title character with the play not half done (though Caesar does come back later, briefly, as a ghost). He could write a play like *Hamlet*, where the main character speaks 1,495 lines (nearly as many as the number spoken by *all* the characters combined in *The Comedy of Errors*) but disappears for unnervingly long stretches—for nearly half an hour at one point. He constantly teased reality, reminding the audience that they were not in the real world but in a theater, as when he asked in *Henry V*, "Can this cockpit hold the vastie fields of France?" or implored the audience in *Henry VI, Part 3* to "eke out our performance with your mind."

His plays were marvelously variable, with the number of scenes ranging from seven to forty-seven, and with the number

of speaking parts ranging from fourteen to more than fifty. The average play of the day ran to about 2,700 lines, giving a performance time of two and a half hours. Shakespeare's plays ranged from fewer than 1,800 lines (for *Comedy of Errors*) to more than 4,000 (for *Hamlet*, which could take nearly five hours to play, though possibly no audience of his day ever saw it in full). On average his plays were made up of about 70 percent blank verse, 5 percent rhymed verse, and 25 percent prose, but he changed the proportions happily to suit his purpose. His history plays aside, he set two plays, *The Merry Wives of Windsor* and *King Lear*, firmly in England; he set none at all in London; and he never used a plot from his own times.

Shakespeare was not a particularly prolific writer. Thomas Heywood wrote or cowrote more than two hundred plays, five times the number Shakespeare produced in a career of similar length. Even so, signs of haste abound in Shakespeare's work, even in the greatest of his plays. *Hamlet* is a student at the beginning of the play and thirty years old by its end, even though nothing like enough time has passed in the story. The Duke in *The Two Gentlemen of Verona* puts himself in Verona when in fact he can only mean Milan. *Measure for Measure* is set in Vienna, and yet the characters nearly all have Italian names.

Shakespeare may be the English language's presiding genius, but that isn't to say he was without flaws. A certain messy exuberance marked much of what he did. Sometimes it is just not possible to know quite what he meant. Jonathan Bate, writing in *The Genius of Shakespeare*, notes that a glancing six-word compliment to the queen in *A Midsummer Night's Dream* ("fair

vestal enthroned by the west") is so productive of possible inter-
pretation that it spawned twenty pages of discussion in a vario-
rum edition* of Shakespeare's works. Nearly every play has at
least one or two lines that defeat interpretation, like these from
Love's Labour's Lost:

> *O paradox! black is the badge of hell,*
> *The hue of dungeons and the school of night.*

What exactly he meant by "the school of night" is really
anyone's guess. Similarly uncertain is a reference early in *The
Merchant of Venice* to "my wealthy Andrew docked in sand,"
which could refer to a ship but possibly to a person. The most
ambiguous example of all, however, is surely the line in *King
Lear* that appeared originally (in the Quarto edition of 1608)
as "swithald footed thrice the old, a nellthu night more and
her nine fold." Though the sentence has appeared in many ver-
sions in the four centuries since, no one has ever got it close to
making convincing sense.

"Shakespeare was capable of prolixity, unnecessary ob-
scurity, awkwardness of expression, pedestrian versifying and
verbal inelegance," writes Stanley Wells. "Even in his greatest
plays we sometimes sense him struggling with plot at the ex-
pense of language, or allowing his pen to run away with him

* An edition that includes the complete works and notes from various
commentators.

in speeches of greater length than the situation warrants." Or as Charles Lamb put it much earlier, Shakespeare "runs line into line, embarrasses sentences and metaphors; before one idea has burst its shell, another is hatched out and clamorous for disclosure."

Shakespeare was celebrated among his contemporaries for the speed with which he wrote and the cleanness of his copy, or so his colleagues John Heminges and Henry Condell would have us believe. "His mind and hand went together," they wrote in the introduction to the First Folio, "and what he thought he uttered with that easiness that we have scarce received from him a blot in his papers." To which Ben Jonson famously replied in exasperation: "Would he had blotted a thousand!"

In fact he may have. The one place where we might *just* see Shakespeare at work is in the manuscript version of a play of the life of Sir Thomas More. The play was much worked on, and is in six hands (one of the authors was Henry Chettle, the man who apologized abjectly to Shakespeare for his part in the publishing of Greene's *Groat's-Worth*). It was never performed. Since its subject was a loyal, passionate Catholic who defied a Tudor monarch, it is perhaps a little surprising that it occurred as a suitable subject to anyone at all.

Some authorities believe that Shakespeare wrote three of the surviving pages. If so, they give an interesting insight, since they employ almost no punctuation and are remarkably—breathtakingly—liberal in their spelling. The word *sheriff*, as Stanley Wells notes, is spelled five ways in five lines—as *shreiff*, *shreef*, *shreeve*, *Shreiue*, and *Shreue*—which must be something

of a record even by the relaxed and imaginative standards of Elizabethan orthography. The text also has lines crossed out and interlineations added, showing that Shakespeare did indeed blot—if indeed it was he. The evidence for Shakespeare is based on similarities in the letter *a* in Shakespeare's signature and the More manuscript, the high number of *y* spellings (writing *tyger* rather than *tiger*, for instance, a practice thought to be old-fashioned and provincial), and the fact that a very odd spelling, *scilens* (for *silence*), appears in the manuscript for *Thomas More* and in the quarto version of *Henry IV, Part 2*. This assumes, of course, that the printer used Shakespeare's manuscript and faithfully observed its spellings, neither of which is by any means certain or even compellingly probable. Beyond that, there is really nothing to go on but a gut feeling—a sense that the passage is recognizably the voice of Shakespeare.

It is certainly worth noting that the *idea* that Shakespeare might have had a hand in the play dates only from 1871. It is also worth noting that Sir Edward Maunde Thompson, the man who declared the passages to be by Shakespeare, was a retired administrator at the British Museum, not an active paleographer, and was in any case not formally trained in that inexact science. At all events nothing from Shakespeare's own age links him to the enterprise.

Much is often made of Shakespeare's learning—that he knew as much as any lawyer, doctor, statesman, or other accomplished professional of his age. It has even been suggested—seriously, it would appear—that two lines in *Hamlet* ("Doubt that the stars are fire / Doubt that the sun doth move")

indicate that he deduced the orbital motions of heavenly bodies well before any astronomer did. With enough exuberance and selective interpretation it is possible to make Shakespeare seem a veritable committee of talents. In fact a more sober assessment shows that he was pretty human.

He had some command of French, it would seem, and evidently quite a lot of Italian (or someone who could help him with quite a lot of Italian), for *Othello* and *The Merchant of Venice* closely followed Italian works that did not exist in English translation at the time he wrote. His vocabulary showed a more than usual interest in medicine, law, military affairs, and natural history (he mentions 180 plants and employs 200 legal terms, both large numbers), but in other respects Shakespeare's knowledge was not all that distinguished. He was routinely guilty of anatopisms—that is, getting one's geography wrong—particularly with regard to Italy, where so many of his plays were set. So in *The Taming of the Shrew*, he puts a sailmaker in Bergamo, approximately the most landlocked city in the whole of Italy, and in *The Tempest* and *The Two Gentlemen of Verona* he has Prospero and Valentine set sail from, respectively, Milan and Verona even though both cities were a good two days' travel from salt water. If he knew Venice had canals, he gave no hint of it in either of the plays he set there. Whatever his other virtues, Shakespeare was not conspicuously worldly.

Anachronisms likewise abound in his plays. He has ancient Egyptians playing billiards and introduces the clock to Caesar's Rome 1,400 years before the first mechanical tick was heard there. Whether by design or from ignorance, he could

be breathtakingly casual with facts when it suited his purposes to be so. In *Henry VI, Part 1*, for example, he dispatches Lord Talbot twenty-two years early, conveniently allowing him to predecease Joan of Arc. In *Coriolanus* he has Lartius refer to Cato three hundred years before Cato was born.

Shakespeare's genius had to do not really with facts, but with ambition, intrigue, love, suffering—things that aren't taught in school. He had a kind of assimilative intelligence, which allowed him to pull together lots of disparate fragments of knowledge, but there is almost nothing that speaks of hard intellectual application in his plays—unlike, say, those of Ben Jonson, where learning hangs like bunting on every word. Nothing we find in Shakespeare betrays any acquaintance with Tacitus, Pliny, Suetonius, or others who influenced Jonson and were second nature to Francis Bacon. That is a good thing—a very good thing indeed—for he would almost certainly have been less Shakespeare and more a showoff had he been better read. As John Dryden put it in 1668: "Those who accuse him to have wanted learning, give him the greater commendation: he was naturally learn'd."

Much has been written about the size of Shakespeare's vocabulary. It is actually impossible to say how many words Shakespeare knew, and in any case attempting to do so would be a fairly meaningless undertaking. Marvin Spevack in his magnificent and hefty concordance—the most scrupulous, not to say obsessive, assessment of Shakespearean idiom ever undertaken—counts 29,066 different words in Shakespeare, but that rather generously includes inflected forms and contrac-

tions. If instead you treat all the variant forms of a word—for example, *take, takes, taketh, taking, tak'n, taken, tak'st, tak't, took, tooke, took'st,* and *tookst*—as a single word (or "lexeme," to use the scholarly term), which is the normal practice, his vocabulary falls back to about 20,000 words, not a terribly impressive number. The average person today, it is thought, knows probably 50,000 words. That isn't because people today are more articulate or imaginatively expressive but simply because we have at our disposal thousands of common words—*television, sandwich, seatbelt, chardonnay, cinematographer*—that Shakespeare couldn't know because they didn't yet exist.

Anyway, and obviously, it wasn't so much a matter of how many words he used, but what he did with them—and no one has ever done more. It is often said that what sets Shakespeare apart is his ability to illuminate the workings of the soul and so on, and he does that superbly, goodness knows, but what really characterizes his work—every bit of it, in poems and plays and even dedications, throughout every portion of his career—is a positive and palpable appreciation of the transfixing power of language. *A Midsummer Night's Dream* remains an enchanting work after four hundred years, but few would argue that it cuts to the very heart of human behavior. What it does do is take, and give, a positive satisfaction in the joyous possibilities of verbal expression.

And there was never a better time to delve for pleasure in language than the sixteenth century, when novelty blew through English like a spring breeze. Some twelve thousand words, a phenomenal number, entered the language between 1500 and 1650, about half of them still in use today, and old words

were employed in ways that had not been tried before. Nouns became verbs and adverbs; adverbs became adjectives. Expressions that could not grammatically have existed before—such as "breathing one's last" and "backing a horse," both coined by Shakespeare—were suddenly popping up everywhere. Double negatives and double superlatives—"the most unkindest cut of all"—troubled no one and allowed an additional degree of emphasis that has since been lost.

Spelling was luxuriantly variable, too. You could write "St Paul's" or "St Powles" and no one seemed to notice or care. Gracechurch Street was sometimes "Gracious Steet," sometimes "Grass Street"; Stratford-upon-Avon became at times "Stratford upon *Haven*." People could be extraordinarily casual even with their own names. Christopher Marlowe signed himself "Cristofer Marley" in his one surviving autograph and was registered at Cambridge as "Christopher Marlen." Elsewhere he is recorded as "Morley" and "Merlin," among others. In like manner the impresario Philip Henslowe indifferently wrote "Henslowe" or "Hensley" when signing his name, and others made it Hinshley, Hinchlow, Hensclow, Hynchlowes, Inclow, Hinchloe, and a half dozen more. More than eighty spellings of Shakespeare's name have been recorded, from "Shappere" to "Shaxberd." (It is perhaps worth noting that the spelling we all use is not the one endorsed by the *Oxford English Dictionary*, which prefers "Shakspere.") Perhaps nothing speaks more eloquently of the variability of spelling in the age than the fact that a dictionary published in 1604, *A Table Alphabeticall of Hard Words*, spelled "words" two ways on the title page.

Pronunciations, too, were often very different from today's. We know from Shakespeare that *knees, grease, grass,* and *grace* all rhymed (at least more or less), and that he could pun *reason* with *raisin* and *Rome* with *room.* The first hundred or so lines of *Venus and Adonis* offer such striking rhyme pairs as *satiety* and *variety, fast* and *haste, bone* and *gone, entreats* and *frets, swears* and *tears, heat* and *get.* Elsewhere *plague* is rhymed with *wage, grapes* with *mishaps, Calais* with *challice.* (The name of the French town was often spelled "Callis" or "Callice.")

Whether or not it was necessary to pronounce all the letters in a word—such as the *k*'s in *knight* and *knee*—was a hot issue. Shakespeare touches upon it comically in *Love's Labour's Lost* when he has the tedious Holofernes attack those "rackers of orthography . . . who would call calf 'cauf,' half 'hauf,' neighbour 'nebour' and neigh 'ne.'"

Much of the language Shakespeare used is lost to us now without external guidance. In an experiment in 2005, the Globe in London staged a production of *Troilus and Cressida* in "Early Modern English" or "Original Pronunciation." The critic John Lahr, writing in the *New Yorker*, estimated that he could understand only about 30 percent of what was said. Even with modern pronunciations, meanings will often be missed. Few modern listeners would realize that in *Henry V* when the French princess Catherine mispronounces the English "neck" as "nick," she has perpetrated a gross (and to a Shakespearean audience hugely comical) obscenity—though Shakespeare's language on the whole was actually quite clean, indeed almost prudish. Where Ben Jonson manured his plays, as it were, with

frequent interjections of "turd i' your teeth," "shit o' your head," and "I fart at thee," Shakespeare's audiences had to be content with a very occasional "a pox on't," "God's bread," and one "whoreson jackanapes." (After 1606 profanities were subject to hefty fines and so largely vanished.)

In many ways the language Shakespeare used was quite modern. He never employed the old-fashioned *seeth* but rather used the racier, more modern *sees*, and much preferred *spoke* to *spake*, *cleft* to *clave*, and *goes* to *goeth*. The new King James Bible, by contrast, opted for the older forms in each instance. At the same time Shakespeare maintained a lifelong attachment to *thou* in preference to *you* even though by the end of the sixteenth century *thou* was quaint and dated. Ben Jonson used it hardly at all. He was also greatly attached to, and remarkably unself-conscious about, provincialisms, many of which became established in English thanks to his influence (among them *cranny*, *forefathers*, and *aggravate*), but initially grated on the ears of sophisticates.

He coined—or, to be more carefully precise, made the first recorded use of—2,035 words, and interestingly he indulged the practice from the very outset of his career. *Titus Andronicus* and *Love's Labour's Lost*, two of his earliest works, have 140 new words between them.

Not everyone appreciated this creative impulse. When Robert Greene referred to him as being "beautified by our feathers," he was mocking a Shakespeare neologism in *beautified*. Undaunted, Shakespeare accelerated the pace as his career proceeded. In plays written during his most productive and in-

ventive period—*Macbeth, Hamlet, Lear*—neologisms occur at the fairly astonishing rate of one every two and a half lines. *Hamlet* alone gave audiences about six hundred words that, according to all other evidence, they had never heard before.

Among the words first found in Shakespeare are *abstemious, antipathy, critical, frugal, dwindle, extract, horrid, vast, hereditary, critical, excellent, eventful, barefaced, assassination, lonely, leapfrog, indistinguishable, well-read, zany,* and countless others (including *countless*). Where would we be without them? He was particularly prolific, as David Crystal points out, when it came to attaching *un-* prefixes to existing words to make new words that no one had thought of before—*unmask, unhand, unlock, untie, unveil* and no fewer than 309 others in a similar vein. Consider how helplessly prolix the alternatives to any of these terms are and you appreciate how much punch Shakespeare gave English.

He produced such a torrent of new words and meanings that a good many, as Otto Jespersen once bemusedly observed, "perhaps were not even clearly understood by the author himself." Certainly many of them failed to take hold. *Undeaf, untent,* and *unhappy* (as a verb), *exsufflicate, bepray,* and *insultment* were among those that were scarcely heard again. But a surprisingly large number did gain common currency and about eight hundred are still used today—a very high proportion. As Crystal says, "Most modern authors, I imagine, would be delighted if they contributed even one lexeme to the future of the language."

His real gift was as a phrasemaker. "Shakespeare's lan-

guage," says Stanley Wells, "has a quality, difficult to define, of memorability that has caused many phrases to enter the common language." Among them: *one fell swoop, vanish into thin air, bag and baggage, play fast and loose, go down the primrose path, be in a pickle, budge an inch, the milk of human kindness, more sinned against than sinning, remembrance of things past, beggar all description, cold comfort, to thine own self be true, more in sorrow than in anger, the wish is father to the thought, salad days, flesh and blood, foul play, tower of strength, be cruel to be kind, blinking idiot, with bated breath, tower of strength, pomp and circumstance, foregone conclusion*—and many others so repetitiously irresistible that we have debased them into clichés. He was so prolific that he could (in *Hamlet*) put two in a single sentence: "Though I am native here and to the manner born, it is a custom more honoured in the breach than the observance."

If we take the *Oxford Dictionary of Quotations* as our guide, then Shakespeare produced roughly one-tenth of all the most quotable utterances written or spoken in English since its inception—a clearly remarkable proportion.

Yet curiously English was still struggling to gain respectability. Latin was still the language of official documents and of serious works of literature and learning. Thomas More's *Utopia*, Francis Bacon's *Novum Organum*, and Isaac Newton's *Principia Mathematica* were all in Latin. The Bodleian Library in Oxford in 1605 possessed almost six thousand books. Of these, just thirty-six were in English. Attachment to Latin was such that in 1568 when one Thomas Smith produced the first textbook on the English language, he wrote it in Latin.

Thanks in no small measure to the work of Shakespeare and his fellows, English was at last rising to preeminence in the country of its creation. "It is telling," observes Stanley Wells, "that William Shakespeare's birth is recorded in Latin but that he dies in English, as 'William Shakespeare, gentleman.'"

Chapter Six

Years of Fame, 1596–1603

N OT FROM ALL PERSPECTIVES were Elizabeth's clos-
ing years a golden age. The historian Joyce Youings calls
the belief in an Elizabethan ecstasy "part of the folklore of the
English-speaking peoples," and adds that "few people alive in
the 1590s in an England racked by poverty, unemployment and
commercial depression would have said that theirs was a better
world or that human inventiveness had restored a good and just
society."

Plague had left many families headless and without sup-
port, and wars and other foreign adventures had created an in-
digent subclass of cripples and hobbling wounded, all virtually
unpensioned. It was not an age in which much consideration
was given to the weak. At just the time that he was making a
fortune in London, Sir Thomas Gresham was also systemati-
cally evicting nearly all the tenants from his country estates in
County Durham, condemning them to the very real prospect

of starvation, so that he could convert the land from arable to grazing and enjoy a slightly improved return on his investment. By such means did he become the wealthiest commoner in Britain.

Nature was a great culprit, too. Bad harvests created shortages that sent prices soaring. Food riots broke out in London, and troops had to be called in to restore order. "Probably for the first time in Tudor England, large numbers of people in certain areas died of starvation," writes Youings. Malnutrition grew chronic. By 1597 the average wage was less than a third (in real terms) of what it had been a century before. Most of the staple foods of the poor—beans, peas, cereals of all types—had doubled in price from four years earlier. A loaf of bread still cost a penny, but where a penny had once bought a loaf weighing over three and a half pounds, by 1597 the standard loaf had shrunk to just eight ounces, often bulked out with lentils, mashed acorns, and other handy adulterants. For laborers, according to Stephen Inwood, this was not just the worst year in a long time, it was the worst year in history.

It is a wonder that any working person could afford a trip to the theater, yet nearly all relevant contemporary accounts make clear that the theater was robustly popular with the laboring classes throughout the depressed years. Quite how they managed it, even when employed, is a mystery because in sixteenth-century London working people really worked—from 6 a.m. to 6 p.m. in winter and till 8 p.m. in summer. Since plays were performed in the middle of that working day, it wouldn't seem self-evidently easy for working people to get away. Somehow they did.

For Shakespeare there was a personal dimension to the gloom of the decade. In August 1596 his son, Hamnet, aged eleven, died in Stratford of causes unknown. We have no idea how Shakespeare bore this loss, but if ever there was a moment when we can glimpse Shakespeare the man in his plays, surely it is in these lines, written for *King John* probably in that year:

> *Grief fills the room up of my absent child,*
> *Lies in his bed, walks up and down with me,*
> *Puts on his pretty looks, repeats his words,*
> *Remembers me of all his gracious parts,*
> *Stuffs out his vacant garments with his form.*

But then it is also the case, as the theater historian Sir Edmund Chambers long ago noted, that "in the three or four years following his loss Shakespeare wrote his happiest work: he created Falstaff, Prince Hal, King Henry V, Beatrice and Benedick, Rosalind and Orlando. Then came Viola, Sir Toby Belch and Lady Belch." It is a seemingly irreconcilable contradiction.

Whatever his mood, for Shakespeare this was a period of increasing fame and professional good fortune. By 1598 his name had begun to appear on the title pages of the quarto editions of his plays—a sure sign of its commercial value. This was also the year in which Francis Meres remarked upon him in admiring terms in *Palladis Tamia.* In 1599 a volume of poetry called *The Passionate Pilgrim* was published with Shakespeare's name on the title page even though he contributed (probably

involuntarily) only a pair of sonnets and three poetic passages from *Love's Labour's Lost*. A little later (the date is not certain) a play called *The Return from Parnassus: Part I* was performed by students at Cambridge and contained the words "O sweet Mr Shakespeare! I'll have his picture in my study at the court," suggesting that Shakespeare was by then a kind of literary pinup.

The first nontheatrical reference to Shakespeare in London comes during this period, too, and is entirely puzzling. In 1596 he and three others—Francis Langley, Dorothy Soer, and Ann Lee—were placed under court order to keep the peace after one William Wayte brought charges that he stood in "fear of death" from them. Langley was the owner of the Swan Theatre, and thus in the same line of business as Shakespeare, though as far as we know the two never worked together. Who the women were is quite unknown; despite much scholarly searching, they have never been identified or even plausibly guessed at. The source of the friction between these people, and what role Shakespeare had in it, is equally uncertain.

Wayte, it is known, was an unsavory character—he was described in another case as a "loose person of no reckoning or value"—but what exactly his complaint was is impossible to say. The one thing all the parties had in common was that they lived in the same neighborhood, so it may be, as Schoenbaum suggests, that Shakespeare was simply an innocent witness drawn into two other men's dispute. It is, in any case, a neat illustration of how little we know of the details of Shakespeare's life, and how the little we do know seems always to add to the mystery rather than lighten it.

A separate question is why Shakespeare moved in this period to Bankside, a not particularly salubrious neighborhood, when his theatrical connection was still with the Theatre, at precisely the other side of the City. It must have been a slog shuttling between the two (and with the constant risk of finding his way barred when the City gates were locked each dusk), for Shakespeare was a busy fellow at this time. As well as writing and rewriting plays, memorizing lines, advising at rehearsals, performing, and taking an active interest in the business side of the company, he also spent much time engaged in private affairs—lawsuits, real-estate purchases, and, it seems all but certain, trips back home.

Nine months after Hamnet's death, in May 1597, Shakespeare bought a grand but mildly dilapidated house in Stratford, on the corner of Chapel Street and Chapel Lane. New Place was the second biggest dwelling in town. Built of timber and brick, it had ten fireplaces, five handsome gables, and grounds large enough to incorporate two barns and an orchard. Its exact appearance in Shakespeare's time is uncertain because the only likeness we have of it is a sketch done almost a century and a half later, from memory, by one George Vertue, but it was certainly an imposing structure. Because the house was slightly decrepit Shakespeare got it for the very reasonable price of £60—though Schoenbaum cautions that such figures were often a fiction, designed to evade duties, and an additional undeclared cash payment may also have been involved.

In only a little over a decade, William Shakespeare had

clearly become a man of substance—a position he underscored by securing (in his father's name and at no small cost to himself) a coat of arms, allowing father and son and all their heirs in perpetuity to style themselves gentlemen—even though the death of Hamnet meant that there would be no male heirs now. Seeking a coat of arms might seem from our perspective a rather shallow, arriviste gesture, and perhaps it was, but it was a common enough desire among theatrical types. John Heminges, Richard Burbage, Augustine Phillips, and Thomas Pope all also sought and were granted coats of arms and the entitlement to respect that went with them. We should perhaps remember that these were men whose careers were founded on the fringes of respectability at a time when respectability meant a good deal.

John Shakespeare didn't get to enjoy his gentlemanly privileges long. He died in 1601, aged about seventy, having been a financial failure by this point for a quarter of a century—more than a third of his life.

Quite how well off Shakespeare became in these years is impossible to say. Most of his income came from his share of ownership of the theatrical company. From the plays themselves he would have earned comparatively little—about £6 was the going rate for a finished script in Shakespeare's day, rising perhaps to £10 for a work of the first rank. Ben Jonson in a lifetime earned less than £200 from his plays, and Shakespeare wouldn't have made a great deal more.

Various informed estimates suggest that his earnings in his peak years were not less than £200 a year and may have been as much as £700. On balance Schoenbaum thinks the lower

figure more likely to be correct, and Shakespeare wouldn't always have achieved that. In plague years, when the theaters were closed, all theatrical earnings were bound to have been much reduced.

Still, there is no question that he was by his early thirties a respectably prosperous citizen—though we gain a little perspective on Shakespeare's wealth when we compare his £200 to £700 a year with the £3,300 that the courtier James Hay could spend on a single banquet or the £190,000 that the Earl of Suffolk lavished on his country home in Essex, Audley End, or the £600,000 in booty Sir Francis Drake brought home from just one productive sea venture in 1580. Shakespeare was well off but scarcely a titan of finance. And it appears that no matter how prosperous he got, he never stopped being tightfisted. In the same year that he bought New Place, he was found guilty in London of defaulting on a tax payment of 5 shillings; the following year he defaulted again.

Though it isn't possible to say how much time he spent in Stratford in these years, it is certain that he became a presence in the town as an investor and occasional litigant. And it is apparent that he was known by his neighbors as a man of substance. In October 1598 Richard Quiney of Stratford (whose son would eventually marry one of Shakespeare's daughters) wrote to Shakespeare asking for a loan of £30—roughly £15,000 in today's money, so no small sum. In the event, it appears Quiney had second thoughts or was somehow deflected from his course, for the letter seems never to have been sent. It was found among his papers at his death.

Rather oddly, this period when Shakespeare was display-
ing wealth in an unusually debonair manner coincided with
what must have been a financially uncertain period for the Lord
Chamberlain's Men. In January 1597 James Burbage, their
guiding light and most senior figure, died at the age of sixty-
seven, just as the company's lease on the Theatre was about to
expire. Burbage had recently invested a great deal of money—
£1,000 at least—in purchasing and refurbishing the old Black-
friars Monastery in the City with the intention of turning it
into a theater. Unfortunately the residents of the neighborhood
had successfully petitioned to stop his plan.

James Burbage's son Cuthbert pursued negotiations to
renew the Theatre's lease—normally a straightforward pro-
cess—but the landlord proved difficult and strangely evasive.
The likelihood is that he had other plans for the site and the
building that stood upon it. After a year of getting nowhere
with him, the men of the company decided to take action.

On the night of December 28, 1598, the Lord Chamber-
lain's Men, aided by a dozen or so workmen, secretly began
to dismantle the Theatre and conveyed it across the frozen
Thames, where it was reerected overnight, according to legend.
In fact (and not surprisingly) it took considerably more than a
single night, though exactly how long is a matter of persistent
dispute. The contract for the construction of the rival Fortune
Theatre indicates a building time of six months, suggesting that
the new theater is unlikely to have been ready before summer
at the earliest (just the time when the London theatrical season
came to an end).

The new Globe, as it came to be called, stood a hundred feet or so in from the river and a little west of London Bridge and the palace of the bishops of Westminster. (The replica Globe Theatre built in 1997 is not on the original site, as visitors often naturally suppose, but merely near it.) Although Southwark is generally described as a place of stews, footpads, and other urban horrors, it is notable that in both Visscher's and Hollar's drawings much of the district is quite leafy and that the Globe is shown standing on the edge of serene and pleasant fields, with cows grazing right up to its walls.

The members of Shakespeare's company owned the Globe among them. The land for the theater was leased in February 1599 for thirty-one years to Cuthbert Burbage and his brother Richard and to five other members of the troupe: Shakespeare, Heminges, Augustine Phillips, Thomas Pope, and Will Kemp. Shakespeare's share varied over time—from one-fourteenth of the whole to one-tenth—as other investors bought in or sold off.

The Globe is sometimes referred to as "a theatre built by actors for actors" and there is of course a good deal in that. It is famously referred to as "this wooden O" in *Henry V*, and other contemporary accounts describe it as round, but it is unlikely to have been literally circular. "Tudor carpenters did not bend oak," the theater historian Andrew Gurr has observed, and a circular building would have required bent wood. Instead it was probably a many-sided polygon.

The Globe had a distinction in that it was designed exclusively for theatrical productions and took no earnings from

cockfighting, bearbaiting, or other such common entertainments. The first mention of it in writing comes in the early autumn of 1599 when a young Swiss tourist named Thomas Platter left a pretty full account of what he saw—including, on September 21, a production of *Julius Caesar* at the Globe, which he said was "very pleasingly performed" by a cast of about fifteen players. It is the first mention not only of the Globe, but also of *Julius Caesar*. (We are much indebted to Platter and his diary for a large part of what we know about Elizabethan theatrical performances in London—making it all the more ironic that he spoke almost no English and could not possibly have understood most of what he was seeing.)

The new theater immediately outshone its chief competitor, the Rose, home of Edward Alleyn and the Admiral's Men. The Rose was only a stroll away down a neighboring lane, and only seven years old, but it was built on boggy ground that made it always dank and uncomfortable. Unable to compete, Alleyn's company retired to a new site across the river, on Golden Lane, Cripplegate Without, where they built the Fortune, which was even larger than the Globe. It is the one London theater of the period for which architectural details exist, and so most of our "knowledge" of the Globe is in fact extrapolated from it. It burned down in two hours in 1621, leaving the Admiral's Men "utterly undone."

The Globe itself didn't last long. It likewise burned down in 1613, when sparks from a stage cannon ignited the roof thatch. But what a few years they were. No theater—perhaps no human enterprise—has seen more glory in only a decade or so than the

Globe during its first manifestation. For Shakespeare this period marked a burst of creative brilliance unparalleled in English literature. One after another, plays of unrivaled majesty dropped from his quill: *Julius Caesar, Hamlet, Twelfth Night, Measure for Measure, Othello, King Lear, Macbeth, Antony and Cleopatra.*

We thrill at these plays now. But what must it have been like when they were brand new, when all their references were timely and sharply apt, and all the words never before heard? Imagine what it must have been like to watch *Macbeth* without knowing the outcome, to be part of a hushed audience hearing Hamlet's soliloquy for the first time, to witness Shakespeare speaking his own lines. There cannot have been, anywhere in history, many more favored places than this.

Shakespeare also at this time produced (though he may of course have written earlier) an untitled allegorical poem, which history has come to know as *The Phoenix and the Turtle*, for a book of poems published in 1601 called *Love's Martyr: or Rosalind's Complaint*, compiled by Robert Chester and dedicated to Chester's patrons, Sir John and Lady Salusbury. What relationship Shakespeare had with Chester or the Salusburys is unknown. The poem, sixty-seven lines long, is difficult and doesn't always get much notice in biographies (Greenblatt in *Will in the World* and Schoenbaum in his *Compact Documentary Life* both, rather surprisingly, fail to mention it at all) but Frank Kermode rates it highly, calling it "a remarkable work with no obvious parallel in the canon," and praising its extraordinary language and rich symbolism.

Yet—and there really is always a "yet" with Shakespeare—

just as he was feverishly turning out some of his greatest work and enjoying the summit of his success, everything in his private life seemed to indicate a pronounced longing to be in Stratford. First he bought New Place—a strikingly large commitment for someone who had not owned a home before—and followed that with a cottage and plot of land across the road from New Place (probably to house a servant; it was too small to make a rentable investment). Then he acquired 107 acres of tenanted farmland north of Stratford for £320. Then, in the summer of 1605, he spent the very substantial sum of £440 to buy a 50 percent holding in tithes of "corn, grain, blade and hay" in three neighboring villages, from which he could expect earnings of £60 a year.

In the midst of these purchases, in the early winter of 1601, Shakespeare and his fellows faced what must have been an unnerving experience when they became peripherally but dangerously involved in an attempt to overthrow the queen. The instigator of this reckless exercise was Robert Devereux, second Earl of Essex.

Essex was the stepson of the Earl of Leicester, Elizabeth's longtime favorite and consort in all but name for much of her reign. Essex, though thirty years Elizabeth's junior, was in his turn a favorite, too, but he was also headstrong, reckless, and foolishly, youthfully disobedient. Time and again he tried her patience, but in 1599 royal exasperation turned to furious displeasure when Essex, as Lord Lieutenant of Ireland, concluded a truce without authority with Irish insurgents, then returned

to England against orders. Enraged, the queen placed Essex under strict house arrest. He was forbidden to have contact with his wife or even to stroll in his own garden. Worse, he was deprived of the lucrative offices that had supported him. The confinement was lifted the following summer, but by this point the damage to his pride and pocket had been done, and he began, with a few loyal followers, to cook up a scheme to foment a popular uprising and depose the queen. Among these loyal followers was the Earl of Southampton.

It was at this point, in February 1601, that Sir Gelly Meyrick, one of Essex's agents, approached the Lord Chamberlain's Men enjoining them to present a command performance of *Richard II* for a special payment of £2. The play, according to Meyrick's specific instructions, was to be performed at the Globe, in public, and the company was expressly instructed to include the scenes in which the monarch was deposed and murdered. This was a willfully incendiary act. The scenes were already so politically sensitive at the time that no printer would dare publish them.

It is important to bear in mind that to an Elizabethan audience a history play was not an emotionally remote account of something long since done; rather, it was perceived as a kind of mirror reflecting present conditions. Therefore staging *Richard II* was bound to be seen as an intentionally and provocatively seditious exercise. Only recently a young author named John Hayward had found himself clapped into the Tower after writing sympathetically about Richard II's abdication in *The First Part of the Life and Reign of King Henry IV*—an error of

judgment he further compounded by dedicating the work to the Earl of Essex. This was no time to be trifling with regal feelings.

Yet the Lord Chamberlain's Men dutifully performed the play as commanded on February 7. The next day the Earl of Essex, supported by three hundred men, set off from his home in the Strand toward the City. His plan was first to take control of the Tower and then Whitehall and then to arrest the queen. It was a harebrained scheme. His hope, evidently, was to replace Elizabeth with James VI of Scotland, and it was his confident expectation that he would accumulate supporters along the way. In fact, no one came forward—not a soul. His men rode through eerily silent streets, their rallying cries unanswered by a sullen and watching citizenry. Without a mob behind them, they had no hope of victory. Uncertain what to do next, Essex stopped for lunch, then fell back with his small (and swiftly evaporating) army toward the Strand. At Ludgate they ran into a party of startled soldiers, who in some confusion drew weapons and managed to fire some shots. A bullet passed through Essex's hat.

His revolution descending into farce, Essex fled back to his house, where he spent what remained of his liberty trying desperately—and a little pointlessly, one would have thought—to destroy incriminating documents. Soon afterward a detachment of soldiers turned up and arrested him and his archsupporter, Southampton.

Augustine Phillips spoke for the Lord Chamberlain's Men at the investigation that followed. We know little about Phil-

lips, other than that he was a trusted member of the company, but he must have made a persuasive case that they were innocent dupes or had acted under duress, for they were excused of any transgression—in fact were summoned to stage *another* play before the queen at Whitehall on the very day that she signed Essex's death warrant, Shrove Tuesday, 1601. Essex was executed on the day following. Meyrick and five other supporters were likewise beheaded. Southampton faced a similar unhappy fate, but was spared execution thanks to his mother's influential pleadings. He spent two years imprisoned in the Tower of London, albeit in considerable comfort in a suite of apartments that cost him £9 a week in rent.

Essex would have saved his own head and a great deal of bother if only he had been born with a little patience. Just over two years after his farcical rebellion, the queen herself was dead—and swiftly succeeded by the man whom Essex had given his life to try to put on the throne.

Chapter Seven

The Reign of King James, 1603–1616

BY THE WINTER OF 1603, if an account left by a French envoy, André Hurault, is entirely to be trusted, Queen Elizabeth I had become a little odd to behold. Her face was caked permanently in a thick mask of white makeup, her teeth were black or missing, and she had developed the distracted habit of loosening the stays of her dress so that it forever hung open. "You could see the whole of her bosom," noted Hurault in some wonder.

Shortly after Twelfth Night, the court retired to the royal palace at Richmond and there in early February the Chamberlain's Men, presumably with William Shakespeare among them, performed before the queen for the last time. (The play they performed is not known.) Soon afterward Elizabeth caught a chill and slipped into a dreamy, melancholic illness from which she never emerged. On March 24, the last day of

the year under the old Julian calendar, she died in her sleep, "mildly like a lamb." She was sixty-nine years old.

To the joy of nearly everyone, she was uneventfully succeeded by her northern kinsman James, son of Mary, Queen of Scots. He was thirty-six years old and married to a Danish Catholic, but devotedly Protestant himself. In Scotland he was James VI, but in England he became James I. He had ruled in Scotland for twenty years already and would reign in England for twenty-two more.

James was not, by all accounts, the most visually appealing of fellows. He was graceless in motion, with a strange lurching gait, and had a disconcerting habit, indulged more or less constantly, of playing with his codpiece. His tongue appeared to be too large for his mouth. It "made him drink very uncomely," wrote one contemporary, "as if eating his drink." His only concession to hygiene, it was reported, was to daub his fingertips from time to time with a little water. It was said that one could identify all his meals since becoming king from the stains and gravy scabs on his clothing, which he wore "to very rags." His odd shape and distinctive waddle were exaggerated by his practice of wearing extravagantly padded jackets and pantaloons to protect himself from assassins' daggers.

We might allow ourselves a touch of skepticism here, however. These critical observations were, in truth, mostly made by disaffected courtiers who had every reason to wish to see the king reduced by caricature, so it is difficult to know how much of a shambling wreck he really was. In one five-year period he bought two thousand pairs of gloves, and in 1604 he spent a

staggering £47,000 on jewels, which clearly doesn't suggest a total disregard for appearance.

Yet there is no doubt that there was a certain measure of differentness about him, particularly with regard to sexual comportment. Almost from the outset he excited dismay at court by nibbling handsome young men while hearing the presentations of his ministers. Yet he was also dutiful enough to produce eight children by his wife, Queen Anne. Simon Thurley notes how in 1606 James and his brother-in-law, King Christian IV of Denmark, undertook a "drunken and orgiastic progress" through the stately homes of the Thames Valley, with Christian at one point collapsing "smeared in jelly and cream." A day or two later, however, both were to be found sitting circumspectly watching *Macbeth*.

Whatever else he was, James was a generous patron of drama. One of his first acts as king was to award Shakespeare and his colleagues a royal patent, making them the King's Men. For a theatrical troupe, honors came no higher. The move made them Grooms of the Chamber and gave them the right, among other privileges, to deck themselves out in four and a half yards of scarlet cloth provided by the Crown. James remained a generous supporter of Shakespeare's company, using them often and paying them well. In the thirteen years between his accession and Shakespeare's death, they would perform before the king 187 times, more than all other acting troupes put together.

Though Shakespeare is frequently categorized as an Elizabethan playwright, in fact much of his greatest output was

Jacobean and he now produced a string of brilliant tragedies—
Othello, King Lear, Macbeth, Antony and Cleopatra, Coriolanus—
and one or two lesser works, notably *Timon of Athens*, a play so
difficult and seemingly incomplete that it is rarely performed
today. James made his own contribution to literary posterity,
too, by presiding over the production of a new "Authorized
Version"—the King James Version—of the Bible, a process
which took a panel of worthies seven years of devoted labor
from 1604 to 1611 to complete and in which he took an in-
formed and leading interest. It was the one literary production
of the age that rivaled Shakespeare's for lasting glory—and,
not incidentally, played a more influential role in encouraging
a conformity of spelling and usage throughout Britain and its
infant overseas dominions.

By the reign of James, comparatively few Britons were any
longer truly Catholic. Whereas Shakespeare had been born
into a country that was probably (albeit discreetly) two-thirds
Roman Catholic, by 1604 few people alive had ever heard a
Mass or taken part in any Catholic rite. Perhaps as little as 2
percent of the populace (though a higher proportion of aris-
tocrats) were actively Catholic. Thinking it was safe to do so,
in 1604 James suspended the recusancy laws and even allowed
Mass to be said in private homes.

In fact the severest Catholic challenge to Protestant rule
was just about to be mounted, when a group of conspirators
placed thirty-six barrels of gunpowder—ten thousand pounds
or so by weight—in a cellar beneath the Palace of Westminster
in advance of the state opening of Parliament. Such a volume of

explosives would have been sufficient to blow the palace, Westminster Abbey, Westminster Hall, and much of the surrounding neighborhood sky-high, taking with it the king, queen, their two sons, and most of the nation's leading clerics, aristocrats, and distinguished commoners. The reverberations from such an event are essentially unimaginable.

The one drawback of the scheme was that it would inevitably kill innocent Catholic parliamentarians. In the hope of sparing them, an anonymous tip-off was sent to a leading Catholic, Lord Monteagle. Hopelessly compromised and fearing an excruciating reprisal, Monteagle handed the letter straight to the authorities, who entered the palace's cellar and found one Guy Fawkes sitting on the barrels, waiting for the signal to strike a light. November 5 has been celebrated ever since with the burning of Fawkes effigies, though the hapless Fawkes was in fact a comparatively minor figure in the Powder Treason, as it became known at the time. The mastermind was Robert Catesby, whose family owned an estate just twelve miles from Stratford and who was distantly related to William Shakespeare by marriage, though there is no suggestion that their lives ever meaningfully intersected. In any case Catesby had spent most of his adult life as a faithful Protestant and had reverted to Catholicism only with the death of his wife five years earlier.

The reaction against Catholics was swift and decisive. They were barred from key professions and, for a time, not permitted to travel more than five miles from home. A law was even proposed to make them wear striking and preposterous hats,

for ease of identification, but it was never enacted. Recusancy fines, however, were reinstated and fiercely enforced. Catholicism would never be a threat in England again. The challenge to orthodoxy now would come from the other end of the religious spectrum—from the Puritans.

Though Shakespeare was increasingly a person of means, and now one of the most conspicuous men of property in Stratford, surviving evidence shows that in London he continued to live frugally. He remained in lodgings, and the value of his worldly goods away from Stratford was assessed by tax inspectors at a modest £5. (But a man as pathologically averse to paying taxes as Shakespeare no doubt took steps to minimize any appearance of wealth.)

Thanks to the scrupulous searching of Charles and Hulda Wallace and the documents of the Belott-Mountjoy case, we know that Shakespeare in this period was living in the home of the Huguenot Christopher Mountjoy, on the corner of Silver and Monkswell streets in the City—though he may not have been there continuously, as plague once again shut the theaters in London for a year, from May 1603 to April 1604. It was also during this period, as may be remembered, that Mountjoy fell out with his son-in-law Stephen Belott over the financial settlement concerning Belott's marriage to Mountjoy's daughter—a matter that must have generated a good deal of heat in the household, judging by the later depositions. It is diverting to imagine a tired and no doubt overstressed William Shakespeare trying to write *Measure for Measure* or *Othello* (both probably

written that year) in an upstairs room over a background din of family arguments. But of course he may have written elsewhere. And the Belotts and Mountjoys may have fought their wars in whispers. We know that one of their other lodgers, a writer named George Wilkins, was a man of violent temper, so perhaps they were too cowed to raise their voices.

The reknowned Shakespeare authority Stanley Wells thinks Shakespeare might have taken time off from the company to return to Stratford to write plays. "He retained a close interest in Stratford throughout his life, and there is nothing to suggest that he didn't retire there from time to time to write in peace," Wells told me. "The company may well have said to him, 'We need a new play—go home and write it.' He owned a rather grand establishment. It is not unreasonable to suppose that he might have wanted to spend time there."

Except that he was creatively productive, nothing of note can be stated with certainty about Shakespeare's life from 1603 to 1607 and 1608, when first his brother Edmund and then his mother died, both of unknown causes. Edmund was twenty-seven years old and an actor in London. Shakespeare's mother was over seventy—a ripe old age. More than that we do not know about either of them.

In the same year that Shakespeare's mother died, the King's Men finally secured permission to open the Blackfriars Theatre. The Blackfriars became the template from which all subsequent indoor theaters evolved, and so ultimately was more important to posterity than the Globe. It held only about six hundred people, but it was more profitable than the Globe because the

price of admission was high: sixpence for even the cheapest seat. This was good news for Shakespeare, who had a one-sixth interest in the operation. The smaller theater also permitted a greater intimacy in voice and even in music—strings and woodwinds rather than trumpet blasts.

Windows admitted some light, but candles provided most of the illumination. Spectators could, for an additional fee, sit on the stage—something not permitted at the Globe. With stage seating, audience members could show off their finery to maximum effect, and the practice was lucrative; but it contained an obvious risk of distraction. Stephen Greenblatt relates an occasion in which a nobleman who had secured a perch on the stage spied a friend entering across the way and strode *through* the performance to greet him. When rebuked by an actor for his thoughtlessness, the nobleman slapped the impertinent fellow and the audience rioted.

Apart from the stage itself, the best seats were in the pit (or so it is presumed) because the hanging candelabra must at least partly have obscured the view of those sitting higher up. With the Blackfriars up and running, the Globe closed for the winter.

On May 20, 1609, a quarto volume titled *Shakespeare's Sonnets, Never Before Imprinted*, went on sale, priced at 5 pence. The publisher was one Thomas Thorpe; this was slightly unexpected, as he possessed neither a press nor retail premises. What he did have, however, were the sonnets. Where he got them, and what William Shakespeare made of his having them, can only

be guessed at. We have no record of Shakespeare's making any public reaction to the sonnets' publication.*

"Probably more nonsense has been talked and written, more intellectual and emotional energy expended in vain, on the sonnets of Shakespeare than on any other literary work in the world," said W. H. Auden, correctly. We know virtually nothing for certain about them—when they were written, to whom they were addressed, under what circumstances they came to be published, whether they are assembled in even remotely the correct order.

In some critics' view, the sonnets are the very summit of Shakespeare's achievement. "No poet has ever found more linguistic forms by which to replicate human responses than Shakespeare in the Sonnets," wrote the Harvard professor Helen Vendler in *The Art of Shakespeare's Sonnets*. "The greater sonnets achieve an effortless combination of imaginative reach with high technical invention . . . a quintessence of grace."

Certainly they contain some of his most celebrated lines, as in the opening quatrain to Sonnet 18:

* A sonnet is a fourteen-line poem perfected by Petrarch (Francesco Petrarca), the fourteenth-century Italian poet. The word comes from *sonetto*, or "little song." The Italian sonnet of Petrarch was divided into two parts—an eight-line octave with one rhyme scheme (*abba, abba*) and a six-line sestet with another (*cde, cde or cdc, dcd*). In England the sonnet evolved a different form, and came to consist of three quatrains and a rather more pithy couplet at the end as a kind of kicker, and with it came a distinctive rhyme scheme: *abab, cdcd, efef, gg*.

Shall I compare thee to a summer's day?
Thou art more lovely and more temperate.
Rough winds do shake the darling buds of May,
And summer's lease hath all too short a date

What is unusual about these lines, and many others of an even more direct and candid nature, is that the person they praise is not a woman but a man. The extraordinary fact is that Shakespeare, creator of the tenderest and most moving scenes of heterosexual affection in play after play, became with the sonnets English literary history's sublimest gay poet.

Sonnets had had a brief but spectacular vogue, set off by Philip Sidney's *Astrophil and Stella* in 1591, but by 1609 they were largely out of fashion, and this doubtless helps to explain why Shakespeare's volume was not more commercially successful. Though his two long poems sold well, the sonnets seem to have attracted comparatively little notice and were reprinted only once in the century of their publication.

As published, the 154 sonnets are divided into two unequal parts: 1 to 126, which address a beauteous young man (or possibly even men), traditionally known as the fair youth, with whom the poet is candidly infatuated; and 127 to 154, which address a "dark lady" (though at no point is she actually so called) who has been unfaithful to him with the adored fellow in Sonnets 1 to 126. (At the risk of becoming parenthetically annoying, it is perhaps worth noting that Sonnet 126 is not strictly a sonnet but a collection of rhymed couplets.) There is also a shadowy figure known often as "the rival poet." The

volume also included, as a kind of coda, an unrelated poem, not in sonnet form, called *A Lover's Complaint*. It has many words (eighty-eight by one count) not found elsewhere in Shakespeare, leading some to suspect that it is not really his.

Many authorities believe that Shakespeare was alarmed and surprised—"horrified" in Auden's view—to find the sonnets in print. Sonnets are normally celebrations of love, but these were often full of self-loathing and great bitterness. Many were also arrestingly homoerotic, with references to "my lovely boy," "the master mistress of my passion," "Lord of my love," "thou mine, I thine," and other such bold and dangerously unorthodox declarations. It was irregular, to say the least, to address a love poem to someone of the same sex. The king's behavior at court notwithstanding, homosexuality was not a sanctioned activity in Stuart England and sodomy was still technically a capital offense (though the rarity of prosecutions suggests that it was quietly tolerated).

Nearly everything about the sonnets is slightly odd, starting with the dedication, which has bewildered and animated scholars almost since the moment of publication. It reads: "To the onlie begetter of these ensuing sonnets Mr W.H. all happinesse and that eternitie promised by our ever-living poet, wisheth the well-wishing adventurer in setting forth." It is signed "T.T".— which is reasonably taken to be Thomas Thorpe—but who is the enigmatic "Mr W.H."? One candidate, suggested surprisingly often, is Henry Wriothesley, with his initials reversed (for reasons no one has ever remotely made sound convincing). Another is William Herbert, third Earl of Pembroke, whose

initials are at least in order and who had a Shakespeare connection: Heminges and Condell would dedicate the First Folio to him and his brother fourteen years later.

The problem with either of these candidates is that they were both aristocratic, while the dedicatee is addressed here as "Mr." It has been suggested that Thorpe may not have known any better, but in fact Thorpe addressed Pembroke directly in a separate volume in the same year and did so with the usual obsequious flourishes: "To the Right Honourable, William, Earl of Pembroke, Lord Chamberlain to his Majesty, one of his most honourable Privy Council, and Knight of the most noble order of the Garter, etc. . . ." Thorpe knew how to address a noble. A more prosaic likelihood is that "Mr W.H." was a stationer named William Hall, who, like Thorpe, specialized in unauthorized productions.

A separate matter of contention is whether the "onlie begetter" is the person being addressed in the sonnets or simply the one who procured the text—whether he supplied the inspiration or merely the manuscript. Most authorities think the latter, but the dedication is vague to the point of real oddness. "Indeed," Schoenbaum wrote, "the entire dedication . . . is so syntactically ambiguous as to defeat any possibility of consensus among interpreters."

We don't know when Shakespeare wrote his sonnets, but he employed sonnets in *Love's Labour's Lost*—one of his very earliest plays by some reckonings—and in *Romeo and Juliet*, where a conversation between the two lovers is ingeniously (and movingly) rendered in sonnet form. So the sonnet as a poetic ex-

pression was certainly on his mind in the early to mid-1590s, at about the time he might have had a relationship with Southampton (assuming he had one). But dating the sonnets is an exceedingly tricky business. A single line in Sonnet 107 ("The mortal moon hath her eclipse endured") has been taken to signify at least five separate historic occurrences: an eclipse, the death of the queen, an illness of the queen, the defeat of the Spanish Armada, or a reading from a horoscope. Other sonnets seem to have been written earlier still. Sonnet 145 contains a pun on the name "Hathaway" ("'I hate' from hate away she threw"), which suggests that he may have written it in Stratford when he was in courting mode. If Sonnet 145 is indeed really autobiographical, it also makes clear that Shakespeare was not an innocent seduced by an older woman, but was rebuffed and had to work hard to win her heart.

The sonnets have driven scholars to the point of distraction because they are so frankly confessional in tone and yet so opaque. The first seventeen all urge the subject to marry, prompting biographers to wonder if they weren't directed at Southampton, who was, as we know, a most reluctant bridegroom. The poems press the fair youth to propagate so that his beauty is passed on—an approach that might well have appealed both to Southampton's vanity and to his sense of his genealogical responsibilities as an aristocrat. One suggestion is that Shakespeare was commissioned (by Burleigh or Southampton's mother or both) to write the poems, and that during the course of this transaction he met and fell for Southampton and the so-called dark lady.

It is an appealing scenario but one based on nothing but a chain of hopeful suppositions. We have no evidence that Shakespeare had even a formal acquaintance with Southampton, much less a panting one. It must also be said that the few specific references to appearance in the sonnets don't always sit comfortably with the known facts. Southampton, for example, was inordinately proud of his auburn hair, yet the admired character in Shakespeare has "golden tresses."

Looking for biography—Shakespeare's or anyone's—in the sonnets is almost certainly an exercise in futility. In fact, we don't actually know that the first 126 sonnets are all addressed to the same young man—or indeed that in every instance the person *is* a man. Many of the sonnets do not indicate the sex of the person being addressed. It is only because they have been published as a sequence—probably an unauthorized one—that we take them to be connected.

"If we take the 'I' in every sonnet to be stable, that's an enormous conceit," Paul Edmondson of the Shakespeare Birthplace Trust and coauthor with Stanley Wells of the book *Shakespeare's Sonnets* told me on a visit to Stratford. "People tend too easily to suppose they are printed as written. We just don't know that. Also, the 'I' doesn't have to be Shakespeare's own voice; there might be lots of different imaginary 'I's. Many of the conclusions about gender are based simply on context and placement." He notes that only twenty of the sonnets can conclusively be said to concern a male subject and just seven a female.

The dark lady is no less doubtful. A. L. Rowse—who, it must be said, never allowed an absence of certainty to get in the

way of a conclusion—in 1973 identified the dark lady as Emilia Bassano, daughter of one of the queen's musicians, and, with a certain thrust of literary jaw, asserted that his conclusions "cannot be impugned, for they are the answer," even though they are unsupported by anything that might reasonably be termed proof. Another oft-mentioned candidate was Mary Fitton, mistress of the Earl of Pembroke. But again some imagery in the text—"her breasts are dun; . . . / black wires grow on her head"—suggests someone darker still.

We will almost certainly never know for sure, and in any case we perhaps don't need to. Auden for one believed that knowing would add nothing to the poems' satisfactions. "Though it seems to me rather silly to spend much time on conjectures which cannot be proved true or false," he wrote, "what I really object to is their illusion that, if they were successful, if the identity of the Friend, the Dark Lady, the Rival Poet, etc., could be established beyond doubt, this would in any way illuminate our understanding of the sonnets themselves."

The matter of Shakespeare's sexuality—both that he had some and that it might have been pointed in a wayward direction—has caused trouble for his admirers ever since. One early editor of the sonnets solved the problem simply by making all the masculine pronouns feminine, at a stroke banishing any hint of controversy. Predictably, the Victorians suffered the acutest anxieties. Many went into a kind of obstinate denial and persuaded themselves that the sonnets were simply "poetical exercises" or "professional trials of skill," as the biographer Sidney

Lee termed them, arguing that Shakespeare had written them in a number of assumed voices, "probably at the suggestion of the author's intimate associates." Thus, any reference to longing to caress a fellow was Shakespeare writing in a female voice, as a demonstration of his versatility and genius. Shakespeare's real friendships, Lee insisted, were of "the healthy manly type" and any alternative interpretation "casts a slur on the dignity of the poet's name which scarcely bears discussion."

Discomfort lasted well into the twentieth century. Marchette Chute, in a popular biography of 1949, relegated all discussion of the sonnets to a brief appendix in which she explained: "The Renaissance used the violent, sensuous terms for friendship between men that later generations reserved for sexual love. Shakespeare's use of terms like 'master-mistress' sounds abnormal to the ears of the twentieth century, but it did not sound so at the end of the sixteenth." And that was as close as she or most other biographers cared to get to the matter. The historian Will Durant as recently as 1961 noted that Sonnet 20 contained "an erotic play on words" but could not bring himself to share specifics.

We needn't be so blushing. The lines he alludes to are: "But since she pricked thee out for women's pleasure, / Mine be thy love, and thy love's use their treasure." Most critics believe that these lines indicate that Shakespeare's attachment to the fair youth was never consummated. But as Stanley Wells notes, "If Shakespeare himself did not, in the fullest sense of the word, love a man, he certainly understood the feelings of those who do."

Perhaps the biggest question of all is, if he didn't write them for publication, what were they for? The sonnets represent a huge amount of work, possibly over a period of years, and at the highest level of creation. Were they really meant not to be shared? Sonnet 54 boasts:

> *Not marble nor the gilded monuments*
> *Of princes shall outlive this powerful rhyme.*

Did Shakespeare really believe that a sonnet scratched on paper and hidden away in a folder or drawer would outlast marble? Perhaps it all was an elaborate conceit or private amusement. More than for any other writer, Shakespeare's words stand separate from his life. This was a man so good at disguising his feelings that we can't ever be sure that he had any. We know that Shakespeare used words to powerful effect, and we may reasonably presume that he had feelings. What we don't know, and can barely even guess at, is where the two intersected.

In his later years Shakespeare began to collaborate—probably with George Wilkins in about 1608 on *Pericles* and with John Fletcher on *The Two Noble Kinsmen*, *Henry VIII* (or *All Is True*), and the lost play *The History of Cardenio*, all first performed around 1613. Wilkins was, on the face of it, an exceedingly unappealing character. He ran an inn and brothel and was constantly in trouble with the law—once for kicking a pregnant woman in the belly and on another occasion for beating and

stamping upon a woman named Judith Walton. But he was also an author of distinction, writing plays successfully on his own—his *Miseries of Enforced Marriage* was performed by the King's Men in 1607—and in collaboration. All that is known of his relationship with Shakespeare is that they were fellow lodgers for a time at the Mountjoy residence.

Fletcher was of a more refined background altogether. Fifteen years younger than Shakespeare, he was the son of a bishop of London (who had, among other distinctions, been the presiding cleric at the execution of Mary, Queen of Scots). Fletcher's father was for a time a favorite of Queen Elizabeth's, but after his first wife died he earned the queen's displeasure with a hasty remarriage and was banished from court. He died in some financial distress.

Young Fletcher was educated at Cambridge. As a playwright—and indeed as a person—he was most intimately associated with Francis Beaumont, with whom he enjoyed a strikingly singular relationship. From 1607 to 1613 they were virtually inseparable. They slept in the same bed, shared a mistress, and even dressed identically, according to John Aubrey. During this period they cowrote ten or so plays, including *The Maid's Tragedy* and the very successful *A King and No King*. But then Beaumont abruptly married, and the partnership just as abruptly ceased. Fletcher went on to collaborate with many others, notably Philip Massinger and William Rowley.

Nothing is known of the relationship between Shakespeare and Fletcher. It may well be that they worked separately, or it may be that Fletcher was given unfinished manuscripts to com-

plete after Shakespeare's retirement. Wells, however, thinks that the careful flow of the plays suggests they worked together closely.

The Two Noble Kinsmen, though almost certainly performed while Shakespeare was still alive, is unknown before 1634, when it was published with a title page attributing it jointly to Fletcher and Shakespeare. *Henry VIII* and *Cardenio* are also ascribed to Fletcher and Shakespeare jointly. *Cardenio* was based on a character in Don Quixote and was never published, it seems, though it was registered for publication in 1653 as being by "Mr Fletcher and Shakespeare." A manuscript copy of the play is thought to have been held by a museum in Covent Garden, London, but unfortunately the museum went up in flames in 1808 and took the manuscript with it. Fletcher died in 1625 of the plague and was buried with—literally with—his fellow playwright and sometime collaborator Massinger. Today they lie in the chancel of Southwark Cathedral beside the grave of Shakespeare's young brother Edmund.

Shakespeare may also have collaborated much earlier on *Edward III*, published anonymously in 1596. Some authorities think at least some of the play is Shakespeare's, though the matter is much in dispute. *Timon of Athens* was probably written with Thomas Middleton. Stanley Wells suggests a date of 1605, while stressing that it is very uncertain. George Peele is also mentioned often as a probable collaborator on *Titus Andronicus*.

"Shakespeare became a different kind of writer as he got older—still brilliant, but more challenging," Stanley Wells told

me in an interview. "His language became more dense and elliptical. He became less inclined to consider the needs and interests of the traditional audience. The plays became less theatrical, more introverted. He was perhaps a bit out of fashion in his last years. Even now his later plays—*Cymbeline*, *The Winter's Tale*, *Coriolanus*—are less popular than those of his middle period."

His output was clearly declining in pace. He seems to have written nothing at all after 1613, the year the Globe burned down. But he did still evidently make trips to London. In 1613, he bought a house in Blackfriars for the very substantial sum of £140, evidently as an investment. Interestingly he made the purchase more complicated than necessary by taking out a mortgage that involved the oversight of three trustees—his colleague John Heminges, his friend Thomas Pope, and William Johnson, landlord of the famous Mermaid Tavern. (This is, incidentally, the only known connection Shakespeare had to that famous tavern, legend notwithstanding.) One consequence of making the purchase in this way was that it kept the property from passing to Shakespeare's widow, Anne, upon his death. Instead it went to the trustees. Why Shakespeare would wish this, as so much else, can only be a matter for conjecture.

Chapter Eight

Death

IN LATE MARCH 1616, William Shakespeare made some changes to his will. It is tempting to suppose that he was unwell and probably dying. Certainly he appears not to have been himself. His signatures are shaky and the will bears certain signs of confusion: He could not evidently recall the names of his brother-in-law Thomas Hart or of one of Hart's sons—though it is equally odd that none of the five witnesses supplied these details either. Why, come to that, Shakespeare required that many witnesses is a puzzle. Two was the usual number.

It was an unhappily eventful time in Shakespeare's life. A month earlier his daughter Judith had married a local vintner of dubious character named Thomas Quiney. Judith was thirty-one years old and her matrimonial prospects were in all likelihood fading swiftly. In any case she appears to have chosen poorly, for just over a month after their marriage Quiney was fined 5 shillings for unlawful fornication with one Margaret

Wheeler—a very considerable humiliation for his new bride and her family. Worse, Miss Wheeler died giving birth to Quiney's child, adding tragedy to scandal.

As if this weren't enough, on April 17 Will's brother-in-law Hart, a hatter, died, leaving his sister Joan a widow. Six days later William Shakespeare himself died from causes unknown. Months don't get much worse than that.

Shakespeare's will resides today in a box in a special locked room at Britain's National Archives at Kew in London. The will is written on three sheets of parchment, each of a different size, and bears three of Shakespeare's six known signatures, one on each page. It is a strikingly dry piece of work, "absolutely void of the least particle of that Spirit which Animated Our great Poet," wrote the Reverend Joseph Greene of Stratford, the antiquary who rediscovered the will in 1747 and was frankly disappointed in its lack of affection.

Shakespeare left £350 in cash plus four houses and their contents and a good deal of land—worth a little under £1,000 all together, it has been estimated—a handsome and respectable estate, though by no means a great one. His bequests were mostly straightforward: To his sister he left £20 in cash and the use of the family home on Henley Street for the rest of her life; to each of her three children (including the one whose name he could not recall) he left £5. He also left Joan his clothes. Though clothing had value, it was extremely unusual, according to David Thomas, for it to be left to someone of the opposite sex. Presumably Shakespeare could think of no one else who might welcome it.

The most famous line in the document appears on the third page, where to the original text is added an interlineation, which says, a touch tersely: "I give unto my wife my second-best bed with the furniture" (that is, the bedclothes). The will does not otherwise mention Shakespeare's widow. Scholars have long argued over what can be concluded about their relationship from this.

Beds and bedding were valued objects and often mentioned in wills. It is sometimes argued that the second-best bed was the marital bed—the first bed being reserved for important visitors—and therefore replete with tender associations. But Thomas says the evidence doesn't bear this out and that husbands virtually always gave the best bed to their wives or eldest sons. A second-best bed, he believes, was inescapably a demeaning bequest. It is sometimes pointed out that as a widow Anne would automatically have been entitled to one-third of Shakespeare's estate, and therefore it wasn't necessary for him to single her out for particular bequests. But even allowing for this, it is highly unusual for a spouse to be included so tersely as an afterthought.

A colleague of Thomas's, Jane Cox, now retired, made a study of sixteenth-century wills and found that typically husbands said tender things about their wives—Condell, Heminges, and Augustine Phillips all did—and frequently left them some special remembrance. Shakespeare does neither, but then, as Samuel Schoenbaum notes, he offers "no endearing references to other family members either." With respect to Anne, Thomas suggests that perhaps she was mentally incapacitated. Then again it may be that Shakespeare was simply too ill to include endearments. Thomas thinks it's possible that

Shakespeare's signatures on the will were forged—probably not for any nefarious reason, but simply because he was too ill to wield a quill himself. If the signatures are not genuine, it would be something of a shock to the historical record, as the will contains half of Shakespeare's six known signatures.

He left £10 to the poor of Stratford, which is sometimes suggested as being a touch niggardly, but in fact according to Thomas it was quite generous. A more usual sum for a man of his position was £2. He also left 20 shillings to a godson and small sums to various friends, including (in yet another interlineation) 26 shillings apiece to Heminges, Condell, and Richard Burbage to purchase memorial rings—a common gesture. All the rest went to his two daughters, the bulk to Susanna.

Apart from the second-best bed and the clothes he left to Joan, only two other personal possessions are mentioned—a gilt-and-silver bowl and a ceremonial sword. Judith was given the bowl. The likelihood is that it sits today unrecognized on some suburban sideboard; it was not the sort of object that gets discarded. The sword was left to a local friend, Thomas Combe; its fate is similarly unknown. It is generally assumed that Shakespeare's interests in the Globe and Blackfriars theaters had been sold already, for there is no mention of them. The full inventory of his estate, listing his books and much else of value to history, would have been sent to London, where in all likelihood it perished in the Great Fire of 1666. No trace of it survives.

Shakespeare's wife died in August 1623, just before the publication of the First Folio. His daughter Susanna lived on until

1649, when she died aged sixty-six. His younger daughter, Judith, lived till 1662, and died aged seventy-seven. She had three children, including a son named Shakespeare, but all predeceased her without issue. "Judith was the great lost opportunity," says Stanley Wells. "If any of Shakespeare's early biographers had sought her out, she could have told them all kinds of things that we would now dearly love to know. But no one, it appears, troubled to speak to her." Shakespeare's granddaughter Elizabeth, who equally might have shed light on many Shakespearean mysteries, lived until 1670. She married twice but had no children either, and so with her died the Shakespeare line.

Theaters boomed in the years just after Shakespeare's death, even more so than they had in his lifetime. By 1631, seventeen of them were in operation around London. The good years didn't last long, however. By 1642, when the Puritans shut them down, just six remained—three amphitheaters and three halls. Theaters would never again appeal to so wide a spectrum of society or be such a universal pastime.

Shakespeare's plays might have been lost, too, had it not been for the heroic efforts of his close friends and colleagues John Heminges and Henry Condell, who seven years after his death produced a folio edition of his complete works. It put into print for the first time eighteen of Shakespeare's plays: *Macbeth*; *The Tempest*; *Julius Caesar*; *The Two Gentlemen of Verona*; *Measure for Measure*; *The Comedy of Errors*; *As You Like It*; *The Taming of the Shrew*; *King John*; *All's Well That Ends Well*; *Twelfth Night*; *The Winter's Tale*; *Henry VI, Part 1*; *Henry VIII*;

Coriolanus; *Cymbeline*; *Timon of Athens*; and *Antony and Cleopatra*. Had Heminges and Condell not taken this trouble, the likelihood is that all of these plays would have been lost to us. Now that is true heroism.

Heminges and Condell were the last of the original Chamberlain's Men. As with nearly everyone else in this story, we know only a little about them. Heminges (Kermode makes it *Heminge*; others use *Heming* or *Hemings*) was the company's business manager, but also a sometime actor and, at least according to tradition, is said to have been the first Falstaff—though he is also said to have had a stutter, "an unfortunate handicap for an actor," as Wells notes. He listed himself in his will as a "citizen and grocer of London." A grocer in Shakespeare's day was a trader in bulk items, not someone who sold provisions from a shop (think of *gross*, not *groceries*). In any case the designation meant only that he belonged to the grocers' guild, not that he was actively involved in the trade. He had thirteen children, possibly fourteen, by his wife, Rebecca, widow of the actor William Knell, whose murder at Thame in 1587, it may be recalled, left a vacancy among the Queen's Men into which some commentators have been eager to place a young William Shakespeare.

Condell (or sometimes *Cundell*, as on his will) was an actor, esteemed evidently for comedic roles. Like Shakespeare he invested wisely and was sufficiently wealthy to style himself "gentleman" without fear of contradiction and to own a country home in what was then the outlying village of Fulham. He left Heminges a generous £5 in his will—considerably more than

Shakespeare left Heminges, Condell, and Burbage together in his. Condell had nine children. He and Heminges lived as neighbors in Saint Mary Aldermanbury, within the City walls, for thirty-two years.

After Shakespeare's death they set to putting together the complete works—a matter of no small toil. They must have been influenced by the example of Ben Jonson, who in the year of Shakespeare's death, 1616, had issued a handsome folio of his own work—a decidedly vain and daring thing to do since plays were not normally considered worthy of such grand commemoration. Jonson rather pugnaciously styled the book his "Workes," prompting one waggish observer to wonder if he had lost the ability to distinguish between work and play.

We have no idea how long Heminges and Condell's project took, but Shakespeare had been dead for seven years by the time the volume was ready for publication in the autumn of 1623. It was formally called *Mr. William Shakespeare's Comedies, Histories, and Tragedies*, but has been known to the world ever since—well, nearly ever since—as the First Folio.

A folio, from the Latin *folium*, or "leaf," is a book in which each sheet has been folded just once down the middle, creating two leaves or four pages. A folio page is therefore quite large—typically about fifteen inches high. A quarto book is one in which each sheet is folded twice, to create four leaves—hence "quarto"—or eight pages.

The First Folio was published by Edward Blount and the father-and-son team of William and Isaac Jaggard—a curious choice, since the senior Jaggard had earlier published the book

of poems *The Passionate Pilgrim*, which the title page ascribed to William Shakespeare, though in fact Shakespeare's only contribution was a pair of sonnets and three poems lifted whole from *Love's Labour's Lost*, suggesting that the entire enterprise may have been unauthorized and thus potentially irksome to Shakespeare. At all events, by the time of the First Folio, William Jaggard was so ill that he almost certainly didn't participate in the printing.

Publication was not a decision to be taken lightly. Folios were big books and expensive to produce, so the First Folio was very ambitiously priced at £1 (for an edition bound in calf-skin; unbound copies were a little cheaper). A copy of the sonnets, by comparison, cost just 5 pence on publication—or one forty-eighth the price of a folio. Even so the First Folio did well and was followed by second, third, and fourth editions in 1632, 1663–1664, and 1685.

The idea of the First Folio was not just to publish plays that had not before been seen in print but to correct and restore those that had appeared in corrupt or careless versions. Heminges and Condell had the great advantage that they had worked with Shakespeare throughout his career and could hardly have been more intimately acquainted with his work. To aid recollection they had much valuable material to work with—promptbooks, foul papers (as rough drafts or original copies were known) in Shakespeare's own hand, and the company's own fair copies—all now lost.

Before the First Folio all that existed of Shakespeare's plays were cheap quarto editions of exceedingly variable qual-

ity—twelve of them traditionally deemed to be "good" and nine deemed "bad." Good quartos are clearly based on at least reasonably faithful copies of plays; bad ones are generally presumed to be "memorial reconstructions"—that is, versions set down from memory (often very bad memory, it seems) by fellow actors or scribes employed to attend a play and create as good a transcription as they could manage. Bad quartos could be jarring indeed. Here is a sample of Hamlet's soliloquy as rendered by a bad quarto:

> *To be, or not to be, I there's the point,*
> *To Die, to sleepe, is that all? I all.:*
> *No, to sleepe, to dreame, I mary there it goes,*
> *For in that dreame of death, when wee awake,*
> *And borne before an everlasting Judge,*
> *From whence no passenger ever returned. . .*

Heminges and Condell proudly consigned to the scrap heap all these bad versions—the "diverse stolne, and surreptitious copies, maimed, and deformed by the frauds and stealthes of injurious impostors," as they put it in their introduction to the volume—and diligently restored Shakespeare's plays to their "True Originall" condition. The plays were now, in their curious phrase, "cur'd, and perfect of their limbes"—or so they boasted. In fact, however, the First Folio was a decidedly erratic piece of work.

Even to an inexpert eye its typographical curiosities are striking. Stray words appear in odd places—a large and eminently

superfluous "THE" stands near the bottom of page 38, for instance—page numbering is wildly inconsistent, and there are many notable misprints. In one section, pages 81 and 82 appear twice, but pages 77–78, 101–108, and 157–256 don't appear at all. In *Much Ado About Nothing* the lines of Dogberry and Verges abruptly cease being prefixed by the characters' names and instead become prefixed by "Will" and "Richard," the names of the actors who took the parts in the original production—an understandable lapse at the time of performance but hardly an indication of tight editorial control when the play was reprinted years later.

The plays are sometimes divided into acts and scenes but sometimes not; in *Hamlet* the practice of scene division is abandoned halfway through. Character lists are sometimes at the front of plays, sometimes at the back, and sometimes missing altogether. Stage directions are sometimes comprehensive and at other times almost entirely absent. A crucial line of dialogue in *King Lear* is preceded by the abbreviated character name "Cor.," but it is impossible to know whether "Cor." refers to Cornwall or Cordelia. Either one works, but each gives a different shading to the play. The issue has troubled directors ever since.

But these are, it must be said, the most trifling of bleats when we consider where we would otherwise be. "Without the *Folio*," Anthony James West has written, "Shakespeare's history plays would have lacked their beginning and their end, his only Roman play would have been *Titus Andronicus*, and there would have been three, not four, 'great tragedies.' Shorn of these eighteen plays, Shakespeare would not have been the pre-eminent dramatist that he is now."

Heminges and Condell are unquestionably the greatest literary heroes of all time. It really does bear repeating: only about 230 plays survive from the period of Shakespeare's life, of which the First Folio represents some 15 percent, so Heminges and Condell saved for the world not only half the plays of William Shakespeare, but an appreciable portion of *all* Elizabethan and Jacobean drama.

The plays are categorized as Comedies, Histories, and Tragedies. *The Tempest*, one of Shakespeare's last works, is presented first, probably because of its relative newness. *Timon of Athens* is an unfinished draft (or a finished play that suffers from "extraordinary incoherencies," in the words of Stanley Wells). *Pericles* doesn't appear at all—and wouldn't be included in a folio edition for another forty years, possibly because it was a collaboration. For the same reason, probably, Heminges and Condell excluded *The Two Noble Kinsmen* and *The True History of Cardenio*; this is more than a little unfortunate because the latter is now lost.

They *nearly* left out *Troilus and Cressida*, but then at the last minute stuck it in. No one knows what exactly provoked the dithering. They unsentimentally tidied up the titles of the history plays, burdening them with dully descriptive labels that robbed them of their romance. In Shakespeare's day there was no *Henry VI, Part 2*, but rather *The First Part of the Contention Betwixt the Two Famous Houses of York and Lancaster*, while *Henry VI, Part 3* was *The True Tragedy of Richard Duke of York and the Good King Henry the Sixth*—"more interesting, more informative, more grandiloquent," in the words of Gary Taylor.

Despite the various quirks and inconsistencies, and to their eternal credit, Heminges and Condell really did take the trouble, at least much of the time, to produce the most complete and accurate versions they could. *Richard II*, for instance, was printed mostly from a reliable quarto, but with an additional 151 good lines carefully salvaged from other, poorer quarto editions and a promptbook, and much the same kind of care was taken with others in the volume.

"On some texts they went to huge trouble," says Stanley Wells. "*Troilus and Cressida* averages eighteen changes per page—an enormous number. On other texts they were much less discriminating."

Why they were so inconsistent—fastidious here, casual there—is yet another question no one can answer. Why Shakespeare didn't have the plays published in his lifetime is a question not easily answered either. It is often pointed out that in his time a playwright's work belonged to the company, not to the playwright, and therefore was not the latter's to exploit. That is indubitably so, but Shakespeare's close relationships with his fellows surely would have ensured that his wishes would be met had he desired to leave a faithful record of his work, particularly when so much of it existed only in spurious editions. Yet nothing we possess indicates that Shakespeare took any particular interest in his work once it was performed.

This is puzzling because there is reason to believe (or at least to suspect) that some of his plays may have been written to be read as well as performed. Four in particular—*Hamlet*, *Troilus and Cressida*, *Richard III*, and *Coriolanus*—were unnatu-

rally long at 3,200 lines or more, and were probably seldom if ever performed at those lengths. The suspicion is that the extra text was left as a kind of bonus for those with greater leisure to take it in at home. Shakespeare's contemporary John Webster, in a preface to his *The Duchess of Malfi*, noted that he had left in much original, unperformed material for the benefit of his reading public. Perhaps Shakespeare was doing likewise.

It is not quite true that the First Folio is the definitive version for each text. Some quartos, including bad ones, may incorporate later improvements and refinements, or, more rarely, may offer readable text where the Folio version is doubtful or vague. Even the poorest quarto can provide a useful basis of comparison between varying versions of the same text. G. Blakemore Evans cites a line from *King Lear* that is rendered in different early editions of the play as "My Foole usurps my body," "My foote usurps my body," and "My foote usurps my head" (and in fact really makes sense only as "A fool usurps my bed"). Quartos also tend to incorporate more generous stage directions, which can be very helpful to scholars and directors alike.

Sometimes there are such differences between quarto and folio editions of plays that it is impossible to know how to resolve them or to guess which version Shakespeare might ultimately have favored. The most notorious example of this is *Hamlet*, which exists in three versions: a "bad" 1603 quarto of 2,200 lines, a much better 1604 quarto of 3,800 lines, and the 1623 folio version of 3,570 lines. There are reasons to believe that of the three the "bad" first quarto may actually most closely

represent the play as performed. It is certainly brisker than the other versions. Moreover, as Ann Thompson of King's College in London points out, it places Hamlet's famous soliloquy in a different, better place, where suicidal musing seems more apt and rational.

Even more comprehensively problematic is *King Lear*, for which the quarto edition has three hundred lines and an entire scene not found in the First Folio, while the latter has one hundred or so lines not found in the quarto. The two versions assign speeches to different characters, altering the nature of three central roles—Albany, Edgar, and Kent—and the quarto offers a materially different ending. Such are the differences that the editors of the *Oxford Shakespeare* included both versions in the complete works on the grounds that they are not so much two versions of the same play as two different plays. *Othello* likewise differs in more than one hundred lines between quarto and First Folio, but, even more important, has hundreds of different words in the two versions, suggesting extensive later revision.

Nobody knows how many First Folios were printed. Most estimates put the number at about a thousand, but this is really just a guess. Peter W. M. Blayney, the preeminent authority on the First Folio, thinks it was rather less than a thousand. "The fact that the book was reprinted after only nine years," Blayney has written, "suggests a relatively small edition—probably no more than 750 copies, and perhaps fewer." Of these, all or part of three hundred First Folios survive—an extraordinary proportion.

The great repository of First Folios today is a modest building on a pleasant street a couple of blocks from the Capitol in Washington, D.C.—the Folger Shakespeare Library. It is named for Henry Clay Folger, who was president of Standard Oil (and, more distantly, a member of the Folgers coffee family), and who began collecting First Folios early in the twentieth century, when they could often be snapped up comparatively cheaply from hard-up aristocrats and struggling institutions.

As sometimes happens with serious collectors, Folger became increasingly expansive as time went on, and began collecting works not just by or about Shakespeare, but by or about people who liked Shakespeare, so that the collection includes not only much priceless Shakespearean material but also some unexpected curiosities: a manuscript by Thomas de Quincey on how to make porridge, for instance. Folger didn't live to see the library that bears his name. Two weeks after laying the foundation stone in 1930, he died of a sudden heart attack.

The collection today consists of 350,000 books and other items, but the core is the First Folios. The Folger owns more of them than any other institution in the world—though surprisingly, no one can say exactly how many.

"It is not actually easy to say what is a First Folio and what isn't, because most Folios are no longer entirely original and few are entirely complete," Georgianna Ziegler, one of the curators, told me when I visited in the summer of 2005. "Beginning in the late eighteenth century it became common practice to fill out incomplete or broken volumes by inserting pages taken from other volumes, sometimes to quite a radical extent.

Copy sixty-six of our collection is roughly 60 percent cannibalized from other volumes. Three of our 'fragment' First Folios are actually more complete than that."

"What we normally say," added her colleague Rachel Doggett, "is that we have approximately one-third of the surviving First Folios."

It is customarily written that the Folger has seventy-nine complete First Folios and parts of several others, though in fact only thirteen of the seventy-nine "complete" copies really are complete. Peter Blayney, however, believes the Folger can reasonably claim to possess eighty-two complete copies. It really is largely a matter of semantics.

Ziegler and Doggett took me to a secure windowless basement room where the rarest and most important of the volumes in the Folger collections are kept. The room was chilly, brightly lit, and rather antiseptic. Had I been blindfolded I might have guessed that it was a room where autopsies were conducted. Instead it was filled with rows of modern shelving containing a vast quantity of very old books. The First Folios lay on their sides on twelve shallow shelves along the back wall. Each book is about eighteen by fourteen inches, roughly the size of an *Encyclopædia Britannica* volume.

It is worth devoting a moment to considering how books were put together in the early days of movable type. Think of a standard greeting card in which one sheet of paper card is folded in half to make four separate surfaces—front, inside left, inside right, and back. Slip two more folded cards into the first and you have a booklet of twelve pages, or what is known as a

quire—roughly half the length of a play or about the amount of text that a printing workshop would work on at any time. The complication from the printer's point of view is that in order to have the pages run consecutively when slotted together, they must be printed mostly out of sequence. The outer sheet of a quire, for instance, will have pages 1 and 2 on the left-hand leaf but pages 11 and 12 on the right-hand side. Only the innermost two pages of a quire (pages 6 and 7) will actually appear and be printed consecutively. All the others have at least one nonsequential page for a neighbor.

What this meant in producing a book was that it was necessary to work out in advance which text would appear on each of twelve pages. The process was known as casting off, and when it went wrong, as it commonly did, compositors had to make adjustments to get their lines and pages to end in the right places. Sometimes it was a matter of introducing a contraction here and there—using "ye" instead of "the," for example—but sometimes more desperate expedients became necessary. On occasion whole lines were dropped.

With the First Folio, production was spread among three different shops, each employing teams of compositors of varying deftness, experience, and commitment, which naturally resulted in differences from one volume to another. If an error was noticed when a page was being printed, as often happened, it would be corrected at that point in the run. A series of corrections would therefore introduce a number of discrepancies between almost any two volumes. Printers in Shakespeare's day (and, come to that, long after) were notoriously headstrong and

opinionated, and rarely hesitated to introduce improvements as they saw fit. It is known from extant manuscripts that when the publisher Richard Field published a volume by the poet John Harrington, his compositors introduced more than a thousand changes to the spelling and phrasing.

In addition to all the intentional alterations made during the course of production, there were many minute differences in wear and quality between different pieces of type, especially if taken from different typecases. Realizing all this, in the 1950s Charlton Hinman made a microscopic examination of fifty-five Folger folios using a special magnifier that he built himself. The result was *The Printing and Proof-Reading of the First Folio of Shakespeare* (1963), one of the most extraordinary pieces of literary detection of the last century.

By carefully studying and collating individual printers' preferences as well as microscopic flaws on certain letters through each of the fifty-five volumes, Hinman was able to work out which compositors did which work. Eventually he identified nine separate hands—whom he labeled A, B, C, D, and so on—at work on the First Folio.

Although nine hands contributed, their workload was decidedly unequal; B alone was responsible for nearly half the published text. By chance one of the compositors may have been a John Shakespeare, who trained with Jaggard the previous decade. If so, his connection to the enterprise was entirely coincidental; he had no known relationship to William Shakespeare. Ironically the compositor whose identity can most confidently be surmised—a young man from Hursley in

Hampshire named John Leason, who was known to Hinman as Hand E—was the worst by far. He was the apprentice—and not a very promising one, it would appear from the quality of his work.

Among much else Hinman determined that no two volumes of the First Folio were exactly the same. "The idea that every single volume would be different from every other was unexpected, and obviously you would need a lot of volumes to make that determination," said Rachel Doggett with a look of real satisfaction. "So Folger's obsession with collecting Folios turned out to be quite a valuable thing for scholarship."

"What is slightly surprising," Ziegler said, "is that all the fuss is about a book that wasn't actually very well made." To demonstrate her point she laid open on a table one of the First Folios and placed beside it a copy of Ben Jonson's own complete works. The difference in quality was striking. In the Shakespeare First Folio, the inking was conspicuously poor; many passages were faint or very slightly smeared.

"The paper is handmade," she added, "but of no more than middling quality." Jonson's book in comparison was a model of stylish care. It was beautifully laid out, with decorative drop capitals and printer's ornaments, and it incorporated many useful details such as the dates of first performances, which were lacking from the Shakespeare volume.

At the time of Shakespeare's death few would have supposed that one day he would be thought the greatest of English playwrights. Francis Beaumont, John Fletcher, and Ben Jonson

were all more popular and esteemed. The First Folio contained just four poetic eulogies—a starkly modest number. When the now obscure William Cartwright died in 1643, five dozen admirers jostled to offer memorial poems. "Such are the vagaries of reputation," sighs Schoenbaum in his *Documentary Life*.

This shouldn't come entirely as a surprise. Ages are generally pretty incompetent at judging their own worth. How many people now would vote to bestow Nobel Prizes for Literature on Pearl Buck, Henrik Pontoppidan, Rudolf Eucken, Selma Lagerlöf, or many others whose fame could barely make it to the end of their own century?

In any case Shakespeare didn't altogether delight Restoration sensibilities, and his plays were heavily adapted when they were performed at all. Just four decades after his death, Samuel Pepys thought *Romeo and Juliet* "the worst that ever I heard in my life"—until, that is, he saw *A Midsummer Night's Dream*, which he thought "the most insipid ridiculous play that ever I saw in my life." Most observers were more admiring than that, but on the whole they preferred the intricate plotting and thrilling twists of Beaumont and Fletcher's *Maid's Tragedy*, *A King and No King*, and others that are now largely forgotten except by scholars.

Shakespeare never entirely dropped out of esteem—as the publication of Second, Third, and Fourth Folios clearly attests—but neither was he reverenced as he is today. After his death some of his plays weren't performed again for a very long time. *As You Like It* was not revived until the eighteenth century. *Troilus and Cressida* had to wait until 1898 to be staged again,

in Germany, though John Dryden in the meanwhile helpfully gave the world a completely reworked version. Dryden took this step because, he explained, much of Shakespeare was ungrammatical, some of it coarse, and the whole of it "so pester'd with Figurative expressions, that it is as affected as it is obscure." Nearly everyone agreed that Dryden's version, subtitled "Truth Found Too Late," was a vast improvement. "You found it dirt but you have made it gold," gushed the poet Richard Duke.

The poems, too, went out of fashion. The sonnets "were pretty well forgotten for over a century and a half," according to W. H. Auden, and *Venus and Adonis* and *The Rape of Lucrece* were likewise overlooked until rediscovered by Samuel Taylor Coleridge and his fellow Romantics in the early 1800s.

Such was Shakespeare's faltering status that as time passed the world began to lose track of what exactly he had written. The Third Folio, published forty years after the first, included six plays that Shakespeare didn't in fact write—*A Yorkshire Tragedy*, *The London Prodigal*, *Locrine*, *Sir John Oldcastle*, *Thomas Lord Cromwell*, and *The Puritan Widow*—though it did finally make room for *Pericles*, for which scholars and theatergoers have been grateful ever since. Other collections of his plays contained still other works—*The Merry Devil of Edmonton*, *Mucedorus*, *Iphis and Ianthe*, and *The Birth of Merlin*. It would take nearly two hundred years to resolve the problem of authorship generally, and in detail it isn't settled yet.

Almost a century elapsed between William Shakespeare's death and the first even slight attempts at biography, by which time much detail of his life was gone for good. The first stab at

a life story came in 1709, when Nicholas Rowe, Britain's poet laureate and a dramatist in his own right, provided a forty-page background sketch as part of the introduction to a new six-volume set of Shakespeare's complete works. Most of it was drawn from legend and hearsay, and a very large part of that was incorrect. Rowe gave Shakespeare three daughters rather than two, and credited him with the authorship of a single long poem, *Venus and Adonis*, apparently knowing nothing of *The Rape of Lucrece*. It is to Rowe that we are indebted for the attractive but specious story of Shakespeare's having been caught poaching deer at Charlecote. According to the later scholar Edmond Malone, of the eleven facts asserted about Shakespeare's life by Rowe, eight were incorrect.

Nor was Shakespeare always terribly well served by those who strove to restore his reputation. The poet Alexander Pope, extending the tradition begun by Dryden, produced a handsome set of Shakespeare's works in 1723, but freely reworked any material he didn't like, which was a good deal of it. He discarded passages he thought unworthy (insisting that they were the creations of actors, not Shakespeare himself), replaced archaic words that he didn't understand with modern words he did, threw out nearly all puns and other forms of wordplay, and constantly altered phrasing and meter to suit his own unyieldingly discerning tastes. Where, for instance, Shakespeare wrote about taking arms against a sea of troubles, he changed *sea* to *siege* to avoid a mixed metaphor.

Partly in response to Pope's misguided efforts there now poured forth a small flood of new editions and scholarly stud-

ies. Lewis Theobald, Sir Thomas Hanmer, William Warburton, Edward Capell, George Steevens, and Samuel Johnson produced separate contributions that collectively did much to revitalize Shakespeare's standing.

Even more influential was the actor-manager David Garrick, who in the 1740s began a long, adoring, and profitable relationship with Shakespeare's works. Garrick's productions were not without their idiosyncrasies. He gave *King Lear* a happy ending and had no hesitation in dropping three of the five acts of *The Winter's Tale* to keep the narrative moving briskly if not altogether coherently. Despite these quirks Garrick set Shakespeare on a trajectory that shows no sign of encountering a downward arc yet. More than any other person, he put Stratford on the tourist map—a fact of very considerable annoyance to the Reverend Francis Gastrell, a vicar who owned New Place and who grew so weary of the noisy intrusions of tourists that in 1759 he tore the house down rather than suffer another unwelcome face at the window.

(At least the birthplace escaped the fate considered for it by the impresario P. T. Barnum, who in the 1840s had the idea of shipping it to the United States, placing it on wheels, and sending it on a perpetual tour around the country—a prospect so alarming that money was swiftly raised in Britain to save the house as a museum and shrine.)

Critical appreciation of Shakespeare may be said to begin with William Dodd, who was both a clergyman and a scholar of the first rank—his *Beauties of Shakespeare* (1752) remained hugely

influential for a century and a half—but something of a rogue as well. In the early 1770s, he fell into debt and fraudulently acquired £4,200 by forging the signature of Lord Chesterfield on a bond. For his efforts he was sent to the scaffold—inaugurating a long tradition of Shakespeare scholars being at least a little eccentric, if not actively wayward.

Real Shakespeare scholarship starts with Edmond Malone. Malone, who was Irish and a barrister by training, was in many ways a great scholar though always a slightly worrying one. In 1763, while still in his early twenties, Malone moved to London, where he developed an interest in everything to do with Shakespeare's life and works. He became a friend of James Boswell's and Samuel Johnson's, and ingratiated himself with all the people with the most useful records. The master of Dulwich College lent him the collected papers of Philip Henslowe and Edward Alleyn. The vicar of Stratford-upon-Avon allowed him to borrow the parish registers. George Steevens, another Shakespeare scholar, was so taken with Malone that he gave him his entire collection of old plays. Soon afterward, however, the two had a bitter falling-out, and for the rest of his career Steevens wrote little that didn't contain, in the words of the *Dictionary of National Biography*, "many offensive references to Malone."

Malone made some invaluable contributions to Shakespeare scholarship. Before he came on the scene, nobody knew much of anything about William Shakespeare's immediate family. Part of the problem was that Stratford in the 1580s and 1590s was home to a second, unrelated John Shakespeare,

a shoemaker who married twice and had at least three chil-
dren. Malone painstakingly worked out which Shakespeares
belonged to which families—an endeavor of everlasting value
to scholarship—and made many other worthwhile corrections
concerning the details of Shakespeare's life.

Flushed with enthusiasm for his ingenious detective work,
Malone became resolved to settle an even trickier issue, and
devoted years to producing *An Attempt to Ascertain the Order in
Which the Plays of Shakespeare Were Written*. Unfortunately the
book was completely wrong and deeply misguided. For some
reason Malone decided that Heminges and Condell were not
to be trusted, and he began to subtract plays from the Shake-
spearean canon—notably *Titus Adronicus* and the three parts of
Henry VI—on the grounds that they were not very good and he
didn't like them. It was at about this time that he persuaded the
church authorities at Stratford to whitewash the memorial bust
of William Shakespeare in Holy Trinity, removing virtually all
its useful detail, in the mistaken belief that it had not originally
been painted.

Meanwhile the authorities at both Stratford and Dulwich
were becoming increasingly restive at Malone's strange reluc-
tance to give back the documents he had borrowed. The vicar
at Stratford had actually to threaten him with a lawsuit to gain
the return of his parish registers. The Dulwich authorities
didn't need to go so far, but were appalled to discover, when
their documents arrived back, that Malone had scissored parts
of them out to retain as keepsakes. "It is clear," wrote R. A.
Foakes, "that several excisions have been made for the sake of

the signatures on them of well-known dramatists"—an act of breathtaking vandalism that did nothing for scholarship or Malone's reputation.

Yet Malone, remarkably, was a model of restraint compared with others, such as John Payne Collier, who was also a scholar of great gifts, but grew so frustrated at the difficulty of finding physical evidence concerning Shakespeare's life that he began to create his own, forging documents to bolster his arguments if not, ultimately, his reputation. He was eventually exposed when the keeper of mineralogy at the British Museum proved with a series of ingenious chemical tests that several of Collier's "discoveries" had been written in pencil and then traced over and that the ink in the forged passages was demonstrably not ancient. It was essentially the birth of forensic science. This was in 1859.

Even worse in his way was James Orchard Halliwell (later Halliwell-Phillipps), who was a dazzling prodigy—he was elected a fellow of both the Royal Society and the Society of Antiquaries while still a teenager—but also a terrific thief. Among his crimes were stealing seventeen rare volumes of manuscripts from the Trinity College Library at Cambridge (though it must be said that he was never convicted of it) and defacing literally hundreds of books, including a quarto edition of *Hamlet*—one of only two in existence. After his death, among his papers were found 3,600 pages or parts of pages torn from some eight hundred early printed books and manuscripts, many of them irreplaceable—a most exceptional act of destruction. On the plus side he wrote the definitive life of

Shakespeare in the nineteenth century and much else besides. In fairness it must be noted again that Halliwell was merely accused, but never convicted, of theft, but there was certainly a curious long-standing correspondence between a Halliwell visit to a library and books going missing.

After his death William Shakespeare was laid to rest in the chancel of Holy Trinity, a large, lovely church beside the Avon. As we might by now expect, his life concludes with a mystery—indeed, with a small series of them. His gravestone bears no name, but merely a curious piece of doggerel:

> *Good friend, for Jesus' sake forbeare,*
> *To digg the dust enclosed heare.*
> *Bleste be the man that spares thes stones*
> *And curst be he that moves my bones.*

His grave is placed with those of his wife and members of his family, but as Stanley Wells points out, there is a distinct oddness in the order in which they lie. Reading from left to right, the years of deaths of the respective occupants are 1623, 1616, 1647, 1635, and 1649—hardly a logical sequence. They also represent an odd grouping in respect of their relationships. Shakespeare lies between his wife and Thomas Nash, husband of his granddaughter Elizabeth, who died thirty-one years after him. Then come his son-in-law John Hall and daughter Susanna. Shakespeare's parents, siblings, and twin children were no doubt buried in the churchyard and are excluded. The

group is rounded out by two other graves, for Francis Watts and Anne Watts; they have no known Shakespeare connection, though who exactly they were is a matter that awaits scholarly inquiry. Also for reasons unknown, Shakespeare's gravestone is conspicuously shorter—by about eighteen inches—than all the others in the group.

Attached to the north chancel wall overlooking this grouping is the famous life-size painted bust that Edmond Malone ordered whitewashed in the eighteenth century, though it has since been repainted. It shows Shakespeare with a quill and a staring expression and bears the message:

> *Stay, passenger, why goest thou by so fast?*
> *Read, if thou canst, whom envious death hath placed*
> *Within this monument: Shakespeare, with whom*
> *Quick nature died' whose name doth check this tomb*
> *Far more than cost, sith all that he hath writ*
> *Leaves living art but page to serve his wit.*

Since Shakespeare patently has never been within the monument, many have puzzled over what those lines mean. Paul Edmondson has made a particular study of the Shakespeare graves and memorial, but happily agrees that it is more or less impossible to interpret sensibly. "For one thing, it calls itself a tomb even though it is not a tomb at all but a memorial," he says. One suggestion that has many times been made is that the monument contains not the body of Shakespeare but the body of his work: his manuscripts.

"A lot of people ache to believe that the manuscripts still exist somewhere," Edmondson says, "but there is no evidence to suppose that they are in the monument or anywhere else. You just have to accept that they are gone for good."

As for the heroes of this chapter, Henry Condell died four years after the publication of the First Folio, in 1627, and John Heminges followed three years later. They were buried near each other in the historic London church of Saint Mary Aldermanbury. That church was lost in the Great Fire of 1666 and replaced by a Christopher Wren structure, which in turn was lost to German bombs in World War II.

Chapter Nine

Claimants

THERE IS AN EXTRAORDINARY—seemingly an insatiable—urge on the part of quite a number of people to believe that the plays of William Shakespeare were written by someone other than William Shakespeare. The number of published books suggesting—or more often insisting—as much is estimated now to be well over five thousand.

Shakespeare's plays, it is held, so brim with expertise—on law, medicine, statesmanship, court life, military affairs, the bounding main, antiquity, life abroad—that they cannot possibly be the work of a single lightly educated provincial. The presumption is that William Shakespeare of Stratford was, at best, an amiable stooge, an actor who lent his name as cover for someone of greater talent, someone who could not, for one reason or another, be publicly identified as a playwright.

The controversy has been given respectful airings in the highest quarters. PBS, the American television network, in

1996 produced an hour-long documentary unequivocally suggesting that Shakespeare probably wasn't Shakespeare. *Harper's Magazine* and the *New York Times* have both devoted generous amounts of space to sympathetically considering the anti-Stratford arguments. The Smithsonian Institution in 2002 held a seminar titled "Who Wrote Shakespeare?"—a question that most academics would have thought hopelessly tautological. The best-read article in the British magazine *History Today* was one examining the authorship question. Even *Scientific American* entered the fray with an article proposing that the person portrayed in the famous Martin Droeshout engraving might actually be—I weep to say it—Elizabeth I. Perhaps the most extraordinary development of all is that Shakespeare's Globe Theatre in London—built as a monument for his plays and with aspirations to be a world-class study center—became, under the stewardship of the artistic director Mark Rylance, a kind of clearinghouse for anti-Stratford sentiment.

So it needs to be said that nearly all of the anti-Shakespeare sentiment—actually all of it, every bit—involves manipulative scholarship or sweeping misstatements of fact. Shakespeare "never owned a book," a writer for the *New York Times* gravely informed readers in one doubting article in 2002. The statement cannot actually be refuted, for we know nothing about his incidental possessions. But the writer might just as well have suggested that Shakespeare never owned a pair of shoes or pants. For all the evidence tells us, he spent his life naked from the waist down, as well as bookless, but it is probable that what is lacking is the evidence, not the apparel or the books.

Daniel Wright, a professor at Concordia University in Portland, Oregon, and an active anti-Stratfordian, wrote in *Harper's Magazine* that Shakespeare was "a simple, untutored wool and grain merchant" and "a rather ordinary man who had no connection to the literary world." Such statements can only be characterized as wildly imaginative. Similarly, in the normally unimpeachable *History Today*, William D. Rubinstein, a professor at the University of Wales at Aberystwyth, stated in the opening paragraph of his anti-Shakespeare survey: "Of the seventy-five known contemporary documents in which Shakespeare is named, not one concerns his career as an author."

That is not even close to being so. In the Master of the Revels' accounts for 1604–1605—that is, the record of plays performed before the king, about as official a record as a record can be—Shakespeare is named seven times as the author of plays performed before James I. He is identified on the title pages as the author of the sonnets and in the dedications of the poems *The Rape of Lucrece* and *Venus and Adonis*. He is named as author on several quarto editions of his plays, by Francis Meres in *Palladis Tamia*, and (allusively but unmistakably) by Robert Greene in the *Groat's-Worth of Wit*. John Webster identifies him as one of the great playwrights of the age in his preface to *The White Devil*.

The only absence among contemporary records is not of documents connecting Shakespeare to his works but of documents connecting any other human being to them. As the Shakespeare scholar Jonathan Bate has pointed out, virtually no one "in Shakespeare's lifetime or for the first two hundred years after his death expressed the slightest doubt about his authorship."

So where did all the anti-Stratford sentiment come from? The story begins, a little unexpectedly, with an odd and frankly unlikely American woman named Delia Bacon. Bacon was born in 1811 in the frontier country of Ohio into a large family and a small log cabin. The family was poor and became more so after her father died when Delia was young.

Delia was bright and apparently very pretty but not terribly stable. As an adult, she taught school and wrote a little fiction, but mostly she led a life of spinsterly anonymity in New Haven, Connecticut, where she lived with her brother, a minister. The one lively event in her secluded existence came in the 1840s, when she developed a passionate, seemingly obsessive, attachment to a theological student some years her junior. The affair, such as it was, ended in humiliation for her when she discovered that the young man was in the habit of amusing his friends by reading to them passages from her feverishly tender letters. It was a cruelty from which she never recovered.

Gradually, for reasons that are not clear, she became convinced that Francis Bacon, her distinguished namesake, was the true author of the works of William Shakespeare. The idea was not entirely original to Delia Bacon—one Reverend James Wilmot, a provincial rector in Warwickshire, raised questions about Shakespeare's authorship as early as 1785. But his doubts weren't known until 1932, so Delia's conviction was arrived at independently. Though she had no known genealogical connection to Francis Bacon, the correspondence of names was almost certainly more than coincidental.

In 1852 she traveled to England and embarked on a long and

fixated quest to prove William Shakespeare a fraud. It is easy to dismiss Delia as mildly demented and inconsequential, but there was clearly something beguiling in her manner and physical presence, for she succeeded in winning the assistance of a number of influential people (though often, it must be said, they came to regret it). Charles Butler, a wealthy businessman, agreed to fund the costs of her trip to England—and must have done so generously, for she stayed for almost four years. Ralph Waldo Emerson gave her an introduction to Thomas Carlyle, who in turn assisted her upon her arrival in London. Bacon's research methods were singular to say the least. She spent ten months in St. Albans, Francis Bacon's hometown, but claimed not to have spoken to anyone during the whole of that time. She sought no information from museums or archives and politely declined Carlyle's offers of introductions to the leading scholars. Instead she sought out locations where Bacon had spent time and silently "absorbed atmospheres," refining her theories by a kind of intellectual osmosis.

In 1857 she produced her magnum opus, *The Philosophy of the Plays of Shakspere [sic] Unfolded*, published by Ticknor and Fields of Boston. It was vast, unreadable, and odd in almost every way. For one thing, not once in its 675 densely printed pages did it actually mention Francis Bacon; the reader had to deduce that he was the person whom she had in mind as the author of Shakespeare's plays. Nathaniel Hawthorne, who was at the time American consul in Liverpool, provided a preface, then almost instantly wished he hadn't, for the book was universally regarded by reviewers as preposterous hokum. Hawthorne under questioning admitted that he hadn't actually read it. "This shall be

the last of my benevolent follies, and I will never be kind to any-body again as long as [I] live," he vowed in a letter to a friend.

Exhausted by the strain of her labors, Delia returned to her homeland and retreated into insanity. She died peacefully but unhappily under institutional care in 1859, believing she was the Holy Ghost. Despite the failure of her book and the dense-ness of its presentation, somehow the idea that Bacon wrote Shakespeare took wing in a very big way. Mark Twain and Henry James became prominent supporters of the Baconian thesis. Many became convinced that the plays of Shakespeare contained secret codes that revealed the true author (who at this stage was always seen to be Bacon).

Using ingenious formulas involving prime numbers, square roots, logarithms, and other arcane devices to guide them, in a kind of Ouija-board fashion, to hidden messages in the text, they found support for the contention. In *The Great Cryptogram*, a popular book of 1888, Ignatius Donnelly, an American lawyer, revealed such messages as this, in *Henry IV, Part 1*: "Seas ill [for which read "Cecil," for William Cecil, Lord Burghley] said that More low or Shak'st Spur never writ a word of them." Admira-tion for Donnelly's ingenious deciphering methodology faltered somewhat, however, when another amateur cryptographer, the Reverend R. Nicholson, using exactly the same method in the same texts, found such messages as "Master Will-I-am Shak'st-spurre writ the Play and was engaged at the Curtain."

No less meticulous in his inventive skills was Sir Edwin Durning-Lawrence, who in another popular book, *Bacon Is Shakespeare*, published in 1910, found telling anagrams sprin-

kled throughout the plays. Most famously he saw that a nonce word used in *Love's Labour's Lost*, "honorificabilitudinitatibus," could be transformed into the Latin hexameter "Hi ludi F. Baconis nati tuiti orbi," or "These plays, F. Bacon's offspring, are preserved for the world."

It has also been written many times that Stratford never occurs in any Shakespeare play, whereas St. Albans, Bacon's seat, is named seventeen times. (Bacon was Viscount St. Albans.) For the record St. Albans is mentioned fifteen times, not seventeen, and these are in nearly every case references to the Battle of St. Albans—a historical event crucial to the plot of the second and third parts of Henry VI. (The other three references are to the saint himself.) On such evidence one might far more plausibly make Shakespeare a Yorkshireman, since York appears fourteen times more often in his plays than does St. Albans. Even Dorset, a county that plays a central part in none of the plays, gets more mentions.

Eventually Baconian theory took on a cultlike status, with its more avid supporters suggesting that Bacon wrote not only the plays of Shakespeare but also those of Marlowe, Kyd, Greene, and Lyly, as well as Spenser's *Faerie Queene*, Burton's *Anatomy of Melancholy*, Montaigne's *Essays* (in French), and the King James Version of the Bible. Some believed him to be the illegitimate offspring of Queen Elizabeth and her beloved Leicester.

One obvious objection to any Baconian theory is that Bacon had a very full life already without taking on responsibility for the Shakespearean canon as well, never mind the works of Montaigne, Spenser, and the others. There is also an inconve-

nient lack of connection between Bacon and any human being associated with the theater—perhaps not surprisingly, as he appears to have quite disliked the theater and attacked it as a frivolous and lightweight pastime in one of his many essays.

Partly for this reason doubters began to look elsewhere. In 1918 a schoolmaster from Gateshead, in northeast England, with the inescapably noteworthy name of J. Thomas Looney put the finishing touches to his life's work, a book called *Shakespeare Identified*, in which he proved to his own satisfaction that the actual author of Shakespeare was the seventeenth Earl of Oxford, one Edward de Vere. It took him two years to find a publisher willing to publish the book under his own name. Looney steadfastly refused to adopt a pseudonym, arguing, perhaps just a touch desperately, that his name had nothing to do with insanity and was in fact pronounced *loney*. (Interestingly, Looney was not alone in having a mirthful surname. As Samuel Schoenbaum once noted with clear pleasure, other prominent anti-Stratfordians of the time included Sherwood E. Silliman and George M. Battey.)

Looney's argument was built around the conviction that William Shakespeare lacked the worldliness and polish to write his own plays, and that they must therefore have come from someone of broader learning and greater experience: an aristocrat in all likelihood. Oxford, it may be said, had certain things in his favor as a candidate: He was clever and had some standing as a poet and playwright (though none of his plays survives, and none of his poetry indicates actual greatness—certainly not Shakespearean greatness); he was well traveled and spoke Italian, and he moved in the right circles to understand courtly

matters. He was much admired by Queen Elizabeth, who, it was said, "delighteth . . . in his personage and his dancing and valiantness," and one of his daughters was engaged for a time to Southampton, the dedicatee of Shakespeare's two long poems. His connections, without question, were impeccable.

But Oxford also had shortcomings that seem not to sit well with the compassionate, steady, calm, wise voice that speaks so reliably and seductively from Shakespeare's plays. He was arrogant, petulant, and spoiled, irresponsible with money, sexually dissolute, widely disliked, and given to outbursts of deeply unsettling violence. At the age of seventeen, he murdered a household servant in a fury (but escaped punishment after a pliant jury was persuaded to rule that the servant had run onto his sword). Nothing in his behavior, at any point in his life, indicated the least gift for compassion, empathy, or generosity of spirit—or indeed the commitment to hard work that would have allowed him to write more than three dozen plays anonymously, in addition to the work under his own name, while remaining actively engaged at court.

Looney never produced evidence to explain why Oxford—a man of boundless vanity—would seek to hide his identity. Why would he be happy to give the world some unremembered plays and middling poems under his own name, but then retreat into anonymity as he developed, in middle age, a fantastic genius? All Looney would say on the matter was: "That, however, is his business, not ours." Actually, if we are to believe in Oxford, it is entirely our business. It has to be.

The problems with Oxford don't end quite there. There is the matter of the dedications to his two narrative poems. At the time

of *Venus and Adonis*, Oxford was forty-four years old and a senior earl to Southampton, who was still a downy youth. The sycophantic tone of the dedication, with its apology for choosing "so strong a prop for so weak a burden" and its promise to "take advantage of all idle hours till I have honoured you with some graver labour," is hardly the voice one would expect to find from a senior aristocrat, particularly one as proud as Oxford, to a junior one . There is also the unanswered question of why Oxford, patron of his own acting company, the Earl of Oxford's Men, would write his best work for the Lord Chamberlain's Men, a competing troupe. Then, too, there is the problem of explaining away the many textual references that point to William Shakespeare's authorship—the pun on Anne Hathaway's name in the sonnets, for example. Oxford was a sophisticated dissembler indeed if he embedded punning references to the wife of his front man in his work.

But easily the most troubling weakness of the Oxford argument is that Edward de Vere incontestably died in 1604, when many of Shakespeare's plays had not yet appeared—indeed in some cases could not have been written, as they were influenced by later events. *The Tempest*, notably, was inspired by an account of a shipwreck on Bermuda written by one William Strachey in 1609. *Macbeth* likewise was clearly cognizant of the Gunpowder Plot, an event Oxford did not live to see.

Oxfordians, of whom there remain many, argue that de Vere either must have left a stack of manuscripts, which were released at measured intervals under William Shakespeare's name, or that the plays have been misdated and actually appeared before Oxford sputtered his last. As for any references within the plays

that unquestionably postdate Oxford's demise, those were doubtless added later by other hands. They *must* have been, or else we would have to conclude that Oxford didn't write the plays.

Despite the manifest shortcomings of Looney's book, in both argument and scholarship, it found a curious measure of support. The British Nobel laureate John Galsworthy praised it, as did Sigmund Freud (though Freud later came to have a private theory that Shakespeare was of French stock and was really named Jacques Pierre—an interesting but ultimately solitary delusion). In America a Professor L. P. Bénézet of Dartmouth College became a leading Oxfordian. He it was who propounded the theory that Shakespeare the actor was de Vere's illegitimate son. Orson Welles became a fan of the notion, and later supporters include the actor Derek Jacobi.

A third—and for a brief time comparatively popular—candidate for Shakespearean authorship was Christopher Marlowe. He was the right age (just two months older than Shakespeare), had the requisite talent, and would certainly have had ample leisure after 1593, assuming he wasn't too dead to work. The idea is that Marlowe's death was faked, and that he spent the next twenty years hidden away either in Kent or Italy, depending on which version you follow, but in either case under the protection of his patron and possible lover Thomas Walsingham, during which time he cranked out most of Shakespeare's oeuvre.

The champion of this argument was a New York press agent named Calvin Hoffman, who in 1956 secured permission to open Walsingham's tomb, hoping to find manuscripts and letters that would prove his case. In fact, he found nothing at

all—not even Walsingham, who, it turns out, was buried elsewhere. Still, he got a best-selling book out of it, *The Murder of the Man Who Was "Shakespeare,"* which the *Times Literary Supplement* memorably dismissed as "a tissue of twaddle." Much of Hoffman's case had, it must be said, a kind of loopy charm. Among quite a lot else, he claimed that the "Mr W.H." noted on the title page of the sonnets was "Mr Walsing-Ham." Despite the manifest feebleness of Hoffman's case, and the fact that its support has withered to almost nothing, in 2002 the dean and chapter of Westminster Abbey took the extraordinary step of placing a question mark behind the year of Marlowe's death on a new monument to him in Poets' Corner.

And still the list of alternative Shakespeares rolls on. Yet another candidate was Mary Sidney, Countess of Pembroke. The proponents of this view—a small group, it must be said— maintain that this explains why the First Folio was dedicated to the earls of Pembroke and Montgomery: They were her sons. The countess, it is also noted, had estates on the Avon and her private crest bore a swan—hence Ben Jonson's reference to "sweet swan of Avon." Mary Sidney certainly makes an appealing candidate. She was beautiful as well as learned and well connected: Her uncle was Robert Dudley, the Earl of Leicester, and her brother the poet and patron of poets Sir Philip Sidney. She spent much of her life around people of a literary bent, most notably Edmund Spenser, who dedicated one of his poems to her. All that is missing to connect her with Shakespeare is anything to connect her with Shakespeare.

Yet another theory holds that Shakespeare was too brilliant

to be a single person, but was actually a syndicate of stellar talents, including nearly all of those mentioned already—Bacon, the Countess of Pembroke, and Sir Philip Sidney, plus Sir Walter Raleigh and some others. Unfortunately the theory not only lacks evidence but would involve a conspiracy of silence of improbable proportions.

Finally, a word should be said for Dr. Arthur Titherley, a dean of science at the University of Liverpool, who devoted thirty years of spare-time research to determining (to virtually no one's satisfaction but his own) that Shakespeare was William Stanley, sixth Earl of Derby. All together, more than fifty candidates have been suggested as possible alternative Shakespeares.

The one thing all the competing theories have in common is the conviction that William Shakespeare was in some way unsatisfactory as an author of brilliant plays. This is really quite odd. Shakespeare's upbringing, as I hope this book has shown, was not backward or in any way conspicuously deprived. His father was the mayor of a consequential town. In any case, it would hardly be a unique achievement for someone brought up modestly to excel later in life. Shakespeare lacked a university education, to be sure, but then so did Ben Jonson—a far more intellectual playwright—and no one ever suggests that Jonson was a fraud.

It is true that William Shakespeare used some learned parlance in his work, but he also employed imagery that clearly and ringingly reflected a rural background. Jonathan Bate quotes a couplet from *Cymbeline*, "Golden lads and girls all must, / As chimney sweepers, come to dust," which takes on additional sense when one realizes that in Warwickshire in

the sixteenth century a flowering dandelion was a golden lad, while one about to disperse its seeds was a chimney sweeper. Who was more likely to employ such terms—a courtier of privileged upbringing or someone who had grown up in the country? Similarly, when Falstaff notes that as a boy he was small enough to creep "into any alderman's thumb-ring" we might reasonably wonder whether such a singular image was more likely to occur to an aristocrat or someone whose father actually was an alderman.

In fact a Stratford boyhood lurks in all the texts. For a start Shakespeare knew animal hides and their uses inside and out. His work contains frequent knowing references to arcana of the tanning trade: skin bowgets, greasy fells, neat's oil, and the like—matters of everyday conversation to leather workers, but hardly common currency among the well-to-do. He knew that lute strings were made of cowgut and bowstrings of horsehair. Would Oxford or any other candidate have been able, or likely, to turn such distinctions into poetry?

Shakespeare was, it would seem, unashamedly a country boy, and nothing in his work suggests any desire, in the words of Stephen Greenblatt, to "repudiate it or pass himself off as something other than he was." Part of the reason Shakespeare was mocked by the likes of Robert Greene was that he never stopped using these provincialisms. They made him mirthful in their eyes.

A curious quirk of Shakespeare's is that he very seldom used the word *also*. It appears just thirty-six times in all his plays, nearly always in the mouths of comical characters whose pretentious utterings are designed to amuse. It was an odd preju-

dice and one not shared by any other writer of his age. Bacon sometimes used *also* as many times on a single page as Shakespeare did in the whole of his career. Just once in all his plays did Shakespeare use *mought* as an alternative to *might*. Others used it routinely. Generally he used *hath*, but about 20 percent of the time he used *has*. On the whole he wrote *doth*, but about one time in four he wrote *dost* and more rarely he favored the racily modern *does*. Overwhelmingly he used *brethren*, but just occasionally (about one time in eight) he used *brothers*.

Such distinguishing habits constitute what is known as a person's idiolect, and Shakespeare's, as one would expect, is unlike any other person's. It is not impossible that Oxford or Bacon might have employed such particular distinctions when writing under an assumed identity, but it is reasonable to wonder whether either would have felt such fastidious camouflage necessary.

In short it is possible, with a kind of selective squinting, to endow the alternative claimants with the necessary time, talent, and motive for anonymity to write the plays of William Shakespeare. But what no one has ever produced is the tiniest particle of evidence to suggest that they actually did so. These people must have been incredibly gifted—to create, in their spare time, the greatest literature ever produced in English, in a voice patently not their own, in a manner so cunning that they fooled virtually everyone during their own lifetimes and for four hundred years afterward. The Earl of Oxford, better still, additionally anticipated his own death and left a stock of work sufficient to keep the supply of new plays flowing at the same rate until Shakespeare himself was ready to die a decade or so later. Now that *is* genius!

If it was a conspiracy, it was a truly extraordinary one. It would have required the cooperation of Jonson, Heminges, and Condell and most or all of the other members of Shakespeare's company, as well as an unknowable number of friends and family members. Ben Jonson kept the secret even in his private note-books. "I remember," he wrote there, "the players have often mentioned it as an honour to Shakespeare, that in his writing (whatsoever he penned) he never blotted out a line. My answer hath been, would he had blotted a thousand." Rather a strange thing to say in a reminiscence written more than a dozen years after the subject's death if he knew that Shakespeare didn't write the plays. It was in the same passage that he wrote, "For I loved the man, and do honour his memory (on this side idolatry) as much as any."

And that's just on Shakespeare's side of the deception. No acquaintance of Oxford's or Marlowe's or Bacon's let slip either, as far as history can tell. One really must salute the ingenu-ity of the anti-Stratfordian enthusiasts who, if they are right, have managed to uncover the greatest literary fraud in history, without the benefit of anything that could reasonably be called evidence, four hundred years after it was perpetrated.

When we reflect upon the works of William Shakespeare it is of course an amazement to consider that one man could have produced such a sumptuous, wise, varied, thrilling, ever-delighting body of work, but that is of course the hallmark of genius. Only one man had the circumstances and gifts to give us such incomparable works, and William Shakespeare of Stratford was unquestionably that man—whoever he was.

Selected Bibliography

THE FOLLOWING ARE THE principal books referred to in the text.

Baldwin, T. W. *William Shakspere's Small Latine and Lesse Greek* (two volumes). Urbana, Ill.: University of Illinois Press, 1944.

Bate, Jonathan. *The Genius of Shakespeare*. London: Picador, 1997.

Bate, Jonathan and Jackson Russell (eds.). *Shakespeare: An Illustrated Stage History*. Oxford: Oxford University Press, 1996.

Baugh, Albert C. and Thomas Cable. *A History of the English Language* (fifth edition). Upper Saddle River, N.J.: Prentice Hall, 2002.

Blayney, Peter W. M. *The First Folio of Shakespeare*. Washington, D.C.: Folger Library Publications, 1991.

Chute, Marchette. *Shakespeare of London*. New York: E. P. Dutton and Company, 1949.

Cook, Judith. *Shakespeare's Players*. London: Harrap, 1983.

Crystal, David. *The Stories of English*. London: Allen Lane/Penguin, 2004.

Durning-Lawrence, Sir Edwin. *Bacon Is Shakespeare*. London: Gay & Hancock, 1910.

Greenblatt, Stephen. *Will in the World: How Shakespeare Became Shakespeare*. New York: W. W. Norton and Co., 2004.

Gurr, Andrew. *Playgoing in Shakespeare's London*. Cambridge: Cambridge University Press, 1987.

Habicht, Werner, D. J. Palmer, and Roger Pringle. *Images of Shakespeare:*

Proceedings of the Third Congress of the International Shakespeare Association. Newark, Del.: University of Delaware Press, 1986.

Hanson, Neil. *The Confident Hope of a Miracle: The True History of the Spanish Armada.* London: Doubleday, 2003.

Inwood, Stephen. *A History of London.* London: Macmillan, 1998.

Jespersen, Otto. *Growth and Structure of the English Language* (ninth edition). Garden City, N.Y.: 1956.

Kermode, Frank. *Shakespeare's Language.* London: Penguin, 2000.

———. *The Age of Shakespeare.* New York: Modern Library, 2003.

Kökeritz, Helge. *Shakespeare's Pronunciation.* New Haven, Conn.: Yale University Press, 1953.

Muir, Kenneth. *Shakespeare's Sources: Comedies and Tragedies.* London: Methuen and Co., 1957.

Mulryne, J. R., and Margaret Shewring (eds.). *Shakepeare's Globe Rebuilt.* Cambridge: Cambridge University Press, 1997.

Picard, Liza. *Shakespeare's London: Everyday Life in Elizabethan London.* London: Orion Books, 2003.

Piper, David. *O Sweet Mr. Shakespeare I'll Have His Picture: The Changing Image of Shakespeare's Person, 1600–1800.* London: National Portrait Gallery, 1964.

Rosenbaum, Ron. *The Shakespeare Wars: Clashing Scholars, Public Fiascos, Palace Coups.* New York: Random House, 2006.

Rowse, A. L. *Shakespeare's Southampton: Patron of Virginia.* London: Macmillan, 1965.

Schoenbaum, S. *William Shakespeare: A Documentary Life.* Oxford: Oxford University Press, 1975.

———. *Shakespeare's Lives.* Oxford: Oxford University Press, 1993.

Shapiro, James. *1599: A Year in the Life of William Shakespeare.* London: Faber and Faber, 2005.

Spevack, Marvin. *The Harvard Concordance to Shakespeare.* Cambridge, Mass.: Belknap Press/Harvard University Press, 1973.

Spurgeon, Caroline F. E. *Shakespeare's Imagery and What It Tells Us.* Cambridge: Cambridge University Press, 1935.

Starkey, David. *Elizabeth: The Struggle for the Throne.* London: HarperCollins, 2001.

Thomas, David. *Shakespeare in the Public Records.* London: HMSO, 1985.

Thurley, Simon. *Hampton Court: A Social and Architectural History*. New Haven: Yale University Press, 2003.

Vendler, Helen. *The Art of Shakespeare's Sonnets*. Cambridge, Mass.: Belknap Press/Harvard University Press, 1999.

Wells, Stanley. *Shakespeare for All Time*. London: Macmillan, 2002.

———. *Shakespeare & Co: Christopher Marlowe, Thomas Dekker, Ben Jonson, Thomas Middleton, John Fletcher and the Other Players in His Story*. London: Penguin/Allen Lane, 2006.

Wells, Stanley, and Paul Edmondson. *Shakespeare's Sonnets*. Oxford: Oxford University Press, 2004.

Wells, Stanley, and Gary Taylor (eds.). *The Oxford Shakespeare: The Complete Works*. Oxford: Clarendon Press, 1994.

Wolfe, Heather (ed.). *"The Pen's Excellencie": Treasures from the Manuscript Collection of the Folger Shakespeare Library*. Washington, D.C.: Folger Library Publications, 2002.

Youings, Joyce. *Sixteenth-Century England*. London: Penguin, 1984.

Sarum Chase, Frank O. Salisbury.

The Reign of Edward VIII, Robert Sencourt.

From Cabbages to Kings, Lisa Sheridan.

Laughter in the Next Room, Osbert Sitwell.

Goodbye, Harley Street, R. Scott Stevenson.

Heads and Tails, Aage Thaarup.

Hertfordshire, Sir William Beach Thomas.

A King's Story, The Duke of Windsor.

The Heart Has its Reasons, The Duchess of Windsor.

Memoirs, The Earl of Woolton.

Silver Wedding, Louis Wulff.

May the Twelfth Mass Observation Surveys, edited by Humphrey Jennings, etc.

The Mackenzie King Record, edited by Pickersgill.

The Desert, Marie Louise Haskins, being a collection of verse containing the poem, 'The Gate of the Year'.

The books I have consulted include the following:

The Queen and the Arts, Harold A. Albert.

Haply I May Remember, Cynthia Asquith.

The Story of Peter Townsend, Norman Barrymaine.

The King in his Country, Aubrey Buxton.

The Light of Common Day, Diana Cooper.

Fit for a King, F. J. Corbitt.

The Little Princesses, Marion Crawford.

My Life of Strife, Lord Croft.

Reminiscences, Marchioness Curzon of Kedleston.

The Royal Tour, Taylor Darbyshire.

Life of Neville Chamberlain, Keith Feiling.

The Sport of Kings, Dick Francis.

King George V, John Gore.

One Man, Many Parts, Lord Gorell.

The Days Before Yesterday, Lord Frederick Hamilton.

The Glorious Years, H. Cozens Hardy.

The Story of My Life, Augustus Hare.

Silver and Gold, Norman Hartnell.

Companion into Hertfordshire, W. Branch Johnson

Self-Portrait of an Artist, Lady Kennett.

Meine Schulerin, Kathie Kuebler.

How the Queen Reigns, Dorothy Laird.

Cosmo Gordon Lang, J. G. Lockhart.

My Scottish Tour, R. H. Bruce Lockhart.

The Royal Embassy, Ian F. M. Lucas.

The Windsor Tapestry, Compton Mackenzie.

Neither Fear Nor Favour, John McGovern.

The Crown and the People, Allan A. Michie.

Meet Me at the Savoy, Jean Nicol.

My Life with Princess Margaret, John Payne.

The Cities of London & Westminster, Nikolaus Pevsner.

Five Out of Six, Violet Powell.

Royal Gardens, Lanning Roper.

Portrait of a Painter, Owen Rutter.

BIBLIOGRAPHY

AND AUTHOR'S NOTE ON SOURCES

MY PUBLISHERS MAKE the claim that this is the first full and unrestricted biography of H.M. Queen Elizabeth the Queen Mother. One might expect the books about so popular a figure to be legion. In reality, the enquiring reader will trace only two earlier books of substance, and neither the pre-war study by Lady Cynthia Asquith—originally issued as *Our Duke and Duchess* nor *Elizabeth the Queen Mother* by Jennifer Ellis, 1953—exceeded "seven score printed pages and ten". I hereby acknowledge my indebtedness to both books, both published by Hutchinson.

I must also particularly acknowledge my gratitude for permission for brief incidental quotation from *King George VI* by Sir John Wheeler-Bennett, published by Macmillan; *Queen Mary* by James Pope-Hennessy, published by Allen and Unwin; and *Thatched With Gold* by Mabell, Countess of Airlie, published by Hutchinson. It will be seen that I have drawn on the archives, correspondence or memoirs of Archbishop Lang, the Duke and Duchess of Windsor, Lord Dawson of Penn, Lady Diana Cooper, Lord Gorell, Lord Frederick Hamilton, Lord Hardinge of Penshurst, Lord Reith, Lord Woolton, Sir William Beach Thomas, Mr. Cecil Beaton, Miss Marion Crawford, Mr. Dick Francis, Mr. Norman Hartnell, Mr. Mackenzie King, Miss Kathey Kuebler, Mr. Bruce Lockhart, Mr. John McGovern, Miss Violet Powell, Miss Lisa Sheridan, Mr. Aage Thaarup, Mr. F. J. Corbitt and Mr. John Payne. To all these or their representatives I express my sense of obligation.

drink for the Queen Mother; the conversation flows with the fluency and easy pleasantries of a team: these are people all comfortably accustomed to one another, eager to hear each other's news, and when luncheon is announced the Queen Mother presently leads the way through communicating doors into the library. Here the shelves of books form a cosy background to the circular table in the middle of the room, and here again a chandelier of Irish glass showers an illusion of sunlight where would otherwise be gloom. The company move to their usual chairs and one of the gentlemen says a simple Grace. Then the talk and soft laughter flows again.

This pleasant noon hour, in congenial company, is the nucleus of the Queen Mother's unobserved professional life. The world is allowed to know little of the Strathmore family portraits at Clarence House; the blond young men in Highland costume, the dark and graceful Edwardian ladies. With the Sickert of King George V, a study in one of the jovial moods she best remembers, with the Sheraton bracket clock bequeathed by Arthur Penn, and with the one kindly full-length painting of her husband, these are the private tokens of her yesterdays . . . of the little girl who played at being a princess and so strangely became a Queen Consort and mother of a Queen Regnant.

The royal lady who was Elizabeth Bowes-Lyon has faced the bewilderments of time without paying the forfeit of her smiling vivacity and sympathetic charm. She finds her sustaining strength in Christian conviction, and the power of her private creed is suggested in the parable that King George VI once spoke to his subjects: "I said to the man who stood at the Gate of the Year, 'Give me a light that I may tread safely into the unknown.' And he replied, 'Go out into the darkness and put your hand into the Hand of God. That shall be to you better than light, and safer than a known way.'"

extension of Stevenage New Town have been mapped across Bowes-Lyon land.

IV

There are times when H.M. Queen Elizabeth the Queen Mother talks of "my little castle", meaning the Castle of Mey, and "my little family", meaning the staff of twenty living in at Clarence House and her five full-time Household officials. "My little family . . ." The phrase is matriarchal and possessive, fond and reassuring, a point of anchorage against the equinoctial gales of change.

In the accustomed routine of the London day, unless the Queen Mother is lunching out, there comes a moment when the ladies and gentlemen of her Household await her in the morning-room on the ground floor. They gather from their offices along the northward corridors: Sir Martin Gilliat, Her Majesty's private secretary; Lord Adam Gordon, her comptroller; Sir Ralph Anstruther, her treasurer; Major Arthur Griffin, the Press secretary, and the assistant secretary and equerry, Captain Aird. They are joined by the ladies in waiting on rota, perhaps Lady Jean Rankin, Mrs. Mulholland or Lady Fermoy. Drinks are ready on the side-tables beneath the windows, and presently the lady of the house steps from the small mirrored and gilded lift in the hall, pristine, smiling, relaxed and expectant.

If one is tempted to think of a woman chairman of the board joining her working colleagues in the directors' dining-room, this impression is lessened by domestic informality. These are cronies talking shop over a gin-and-tonic during the midday interlude from business pressures, and yet there is, unmistakably, the half-military, urbane air of a Queen and her entourage. The room glistens with the sparkle of the crystal chandelier reflected in the mirrors: there is a gilt-framed mirror above the brass chiming clock on the mantelpiece, and mirrors between the pale blue satin curtains of the windows, and the glass catches and renews each human movement. One of the gentlemen pours a

In her peaceful country sitting-room, eight-sided as in Queen Adelaide's day, the walls panelled in light maple and the chairs covered in soft pink with white flower patterns evoke a characteristically delicate and feminine atmosphere. All her life, the Queen Mother has conducted a wide and impulsively warm personal correspondence, constantly reaching out to old friends, but the strongest links inevitably have to be broken. The heart may flinch when it is difficult to know whether an urgent message or a telephone call will bring good or bad tidings. The deaths of the Princess Royal, Lady Alexandra Worsley, the Earl of Caithness, who was so understanding a factor at Birkhall, and Sir Pierson Dixon, among others, all grieved the Queen Mother although the world was unaware of the harsh repetition of sad news. When one has many friends, the bell but seems to toll more often.

Steady in duty, and living with energy in the present, the Queen Mother seldom dwells on the past and would not care to catalogue the changes she has seen. And yet two-shilling tourists troop incredibly through Glamis Castle—"From here the present ROYAL APARTMENTS are visited. These rooms were arranged by Cecilia, Lady Strathmore, for her youngest daughter and the then Duke of York . . ."—and the house at Ham from which Cecilia married has become an old folks' home. Through No. 20 St. James's Square, where Rose Bowes-Lyon once practised Schumann, flow the export whisky orders of the Distiller's Company; and the young dancers of the Royal Ballet School now practise their *glissades* and *entrechats* in White Lodge, Richmond, where a young bride once grappled with the problems of the chilly rooms and the good plain cook. These are at least tangible, though changed, the cast-off garments of old scenes. But the traffic of Hyde Park now spins over the site of No. 145 Piccadilly, and No. 17 Bruton Street has long since disappeared. The gardens of Royal Lodge are graced by statuary copied from pieces in the grounds of St. Paul's Walden Bury; and it is as well to have these tell-tale hostages of sentiment, for plans for an

Fontevrault, the gardens of Villandry and the chateau of Usse and she lunched once again in a country restaurant, on this occasion with the Vicomte de Noailles, who had planned her sightseeing with the finesse of a professional courier. Moreover, before returning to England, the ardent sightseer flew to Melun and contrived a side trip to Fontainebleau where, incidentally, she recognized some of the furniture used for her State visit to Paris before the war. She evidently resolved with gusto to repeat such a holiday the following year, perhaps after visiting Australia or in the autumn. But when the time approached the Queen Mother fell ill with appendicitis, the Australian tour was cancelled, and a placid cruise of the West Indies in the royal yacht *Britannia* occupied her convalescence. Before a suitable opportunity next occurred it was already 1965.

This time, the Queen Mother whisked her group of seven to Provence where the little eighteenth-century Chateau Legier, near Arles, had been placed at her disposal at a token rental of a franc a week. As it chanced, the allure of Provence in April was marred by two days' rain and several windy days when the mistral blew unpleasantly. The chateaux of Provence, however, bask in a privacy rare among their cousins of the Loire. The Queen Mother's field of thorough sightseeing extended from the tapestries of Aix-en-Provence to the Roman antiquities of Nimes and for much of the time freedom of choice and the illusion of anonymity prevailed.

And yet, returning, "who does not feel a lifting of the heart?" as the Queen Mother has said, at once more being home, "that precious word . . ." Home again . . . and the accustomed salute from Searles, the gate-keeper at Royal Lodge; her housekeeper awaiting her at the open door; the welcoming dogs . . . Like any gardener, the Queen Mother can hardly wait to get into the garden and see which plants and shrubs have flourished or which declined. Then letters are always awaiting her in the red leather box on her husband's big desk, the desk in the Octagonal Room that the Queen Mother will never allow anyone but herself to use.

Britain's desired entry into the Common Market had caused Princess Margaret to cancel an official visit to Paris, under the pressure of advice. "I am sure we can find a way round it," the Queen Mother is apt to say in such difficulties, and the way round this time involved nothing more than a personal letter which she wrote herself to President de Gaulle indicating her holiday plans. When the Queen Mother arrived at her hotel near Montbazon, it was to find a letter in the President's hand welcoming her to France.

The Chateau du Puits d'Artigny has all the Michelin de luxe attributes of *situation très tranquille, isolée* and the Queen Mother had royally taken the whole of the first floor for her fifteen friends, among them the Earl and Countess of Euston, Lady Fermoy and Sir Pierson Dixon. Formerly the home of Francoise Coty of the perfume millions, lush and gilded, the hotel gave every satisfaction but there had been no secrecy in the Queen Mother's holiday and discretion could not prevent an army of French cameramen from greeting her at the entrance. In her goodness of heart Queen Elizabeth the Queen Mother also could not resist receiving the deputation of local officials who wished to welcome her and so the pretence of privacy was once more relinquished. On her sightseeing drives groups of people awaited to wave to her in the villages but these salutations, after all, gave her genuine pleasure. She lunched with the Marquis and Marquise de Vibraye at Cheverny and so saw the only fifteenth-century castle still in occupation by direct descendants of the original family, and it did not matter that her hosts were unable to resist the courtesy of summoning the local Hunt, pink-coated, to greet her with an appropriate fanfare of hunting horns.

The Queen Mother, in fact, enjoyed herself immensely. She trekked through at least some of the 365 rooms of Chambord and gazed at the unique reflection of the Chateau de Chenonceaux in its river moat. She ventured on foot, though immediately recognized and presented with impromptu bouquets, through the streets of Chinon. She visited the twelfth-century Abbey of

audience as can conveniently be reached. Happily the fractured bone healed normally and during her daughter's absence on the 1963 royal tour of Australia and New Zealand, the Queen Mother was once again able to hold the series of six New Year investitures at Buckingham Palace as the Queen's deputy.

In the midst of these ceremonies the Queen Mother faced a remarkable and all but forgotten fact. It would soon be forty years since she first became a royal lady by her marriage to the Duke of York. Did she wish any public observance of this ruby anniversary? If the possibility was allowed to progress beyond secretarial discussion, it was certainly declined, and yet the Queen Mother indeed celebrated the jubilee in her own unobtrusive and determined way. If nearly forty years had passed since she first became royal, forty years had also elapsed without a truly private holiday, a holiday without embassies or even presentations, *a holiday in a hotel!*

The so-called private visit to Italy with Princess Margaret four years earlier had proved so enjoyable that it whetted the appetite. On one fresh and sunny morning of that Roman spring, the Queen Mother had driven out into the country on the Via Ardeatina, and lunched in the open air at a quiet trattoria, among ordinary guests, choosing her dishes, like everyone else, from the menu. She had snatched the few hours from her "programme", that remorseless programme, and it was her first such meal in a public restaurant since before her marriage. In Paris, too, the royal visitor responded to the invitation of a racing acquaintance, the Marquis de Ganay, to lunch at his home near Fontainebleau, the fifteenth-century Chateau de Courances, and in the afternoon she visited the castle of Vaux-le-Vicomte, the model for Versailles. To visit the chateaux of the Loire Valley had been an unfulfilled project first planned in her girlhood and the Queen Mother sought no better celebration of her forty years than to sweep up her friends into a party for a truly private holiday at long last.

As it happened, cold draughts were blowing through the diplomatic corridors of France. The French attitude towards

birthday to you!" It was a kindly and unexpected demonstration that she has never ceased to reign in public affection, but the Queen Mother has taken more and more to spending her birthday out of sight at Sandringham or the Castle of Mey.

Clarence House was nevertheless firmly in focus on November 3rd when Princess Margaret's first son was born there at 10.45 a.m., and the Queen Mother and Lord Snowdon, unseen by the waiting throng, peeped down at the street, no doubt enjoying the joke of a van displaying a stork advertisement on its side that had stopped at the kerb. In the Music Room at Buckingham Palace on December 18th, the baby was christened David Albert Charles; and so there was another David, in sweet tribute, and the mother and grandmother faced the next New Year with new contentment. Yet even a Queen in her sixties is fortunate if life can be led without mishap. In September, 1962, the Queen Mother flew to London from Scotland for the christening of the Duchess of Kent's baby son, the Earl of St. Andrews, the Queen Mother's first grand-nephew in the royal male line. On returning to Birkhall, she stumbled in the house and again found herself laid up with a small fractured bone in her left foot, the second such painful accident she had suffered within fifteen months.

She made a good attempt to treat the injury lightly, and it had its comical side. Her old friend, Lady Fermoy, fell and broke her thigh only a few days later, and the two commiserated with one another by telephone. Then, as soon as possible, wearing a supporting shoe, the Queen Mother hobbled to pay a call at the London Clinic "to help get the patient up," as she professionally told a nurse.

But it was most vexing, and the Queen Mother limped through most of her engagements that autumn in London. She had an engagement at the Royal Albert Hall, for example, and when the Queen Mother presides over a function there—perhaps a Women's Institute assembly or a charities festival—she is not only prepared to make an inaugural speech but also often descends from the platform to shake hands with as many members of the

children the Queen Mother is a confidante always ready to "talk things out".

When Prince Charles was a little boy she delighted him with simple conjuring tricks, passing a vanishing penny through her fingers, producing a thimble from thin air and, gradually improving her repertoire with magical apparatus, she can still bewilder a teen-age audience. Human relationships are built up on little things, on sweets in a Granny's handbag, on vanishing pennies, on singsongs in a car speeding between Birkhall and Aberdeen airport. The Queen Mother sings very sweetly, for she learned in the old days at Glamis when, to the ring of a tuning-fork, the family merrily sang round the table.

With her good sense, the Queen Mother does not live in the past, for the way back is still barred with poignancy. Other than the death of her husband, the saddest shock that Her Majesty had experienced came in September, 1961, when her brother, David, was staying with her at Birkhall and died of a heart attack. He was buried three days later at St. Paul's Walden in the moan and chill of a great gale that swept across Britain, and his sister could scarcely realize that the whole of his life had been enfolded within her own.

III

On December 11th, 1961, the Queen Mother privately celebrated her silver jubilee of twenty-five years as a Queen but it was an occasion, she was happy to note, that passed entirely unobserved by the public. The newspapers had turned their attention to the quarter-century since the Abdication and so left unquestioned the true cause of the bouquets arriving at Clarence House. The Queen Mother's quiet pleasure at this lapse was not unmixed, one thinks, with dry amusement. As ever, she disliked the beam of limelight that sometimes swerved from her daughter in the centre of the stage towards her supporting performance. On one of her birthday anniversaries, a crowd of about a thousand people had gathered outside Clarence House, singing "Happy

each of the 'presentations' was invited to sit beside her and talk to her for a few moments. A day or two later, after flying to Cambridge, she used a wheelchair for part of the time while touring the tents and enclosures of an agricultural show.

The Queen Mother once said that the helicopter transformed her life. This meant not only that it saved her time and enlarged the horizons of friendship and contact with kith and kin but that it also enabled her to spread many more royal duties still farther afield. Stepping from these gaunt red-painted machines of the Queen's Flight, a little figure with feathery millinery, pastel mink, three-string pearls, the Queen Mother radiates on public occasions a droll sense of fun and contemporary excitement. And in private her older grand-children derive buoyant satisfaction from a grandmother who drops in by helicopter. She flies direct to Peter Cazalet's lawn in Kent with time to lunch and inspect her horses before travelling on to Saturday tea with Princess Anne at Benenden School. Occasionally she has landed conveniently close to Gordonstoun School to call upon the Prince of Wales, and a mid-term holiday provided a suitable excuse for a flying picnic to the Castle of Mey.

But the Queen Mother is a *reliable* rather than a casual grand-parent. When Prince Charles was a new boy at Gordonstoun and was allowed to visit relatives for the first time, it was the Queen Mother who flew up to Birkhall and sent a car to pick him up with two of his friends. Now the mid-term break with his grandmother has become a settled feature of the Prince's scholastic year, as far as royal fixtures allow, and the Queen Mother in reality warmly keeps open house for her grandson and his friends. That she has established a rewarding relationship is clear from the devoted attention that the Prince shows her in public. Grand-children are a recompense at the nursery stage and the Queen Mother showers her affection in turn on Prince Andrew and little Prince Edward and on Princess Margaret's children, David, Viscount Linley, who was born in 1961, and Lady Sarah Armstrong-Jones, of the 1964 vintage. But with her older grand-

her that Sir Arthur Penn was seriously ill, and she repeatedly went to see him in hospital before leaving London. That valiant knight, whom she had known since early girlhood, had always said he would serve her till the day he died, and in fact he died on December 30th, the day before he was due to retire. Early in February another personal grief came to the Queen Mother in the death of her eldest sister, Lady Elphinstone. Above all she was most concerned at the possible effect on her sister, Rose—who was seven years younger than Mary Elphinstone and ten years older than herself—and many of the year's activities were redrawn largely for Rose's benefit.

It had been arranged, for example, that the Queen Mother should pay an official visit to Tunisia in April. For Lady Granville this apparently became the excuse for a pleasant seven-day cruise outward on *Britannia*. The two sisters revisited Gibraltar together; and Lady Granville rested while the Queen Mother was energetically ashore in North Africa. Then the two sisters joined the Queen and Prince Philip for a sightseeing visit to Sardinia before flying home. Princess Margaret's new married establishment at No. 10 Kensington Palace lay across the tulip-filled private inner court-yard from Lady Granville's grace-and-favour suite; and this neighbourly association enabled Aunt Rose to find new interest and share all the more deeply in Princess Margaret's anticipation of her first child.

As so often in the life of the Queen Mother, sunshine and darkest shadow fretted constantly throughout the course of 1961. One nuisance was that she suffered a fall during the Ascot house-party at Windsor Castle, and cracked a small bone in her foot. Though some engagements were necessarily cancelled, she was determined to launch the liner *Northern Star* on Tyneside and a ramp was specially built for a wheelchair. But on realizing that the crowds could not see her as she was pushed along, the Queen Mother disregarded doctor's instructions and walked from the platform. A reception for the Nuffield Hospitals Trust was less conventionally staged with her foot resting on a cushion, and

Queen Elizabeth the Queen Mother is commanded by Her Majesty to invite——" etc. etc. For the wedding service, Princess Margaret chose the old form of wording because it was the same as her mother had used, and one readily detects in the preparations the tug of the private affections that carry such weight in the Queen Mother's affairs. The very date of the wedding was chosen because it coincided with Rose, Lady Granville's seventieth birthday and would give added pleasure to the aunt after whom Princess Margaret Rose was named.

The street decorations were agreed in a theme of spring flowers and roses; and Norman Hartnell undertook to submit six designs for the wedding-gown, designs for the bridesmaid's dresses and for the Queen Mother's own superb gown in white and gold. Every usual accessory of a wedding, and the thousand extra details of a royal marriage, in short, occupied the Queen Mother's absorbed attention.

Only nine days after the wedding, still doing her best to conceal a slight limp, she herself flew off on her official tour of the Rhodesias and Nyasaland. For her sixtieth birthday photographs, she bounced little Prince Andrew on her knee and so gratified the British public who until that moment had not seen a photograph of the baby . . . and were now of course eagerly and prematurely watching for signs of more grand-children to come.

II

One of the many pleasant sequels of Princess Margaret's marriage for the Queen Mother was her friendship with Tony's mother, the Countess of Rosse, a friendship which instantly put down new roots in their common enjoyment and expert knowledge of gardening. For a Queen, even for the unquenchably sociable Queen Mother, the spadework of truly making new friends becomes more difficult; and the Queen Mother in her early sixties became painfully conscious of losses among her closer companions and relatives. At Christmas, 1960, it distressed

obvious reason. The Queen and Princess Alexandra were guests; the servants wore the scarlet coats of semi-state livery; the dancing went on until 3 a.m. and bacon-and-egg breakfasts were served at tables in the main corridor until four o'clock. The Queen Mother headed the conga line that curled from the first floor drawing-room, down and around the house and then led it back, flushed, panting a little, "but her face lit with a great beam of happiness", as one witness noted. Princess Margaret that evening "positively bounced with excitement".

It becomes evident that the party privately celebrated Princess Margaret's "understanding" or unofficial betrothal. At a time when the gossip columns were still naming prospective suitors, the Royal Family indulged in the sly fun of maintaining secrecy. The Queen's Press secretary, Commander Colville, for instance, impassively submitted to constant interrogation by the inquisitive, while secretly amused that the dominant feature of his room was a huge blown-up photograph of the royal children . . . taken by Antony Armstrong-Jones.

It appears that the Queen Mother proposed that the engagement should be formally announced a month or so after the arrival of the Queen's third baby. As it transpired, the announcement was precipitated only a week after the birth of Prince Andrew. The news leaked out that the Queen was seeking through the Crown Equerry for a pair of well-matched Cleveland bays. To the initiated this could mean only that two bays were specially required for their traditional task, to pull a glass coach used for royal weddings and so, with the secret in jeopardy, an announcement was quickly made rather than risk a renewed outcry of rumour.

The wedding took place in Westminster Abbey on May 6th, but the staff of Clarence House were at the control-centre of arrangements and the Queen Mother fondly and happily immersed herself in the sea of intricate detail. It took three interviews with responsible officials, for instance, to fix the wording of the invitations sent to 2,000 guests, "The Lord Chamberlain to

dinner apart. On off-duty days, the Queen Mother liked to watch racing on television and hear the Dales radio serial at teatime; and in the evening was placidly content to don her reading glasses for an hour or two with a book, while the crashing of car doors and the young laughter announced the turbulent flow of Princess Margaret's friends downstairs.

A newcomer to her staff at this time thought it strange that mother and daughter should so frequently communicate by little notes, sealed and ceremoniously addressed, "Her Royal Highness, Princess Margaret" or "Her Majesty, Queen Elizabeth", but this was a well-tried convenience amid the constant bustle of a royal day. When Princess Margaret went to see the modern Romeo and Juliet musical "West Side Story" with a group of friends, and then went to see it twice more with Tony, the Queen Mother already knew that the old Townsend snapshots in Princess Margaret's room had quietly disappeared. The Princess told her mother of colourful adventures in Wapping or Sussex when unrecognized with Tony, and the Queen Mother was reminded of playing truant with her own husband in the far-off days before he came to the Throne.

In July, 1959, Queen Elizabeth the Queen Mother gave a luncheon party at Clarence House to honour the High Commissioner for Rhodesia and Nyasaland, and Mr. Armstrong-Jones was among the guests. At Royal Lodge she would sometimes refrain from intruding when the young people were in the garden alone and was unperturbed when they were still at the swimming pool in the dusk. It would have been amusing for the Queen Mother to have seen Tony's studio in Pimlico, but for the certainty of recognition and the difficulties of the spiral iron staircase.

There were alarums at Birkhall one day when an owl flapped down a chimney, scattering soot. Highland lore regards such a visit as bad luck, although Tony is supposed to have protested at this slight on a bird with camera-lens eyes. At Clarence House, early in November, the Queen Mother gave a dance, for no very

THE SUNLIT PLAIN

I

AT THE GATE OF HER sixtieth year, Queen Elizabeth the Queen Mother had the happiness of knowing that Princess Margaret had fallen deeply in love with Antony Armstrong-Jones. The romance was indeed a possible match that she had approvingly fostered and furthered by every stratagem known to mothers. "They are two of a kind" summed up her view, and the dapper and good-looking young photographer was an ever welcome guest at both Royal Lodge and Birkhall through the summer of 1959, although he had been in the mainstream of Princess Margaret's closer friends, constantly coming and going at Clarence House, at least a year earlier.

The Queen Mother remembered being photographed, and amused, by the young man after Lady Anne Coke's wedding to Colin Tennant at Holkham Hall in 1956. She would have noticed with maternal alertness that "Tony" crept increasingly into her daughter's chatter—his photographic scenery for the Cranko revues, his advice on cameras, his fashion sketches, his car "going like crazy", his fun, and it was on her furtherance that Antony Armstrong-Jones photographed the Queen and Prince Philip, Prince Charles and Princess Anne at Buckingham Palace later in the year.

In more personal matters, the Queen Mother believed in smoothing the way without apparent intervention. At Clarence House she and her daughter usually joined the officials of her Household in the library for luncheon, but often had tea and

us work!" Although it is claimed that political adversaries of the Italian government staged the outburst, the Queen Mother worried about it all the way back to the British Embassy and sent a message to the Lord Mayor of Rome pleading for the affair to be viewed with clemency. Hundreds of such kindnesses have been reported, thousands more lie like the bulk of an iridescent iceberg beneath the surface, and all are but an ingredient in the Queen Mother's popularity.

On the day that she received the Freedom of the City of London, she sent her bouquet of red roses to the girls of her milliner's workroom, remarking that her hat, *their* hat, had given her much confidence and pleasure. Presented with a magnificent bouquet in Bulawayo she sent it by air to an aged African butler in hospital in Salisbury whom she had met at Government House three years earlier and still remembered. Many of her daily bouquets are transferred to give happiness twice over in this manner. When her aged chiropodist, Robert Sahli, fell ill, she travelled out to the somewhat distant suburb of Wanstead to see him, taking flowers. When an old Glamis still-room maid was treated in a Dartford hospital, the Queen Mother wrote to the matron and nursing staff to thank them for their kindness to the patient.

In Blantyre the Queen Mother was told of an old lady, a god-daughter of Cecil Rhodes, who was confined to her room in an old people's home and could not join the other residents at tea with her. "I will go upstairs to her if I may," she said. Here again, it made a good newspaper story. But what the reporters did not know was that the Queen Mother had injured her hip, falling on concrete stairs at Hurst Park races, three months before and was still under physio-therapy and massage. No one will know the pain and difficulty that the apparently small effort cost her.

independent republic of Zambia—while visiting another mine of the Copperbelt she stood with the management officials looking into the opencast pit. A truck with a full load was coming up the road beneath her and, to quote an eye-witness, "The Queen Mother saw that it was driven by an African. She looked down and waved her hand. The driver, even more surprised, recognized her and took one hand from the wheel to raise his red mining helmet, giving her a flashing smile." The episode was nothing and yet it was everything, and one ventures to think that it carried a recognition of immense significance if the Crown can consolidate the Commonwealth ideal.

In the Queen Mother's lifetime the sphere of royal duty has become the world itself. She again flew the Atlantic to visit Montreal and Ottawa in 1962, and she made good an omission and briefly visited Toronto—as well as paying an official visit to Jamaica—in 1965. (The previous year, she had completed all the arrangements for another six-week tour of New Zealand and Australia when, only four days before she was due to fly out, as one remembers, she had to be rushed off to hospital for an emergency operation for appendicitis.) And this geographic stocktaking takes no account of her travels within the British Isles: to Northern Ireland, the Channel Isles and the Isle of Man, for example, all within an eighteen month period of 1962–63. Nor have we followed her allegedly unofficial private travels: her visit to Rome and Paris with Princess Margaret in the spring of 1959; her cruise on a State Visit to Tunisia in 1961 aboard the royal yacht *Britannia*, and in 1964 her own recuperative cruise of the West Indies after her appendix operation. The most-admiring author cannot compress a two-volume odyssey into a one-volume work. And if with admiration one at last renounces impartiality in writing of this warm-hearted, disarming, selfless and dedicated gentlewoman, one is not alone.

An incident that greatly troubled the Queen Mother took place in Rome when a woman carrying a baby in her arms broke from the crowd and ran towards her, shouting, "Give us bread! Give

climb around the station called Equator, where she posed amiably
for the cameras, and the verse gallantly declared,

> "We railwaymen are deadly dull,
> Our lives run straighter than the line,
> Today our cup is more than full,
> For you provide our Valentine".

Another notable feature of the tour was that the Queen
Mother spent a night at Tree Tops, the hotel in the tree branches,
where her daughter had become Queen on the night that George
VI died seven years before. The hotel had been destroyed by fire
and rebuilt on a slightly different site but, like her daughter, the
Queen Mother sat enthralled on the verandah until nearly mid-
night watching rhinoceros, bush buck, buffalo and forest hogs
coming to drink at the water hole below. Next, a fascinating
journey was made through the Queen Elizabeth National Park
to a camp overlooking Lake Edward; and on returning home, the
Queen Mother could tell her grandson, Prince Charles, of the
five elephants that had awakened her, crashing against her
verandah, of the wallow of glorious mud in which no fewer
than 200 hippos snorted and frolicked and, for fuller proof
of adventure, the grandmama had her photographs: the one
she took within fifteen feet of a lioness which had just killed
an antelope, several of the crocodile that had washed against her
launch, and others of the spectacular rush of the Nile at Murchison
Falls . . .

It would perhaps be unnecessary, if not tedious, to chronicle
all the travels of the Queen Mother within the last decade. The
Press praised her "healing touch" when she returned from Kenya,
and the healing touch was used, less advisedly and yet with
tranquillizing effect, when she visited the Rhodesian Federation in
1960 to open the Kariba Dam. No one could charge her at this
stage with being the apostle of British Imperial rule but what the
Queen Mother achieved on this visit in cementing friendship can
be illustrated in a single scene. In Northern Rhodesia—now the

visit to Kenya to open the new Nairobi airport had been upset and cancelled, but the Queen Mother almost immediately promised a visit for the following year. And here again the journey had a strangely bitter-sweet savour for her sister-in-law and namesake, Elizabeth Bowes-Lyon, Michael's widow, died on January 19th; and in travelling again over the sunny plains she had known in the first years of her marriage the Queen Mother was chilled by the clinging remembrances. Moreover, she flew out to Nairobi on February 4th as if into the teeth of a political gale. The African elected members of the Kenya Legislative Assembly had decided to boycott the visit since "conditions do not permit full participation by African people in events of celebration and joy". In the event the roaring and cheering crowds in Nairobi could not have been happier. An oddity was a tribal gathering of the Masai who had been praying for weeks for rain on their sun-scorched plateau. As she faced the elders, she expressed her hopes that they would be blessed by rain, the first drops fell within half an hour and the deluge was so heavy that the take-off of her aircraft was delayed.

Again, before her visit to Mombasa, the violent voice of Cairo Radio called for the Arab community to shun "this visit of the leader of the imperialist dogs" but, instead, the streets and squares were packed with cheering and welcoming throngs. To forty Arab sheikhs and leaders who came to welcome her, the Queen Mother replied that their friendship had stood the test of time. Back in Nairobi, a concourse of the Asian community greeted her in the city park, and she thanked the Asians for the part they had played in the peaceful progress of Kenya. At Kitale, a subversive anti-white movement suddenly reversed gears into loyalty when hundreds of Suk tribesmen gathered to show their allegiance. In London, the phrase "Queen Mother Wins Over Terrorists" made an irresistible headline. Not less newsworthy was the valentine placed on her breakfast tray at the behest of the seventy railway workers aboard the royal train. A pattern of scrolls and spirals represented her railway mountain

"I'll open it," the Queen Mother reaffirmed in London, "but I hope I get there before I'm in a wheelchair." And she made it, in an unusually hot summer, facing the Australian crowds in blazing sun with fortitude that drew both their admiration and compassion. It made headlines when she withdrew to a closed car when the heat was unbearable. But in the course of the odyssey she lost nearly as much weight as her husband had done in South Africa.

No doubt the final adventure of this exhausting tour should be added. It was a matter of pride that a Qantas Australian air-crew should fly her home, although the aircraft was an American Constellation. For that honoured and jaunty air-crew it was sheer bad luck that a cylinder head cracked while the plane was still over the Indian Ocean 400 miles from land, and broken metal peppered the cowling. The pilot, Captain Robert Uren, nursed the aircraft along on three engines but the need for a new engine and cowling turned a refuelling stop in Mauritius into a delay of two days.

A second plane rushing a new engine from Australia was forced back by storms and the Queen Mother was still stranded in tropical rainstorms at La Reduit, the Governor's house in Mauritius, when she should have been safely in London. She was enjoying the rest, she explained, but she was brimming over with sympathy for the air-crews. When her plane eventually took off, it developed ignition trouble and another prolonged stop had to be made at Entebbe. Captain Uren fumed at the imperfections and the Queen Mother, not content with sympathy made a point of mentioning the disappointed crew at her Guildhall welcome-home reception. "I have some experience of the disappointment of seeing a dazzling success snatched from one, even after the last fence," she said, a reference to Devon Loch, "and my sympathy is so much with the gallant crews who worked so unceasingly to complete their task."

Burning cheeks burned less for this gratifying appreciation, nor was this the end of the story. Owing to the delay, a scheduled

that, in her fifty-eighth year, in the six strenuous weeks, she allowed herself only one day free from official duties.

Flying outward via Montreal and Vancouver, the royal voyager even rose at 4.30 a.m. to see as much as possible during an hour's touchdown at Honolulu, and the Governor drove her to Waikiki Beach while the plane refuelled. Arriving in Auckland, she herself reminded New Zealanders that it was thirty years since her last visit, but photogenically she had improved almost beyond recognition and despite passing youth her personal charm was undimmed. Probably no one realized that her speeches were prepared for her in larger type to avoid wearing glasses, or that she very occasionally felt unsteady on her high heels. At Wellington an elderly racing owner, Sir Ernest Davis, was so captivated that on the spur of the moment he presented her with a horse that had just come home a winner, the black gelding Bali Ha'i. But despite the outer radiance the Queen Mother soon felt so extremely tired that her medical adviser suggested she should rest in bed one afternoon. It was perhaps twenty-one years since she had sadly remarked to Marion Crawford, "We aren't supposed to be human", and still she herself was supposed to be nothing but royal.

She flew to small hitherto unvisited towns such as Kataia and Hamilton and showed herself in the evening in the gala finery that she might have worn at a State Banquet in London. An average day saw her making a morning flight from Wellington to Blenheim and an afternoon three-hour flight to Dunedin, snatching a nap in the plane before a forty mile car drive, a massive Highland jamboree and an evening reception. Fourteen such days, with the thermometer in the eighties inevitably brought new signs of strain.

"Well, I made it," she said to Sir George Holland, the first in line to meet her in Canberra. But this was in reference not to the fatigues of the tour but to a long-standing undertaking to open the headquarters of the British Empire Servicemen's League. The promise, first exacted in 1949, had been renewed in 1951 and 1952.

wealth as a new comradeship of peoples, the creative task to which in the end he gave his last energies. The King's ideal has remained in flux, ferment and change as in his lifetime, but whenever a royal mission could help to resolve dispute or dissension or remove the seeds of doubt, the Queen Mother was "on call", as she is still.

In 1957 the experimental Federation of the Rhodesias was in the crucible and the Queen Mother flew out on a round tour taking her from Salisbury and Bulawayo to Lusaka in Northern Rhodesia and Blantyre in the then Protectorate of Nyasaland. She was, in fact, the first royal visitor that the Protectorate had known. The Queen Mother arrived at the State Assembly in Zomba in full royal rig of tiara and white chiffon to receive from 140 chieftains their tokens of loyalty to the Crown; and although Zomba is now the capital of the new independent state of Malawi its membership of the Commonwealth may have been reaffirmed in the Queen Mother's goodwill. The same may be true of Northern Rhodesia, now the Republic of Zambia, where she descended in cotton kit 1,400 feet to the rockface of the copper mines, and strikes and riot squads were forgotten in the African anxiety to see her. Back in Southern Rhodesia she held a tribal parley or Indaba, reminding the tribal chieftains of the sixty years of peace that had never been broken. The results of the tour, judged at the time by current standards, were acclaimed as successful. "The Queen Mother goes home having fanned the flame of loyalty and won the allegiance of many doubters," wrote the *Daily Mail* correspondent.

In the spring of 1958, the Queen Mother embarked on a tour of New Zealand and Australia and set a new achievement to her record, for she was to be the first member of the Royal Family to fly around the world. Her prime objective being the renewal of fraternal ties cemented in the Queen's Coronation visit five years earlier, she expressed a preference for informal open-air gatherings at which she might mingle with and talk to as many people as possible. Her advisers were ultimately stunned to find

secrecy.) Despite the professional co-operation of a ghost writer, the Queen Mother could be overheard to say nothing more fervid than, "Good afternoon, Peter, it's been a long time. It's so very lovely to have you here again."

Townsend had in fact freshly returned from a tour around the world which he made "to forget" and the Queen Mother evidently felt that it would have been cruel and needless to repel an old friend. There were further meetings, difficult though they may have been, before Townsend returned to the Continent, but there could be no rekindling of the old lost illusions. With a mother's shrewd insight, indeed, the Queen Mother was already watching Princess Margaret's growing friendship with a young man whom she had first met two years earlier, an agreeable and talented young man just five months older than the Princess, Mr. Antony Armstrong-Jones.

IV

One turns back through the records of the 'fifties and sees the Queen Mother installed as Chancellor of London University, unveiling the memorial to the Fallen at Dunkirk, holding a Privy Council at Clarence House during the Queen's absence in Nigeria, and holding the last of the Presentation Parties at Buckingham Palace, more by accident than design. In May, 1937, Her Majesty had held her first Court, with the King, as Queen Consort. Those feathery parades of debutantes were replaced after the war by afternoon Presentation Parties but when these in turn were deemed obsolete and were discontinued, two final Presentation Parties were held for overseas debutantes. The Queen, however, fell ill with sinusitis (a weakness which at times still causes the Queen Mother concern for her) and so it was Queen Elizabeth the Queen Mother to whom the last debutante made the last curtsey.

The Commonwealth connotation was an apt one. The Queen Mother can never forget her husband's vision of the Common-

between the Queen Mother and the Group-Captain at Clarence House on October 18th and what passed between them cannot be conjectured.

It happened strangely that a public event planned long beforehand interposed itself into the very heart of the Townsend phase. On Friday the 21st, in heavy rain, the memorial statue to King George VI in the Mall was unveiled by the Queen in the presence of the Cabinet and the Royal Family. "He shirked no task, however difficult," said the Queen "and to the end he never faltered in his duty..." The words dripped as cold to the impetuous heart and as irrevocable as the rain itself. That weekend, the Queen Mother took refuge with her brother, David, at St. Paul's Walden Bury. On the Tuesday, five days later, Princess Margaret called on the Archbishop of Canterbury at Lambeth Palace and, according to Randolph Churchill, she then said, "Archbishop, you may put your books away. I have made up my mind..." Five days more, and she issued her public statement "I would like it to be known that I have decided not to marry Group-Captain Peter Townsend... mindful of the Church's teachings that Christian marriage is indissoluble, and conscious of my duty to the Commonwealth, I have resolved to put these considerations before others..."

It seems probable that the Queen Mother attempted to persuade the Princess not to issue a statement, and it might have been better to have allowed public interest to fade with Townsend's further withdrawal to Brussels. Three years later, public interest naturally erupted as avidly as ever at the surprise sequel—in March, 1958—when Peter Townsend went to have tea with the Queen Mother and Princess Margaret at Clarence House. What happened at *that* meeting? The American public, though not the British, have been entertained by the reminiscences of John Payne, the Princess's personal footman, against whom the Queen Mother gained an injunction in 1960 to restrain him from publishing matters known to him by having been in her service. (Royal servants are usually bound by their contract of service to observe

he did not speak for the Government the core of his advice was already known to the Queen Mother. It was that Princess Margaret had to give notice in writing to the Privy Council of her intention to wed Group-Captain Townsend, and if Parliament did not object within one year the marriage could take place. At the same time, the Prime Minister also had to advise that if the Princess wished to retain her royal status, the probabilities were that Parliament would object and the Government's views would be supported by the Commonwealth governments. The marriage would then not only deprive Princess Margaret of her rights of succession and other royal rights but she also would be deprived of her Civil List allowance—due to rise to £15,000 a year on an approved marriage. Moreover, it might not be practical for her to live in England where a division of public opinion might cause a constant clash with the interests of the Throne.

The Queen Mother evidently took the prudent view that parental opposition might at one stage merely strengthen the Princess's resistance. Having decided to leave Princess Margaret apparently unfettered until the last moment, she tactfully remained at Mey and indeed reached Clarence House on October 14th barely half an hour before Townsend himself arrived at Princess Margaret's invitation. The Queen Mother found her home besieged by cameramen and cars of film equipment, the symptoms of world interest that trailed the lovers relentlessly throughout the ensuing seventeen days.

In retrospect one may see that the handling of Townsend's return was maladroit. Had he been a guest at sequestered Birkhall, public curiosity would have been denied a firm focus and much of the drama of the meetings, the car drives, the weekend with friends, the comings and goings, would have sapped from the charade. But perhaps the denial of the shelter of Birkhall or Mey was a more deliberate and resourceful strategy than appears. The argument that the late King would have opposed the marriage was by no means the only expedient at the Queen Mother's command. A lone meeting of nearly two hours in fact occurred

newspaper was printed in the western world that failed to remind its readers that the Princess was now legally free to wed without the Queen's consent.

In any ordinary family a headstrong daughter can suffer the illusion of love for an older man without the vocal forces of western civilization baying at her heels. When there are objections, a mother may reason, cajole or quarrel, with scarcely a ripple beyond the family circle. But the Townsend drama was whipped into a whirlwind of sensation and speculation and became willy-nilly a melodrama, played upon the brightest stage. There were times when the Queen Mother seemed in public to wash her hands of the affair, while it is evident that in private she patiently and subtly exerted a tender maternal pressure born of love and cherished understanding.

Queen Elizabeth the Queen Mother liked Peter Townsend, his looks, his manners, his intuitive knack in taking the burden of a conversation, his thorough and trustworthy efficiency as a man, and his engaging personality and true sympathy as a friend. When his marriage ended in failure she was distressed and sorry for him. But with her daughter's profession of love, she faced the same double-edged royal dilemma of divorce, the irrefutable formula: that the Queen was head of the established church which held Christian marriage to be indissoluble and the Queen's sister could therefore not marry a divorced man. And Princess Margaret especially could not marry him while she was third in succession to the Throne and might thus by the hazards of human life be called on in turn to Defend the Faith.

Amid the sandstorm of surmise, the clear fact emerges that when the agreed eighteen months of separation were over, Princess Margaret told her mother and the Queen that she had not changed her mind. Sir Anthony Eden, the Prime Minister, was a guest at Balmoral for the weekend of October 1st and the Queen Mother withdrew to the Castle of Mey. Sir Anthony had himself been through the divorce mill, so ambiguous are the British constitutional difficulties of Church and State, and although

modestly thought it absurd that the *Daily Mail* should comment on her American visit "She has done more to promote Anglo-American friendship and understanding than all the diplomatic activities of the entire year". The Canadian Press even began to discuss the Queen Mother as the next Governor-General and the possibility was put to the Queen. "Oh, dear, we couldn't spare Mother," she said. "We should miss her far too much." The remark was lightly made and it remains questionable whether the Queen Mother's exile would have averted the bomb tragedies of the separatist movement in Quebec. For exile it would have been, albeit in a friendly sister country, in the prolonged five-years' absence from her friends and family in London.

III

The Queen Mother's attitude towards publishing and the Press is as wary and equivocal as that of any other public figure. She once officially visited the Press Club in London, demonstrated her skill at snooker and talked "off the record" with a dexterity that gave nothing away. In public she tries to ensure that the cameramen have a good position and a rewarding pose. In private, one suspects she often manipulates any opportunity to lessen her share of the limelight in order not to subtract a fraction from the prestige and enhancement of the Queen. The Townsend uproar in Coronation year was all the more vexatious and undesired; and when in the autumn of 1955 the storm recurred in a new crescendo with Townsend's return to London, the Queen Mother must have scanned the headlines with a consternation that resolved into deepest dismay.

When Princess Margaret quietly celebrated her twenty-fifth birthday on Sunday August 21st, a Balmoral farmer reaped a rich harvest in parking fees from the hundreds of cars and fleets of motor-coaches that brought an estimated 10,000 people merely to watch her entering Crathie Church. Yet this was only the local manifestation of a world-wide inquisition. Scarcely a

was not a single copy in the United States. He made do with band-parts of 'My Country, tis of thee' which is fortunately the same tune. The ninety presentations were stop-watch timed to take thirty seven seconds apiece, and inevitably the guest of the evening slowed this schedule by holding each proferred hand for nearly a minute in her own warm hand.

In Washington, as the guest of President and Mrs. Eisenhower at the White House, the Queen Mother caught up with long-desired sightseeing as varied as the Smithsonian Institute, the Library of Congress and the Pentagon, and in that vast warren especially the drug-store, "an amazing shop".

With Mrs. Eisenhower, she could laugh at a wartime incident when it was arranged for two high-ranking American army officers to visit Windsor Castle and, not to embarrass them, the King and Queen promised to keep out of sight. At the last moment, they had forgotten the promise until they saw the Americans, and the King and Queen quickly had to crawl under a low hedge to escape into hiding. The officers were General Mark Clark and, of course, Ike Eisenhower.

Next, the royal tourist visited Annapolis and Richmond, Virginia. She spent a night in Williamsburg, lodged amid the Regency trappings of the second-floor suite at the Williamsburg Inn and dining at the King's Arm Tavern. Next day she drove through the carefully restored period streets in a horse carriage, "quite amazed", as she said "at the skill and patience with which the serene atmosphere of the Colonial city has been brought back to life". On Armistice Day, at the eleventh hour of November 11th, she knelt at prayer in George Washington's pew at Bruton Church.

While in Ottawa the Queen Mother heard that her friend Lady Annaly, the former Lavinia Spencer, was ill, and within three hours of returning to London she hurried to pay her a surprise visit at Westminster Hospital. This was the "human sidelight" that the newspapers too often managed to discover and featured avidly, much to the Queen Mother's distaste. She no doubt

in New York in 1953, her host, Sir Pierson Dixon, suggested she might like to see the newspapers and pointed, smiling, to the editorial in the *New York Times*, "Of all the many reasons for welcoming Queen Elizabeth the Queen Mother the pleasantest is that she is so nice . . ."

Protocol in itself had caused it to be stressed that the visit was an entirely unofficial one, but if the Queen Mother had hoped to shed the royal aura, she was to be disappointed. Aboard the *Queen Elizabeth*, she had a three-room suite on the main M deck, while her companions—Lady Jean Rankin, the Hon. Mrs. Mulholland, Sir William Elliot, Oliver Dawney and others were located in adjoining cabins. At sea, however, as soon as the small, familiar pastel-clad figure appeared on deck, people scrambled from their chairs and began a polite clapping. Next day a message went round by word of mouth by the deck staff asking people "not to bother" when she took a constitutional. But if the Queen Mother inspired this instruction, it made no difference; and the clapping, sometimes timid, sometimes strong, and always a genuine expression of affection—broke out wherever she went— in the dining-room, in the cinema—throughout the five days of a somewhat stormy crossing.

At the outset in New York the newspapers made some impatient criticism of the "stuffed shirts" who whisked her out of sight, but the visitor keenly wished to do a little off-beat sight- seeing, if that were possible, before her scheduled programme; and her hosts, the Pierson Dixons, had to exercise every ingenuity to help fulfil her wish. In their house at Riverdale, their guest enjoyed from her bedroom windows, a superb view of the Hud- son and the wooded bluffs of the western shore, but her car rides were fugitive entrancements mainly undertaken at dusk or by night and usually with an inescapable cavalcade of observers.

The Queen Mother's first official engagement was at the Columbia University Charter Banquet at the Waldorf Astoria, to celebrate the bicentenary of the founding of the University under a charter of George II in 1754. In all that vast gathering there was

marks of dexterous guiding management, and they were of course arranged through the Queen Mother's Household, for Princess Margaret had no separate establishment.

Meanwhile, Queen Elizabeth the Queen Mother fulfilled dreams of her own with which to restore her downcast spirits. Ever since discovering in girlhood the presence of an Aunt Hyacinth in Philadelphia, she had cherished the whispering thought of perhaps visiting America one day in private. Hyacinth Jessup was long since dead but the State Visit of 1939 and the persuasions of Eleanor Roosevelt, President Eisenhower and other congenial friends had kept the dream alive. In any event, the Queen Mother's three weeks' visit to the United States and Canada in 1954 was exceptionally well-timed. The Queen and Prince Philip returned to London from the success of their Commonwealth tour to face an intensive season of official business, and no shadow of guidance was needed any longer from Clarence House. After the Balmoral break, the Queen Mother remained in England long enough to play her decorative part in the State Visit of the Emperor Haile Selassie of Ethiopia, which began on October 14th. Then on October 21st she sailed on the liner that bore her name, *Queen Elizabeth*. Among other considerations, it was just as well that Princess Margaret should have for the first time a foretaste of life without Mother.

II

A royal lady, though used to flattery, is sometimes oddly touched by the sincere word. It had happened that on Queen Elizabeth's thirty-sixth birthday in Abdication Year a woman had written to her, "I wanted so much to wish you happiness on your birthday. God bless you. You don't know how much we love you. Whenever I see you, you are always smiling, and it sort of cheers my life to see you smile." The remembrance of that letter had lingered and consoled her through all the mental agonies of the events that made her Queen. So similarly when she arrived

that Townsend spent his "last night in England" at his Sussex
cottage after all was decided, Townsend approached the Queen's
secretary, Sir Alan Lascelles, two months before the Coronation
and informed him that he and Princess Margaret wished to be
betrothed. Simultaneously, the Princess told her mother that
she was in love with Townsend and during the ensuing family
agitation the Queen was advised that she could not validly give
her consent to Princess Margaret's marriage to a divorced man.

It was like the dilemma of the Duke of Windsor visited upon a
younger generation, played by a different orchestra with different
overtones. The Queen and the Queen Mother each had cause to
hope that the Princess's love would prove a passing infatuation.
The Queen Mother perhaps assumed at times the rather vague
manner which she had adopted long before as a defensive cloak
against the late King's testiness. She had cause to remind herself
that if her husband had been alive this new confusion would
never have come about. For two months the royal ladies wavered
in a sea of discussion until the Queen Mother prevailed upon her
younger daughter to wait in patience until she was twenty-five
and to accept the counsel that Peter's absence abroad would be
better for the time being. Townsend had been due to accompany
the Queen Mother and Princess Margaret on their visit to
Southern Rhodesia. Instead, he was given a choice of posts abroad
and transferred as air attaché to Brussels.

In the lull thus imposed on her perplexities, the Queen Mother
devoted a great deal of tactful guile to providing preoccupations
for Princess Margaret. Her occasional motherly presence at
rehearsals of "The Frog", the Edgar Wallace play which Princess
Margaret assisted in staging in aid of charity at the Scala Theatre
suggests her encouragement if not a more active connivance in
this diverting venture. Billy Wallace, Colin Tennant, Lord
Porchester, Mrs. Gerald Legge and others of her close personal
circle, one may note, were also concerned. Princess Margaret's
visit to the British Forces in Germany in 1954 and her tour of the
West Indies in the royal yacht *Britannia* in 1955 similarly bear the

complete dedication of those around them, and Peter Townsend was perhaps to provide an unhappy illustration of this failing. He had married as a young airman and had two sons. As an R.A.F. fighter ace of the Battle of Britain, he became appointed an Equerry of Honour, a new post imaginatively created in wartime for heroes to render occasional duty close to the King. His Court career was meteoric and successful. But from the South African tour of 1947 his immersion in his duties was so demanding and time-consuming that his marriage suffered and in the autumn of 1952 he divorced his wife.

The Queen Mother may have blamed herself for not foreseeing the coming catastrophe, but events had slipped uncontrollably into the no-man's-land of emotion. Peter Townsend was twelve years older than Princess Margaret and the total concord of their affections must have seemed as inconceivable to the Queen Mother as would have been her own closer attachment to Arthur Penn, who was fourteen years her own senior. As with Penn, she regarded Townsend as a *chevalier sans reproche*, as indeed he was. After the King's death, she failed to recognize the danger signs as her younger daughter's over-wrought grief solidified around Townsend, a substitute father figure as some deemed him, in whom she too found implicit sympathy and help. Without sinking into what Mr. Malcolm Muggeridge has called the "royal soap opera", one has to interpret evidence that has no doubt gained significance after the passage of time. Behind the veneer of King's Cup racing planes and polo ponies, Townsend was at heart an ascetic with an enquiring religious disposition. The Queen Mother had perhaps no reason to link the crucifix on Princess Margaret's writing desk with the three little photographs that appeared on her daughter's bedside table. But after the decree nisi, Mrs. Peter Townsend remarried; and suddenly in the Spring of 1953 Princess Margaret faced the dazzling and inescapable conclusion that the man to whom she was drawn with such unwavering affection was, in civil law, newly free to wed.

According to Norman Barrymaine, who was so close a friend

TROUBLES AND TRAVELS

I

AT HER DAUGHTER'S CORONATION, Queen Elizabeth the Queen Mother seemed a serene and untroubled figure and only old and trusted friends such as Arthur Penn and Lord Salisbury knew of the sorrows and difficulties that she kept to herself. Only a month and a day before the Coronation, grief came in the death of her elder brother Michael; a sadness deepened in that his widow was her old school friend, Elizabeth Cator; and only three weeks after the Coronation the death of her brother-in-law, Lord Granville, Rose's husband, brought anxious concern for her sister's future in the solitudes of widowhood that a family may mitigate but never assuage. And among these distresses perhaps nothing weighed more heavily on the Queen Mother's mind than the difficulties surrounding Princess Margaret's ardent private decision that she wished to be betrothed to Peter Townsend.

One might wish to efface the episode but, as the Queen Mother once told a photographer, "You must show me a little older . . . one does not stand still." In every life, no matter how marshalled and orderly, an arbitrary misjudgment may cause one to stray from the smooth highway of settled circumstance into the wildlands of mischance and vexation. For the Queen Mother the false step was taken in 1952 when she appointed Group Captain Peter Townsend as Comptroller of her Household. Through no direct fault of his, the step was no sooner taken than regretted. Since Queen Victoria's reign, it has been in the nature of royalty that in their own dedication they accept, often unthinkingly, the

course she invariably waits till after the meeting to see the films of the last three furlongs of the races taken by the official camera patrol, especially eager to discover why and how her horses are defeated. It has been said that the Queen Mother has "been the making" of the intense popularity of steeplechasing in Britain and it is a relevant satisfaction to everyone concerned with her horses that her racing colours have achieved a century of wins.

the owner's expenses were heavy and experts calculated that her accounts were probably still in the red.

After a poor performance in the 1964 Grand National, Laffy provided the Queen Mother's twentieth win of the 1964–65 season. Flying back from Jamaica one Saturday morning the Queen Mother was on the racecourse at 2.15 in time to see him win the Manifesto Chase for the second year running, a victory which placed her at the head of the winning owners' list with nearly £9,000 in prize money. Another memorable day occurred at Folkestone when the Queen Mother was able to pat three winners; and it was of this occasion, at the time of the Olympic Games that four-year-old Prince Andrew enquired, encouragingly "Will Granny get a gold medal?" Laffy also won the Ulster Harp National, the first royal win seen on the Downpatrick course for fifty years, and the Queen Mother has also kept hopeful young geldings stabled in Eire, the first such patronage since the days of Edward VII. In 1962, she was the first royalty to take a first prize for a horse at the Royal Dublin Show.

The Queen Mother has not yet won the Grand National at Aintree, although The Rip became first favourite in 1965 after winning a proving steeplechase by twenty lengths. Alas, in the National, he cleared every fence but merely finished seventh, far behind the American winner Jay Trump. That other classic the Cheltenham Gold Cup, similarly eludes the royal devotee's grasp. Indeed, despite countless hopeful pilgrimages, she had never won at the National Hunt Festival at Cheltenham until her horse Antiar gained a victory there in 1965 which incidentally placed his owner second in the table of National Hunt owners that season with prize money totalling £11,847.

With this milestone, the Queen Mother's enthusiasm had widened to fourteen horses in training in Kent under Peter Cazalet and five others under the Irish trainer, Jack O'Donoghue, in Surrey. At Clarence House she subscribes to the Exchange Telegraph racecourse commentary service in order to hear her horses' progress when she cannot watch on television; and on the

was every onlooker's conviction, yet whether the full-throated roar of the crowd caused disaster or else a sidelong glimpse of the water jump deceived him or whether a sudden cramp deprived him of movement can never be known. Suddenly his legs splayed outward and he fell on his belly . . . to be passed the next moment by every horse remaining in the field.

The Queen Mother strove in her own disappointment to console Dick Francis. "That's racing, I suppose," she said. "Please don't be upset. There'll be another time." Yet there was nothing physically wrong with Devon Loch; he remained in form and seven months later he won his next race in, to quote the Queen Mother's own racing records "such a run as could hardly be imagined. Though Northern King led over the last flight, and was still in front sixty yards from the post, Devon Loch passed him so fast that he won by two lengths".

This gallant jumper eventually went lame and ended his days at Sandringham, but the Queen Mother's hopes and her taste for the uncertainty and drama of the 'chase remained unquenched. A horse named Double Star proved his brilliance and then mysteriously failed her until early in 1960 he broke a sequence of thirty losers over fences, but his owner's faith in him never faltered. The Queen Mother is a shrewd judge of horses in her own right—apart from the skill and experience of her advisers—as she perhaps once proved when she made three bets on the Flemington course in Melbourne and backed two winners. At about the time of Double Star's return to success, she bought The Rip as a five-year-old from a Sandringham neighbour without professional advice and solely on her own judgment after inspecting him in the yard of a Norfolk public-house. Two years later, The Rip, Double Star and Her Majesty's French-bred Laffy won three successive races in her colours at Lingfield one afternoon. This was her first hat-trick as a racing owner, and the victories principally of The Rip and Laffy in 1961–62 contributed to their owner's best season up to that time, with twenty-three wins that secured her over £7,000 in stake money. With eleven horses in training, however,

some success. Throughout that winter the Queen Mother staunchly followed his fortunes in all weathers, and Francis recalls a day of pelting rain at Lingfield when only six spectators watched the horses parade: "But H.M. the Queen Mother was waiting under one of the big trees there to see her horse, and to give me the usual encouragement before I set off".

When Dick Francis first rode a royal horse to victory, he was totally unprepared for the tremendous roar from the crowd and wondered what had occurred until he realized that the terrific cheers were, of course, for the owner. Was Devon Loch, the intended successor to M'as-Tu-Vu, similarly taken by surprise, and put out of stride, in the shattering wave of sound—a triumphant ovation given seconds too soon—when he failed so signally in the 1956 Grand National?

Devon Loch is the only horse to have gained immortality by losing a race, but the reason for his failure will always remain a mystery. Bred in Ireland, he had won only a flat race of two miles for amateur riders when purchased by the discerning Major Cazalet, and after only one or two placings he strained a tendon and missed two years of racing. Yet Devon Loch was a horse of spring and sense, as his riders said, who won a novice steeplechase when four days' rain had steeped Hurst Park course in sticky mud. He rose on the ladder of novice and handicap races until, at Cheltenham, he was nearly last on the first circuit of a three-mile race only to put on such an extraordinary burst of speed in the second circuit that he finished third. Shortly after that endeavour he became all Britain's favourite for the 1956 Grand National.

As if to enhance her own zest, the Queen Mother also entered M'as-Tu-Vu. In the event, he completed the first circuit despite the usual melée of falling horses, and at the stands the royal owner had the immense excitement of seeing both her favourites still in action. But M'as-Tu-Vu fell at the twentieth of the thirty jumps, while Devon Loch sailed on, meeting every fence perfectly, as in a dream. Less than fifty yards from the winning post, he had the invincible certainty of a win by many lengths. Such

Grocers Company—the first woman to be made free of Grocers' Hall in eight centuries of recorded history—the Queen Mother was therefore greeted by the Lord Mayor in his crimson and gold reception robes. Once again, indeed, for a short time, she was the first lady of the land.

V

It was during this busy season of 1953–54 that Queen Elizabeth the Queen Mother turned increasingly for recreation to racing, and especially steeplechasing under National Hunt rules, the sport that has become her greatest relaxation. Her more intensive interest developed, as we have seen, with the partnership in Monaveen when her daughter was still Princess Elizabeth; and the horse—at one time harnessed to a Limerick milk-cart—became the most popular animal in Britain when entered in the 1950 Grand National. In a field of forty-nine, in the world's greatest steeplechase, Monaveen so distinguished himself that he was one of only seven horses to clear every jump and he finished fifth. When, the following season, he broke a leg and had to be shot, his senior owner was so upset that she could not bear to accept a statuette of Monaveen that was to have been presented to her. The Queen Mother's first horse in her own colours of "blue, buff stripes, blue sleeves, black cap, gold tassel" was Manicou, which she acquired from Lord Mildmay's estate in 1950, and he justly won the King George VI 'Chase for her that year but broke down soon afterwards and was relegated to stud.

When the Queen was about to go overseas in 1953, her mother had only one steeplechaser in training with Peter Cazalet, but this jumper M'as-Tu-Vu, was so obliging that he won a race at Sandown Park on the very afternoon that the Queen Mother was seeking enjoyment there with her daughters just before the Queen's departure. According to his jockey, Dick Francis, M'as-Tu-Vu "had no idea what to do when he found himself out in front" but clever placing and riding both brought him

its glittering candelabra and chiming clocks, its flowers and delicate pictures and painted furniture became for a time the cynosure of statesmen and diplomats and government Ministers.

The French Ambassador, Rene Massigli was charmed by a stand-in Head of State who took time off to show him her French impressionists, and especially a Monet 'The Rock' that the artist had given to Clêmenceau. The Queen had approved the New Year Honours List before departure and the Queen Mother disposed of it in six investitures at Buckingham Palace, raising three commoners to the peerage, conferring a viscounty upon Lord Leathers, investing three Privy Councillors and using the ceremonial sword of the Queen to touch the shoulders of more than a hundred knights. What did it matter if, embellishing each honour with conversation, she ran a little behind time? It would need an all-seeing angel to trace the consequences of her friendly involvement. In bestowing the accolade upon Jacob Epstein, for example, she mentioned Princess Margaret's readiness to sit for him, and this led to her bust in bronze which is probably the only royal piece among the sculptor's works.

With Princess Margaret, the Queen Mother held a Privy Council at Clarence House when, among other duties, she pricked the roll to nominate new sheriffs. The tradition is that Queen Elizabeth I was sitting sewing in the garden when the parchment roll was brought to her and, having no pen to hand, she pricked it with her bodkin. The ceremony of pricking was maintained for ever after and was thus, after her daughter, the third Queen Elizabeth to observe the custom. To allow the police and others on duty at Buckingham Palace opportunities of leave, the reception of foreign diplomats was transferred to the splendour of her own first-floor drawing-room, and British ambassadors newly appointed overseas came to her to kiss hands on taking up their posts. The Queen had directed that the Queen Mother should receive from the Lord Mayor of London the same privileges as those accorded to herself or to a foreign Head of State. On entering the City of London to receive the freedom of the

again in a royal train through an African landscape evoked a thousand echoes of the past, though her indefatigable smiles and cheerfulness gave no hint of sadness. More echoes must have muttered and whispered later that summer at Balmoral when the Queen and Prince Philip were immersed in the preparations for their visit to New Zealand and Australia, the tour around the world that the Queen Mother had been formerly planning to undertake with the late King. Instead, on November 23rd, 1953, it was as a widow that she bade farewell to the Queen, her daughter, and to Prince Philip under the garish lights of London Airport.

A few days later, the skirl of bagpipes disturbed the early morning calm of St. James's, and at the sound of the familiar traditional airs, the office staff of Clarence House sat down to their desks, as one said, with "a sense of zest and fun". Pacing up and down the carriage drive beneath the Queen Mother's windows was her newly-appointed personal piper, Pipe Major Leslie de Laspee of the London Scottish. Three mornings a week since then, in all ordinary circumstances when the Queen Mother is in London, the piper has ceremoniously marched and played for fifteen minutes, a picturesque addition to the London scene. The Queen Mother likes to guess the tunes and sometimes sends out a message on the more difficult one she identifies. She is rarely defeated.

IV

In the six months while Queen Elizabeth II was absent from Great Britain, in 1953–54, Queen Elizabeth the Queen Mother was a deputy Queen as no royal relict before had ever been. With Princess Margaret, the Duke of Gloucester, the Princess Royal and the Earl of Harewood she was one of five Counsellors of State appointed to transact the royal prerogative in the Sovereign's place, but of these the Queen Mother was the most prominent in the royal leadership of the nation. Clarence House, with

her procession, Queen Mary had sat with "the little Princesses" and now the Queen Mother and Princess Margaret had a seating space left between them in their box for the heir to the throne, the five-year-old Prince Charles, who presently made his appearance between his grandmother and his aunt, a small figure in white silk, resplendent with brilliantined hair.

The little Prince lent a happy domestic touch to the pageantry, now asking his grandmother questions, now heaving sighs, now scrambling for the handbag beneath the Queen Mother's chair, now watching absorbed, head cupped in hands. In the streets, during the processional ride, the beloved figure of the Queen Mother received as usual an affectionate and overwhelming welcome from the crowds and for her, as always, a deep stirring of inward emotion had to be held in check. Throughout London's own festivities, moreover, the Queen Mother enjoyed one special view that was known to few. From a platform against the wall of Clarence House under the dark trees, she could look down unseen at night into the radiantly illuminated avenue of the Mall and she stood here unobserved for a few minutes every evening, with David, with Rose, with Arthur Penn and other friends, gazing into the very heart of the dancing London crowds.

The following month the full context of royal professionalism was regained when the Queen Mother and Princess Margaret flew out by Comet primarily to open the Rhodes Centenary exhibition in Bulawayo but also to undertake a sixteen-day tour of Southern Rhodesia. At first sight of the itinerary the Queen Mother murmured, "It is not very crowded!", and fuller engagements were presently added to schedules that already included Salisbury, Gwelo, Umtail, Fort Victoria and the Zimbabwe ruins.

"Greeting great white Queen and great white Princess" delightfully proclaimed a triumphal arch in Bulawayo. The Queen Mother inspected native irrigations and attended tobacco auctions, unveiled memorials and laid foundation stones, including the first plinth of the University of Rhodesia. Travelling once

House was the unquestioned and sensible solution for the new Queen Mother. One brighter side to the necessary move was that she was now next-door neighbour of her dear friend, the widowed Princess Royal, Princess Mary, who occupied the southern suite of St. James's Palace and with whom, in fact, she shared the garden.

Parliament defrayed the cost of alterations by £8,000 charged to the Royal Palace vote, and the Queen Mother was granted an annual Civil List allowance of £70,000, an ungenerous sum for her staff, expenses and other outgoings, considering that it measured two-thirds less in post-war purchasing power than the pre-war £70,000 allotted to Queen Mary as a dowager in 1937. (The Commonwealth peoples, for whom the Royal Family also toil, make no contribution whatever to royal finances.) A stringent check was also made on traditional pieces of Crown furnishing and even curtains which the Queen Mother wished to retain in her own new setting. Queen Mary visited the house once or twice, happy to see the plaster-framed portraits of King George III and his family still in place in the State dining-room, but the old Queen did not live to see the completion of the works and died on March 24th, 1953.

Queen Elizabeth the Queen Mother formally moved into Clarence House on May 18th, only two weeks before the Coronation. With her was her faithful but reconstituted staff, with Sir Arthur Penn as treasurer; a young private secretary, Captain Oliver Dawnay; Group-Captain Peter Townsend as comptroller and a resident lady in waiting, Lady Hyde. These formed the firm nucleus of her entourage, her strength and support, in the hospitality and entertainment with which the Queen Mother supplemented the Coronation festivities; and in the televised ceremonial of the Coronation the Queen Mother was of course both a participant in the processions and a spectator of her daughter's crowning. It had not been the custom of Queen Dowagers to witness the Coronation subsequent to their own, until in 1937 Queen Mary had set a constitutional precedent. In that year, after

tasks of her removal. A similar marble fire-surround, with the gentle inscription *Patientia Vincet* (Patience Conquers), now also graces her boudoir in the Castle of Mey. The elaborate fittings of Prince Philip's bedroom and study were meanwhile transferred to Buckingham Palace. The colouring and paint-work favoured by the young couple at Clarence House were not always to the Queen Mother's taste and she asserted her own colour schemes. Far from the former nursery suite on the second floor being adapted as a separate flat for Princess Margaret, as some supposed, the Princess's sitting-room was on the ground floor; and the existence of a private cinema in the basement was one of the minor advantages of moving into a house so recently overhauled and modernized.

For more than a decade Clarence House has been one of the pleasant landmarks of London as the Queen Mother's home, but it emerged from the war years in total disrepair. It still lacked electricity in many rooms, the old gas brackets sprouted from the walls and it had no separate bathrooms, the only bath being a rusting antique installed in a bedroom cupboard. Originally designed by Nash as a mansion for the Duke of Clarence, brother of George IV, it incorporated part of an earlier building and remained a convenient pied-a-terre—linked as it was with the State Apartments and diplomatic quarters of St. James's Palace—when the Duke of Clarence succeeded as King William IV. In 1866 it became the residence of Queen Victoria's second son, the Duke of Edinburgh, and later of her youngest son, the Duke of Connaught. But it was a warren of dark panelled corridors and, other than wartime use as Red Cross offices, it had been little occupied for thirty years before it underwent a brilliant transformation to become the London home of Princess Elizabeth. In May, 1952, the new Queen moved to Buckingham Palace and took up temporary quarters in the Belgian Suite rather than disturb her mother so soon. Since Queen Alexandra's time it had become the convention for the dowager Queen to occupy Marlborough House, but Queen Mary was happily still living, and Clarence

discovering that this local gift forms the hearth-rug in her own panelled bedroom.

Its owner has occupied Mey in spring and autumn as well as high summer. The helicopter flight from Birkhall takes only an hour, and the sandy beaches and rocky shrimping pools can be regularly—and unobtrusively—visited from Balmoral. The legend that Princess Margaret dislikes Mey and has seldom been there ranks among the Royal Family's triumphs over unwanted publicity. When the Queen Mother drops out of sight, she is usually at Mey, and nephews and nieces, grand-children and a younger generation of grand-nephews and nieces fill the house with laughter.

In placid mood, the Queen Mother enjoys fishing the Thurso river with the Vyners and other friends. The afternoon may bring no higher reward than peaceful enjoyment of the quiet eddies of the stream but the patient angler once landed a twenty-pound salmon, and sometimes gaily returns with, say, two eight-pounders. Moreover, the lady of Mey takes part in the life of the neighbourhood. She was an early visitor when a comemmorative exhibition of a local artist was staged in a nearby farmhouse. The Thurso lifeboat guild held a sale of work and she made it a timely opportunity for Christmas shopping. Her sixty-second birthday found her at the Caithness agricultural show, presenting prizes for the best sheep and poultry and home-bottled fruit. The Queen Mother has taken more and more to spending her birthday at Mey. It is a house that for her has never known tragedy. In all her visits, there has been only happiness.

<div align="center">III</div>

King George VI found his Consort so devoted to the domestic hearth that he sometimes delighted in giving her a fire-surround or mantelpiece as an anniversary gift. Such a fireplace, of white marble, adorned her bedroom in Buckingham Palace and its transfer and installation in Clarence House was one of the many

the evanescent dream of retirement dispersed like morning mist after the dark night. The autumn and even July of her daughter's Accession year found her busy as ever, and the castle needed such drastic repair and refurbishment—including thermostatic heating and an electric kitchen—that three years elapsed before her personal Standard formally flew from the flagstaff. And yet the interest of Mey, more than her changes at Clarence House, tided the Queen Mother over the wrench of widowhood.

The Vyners kept open house for her and the poignant memories that marred her visits to Balmoral were eased, if not dispelled, by purposeful visits to antique shops collecting local prints and rummaging for lost treasures linked with the castle's history. A local lady remembered a set of old chairs from the dining-room that had been sold at the auction of the original contents. The Queen Mother purchased them and enjoyed restoring them to their former home. The Sword of State of the Earls of Caithness had hung in the castle through three centuries and passed at last out of the family. The new châtelaine traced the sword through successive owners until she learned it had been bought as a museum piece by the Corporation of Glasgow. The city fathers heard of her interest and presented it to her.

Now it rests in a niche in the entrance hall, and is kept company by the papier-mache life-size blackamoor that once stood guard in the hall of No. 145 Piccadilly. Instead of the pale pine bird-case with its mournful moorland specimens, another painted African figure crouches beneath an oyster-shell tub of plants and flowers. These decorative fancies set the theme of Mey: the drawing-room with its 1870 Brussels carpet, a foil to white and gold Chippendale; the cosy boudoir in the old tower carpeted with rush matting and tartan rugs; the bedrooms inviting with chintz and muslin and pile carpeting and warm mahogany. The Women's Rural Institutes of Caithness once made a rug for Mey, white in background with *fleur de lis* of blue and gold. Each member of the scattered twenty-nine institutes of the region worked upon it: and one can deduce a great deal of the Queen Mother on

herself in a small entrance hall dominated by a pine showcase of stuffed birds and, as at Royal Lodge twenty years before an imposing oak door opened unexpectedly into a ground floor bathroom. And yet, as at Glamis, vaulted arches rose to support the massive structure of the tower and a spiral stone staircase led up to the drawing-room. The tall windows looked across the rocky coastline towards the red-cliffed Orkney Islands and the Queen Mother exclaimed at the magnificent view. Packed into the square five-storied castle tower and its wings were forty bedrooms, but this surprising number took account of every small attic and partitioned room as well as eight rooms in a wing occupied by a gardener and his family. Another oddity was that an electric lift, powered by a motor-driven dynamo, served the four main floors. In the grounds the twenty-five acres included an alleged deer park and a walled garden, neglected trout ponds and a roughly constructed seawater bathing pool.

The Queen Mother inspected the estate as if trapped in a dream and reported excitedly to southern friends that she had seen seals splashing on the rocks. Outwardly she said that it would be nice to think about, but she revisited Barrogill twice more during her stay and then talked diffidently of a survey. In August, when she came again, the place had still not been sold, and in finally making up her mind she visited the castle five times within a week. As at Glamis there were alluring stories of ghosts and bricked-up rooms for the imaginative, and there was even a swinging trap-door resembling the Glamis pattern. When asked the following year why she had bought the place, the Queen Mother explained that it was because "it was a lovely little castle which was in danger of becoming derelict". But clearly she bought the old house, to which she restored the name the Castle of Mey, largely because it filled a spare niche in her generous heart and opened appealing new prospects of private life.

The purchase was in an arid sense to prove a mistake. Scarcely was the ink dry on the contract than the autumn gales blew tiles from the roof. The Queen Mother's time was never unfilled and

Air Commodore piloted a jet as high and as fast as any of her squadron's pilots."

II

In June the Queen Mother went to stay with her friends, Commander Clare and Lady Doris Vyner in their whitewashed house near the northernmost tip of the Scottish mainland, the House of the Northern Gate at Dunnet. The calm flat Caithness landscape and the friendly incurious people brought a new ease and evoked afresh the wistful thought of retirement, far from the jostling pressure of public events. It was a phase of wishful thinking, of the nostalgic allure of her uncomplicated girlhood, a girlhood that no doubt seemed strangely close now that she was a widow and still young of heart. Then she heard that Barrogill Castle was for sale, only a mile or two farther along the coast from the Vyners and six miles from John o' Groats. The sale particulars cautiously described the grey pile as having "all the external dignity of an ancient Highland residence" and as soon as the Queen Mother drove down the mile-long avenue of stunted trees and saw the lacquered cannon mounted in the forecourt, as at Glamis, she was captivated with the idea of possessing it.

The estate was being divided and sold up, and another viewer of the Castle that year thought it gaunt and windswept, shabby and neglected, the rooms dark and cramped and furnished with cluttered drabness. Yet indubitably it was a castle, a Scottish tower house, if not a fortress, with walls of masonry six feet thick. It had been built by the fourth Earl of Caithness in 1570—shortly after he incurred the gratitude of Mary, Queen of Scots, by serving as chancellor on the jury which acquitted her lover, Bothwell, of murdering Earl Darnley—and the Earls of Caithness had lived there for three hundred years.

It was under the auspices of a more recent owner, Captain F. B. Imbert-Terry, however, that the Queen Mother first entered the castle she was to make her own. From the June sunshine she found

few days later. The Comet's trials and proving airfield lay close
to Hatfield House, so interwrapped are England's stately homes
with Britain's modern technics; and thus it was from Hatfield,
where Queen Elizabeth I held her first Privy Council, that
another Queen Elizabeth set out for her first jet-flight. One could
hardly find a better illustration of what the British mean by
continuity.

The travelling party included the Queen Mother, Princess
Margaret, Lord and Lady Salisbury, Sir Geoffrey and Lady de
Havilland, Sir Miles Thomas, and at the last moment at her
invitation the Queen Mother's chauffeur. The plane flew towards
Switzerland as they lunched, afforded a good view of the Jungfrau
over coffee, skirted the Gulf of Genoa and the Mediterranean
towards Bordeaux during the sunny afternoon and touched down
at Hatfield four hours after take-off having covered 1,850 miles.
At one time, the Queen Mother took the test pilot John
Cunningham's seat at the dual controls. "Can we fly faster than a
Meteor?" she asked, and was shown how a speed just surpassing
the R.A.F.'s then fastest jet might indeed be achieved. As she
watched the needle near red on the speed indicator, the plane
began to porpoise, to pitch up and down like a boat in a rough
sea, and Cunningham eased back the controls. The limit of aero-
dynamic stability had been reached, but neither the royal nor the
real pilot knew anything of course of the fatal and then un-
suspected weakness of structure which subsequently caused two
fatal crashes in the early Comet services. Says Sir Miles Thomas,
"I still shudder whenever I think of that flight."

But the Queen Mother landed in exhilarated and smiling mood.
Her sense of fun, bubbling up again, impelled her to send a tele-
gram to No. 600 Squadron of the R.A.F., of which she was
Honorary Air Commodore, "Today I took over as first pilot.
We exceeded a reading of 0.8 mach at 40,000 feet." The com-
manding officer replied with aplomb, "Excited with news of
Your Majesty's jet flying. Your squadron is honoured to have
been in your thoughts and overwhelmingly proud that their Hon.

larity derived from the late King. Even if it were not so, she saw the new reign solely and unquestionably in terms of her daughter. No counselling senior figures should stand in the way. The very ring of resurgent youthfulness in the phrase "the new Elizabethans" which so suddenly came into vogue seemed to suggest to Queen Elizabeth the Queen Mother that the time had come to move into retirement.

Such was the evident sombre tenor of her thoughts when the new Queen first gently drew her back into the sunlight. Just as the Queen Mother had once tried to divert Princess Elizabeth from worrying over her father by providing the racing interest of Monaveen, so her daughter, with identical strategy, now proposed an expedition to Beckhampton to see the five royal racehorses which Noel Murless had in training there. Lunching with Mr. and Mrs. Murless, the Queen and her mother heard of his decision to transfer to Newmarket, a critical juncture in the trainer's affairs, and so another link was forged in the mesh of everyday interests.

Shortly afterwards, in contrast, the Queen Mother attended the confirmation of the young Duke of Kent in the private chapel of Windsor Castle, a ceremony implicit with preoccupations in young life springing up all around her. The Duke of Windsor called upon her while in London and the resentments and memories of the past seemed far away. Early in May the Queen Mother picked up the threads of duty when she made a special journey to Scotland to inspect the 1st Battalion the Black Watch before they left for the battle-front of Korea. Then, later in the month, an enlivening and impromptu adventure befell her.

On May 2nd the world's first passenger jet airliner, the Comet, made its inaugural overnight flight to Johannesburg; and the Queen Mother happened to comment on this achievement while lunching with her friends, Lord and Lady Salisbury, at Hatfield House. "Why don't you try it, Ma'am?" said Lord Salisbury. Amid merriment his guest enquired, "Do you mean they have a Comet to spare?", and a flight was arranged by telephone for a

to curtsey to her daughter, the new Queen Elizabeth II. On the evening of February 7th, 1952, the new Queen, so dramatically flown back from Africa, telephoned her from Clarence House for their first sad and terrible conversation, but the Queen had to remain in London overnight for her Accession Council the next morning. On February 13th an announcement was made that the mother of the Queen wished to be known as Queen Elizabeth the Queen Mother.

In the first two months of the reign the Queen Mother effaced herself from public life. It could not have been otherwise. The return to the familiar rooms at Buckingham Palace, where she was now a technical intruder; the homecoming to Royal Lodge, where her husband would no longer make jokes around the names of the rhododendrons and where even the familiar morning sound of the water running for his bath was absent, each waking day in some small natural incident revived the poignancy of nevermore.

The Queen Mother had been married for nearly twenty-nine years, and she was still only fifty-one years of age. She had her two daughters and her two grand-children: these were blessings to count, and the questioning turmoil of sorrow was alleviated by the soft and comforting texture of family and friends, of David and Rachel, Michael and Elizabeth, her sister Rose, her sister-in-law, the Princess Royal; her firm friends, Lady Doris Vyner, Lady Lavinia Annaly, Lady May Abel Smith, Lady Katherine Seymour, Lady Fermoy, and many more. The widowed Queen may have asked in thankfulness how she had earned so many friends, and so much affection and, as she tried to assess the shadowed and unimagined future, she began to fret a little about the hazards to her staff. Within five weeks a new red leather despatch-box was brought to her desk emblazoned in gold with the words "H.M. Queen Elizabeth the Queen Mother". The new Queen had insisted on the makers hurrying it through, as a consoling symbol to her mother of future usefulness. But the Queen Mother happened in genuine modesty to believe that her personal popu-

QUEEN MOTHER

I

THE KING IS DEAD, long live the King ... so runs the ancient formula. The King is dead, but his Queen lives on, widow and waif, an amorphous nonentity. The Queen Dowager enjoys no fixed place in tables of precedence; and the historical precedents are lean and unhelpful. Queen Adelaide, the relict of William IV, retired at the age of forty-five into semi-invalidism at Bushey. Queen Alexandra, who was sixty-five when her husband died, passed into a placid shadow realm from which she emerged chiefly as a walk-on for State occasions and as a focus of adulation for her Rose Day drives, an annual ritual of charity which she disliked intensely. Queen Mary found herself assigned a more prominent rôle as the mother of a bachelor King, and her stature increased when the circumstances of her eldest son's abdication caused the nation to regard her as a prime exemplar of the untarnished traditions of the Throne. Even Queen Mary, however, withdrew on King George VI's wishes to Badminton House during the war and emerged afterwards only as an old lady, to enjoy the London sunset of the last years of her life.

A widowed Queen is divested in due course of the Crown Jewels, she must usually leave her home, must sort through her late husband's papers and possessions and indeed may enjoy the use of Crown furniture only at the Sovereign's will. (It was thought merciful of Queen Victoria that she permitted Queen Adelaide to move her bedstead from Windsor.) As fate willed it, the widow of George VI had to wait for two days at Sandringham

to Africa the following day. The King chose the musical show at Drury Lane Theatre, *South Pacific*, with its songs of nostalgic distant islands; and the following morning the Queen and King were both at London Airport to bid the young people farewell.

And so the relentless span of time crept round to February 5th, 1952, the last full day of the King's life, when in the late afternoon the Queen spent an hour as usual with her grand-children, Charles and Anne, and her husband joined her in the nursery when he returned from shooting. After dinner he sat relaxed and contented, listening to a broadcast description of the reception given to Princess Elizabeth and Prince Philip in Kenya, and then, according to one of his staff, he retired early to work at some papers, leaving the Queen to take her guests to the ballroom for a film show.

In the morning Queen Elizabeth's maid, Gwen Suckling, brought her tea as usual. A few minutes later a message was sent in from Captain Sir Harold Campbell, the King's equerry-in-charge, requesting to see Her Majesty. This was so unusual that the Queen must have at once realized what was wrong. She had known Sir Harold for more than twenty years and now it was his task to tell her that the King had died peacefully in his sleep; a task that she made curiously easy.

She went to the King; and presently she received the unavailing doctors, and in the King's study she gave the orders for the day, as she had always done whenever her husband was unwell. Her staff would have relieved her of these tasks, but she wished to work on, and she gave instructions for a vigil to be kept at the King's open door, quietly saying, "The King must not be left". Pale but outwardly composed, not yet clad in mourning, she began writing letters and tried to encourage Princess Margaret to follow her example. She prepared food for the two corgi dogs, as was her custom, knowing that the anodyne of occupation snatched each slow passing minute from her ultimate breakdown. "She was a source of strength to everyone," said a member of her staff.

Princess Elizabeth and Prince Philip had meanwhile returned from Canada after a most successful visit, and the Lodge was the scene of a happy family reunion. The Queen at last felt the lifting of the oppression that had burdened her for so long. The young couple assumed the duties of the tour to Australia and New Zealand in the King's stead; while an invitation came to the King and Queen from the Prime Minister of South Africa, Dr. Malan, placing a house at their disposal so that King George could enjoy the warmth and sunshine. The commencement of this holiday was arranged for March 10th.

The tour to Australia was to take Princess Elizabeth and her husband through Kenya, and it was a time for both the King and Queen of looking back through old photographs and souvenirs, recollecting and eagerly telling their daughter of their own adventures there, when they were still a newly married young couple before she was born. At Sandringham, too, pleasant and nostalgic experiences gathered around them at the end of the year. Some four years earlier, the King had set plans in motion for an enclosed garden of the Scottish pattern such as his wife had always known. The new garden was but a step from his own temporary bedroom near the north door; there were pleached lime walks to keep the wind at bay and, with memories of Glamis, husband and wife were able to walk there for a little each day. One morning, the King put a stick to his shoulder, as if cocking a gun, and murmured, "I believe I could shoot now", and the Queen experienced an overwhelming if illusory surge of confidence that all was well.

With Prince Philip, Lord Dalkeith and others, the King resumed shooting on New Year's Day. He moved about his fields in his Landrover and sat waiting for the drive of the birds without over-exertion. The Queen was so reassured that she played truant with Princess Elizabeth two weeks later to go racing at Hurst Park, and on January 30th the whole family went to London for a theatre party. It was to be a happy *bon voyage* evening with Princess Elizabeth and her husband who were flying

King's illness, the Canadian authorities suggested that her visit should be deferred. The King's medical crisis was the subject of concern throughout the world and the Queen was emotionally moved and comforted once more by the messages that poured in not only from governments but also from ordinary people everywhere. She herself particularly took the King's eight nurses, who were serving a duty rota, under her wing and many of the flowers and other gifts were diverted to them.

All went well during the operation. Three days later, the King was sufficiently recovered to be able to sign the warrant for the appointment of Counsellors of State, naming the Queen and her two daughters, with the Duke of Gloucester and the Princess Royal. On October 4th the Queen and Princess Elizabeth jointly presided over a Privy Council at Buckingham Palace. This ancient committee, originally the King's council, is the machinery through which the royal prerogative is exercised. On this occasion, four Privy Counsellors were present, an Order for the Prorogation of Parliament was approved, and the following day the King himself signed the necessary documents for the Dissolution of Parliament.

Through these long anxious days, the Queen spent hours sitting quietly at her husband's bedside until, in mid-October, he was sufficiently recovered to sit in his chair. Of the nurses, one had begun her training in Edinburgh, another had passed her preliminary nursing examination while still at school, a third was devoted to her sister who ran a nursery school. The Queen soon knew all their different stories, and the confidences which she in turn entrusted to them have never been betrayed. At the end of November—with the General Election settled and Winston Churchill again at the head of government—the King was able to return to Royal Lodge. "As we drove through the gates we felt at once the calm of this place," he wrote to a friend. The Queen had not set foot in the Lodge for four months and, in her own little chapel in the grounds, she joined in the national thanksgiving for the King's recovery.

slow. By August 4th, however, when the Queen celebrated her birthday with him at Balmoral, the two months' rest had restored his confidence and vigour, and he was able to go grouse-shooting on Princess Margaret's twenty-first birthday on August 21st.

The sunshine and the shadow ... The following week the King developed what seemed to be a chill and the doctors now had grave suspicions—which they kept to themselves—as to the deeper cause of his illness. The King flew to London for a fuller medical examination, thinking the matter so comparatively trivial that he preferred his wife not to trouble to accompany him and he returned to Balmoral Castle the following day. Within a week he was nevertheless advised to return to London for a fuller examination which involved a bronchoscopy to take samples of tissue from the lung.

On September 18th in London the King and Queen were told that a blockage of one of the bronchial tubes left no alternative but the removal of the left lung. Perhaps the King accepted this explanation, but the Queen privately asked to be told the truth and then learned what apparently her husband never knew, that he was suffering from cancer. Perhaps husband and wife each kept their misgivings one from the other. Confronting the situation with philosophic courage, the Queen was also gently warned of the cardiac complications. She faced the danger that the King might die on the operating table and moreover, these awful discoveries came at a time when she was pitifully vulnerable. The King's operation was arranged for September 23rd, and Princess Elizabeth and the Duke of Edinburgh were due to sail on the *Empress of France* on September 25th to undertake a tour of Canada. (A political complication also perturbed the royal secretaries, for Mr. Attlee as Labour Prime Minister wished for a General Election before His Majesty's scheduled visit to Australia and he had already sought the Prorogation and Dissolution of Parliament.)

In the event, it was decided that the Princess could gain time by flying the Atlantic and, within hours of being informed of the

to the Queen, not so much her fiftieth birthday on August 4th, for she preferred to discount the years, but the birth on August 15th of her first grand-daughter, Princess Anne. The King had gone on ahead to Balmoral, while the Queen waited in London for the happy event. Advised by telephone on the sunny Monday morning that the birth was imminent, she hurried to Clarence House, arriving at 11.45, and the baby was born five minutes later. There were acute memories for the Queen of the difficulties when she had wished to name her own second baby Ann, and now her husband at Balmoral was charmed by the names Anne Elizabeth Alice Louise. So unclouded was the family atmosphere that, with the King's returning strength, Princess Elizabeth was able to join Prince Philip in the Mediterranean for much of the winter, and the Queen's task lay in preserving the serenity of her own domestic scene and in softening the occasional irascible outbursts from her husband that so tried his nerves. In the international field the lowering shadows of the Korean war, where British troops were in action, and the crisis in Anglo-Persian relations under the hysterical claims of Dr. Mussadiq, both combined to depress him. "The incessant worries and crises got me down properly," he wrote to a friend. Then in May came the celebrations of the Festival of Britain, that interesting exercise in a timed national renaissance, which the King inaugurated in a ceremony on the steps of St. Paul's. The Queen was eagerly looking forward to a holiday with her husband in June when they intended to visit her sister Rose in Northern Ireland, where the Earl of Granville was Governor-General. On May 24th, however, the King felt unwell and was ordered to bed with influenza.

This time the invalid's powers of recovery were seriously reduced. The doctors discovered a small area of catarrhal inflammation in the left lung, and he was still coughing in his bedroom when King Haakon of Norway came to London on a State Visit. The Queen had to camouflage her worries through all the resulting gala ceremonial of State drives and banquets, and her husband's convalescence at Royal Lodge and Sandringham was

interest and comfort the Queen herself in another private sadness, namely, the death at a comparatively early age of sixty-five of her eldest brother Patrick (the fifteenth Earl of Strathmore).

Thus went the swing of light and shadow, as on a day of sunshine and rain. Princess Margaret, now nearing her twentieth year, similarly needed a special preoccupation to prevent her from fretting over her father and the Queen devised her holiday visit to Italy, with Major Harvey, Her Majesty's secretary, and his wife, as escorting friends and mentors. As parents, the King and Queen watched with pride Princess Margaret's undoubted success in the public engagements that she now undertook with dignity and charm. In the previous year, when only just eighteen, she had notably represented the King in Amsterdam for the installation of Princess Juliana as Queen of the Netherlands; and in private, the King and Queen had no doubt discussed her future and perhaps wondered where and when her husband would be found. But there was plenty of time. Only the inquisitive world thought otherwise, and the Princess had only to appear in public with an eligible young man for his name to be headlined as a romantic suitor. Her escorts, such as the tall Marquess of Blandford, the fair Earl of Dalkeith, Mr. Billy Wallace and Mr. Colin Tennant, all aroused surmise. If the Queen herself had her own favourites among the personable young men who presented themselves, she kept her own counsel. On public occasions it was often the newly-appointed Deputy Master of the Household, Group-Captain Townsend, who acted as equerry among other duties.

II

The King made a good recovery from his operation and, his doctors recommended that with precautions against overstrain, the deferred visit to Australia and New Zealand might be possible after all in 1952. In March, 1950, President Auriol of France and his wife came to London on a scheduled State Visit; and the August of that year of course brought another happy milestone

and silver Music Room of the Palace on December 15th. One looks now at the photographs of that private family gathering; and for one moment the Queen, in her dress of gold tissue, and her brother, David, are alone together: David with the flower of a godfather in his buttonhole standing as if protectively behind the little Elizabeth Lyon of long ago, and on the Queen's face is the look of anxious care that her family had noticed in the months of self-questioning before she decided to wed.

By the end of the year, however, the King's health had so much improved that the threat of amputation was past. As a grandmother should, the Queen had the very real pleasure of mothering her daughter's child, for Princess Elizabeth fell ill with measles at Sandringham and had to remain in isolation. On the Royal Family's return to London, the Queen next enjoyed an early view of the renovations at Clarence House, the Nash mansion a stone's throw from Buckingham Palace which after mouldering for decades as a royal white elephant was now to be Princess Elizabeth's future home. In February the King was well enough to hold his own Investiture of the New Year honours. But the doctors had to disappoint the Queen by admitting that they were not yet satisfied, and on March 12th the King underwent an operation to improve the circulation of his right leg.

As both wife and mother, the Queen strove desperately to keep her worst fears to herself. It was at this time, indeed, as an extra distraction for Princess Elizabeth, that she asked her old friend, Peter Cazalet, who had become a professional National Hunt trainer, to look about for a steeplechaser of quality which she proposed to own in partnership with the Princess. The Queen had noticed how the zest and uncertainty of racing could absorb her elder girl and, a curious twist, this attempt to divert her daughter from worrying was the beginning of the Queen Mother's own ardent interest in steeplechasing. But it was early summer before Mr. Cazalet acquired Monaveen. By then the King had again made a good recovery and the actual purchase of the horse, as it turned out, was in its own small way to help

The King had been aware for some time of a tendency to cramp in his legs and though he made light of it, sometimes jigging a comical little dance, he eventually had to admit to his wife that the pain of the 'pins and needles' kept him awake at night. His medical advisers prescribed a course of treatment that afforded relief, but the King's right foot remained swollen and on November 12th—only two days before the birth of Prince Charles—four doctors undertook a full-scale examination. What they had to tell the Queen was distressing and required all her resources of courage. Her husband's symptoms were of early arteriosclerosis; there was a risk of gangrene developing and the specialists feared that his right leg might have to be amputated.

Under the intense shock of this discovery, the King and Queen realized that if they had to face their daughter that same evening over the dinner-table, it would be impossible to conceal the truth. Fortunately Earl Mountbatten's daughter, Lady Brabourne, accepted the Queen's deft hint that something was amiss, and invited the Princess and Prince Philip to dine out with her that night. The projected visit to Australia and New Zealand would clearly have to be cancelled but meanwhile the King and Queen kept up a united front that all was well. Shortly after 9.14 p.m. on November 14th, word was brought that a grandson had been born and the Queen went down in the lift to the Belgian Suite to take the seven pound six ounce baby in her arms for the first time. Then she sat down to her telephone so that all those close to her should hear the happy news before anyone else: among them Queen Mary, her sister, Rose, her brother, David, her brother Michael and her sister-in-law, the other Elizabeth, and so on.

The next day Princess Elizabeth could be safely told that her father had been advised to rest, and the following week the first public bulletin was issued mentioning "an obstruction to the circulation through the arteries of the legs". In fact, the King was such a good patient that his improvement surprised the doctors and he was able to attend his grandson's christening in the gold

LIGHT AND SHADOW

I

THE LIFE OF THE PRESENT Queen Mother—the then Queen of England—presented in the seven years 1945-52 a constant interplay of light and shadow, of alternate rejoicing and intense anxiety or grief. The Queen's old nurse, Alah, Clara Knight, who had seldom missed a Christmas at Sandringham, died suddenly just after the first post-war festivities. It had seemed that she would always be within reach, one of the family, with her knitting and mending and stories of the past, a dear and understanding friend. All through the years she had shared every sorrow, every joy, every crisis, and the Queen since her father's death, had perhaps sought Alah's reassuring company more frequently. When she died, the Queen said to an old friend, "I feel that so much of my own life has gone with her", and on the coffin of the old nurse a wreath of violets was laid with the inscription "In loving and thankful memory. Elizabeth R.".

When Princess Elizabeth expectantly brought out the old pram "to get my hand in", as she explained, her mother thought wistfully how much Alah would have enjoyed the preparations. "I wished so much that Alah had lived to see him," she told her sister, Lady Rose Granville, shortly after Prince Charles was born. There is a deep fulfilment mingled with sweet incredulity in the first glimpse of one's first grandchild, but for the Queen this happiness was shadowed by an unexpected turn in her husband's health, an anxiety which they both agreed should be kept secret from Princess Elizabeth until she grew stronger.

At the last moment, the bridal bouquet disappeared, although it was presently found in a cupboard. As one of the dressers noted, "the Princess had her head in the clouds", and it was the Queen who smoothed these disturbances. One of her staff on this day of deep but checked emotion had never more admired her self-control. It was the Queen's idea, similarly, that at the wedding breakfast each plate had beside it a bunch of white heather, sent down from Balmoral.

"What a wonderful day it has been," she said afterwards and, philosophically, "They grow up and leave us, and we must make the best of it." The first disconsolate impact of the blank in her motherly world was effaced by a letter from the bride on her honeymoon saying that after all the long wait before the engagement and the long time before the wedding had been for the best. "I was so glad you wrote and told Mummy . . ." the King had occasion to reply. "I was rather afraid that you had thought I was being hard hearted about it . . . I have watched you grow up all these years with pride under the skilful direction of Mummy, who as you know is the most marvellous person in the World in my eyes . . ."

With this "marvellous person", always so cheerful and outwardly confident, a petite and now plump little person, the King set aside a day of thanksgiving and rededication for their Silver Wedding celebrations. The precedent of a semi-state drive to a thanksgiving service in St. Paul's Cathedral had been established by King George V and Queen Mary in 1918. Under the harsh monotony of austerity and shortage that, thirty years later, followed the long struggle of another war, the British people welcomed the observances of national pageantry, "a flash of colour on the hard road we have to travel", as Winston Churchill had said of the Princesses's wedding. A felicitous side-effect was the issue of a special Silver Wedding postage stamp on which the Queen herself appeared, posed in profile against that of her husband, wearing the necklace of diamonds and rubies that had been his wedding gift. Queen Elizabeth had never looked more

On July 10th the announcement was made known to the world:

It is with the greatest pleasure that The King and Queen announce the betrothal of their dearly beloved daughter The Princess Elizabeth to Lieutenant Philip Mountbatten, R.N., son of the late Prince Andrew of Greece and Princess Andrew (Princess Alice of Battenberg) to which union The King has gladly given his consent.

A mother knows no phase more crowded with gossipy happy event nor with the sweetness of memory than when she prepares for her daughter's marriage. Friends suspected a maternal desire to defer the wedding-day till the Spring because of the promise of better weather, but it was difficult to thwart youthful impatience even long enough to make the arrangements for wedding guests. Norman Hartnell had undertaken to visit the United States to receive a dressmaker's award, the Neiman-Marcus 'Oscar' of couturiers, and had to cancel his visit in order to make the wedding-dress in time. In a delirium, Hartnell roamed the London art galleries in search of inspiration, and he has confessed that he found his theme in "a Botticelli figure in clinging ivory silk, trailed with jasmine, smilax, syringa and small white rose-like blossoms". The Queen and her daughter approved the design and only on the eve of leaving for Balmoral. For herself the Queen commanded "a dress of apricot and golden brocade, gracefully draped and trailing".

There were the inevitable wedding-day crises, usual in any family, although royal crises are somewhat gilt-edged. The Princess had elected to wear her mother's sun-ray diamond tiara—in reality a part of the Crown Jewels—and as the piece was being set upon her head, the old wire frame snapped: "We have two hours, and there are other tiaras," said the Queen, calmly, as a jeweller rushed the piece to his workshop for repair. The bride had proposed to wear the double string of pearls which her parents had given her as a wedding gift, but it had been placed among the wedding-presents on show at St. James's Palace and a secretary had great difficulty in bringing it back through the police cordons.

stockinged feet. "It was so like Mummy to set out in those shoes," the Princess said. It was so like Her Majesty, climbing a mountain, so far from home, always to wish to look her formal best.

The King and Queen returned to London on May 12th, the tenth anniversary of their Coronation. Despite the physical demands of the tour, they felt relaxed after the untroubled cruise home. The King could joke that they had all reduced, but no doubt the Queen was horrified to discover that her husband, never with a surplus ounce, had in fact lost seventeen pounds.

IV

The wedding of Princess Elizabeth on November 20th, 1947, was pleasantly to run nearly parallel in the chain of events with the Silver Wedding of King George VI and Queen Elizabeth only five months later. Princess Elizabeth danced a little jig of joy on the *Vanguard's* deck when she first sighted the English coastline, deliriously happy with the prospect that the difficulties of her engagement were finally to be smoothed away. It no longer mattered that the newspaper rumours once more reached fever pitch. Prince Philip—who had now become Lieut. Philip Mountbatten, R.N., a naturalized British subject—was a deliberate omission from the official list of guests at the Royal Ascot house-party at Windsor Castle. Nevertheless, at the end of the week the Queen gave a dance for a hundred young people, all friends of Princess Elizabeth, at which the Princess and the notable absentee danced nearly every dance together. On July 8th, the young man was invited to Buckingham Palace for dinner, and he and the Princess were a little behind-hand in entering the dining-room together. Philip had telephoned the King earlier in the day to notify his intentions, which had already been approved. The Queen immediately noticed that her daughter's right hand covered the fingers of her left hand, and she at once went and kissed her. "It's too big!" said the Princess, laughing, showing her diamond ring, and it had in fact to be returned to the jewellers for fitting.

anxious preparation by her frank appreciation of their cakes."
She obligingly asked for the recipes and, after listening to a Bantu
choir, "she spent more than half an hour going round the ranks of
singers and talking to them".

Whenever the royal train stopped overnight in a siding near
a vineyard or farm, the Royal Family, at the Queen's suggestion,
always walked to the house next morning to express thanks for
the owner's hospitality. This, too, was an effective exercise in
public relations. The schedules of the White Train were often
delayed, after the listed presentations in some small town,
because the Queen made her way towards some small group at the
back of the platform. At the little town of Camper an old man
came to the royal group to ask if Princess Elizabeth could turn
her head towards his invalid son, lying in a car at the rear of the
crowd, so that he could see her. The Queen overheard the
request, and took both her daughters over to talk to the boy.

Looking back at the tour, the Queen must have remembered
the focused cameras, the previously unimaginable grandeur of the
scenery, the great rally of mounted Basutos, the swirling dust
clouds at the native meeting grounds, the salute of the hooded
cobras poised erect by their keeper to salute her at Port Elizabeth,
the barbecues with the open wood fires, the white thunder of
Victoria Falls and the warm and encouraging welcome every-
where, even at republican Stellenbosch, where her smile broke
the frigid and at first deliberate silence. At Bloemfontein the
Queen called unexpectedly on the 82-year-old widow of Dr.
Steyn, President of the Orange Free State Republic from 1896
to 1900. "A wonderful old lady," she wrote to Queen Mary.
"She said that she always remembered a luncheon in London
when you were Princess of Wales and how much she admired
you . . . She sent you many messages . . . " Near Bloemfontein,
walking up the granite hill slope to the grave of Cecil Rhodes,
the Queen found she could not undertake another step in her
high-heeled cutaway shoes, and Princess Elizabeth had to lend
her mother her own sandals and continue the climb in her

ing how much they expect us to do and go on doing for so long at a stretch. I hope we shall survive, that's all . . . " The tour party was as experienced, adaptable and congenial as the Queen could have wished. Apart from the King's secretaries, the Queen had her own secretary, Major Harvey; her two ladies in waiting, Lady Harlech and Lady Delia Peel, with Lady Margaret Egerton as lady in waiting to the Princesses, and 'the two Peters' as equerries. Wing-Commander Peter Townsend and Lieutenant-Commander Peter Ashmore were in attendance on the King but, as so often, were also agreeable riding and dancing partners to the Princesses. Peter Ashmore was a bachelor and like Prince Philip, who was the same age, he had served on destroyers. This perhaps forged a common interest with Princess Elizabeth while the older and married Peter Townsend was already a sympathetic friend and counsellor to Princess Margaret.

The pattern had formed before *Vanguard* docked and, in the first hours ashore, the banquet in City Hall provided a minor but equally unforeseen complication: seven lean years of war and austerity had unaccustomed the visitors to more than mouthfuls so that they could scarcely touch the food on their plates. After a day or two the Queen tactfully had to request smaller menus. An American correspondent described the tour as "an endless procession of official receptions, tedious reviews, soporific speeches and tiresome dedications", but for the Queen every unremitting duty had to be filled with new significance; and every introduction, every handshake, every smile was intently directed toward winning a friend. The unique phenomenon of the royal journey was the ivory-and-gold White Train, with its fourteen coaches, a third of a mile long from locomotive to baggage tender, a snaking caravan intended to be as restful and yet efficient a travelling home as could be devised. Yet the Queen always made a point of sitting by the window on long runs, to be there ready to return the wave of some isolated farmer. As Jennifer Ellis has said, "She attended countless tea parties and rewarded the wives of officials who had spent days beforehand in

a bizarre clash of circumstances, the Royal Family's happy departure for the sunshine chanced to coincide with the onslaught of the coldest and most bitter winter of a century's records. The *Vanguard* withstood a hard buffeting in the Bay of Biscay but as she ploughed south and the Queen shaded herself from the sun, the news from England was of unceasing blizzards and blocked and frozen roads, of power cuts and failures and dwindling stocks of fuel, of food ships held up in dock and trains and trucks brought to a halt with direly needed supplies. Snow fell in some districts every day for three months and, with war-crippled power plants and diminished food supplies, the people stolidly endured hardships greater than even the war itself had imposed. The little party on the *Vanguard* felt unhappily guilty to be away from it all. "We think of home all the time," the Queen wrote to Queen Mary. "Bertie has offered to return but Mr. Attlee thought that it would only make people feel that things were getting worse."

The Prime Minister with a series of telegrams reassured the travellers that the crisis was being treated with the same urgency as a military operation, though this scarcely diminished the sense, as one member of the party put it, "of being cosseted and set apart in the sun". When the *Vanguard* sailed into Table Bay the Queen's mail brought an Aberdeen newspaper with pictures of sheep frozen in the fields near Birkhall. This afforded unpalatable breakfast-tray scanning, and yet a few minutes later the Queen stepped out on deck to the happy view of schoolchildren massed on Signal Hill, their white outfits forming a living slogan, Welcome.

By car, train and plane, the Royal Family were constantly on the move through South Africa and the Rhodesias from February 17th to April 24th. The full and overpowering schedules were not received aboard *Vanguard* until two days before the travellers disembarked at Cape Town. The Queen wrote to Queen Mary that she feared the tour would be "very strenuous" but Princess Elizabeth put it with more youthful and reckless verve, "My heart rather sinks when I think what is ahead . . . it is absolutely stagger-

the Royal Family from their cars to the church door. And once again, the photographs of the Queen, the Princess and the debonair usher were more widely featured in the Press than those of bride and bridegroom. For the Queen it was a happy release from this distressing and unavoidably intrusive atmosphere when the Royal Family sailed on the battleship *Vanguard* on February 1st, 1947, for the tour of South Africa.

III

A visit to the then dominion of South Africa had first been mooted in wartime by General Smuts and he and his son spent a week-end at Windsor in 1946 making the final arrangements. The King, as he subsequently wrote to General Smuts, felt "rather fearful about it", fearful of the dissensions that still dragged on from the Kruger republic. Only five years had passed since the Nationalist Party had voted for secession from the British Crown and the King could overlook no opportunity of reconciliation. But the Queen, unborn when the Boer War began, was to apply balm to British and Dutch susceptibilities with a single widely publicized remark. It happened that a Boer veteran grunted, "Pleased to have met you, Ma'am, but we still feel sometimes that we can't forgive the English for having conquered us."

"I understand that perfectly," said the Queen, with her sweetest smile. "We feel very much the same in Scotland, too."

As it turned out, the Afrikaan and British people ultimately differed little in wealth of welcome, and it was an enormous Zulu who gave the Queen a fright one day, breaking from the crowd and rushing towards the slow-moving royal car, gesticulating and shouting with apparent ferocity. The Queen held him off with the point of her parasol till the police seized him, to discover only that he loyally wished to give a ten-shilling note to Princess Elizabeth.

In more prosaic reality, the Queen's deepest concern during at least the early part of the tour was with the people of Britain. By

birthday with a theatre party. Her parents agreed that it was for
her own age group, and there was no parental veto on the choice
of play, *The First Gentleman*, concerned though it was with the
amours of King George IV. The newspapers listed the guests as
Princess Margaret, Andrew Elphinstone, Mrs. Vicary Gibbs and
Wing-Commander Peter Townsend, and the Queen must have
noted with relief that although Prince Philip had made a lively
sixth, he was not mentioned.

An appalling and unexpected complication was that the court-
ship continued under incandescent publicity. Rumours were so
widespread in the autumn of 1946 that an engagement was three
times officially—and correctly—denied from Buckingham Pal-
ace. Princess Elizabeth could plead to her mother that an
announced engagement would clear the air but since Prince
Philip was still constitutionally in line to the throne of Greece
there remained difficulties in that country to be cleared away. The
King received advice that the young couple should wait until
after the conclusion of the Royal Family's coming visit to South
Africa; and the Queen could not but notice that her elder
daughter was quiet and subdued as she prepared her wardrobe.

Yet blossoming romance was in the air. A cause of quiet
private happiness to the Queen was the marriage of her nephew,
Andrew Elphinstone, to Mrs. Vicary Gibbs, a young war widow
who had been appointed lady in waiting to Princess Elizabeth
two years before. The wedding reception was held in the River
Room at the Savoy Hotel, and the King and Queen afterwards
looked through the photographs for release to the Press. They
seemed unexceptional, although in one picture Princess Elizabeth
and Prince Philip could be seen in a group with King George
of Greece, Margaret Egerton and other guests. In the published
photograph, practically every newspaper "touched out" King
George and the wedding guests leaving only an engaging and
highly newsworthy picture of the Prince and Princess. At another
wedding, that of Patricia Mountbatten, daughter of Earl Mount-
batten, to Lord Brabourne, Prince Philip acted as usher, escorting

when she discovered that Prince Philip was the dinner-guest *a trois* one night with Princess Margaret, she perhaps raised an eyebrow. But she had already become aware that the quirk of an eyebrow could divide mother and daughter.

No matter how superficial, there is always a family moment of rift with the younger generation. Perhaps with the Queen, in her forty-sixth year, it was the moment when she glanced from a Palace window to see a young lady in waiting cycling across the forecourt with a shopping basket, her hair in a scarf. The Queen was affronted.

"Surely that's not——?" she said. "She really can't come here like that! She must wear a hat."

"Don't be old-fashioned, Mummy," said Elizabeth. These days girls simply don't *have* a hat."

The Queen thereupon wore a superb hat, a confection of pinky-lilac ostrich-plumes and chiffon by Aage Thaarup, for the Victory Parade through London, the hat of a lifetime, assuredly not old-fashioned. The King was always attractively gallant at such times, standing back to admire his wife before they left the Palace and asking those around if they did not think the effect delightful. The Princesses often watched their mother's preliminary hat-fittings and envied her millinery. The trivial can conceal truth, and so far, in tastes and preferences, the Queen felt no chill of obsolence. It was only her maternal view that Princess Elizabeth was still too young and unsophisticated to be sure of her first love affair that stirred faint tremors in the sensitive reciprocity of mother and daughter. And as a member of the Queen's staff has agreed, neither the Queen nor her husband could make up their minds what was best for their daughter. "They wanted the best for her," wrote Marion Crawford, "and it is never easy for parents to decide what that best is."

Meanwhile, the young people enjoyed a new measure of grown-up freedom. Entertaining her own friends, choosing her own clothes (in which she often copied her mother or sought her advice), Princess Elizabeth celebrated the eve of her twentieth

they remembered Lilibet insistently asking all and sundry whether Papa had "sent off Philip's Christmas card," proclaiming that "as long as he gets it I don't mind". This was a greeting she wanted sent through speedy diplomatic channels in return for a Christmas card he had sent her from Athens. Their cousinly acquaintance had been improved at Coppins and Royal Lodge where, in October, 1941, the tall and sailorly Philip had been an amusing visitor, full of comical war stories of the Mediterranean. Lilibet returned from Coppins one weekend to say that she had danced with Philip; and he was one of the five guests to dinner at Royal Lodge on Christmas Eve, 1943, when they all sat snugly around in the firelight afterwards and told ghost stories, "Most disappointing!" as Princess Margaret rated them in a letter to a friend. "We settled ourselves to be frightened and we were NOT!" And three months later Prince Philip's hopes were so high that King George of Greece had interceded to plead his nephew's interest.

The King and Queen consulted anxiously. "We are going to tell George that P. had better not think any more about it for the present," the King wrote at this time. But Prince Philip's photograph appeared on Princess Elizabeth's mantelpiece and when some objection was raised that he might be recognized, another photograph appeared, with Prince Philip lurking thinly disguised behind the romantic blond beard. Prince Philip's service with *Whelp* in the Pacific deferred the problem for a space. And then, early in 1946, Prince Philip was home, an asset to the Mountbatten dinner-parties in Chesham Street, gaily engaging and as one fervent gossip phrased, "a charmer who charmed the charming Queen".

The King and Queen were in agreement in initiating the matter of Prince Philip's naturalization with the Home Office. "I like Philip," the King had cause to write. "He is intelligent, has a good sense of humour and thinks about things in the right way." The Queen had decided it was time for Princess Elizabeth to give her own dinner-parties to return the hospitality of her friends, and

people. From our own experience we know what the Bible can mean for personal life."

II

While the Queen probably felt no older at forty-five than at thirty-five, sharper truths were creeping in. Both her daughters had inherited a share of her determination, deepening at times to obstinacy, and, to get her own way, both at times would employ the devious stratagems of her own girlhood. Princess Elizabeth besieged her father for a year with entreaties to be allowed to join the Services, until in March, 1945, he no longer had the heart to resist her persuasions and she underwent training as a Second Subaltern in the A.T.S. Princess Margaret had been no less insistent on the first of the Windsor pantomimes, producing drawings, arranging parts, talking pantomime constantly, until at length the King gave way. In the autumn of 1945, similarly, Princess Elizabeth suffered a riding accident and was laid up, bruised and aching, for a few days, whereupon Princess Margaret, aged fifteen, begged to be allowed to take over her engagements, especially one involving a public speech that began, "Now that the long years of war are over and victory is won, we must look forward with glad determination and courage to the tasks that lie ahead." It may have struck the Queen that 'glad determination' were the salient words.

Princess Elizabeth would moreover soon be twenty and the problem of her marriage already loomed over her parents. The Queen, remembering her own long string of suitors, perhaps found it as difficult to believe as her husband did that Lilibet had fallen in love with the first eligible young man she had met. "We both think she is too young ... she has never met any young men of her own age," the King had written in explanation to his mother many months before. Neither he nor his wife could precisely see how the situation—and there was recognizably a 'situation'—had developed. As early as the Christmas of 1940

created a charming atmosphere of shyness and humility . . . 'I thought—perhaps—I might wear—a *dress* which perhaps you *know*—with bead embroideries?' " Her friends found that she had grown accustomed to the aura of a Queen without diminishing her endearing sympathy and playful humour. Already, in the memoirs of King George VI's reign, one can notice how often the King's visitors at Buckingham Palace "happened to meet the Queen in the corridor" and how often the Queen offered consolation, or encouragement for Ministers who were relinquishing their portfolios, for diplomats taking up new posts abroad, meetings invariably of useful purpose though ostensibly always occurring by merest chance. Wit and mischief were never far off. Meeting Sir John Reith when he was wearing his new ribbon of the GCVO, the Queen said that it was her duty as Grand Master of the Victorian Order to sign the parchment document of appointment and she mentioned smilingly that she was always afraid of making a blot while doing so. A blot, replied Sir John, would enhance the value of the document, and he would hope to find one. When three weeks later it arrived there was admittedly no blot. But below the signature 'Elizabeth R', was "a full stop, which was a very large full stop indeed".

A Queen Consort can rarely express her motivations in public, but Queen Elizabeth has sometimes spoken of the three D's— Discernment, to judge between the false and true, Decision, to turn judgment into action, and Design, to give practical form to a plan of action. And there was a fourth D, reposing in depths too intimate for speech-making, D for Devout, to trust in God. The house governor of St. Mary's Hospital once remarked that it was a miracle St. Mary's was never hit by bombs during the war. "A miracle?" said the Queen. "That may be so. You know, I include St. Mary's in my prayers every night." A public message from the Queen to the World's Evangelical Alliance, on one occasion, also contained an admission of more than usual significance: "I can truly say that the King and I long to see the Bible back where it ought to be, as a guide and comfort in the homes and lives of our

wooden table, or on cloths spread in the sun, the typical picnic was of "cold grouse, a salad, different kinds of sandwiches, bread and butter and cake".

The holidaymakers returned to Balmoral Castle in time for the ceremony of Beating the Retreat by one of the Highland regiments in the dusk on the front lawn. With this one royal difference, it was like the old days at Glamis: the pipers marching around the dining-table and away, until the music faded in the distance, and now a new generation renewing the fun of charades. The Game, as it was always called, the game which Winston Churchill "obviously regarded as inane", as Mrs. Roosevelt once noted, was always in the right company fun of infinite variety, never to be despised. At times the pastime involved acting out syllables and words to be solved by others. It was a performance truly memorable, when the word 'Crimea' saw a crime involving the Queen as a bewildered foreigner; the last syllable 'ea' providing a political meeting full of helpful 'Hear, hears' and the full word featured Princess Margaret as a Russian spy and the Queen as Florence Nightingale, with a red-chiffon scarf for bloodstained bandage.

Dressing up, acting, talking—still at heart the little girl who had held a 'conversation' with Lord Gorell—the Queen had little reason to notice the milestone of her mid-forties. The war had snatched a span out of everyone's life, and one felt justified in discounting five years. She was less argumentative, more subtle and no doubt more practised in caution than of old. Mr. Mackenzie King found the King "looking older, inclined to be rather excitable" the previous year, but the Queen "could not possibly have been more friendly". This was the common experience. It was equally still the experience of those close to her that her gaiety and cordiality cloaked the true strength of her personality. "Though she may fight with masked batteries," Cynthia Asquith had said, "her purpose is nearly always fulfilled."

Cecil Beaton was beguiled by the Queen's "slightly hesitant" manner of speaking. "It gave great point to the delayed word and

12—TQM

Racing was now, in fact, to join gardening and the human pleasures of sociability among the chief preoccupations of the Queen's leisure. On August 15th the King and Queen rode to the State Opening of Parliament amid the rejoicing of VJ-Day. The Queen had helped her husband to rehearse two alternative speeches in case the war with Japan ended; the happy coincidence of the day marked the official end of hostilities in Asia, and an impromptu family dinner-party was staged at Buckingham Palace that evening. The following week the Balmoral estate was devoted to a supreme family gathering.

Among the guests were the Queen's sisters, Rose and Mary, her brother, David, and many old friends. The Queen had visited Rose, Countess of Granville, that summer on the Isle of Man, where her husband was Lieutenant-Governor, enabling Rose to burn her own tiny candle of deputy queenship. Mary Elphinstone was installed with her now grown-up family at Birkhall: her eldest boy Andrew, the second son, had returned safely from a German prison-camp; and there were David's children, Simon and Davina, with just two years dividing them, teen-agers as attached as ever David and Elizabeth had been in the long ago. The guests also included the ever faithful Arthur Penn, Piers Legh and his American wife, and the Eldons, Cranbornes, Salisburys, Adeanes and others. This occasion saw the brilliant summer day, on the anniversary of the outbreak of war, indeed, when the King proposed trying for everything on the game card and the bag memorably included everything from a stag—shot by Princess Elizabeth—to trout, salmon and an accidental sparrow-hawk. The Queen, however, supervised the picnics, and the three sisters revelled in a memorably happy day together at the Queen's two-room cottage, an old schoolhouse on the moors. This was of the simplest order, "one room used as a dining-room with a little table in the centre, and an open fireplace opposite the door; the other, a large room, evidently the kitchen . . ." which also had "a huge open fireplace with equipment for cooking food", as an earlier guest, Mr. Mackenzie King, has described it. At the rough

THE AFTERMATH

I

QUEEN ELIZABETH celebrated the forty-fifth anniversary of her birthday on Saturday August 4th, 1945, with a family outing to Ascot races with the King and Princess Elizabeth. Among the runners was her husband's own Hampton-bred horse, Rising Light, and the royal party had the immense fun of seeing the colt catch up with his rival in a last-second spurt and win by inches in a most exciting finished. This royal win was the day's sole exception to five wins by the inimitable Gordon Richards; and for the King it was the first horse of his own, as distinct from his leased National Stud string, that he had ever seen ridden to victory.

The very name, Rising Light, seemed a propitious augury; and if there were jokes at the family dinner-party about the half-way mark to ninety, the Queen could reply that she still felt like a rising light herself. To maintain her enjoyment, the royal party again went to Ascot races on the Bank Holiday Monday and had no sooner appeared in the royal box than another of the King's own horses, Kingstone, obligingly demonstrated a win by four lengths. The Queen found Princess Elizabeth's racing zest infectious. The Sport of Kings had provided some lighter moments of relaxation during the war, particularly at Newmarket in 1942 when the King and Queen saw Sun Chariot win a wartime Oaks in the royal colours, and again at the 1945 Derby when Rising Light was placed fifth to the rueful dismay of the Queen and her daughter.

suffered for five years under the Nazi yoke. Here above all the jubilant and loyal demonstrations of welcome touched emotions of the royal couple and surprised them both in their humility. "The Queen and I have been overcome by everybody's kindness," the King wrote to Archbishop Lang. "We have tried to do our duty in these five long exacting years."

The ashes of the gentle old man were laid to rest at Glamis in the presence of the King and Queen and other family mourners, and the Queen returned from the funeral with the sense of loneliness and of a new beginning that we all have on the death of our last parent. The talk now was of the makings of the peace, and to Sir John Reith the Queen was emphatic on one occasion that the Christian ethic should be the basis of post-war policy. There were discussions of a broadcast in which the King might make his own similar views known to the world, and the Queen interposed, "He really does believe it, you know."

The unconditional surrender of the German forces was signed in the small hours of Monday morning May 7th, 1945, but on the Sunday evening crowds were already gathering around Buckingham Palace as if drawn to the magnet of a national shrine. On the Tuesday afternoon Mr. Churchill made the official announcement of victory in Europe and from that moment the multitudes outside the Palace chanted "We want the King! We want the Queen!" until Their Majesties went out with their daughters onto the balcony and waved and smiled towards that excited and swirling sea. "We went out eight times altogether," the King noted. That evening he broadcast to his peoples, necessarily not the firmer words of Christian post-war policy which the Queen had desired, for these were to be left to governments, but one may perhaps discover the wifely influence, and certainly the full agreement of the Queen, in the King's call to an act of national thanksgiving. During the next two days he and his wife drove in State through East and South London, moved beyond their expectations by the reception they encountered everywhere. It was the fervour of the Coronation over again, a fervour in an unpainted, threadbare, dusty, shabby, makeshift post-war world. As in the Coronation year, they made journeys to Edinburgh and Belfast; and their welcome was nowhere greater than when they visited the newly liberated Channel Isles in the cruiser *Jamaica* and moved again among the only British peoples who had

the Order of the Bath. This caused a contretemps a few years later when, on being awarded a higher class of the Order, the Brigadier was supposed to return the insignia of the lower rank. "I've lost it," he declared, unconvincingly, and added that he couldn't care less what the loss cost him: "That insignia was given me by Her Majesty the Queen and I refuse to part with it for all the money in the world." The matter was glossed over.

But these were the highlights of the drab and monotonous years of war, of unchanging, inescapable and persistent routine when time was measured only by the fresh campaigns and the successive weapons that the enemy hurled towards Britain, the flying bombs and then the rockets. The Queen was one of the few members of her sex who knew the official estimates of casualties, 12,000 dead or injured and 200,000 houses damaged in the London area by the V.1 'buzz bombs' within fourteen days. "Very inhuman," she wrote, in describing the indiscriminate slaughter to Queen Mary. There was a time in 1944 when Folkestone and Dover bore the brunt of shellfire and aerial attacks from the French shore, and Winston Churchill's visits to these towns were widely publicized. The Queen decided that these tours of inspection were insufficient for the feminine element of the population, who were in fact under shellfire as the women of England had never been before and she too made her own conscientious and separate visits. The Queen was also very distressed when one of the early flying bombs wrecked the Guards Chapel at Wellington Barracks during Sunday service. Among the dead were many whom she knew, including an old and close friend, the sister of her treasurer, Arthur Penn. Her nephew, John, son of her eldest brother and heir to the Strathmore title, was killed in the fighting of Halfaya Pass in 1941. Her brother-in-law, the Duke of Kent, died in a plane crash in 1942. The toll of the war within her personal circle would no longer bear enumeration. And on November 7th, 1944, a close though not unexpected bereavement was the death of her father, Lord Strathmore, at the age of eighty-nine.

plete silence. "I have had an anxious few hours," the Queen wrote to Queen Mary. "Of course I imagined every sort of horror, and walked up and down my room staring at the telephone."

The King returned safely two weeks later, tired but sunburned after a tour markedly cheering to the troops who felt that they merited this recognition. The Queen meanwhile had also enjoyed a new experience. Before the King's departure she had again been appointed a Counsellor of State and was thus empowered to hold an Investiture at Buckingham Palace. No prior announcement was made, and the King's expected appearance served to camouflage his absence abroad. These wartime ceremonies held in the Grand Hall of the Palace and splashed with colour by the Yeomen of the Guard, saw the decoration and occasional ennoblement of thousands of men of the Services and of the Commonwealth throughout the war, and hundreds of relatives and other guests were permitted to watch this great moment of their heroes. One day in June, the band as usual had played waltzes and minuets and was in the middle of "A Fine Old English Gentleman" when quietly and unexpectedly the Queen came through the doors onto the dais. No Queen had held an Investiture since Queen Victoria. The first hero to step forward from the waiting file was Wing-Commander Guy Gibson, of dam-busting fame, to receive the V.C. More than 230 men and women were decorated in the course of the morning, the Queen having practised the deft art of taking the decoration from the velvet cushion behind her without turning her head.

As Counsellors of State the following year, when the King visited his armies in Italy, both the Queen and Princess Elizabeth also received addresses from the House of Commons and House of Lords and the Queen for the first time had the diversion of signing assent to several Parliamentary Bills—which at the touch of her pen became law: Bills more romantic in the assent than in observance, mainly concerned as they were with rural sewage. The Queen also held another Investiture when, in the long rota of the decorated, a certain Brigadier was made a Companion of

lonely searchlight units, continually toured hospitals and was tireless—though forbearing in scrutiny—in her visits to women's service units. For spare afternoons a counterpart of the old Glamis wartime sewing parties was held by the wives of Palace staff at trestle-tables in the State Apartments, and the items made by the Queen joined the stock-pile without distinction. During a lull in the enemy bombing campaigns, children began drifting back to the cities, sometimes arousing friction between the parents of evacuee children and the foster-parents who sheltered them. After discussing this problem, the Queen sent out a letter of thanks, adorned with her own Coat of Arms, to thousands of house-holders who had taken in children. This essay in royal public relations caused immense pleasure and renewed the wearied and care-worn spirit of hospitality.

Although the King had visited his troops in France in 1939, the Queen had not yet been called on to endure the suspense of a wife whose husband was engaged in one of the active theatres of war. Even this experience was however to be hers in June, 1943, when the King seized on the opportunity of visiting his victorious troops in North Africa. The plan was made in close secrecy. The King was to fly under the incognito of 'General Lyon'—using his wife's maiden name—in Winston Churchill's handsomely fitted York transport plane, with a refuelling stop at Gibraltar. But there were risks in circling enemy-occupied France, over waters in which, that very month, the Germans had shot down an unarmed neutral passenger plane on a scheduled flight. This was the aircraft in which Leslie Howard, the actor, lost his life. The loss was notified on June 2nd, and the King was due to fly on June 10th. Husband and wife so realistically faced the possible danger that the King summoned his solicitor and put his affairs in order the night before he left.

The King flew out late at night and the Queen heard at break-fast that the aircraft had been reported near Gibraltar and would be landing shortly. At 9.45 came the message that thick fog had closed Gibraltar airfield and the plane had flown on. Then com-

he returned that night, his face strained and white, she said characteristically that she ought to have been there. And in a sense she was, for the first Queen's Messenger food convoy went into action there and fed 12,000 people for three days. When the scheme was first discussed with Lord Woolton, the Queen had insisted on privately financing a convoy as well as giving her name, and her cheque had arrived the following day. Her cousin, Lilian Bowes-Lyon, had a flat in Poplar, where she was a convinced social worker and W.V.S. organizer, and the Queen sometimes visited her to gain a completely personal and inner view of the needs of the poor. At the very end of the war, Lilian phoned to ask why the mobile canteens were parked in Hyde Park while people were queuing for potatoes, and the whole fleet was stocked up at the Queen's wish and sent to her cousin's list of distribution centres in the East End.

In October, 1942, Eleanor Roosevelt visited England to find the King and Queen at the Palace both suffering from heavy colds, living in chilly rooms, the Queen's bedroom fitted only with fragile windows of thin wood and isinglass. The Queen showed her how the splinters of another bomb had dropped through her former room and lodged in the King's wardrobe. "We were served on gold and silver plates," Mrs. Roosevelt noted, "but our bread was the same kind of war bread every other family had to eat. Except for game that occasionally appeared, nothing was served that was not served in any war canteen."

The Queen in fact faced nearly every commonplace hardship of the war. The clothes that she had worn in Canada regularly appeared in her wardrobe until 1947. In buying gifts at a Red Cross stall, she had to admit that she had run out of clothing coupons. The tranquil comfort she enjoyed at Royal Lodge was edged by the constant horror and devastation faced in visits to Bristol, Bath, Southampton and other cities, tours that inflicted a harsher and more prolonged view of war on the civil front than many other women sustained. But there is evidence that the Queen constantly felt she was not doing enough. She visited

as the Queen paused at their bomb-shattered homes, "Ain't she lovely! Oh, ain't she just bloody lovely!"

Many of the windows of Buckingham Palace were shattered by a near miss on September 9th when the King and Queen were sleeping at Royal Lodge. Four days later a German aircraft made a direct attack on the Palace while they were transacting morning business with Alec Hardinge in a room overlooking the quadrangle. The King and Queen looked out at the low zooming roar of the aircraft and saw the bombs falling. The next second they heard the roar of explosions, then they rushed into the corridor and the King simultaneously pulled the Queen back onto the floor. "We all wondered why we weren't dead," he wrote afterwards. Two great craters had appeared in the quadrangle. Other bombs fell in the forecourt and also wrecked the Chapel. "A magnificent piece of bombing, Ma'am, if you'll pardon my saying so," said one of the Palace policemen to the Queen. Though both badly shaken, the King and Queen promptly went round the Palace to talk to the servants. One man recalls that their clothes were stained with the brick-dust that still hung like a pall around the ruined Chapel. "I'm glad . . ." said the Queen. "It makes me feel I can look the East End in the face."

She shared in the message from the King which was posted up for the Palace staff, "The Queen and I know only too well the strain to which the Staff . . . both men and women, have been subjected . . . Please convey to everyone how greatly we appreciate the fine spirit which they have displayed." But there were few to commend the Queen as she exposed herself to the heroism and human tragedy of East and South London. "I feel quite exhausted after seeing and hearing so much sadness, sorrow, heroism and magnificent spirit," she once wrote to Queen Mary. "The destruction is so awful, the people so wonderful—they *deserve* a better world."

When the King went to Coventry, his wife did not accompany him, on advice, lest her presence should impede the work of rescue in ruins perilous with unexploded bombs and land-mines. When

London the King and Queen chanced to be in the street, touring Civil Defence centres with the Home Secretary, when the sirens wailed and they went as directed to a shelter beneath the police-station. As their Majesties entered in the dim lighting the people could hardly believe their eyes and then of course raised one of those tremulous but sincere cheers of a small group of people, and eagerly gave up chairs, and a canteen worker came forward with her strong brew of tea in stout china cups. The King and Queen were never more truly Londoners than at that moment.

Their old home at 145 Piccadilly was destroyed in an early raid by a direct hit. From September 7th onwards, as the more intensive assault on London began, the King and Queen were out and about, often together, sometimes separately, and frequently before the fires had been quenched in the bomb rubble. A woman would take the Queen's arm gasping that her little shop was wrecked but that she was still serving customers. "It is splendid to hear . . . it is sad to see" the Queen would say, again and again, in different districts. The sight of the small, plump friendly figure moving among them was steadying and gave every participant a stronger reassuring sense of individuality and courage in this grim battle of the Home Front. A woman might sob out a story of her children, and the tears that so often sprang to the Queen's eyes raised adoration from the crowd.

There were stories about the Queen that spread lip to lip and became part of Cockney folklore. An old woman was in distress because her frightened dog refused to budge from a hole in the debris. "Perhaps I can try," said the Queen. "I am rather good with dogs," and knelt in the dust to coax him out successfully. A woman with a disabled arm was trying to dress her baby while the local officials accompanying the Queen looked on. "Let me help," said the Queen, and took the baby. She never wore black and she never wore green, a colour some considered unlucky. Her choice of lavender, lilac or dusty pink made her conspicuous in the drab wrecked surroundings. That, of course, was queenship. One eye-witness remembers a group of women crowding about her

probably it was the Queen who inspired the day as a national rallying point. "I shall never forget the emotion of that service at Westminster Abbey," wrote Lord Croft, then Under-Secretary for War, "... the King and Queen surrounded by all their Ministers and accompanied by the Queen of Holland and the King of Norway, monarchs of two countries already stricken in defeat. It was with a terrible weight on our hearts that we appealled for the succour of Divine Providence. It seemed almost unbelievable that any but a fraction of our Army could be saved." Within ten days, 335,000 troops were rescued from the beaches ... and men have spoken ever since of the miracle of Dunkirk.

The fervour of the Queen's own letters at this time must wait upon posterity. Close friends were among the battle casualties. The next phase was, of course, the Battle of Britain itself and the preparations for imminent invasion. A plan under a picked body-guard called the Coats Mission—from its commander, Colonel J. S. Coats—was rehearsed for the safe escort of the Royal Family to a place of safety if the Germans landed. Four houses in different parts of the country were equipped for their reception, but the Queen did not trouble to see or supervise any of them. On the other hand, Lord Halifax, the Foreign Secretary, who enjoyed the privilege of walking through the grounds of Buckingham Palace as a short-cut to Whitehall, one morning heard the rattle of rifle fire in the Palace grounds and enquired the reason. He discovered that the Queen, among others, was practising with service weapons—a .303 rifle and a .38 revolver—and Lord Halifax decided it would be prudent to cease his Palace walks.

King Haakon of Norway, having undergone the stern reality of invasion, was horrified at the security arrangements. Palace provisions were consigned to one of the highly secret retreats in canvas packing clearly marked 'Royal Mews'. When air-raid alerts sounded, the King and Queen escorted their guests to a housemaids' sitting-room in the basement which, reinforced by heavy timber, alone served as shelter, and deeper shelters were not provided until 1941. During one of the first air-raids on

of mercy. "But why Queen's Messengers?" Her Majesty asked. "What will I have done?"

Lord Woolton was moved to speak out. "But don't you know what you mean to all of us in this country? It isn't only your high position . . . it's the fact that people think of you as a person who would speak the kindly word and, if it fell within your power, would take the cup of hot soup to the needy." Whereupon, as Lord Woolton tells, the Queen put up her hands and said, "Oh, my Lord, do you think I mean that? It is what I have tried so hard to be."

<p style="text-align:center">II</p>

The great westward onslaught of the German armies through the Low Countries began on May 2nd, 1940, and eleven days later Queen Wilhelmina of the Netherlands arrived at Buckingham Palace, swept to the English shore by defeats and misadventures beyond her control. She arrived with no more than she was wearing, and Queen Elizabeth provided extra clothing and above all the sympathetic kindliness and consolation that the distressed Queen so direly needed. But this was total war. Hitler had drawn up explicit instructions for the treatment of crowned heads and their kinsfolk captured by paratroops, and it was suggested at about this time that Princess Elizabeth and Princess Margaret should be taken to greater safety in Canada. But the Queen declined. "They could not go without me," she said, "and I could not possibly leave the King."

Outwardly, as the enemy armies swept relentlessly nearer, all was calm. On May 24th the Germans entered Boulogne and so gazed as conquerors across the English Channel and on that day the King broadcast an appeal for a Day of National Prayer to be held on the Sunday, two days later. To the agnostic this was a gesture of ludicrous superstition, but to the faithful and to half-believers it was just and proper to seek the aid of the Almighty at so dark an hour. It is notable that the call came from the King, and not primarily from the leaders of religious thought, and

of a bombing attack, the Royal Family went to Sandringham as usual at Christmas, and the first of the King's wartime Christmas broadcasts contained an impressive and helpful quotation included, it was thought, at the Queen's suggestion: "I said to the man who stood at the Gate of the Year, 'Give me a light that I may tread safely into the unknown'. And he replied, 'Go out into the darkness and put your hand into the Hand of God. That shall be to you better than light, and safer than a known way ...' "

None knew better than the Queen that she constantly had to set an example. In retrospect, a quarter-century later, it seems absurd to say that the Queen's serenity was a source of strength to the nation, but it was true at the time. In the phase of "the phoney war", when the adversaries silently prepared for the real struggle, she continued to attend concerts and art exhibitions, recognizing amid some protests to the contrary that these civilized essentials were indirect accessories of morale. Her purchase of two paintings by Duncan Grant was announced at this time. The treasures of the National Gallery necessarily disappeared into safe-keeping in the West Country, but pictures from Royal Lodge were included in an exhibition of British painting that took their place. Later, during the air-raids, when lunchtime concerts were given under the sandbagged laylights of the Gallery and Beethoven and Mozart were played with such moving defiance, the Queen made a point of being present from time to time. When a scheme was set afoot for artists as part of their war service to record the British scene in paintings and drawings while it still remained unravaged, the Queen commissioned John Piper to undertake twelve water-colours of Windsor Castle.

Yet, as with her peacetime patronages, the Queen was reluctant to lend her name to any movement in which she played no active part. Later, when the air-raids were at their height, Lord Woolton as Food Minister worked out plans for a fleet of travelling vehicles to provide hot meals in blitzed areas where they would be needed, and sought permission to call them Queen's Messengers, because the women in charge of the convoys would indeed be messengers

On September 15th, by coincidence the day that the Duke received his appointment, the Queen became Commandant-in-Chief of the three women's defence services, the "Wrens, Waafs and Waacs", but evidently she had already made clear at the breakfast-table that she would never wear uniform. She had not the figure for it and is said to have been adamant in refusal when others suggested that she might change her mind. The Queen accepted the prior importance of offering her harassed husband the softer feminine home atmosphere that she alone could provide. At her wish they began returning each night to Royal Lodge and "she seemed to drop her cares at the gates", as the observant Miss Crawford said. She had already practised her feminine persuasiveness over the teacups with the U.S. Ambassador, Joseph Kennedy, though not entirely with the desired effect. Indeed, as a result of this and other talks, President Roosevelt was to write, "Joe sat down and wrote the silliest message to me I have ever received. It urged me to do this, that and the other thing in a frantic sort of way." But if the Queen had earlier contrived to communicate only her perplexities, a firmer note of resolve entered into a broadcast to women which she gave that November from the Palace.

It embodied the Queen's own text and her own point of view. She recalled her previous broadcast, a farewell message to women and children just before leaving Canada, "in an atmosphere of such goodwill and kindliness that the very idea of strife and bloodshed seemed impossible". Now she talked of the women of France and Poland and the women at home, "The greater your devotion and courage, the sooner shall we see again in our midst the happy ordered life for which we long ... We put our trust in God, who is our refuge and strength ..."

Her words were carried to South Africa and New Zealand, but in reality she voiced her deepest thoughts. God was indeed her refuge. If a member of her private staff thought it noteworthy that "the Queen never showed that she was worried", it was because her inner faith was so strong and sure. Despite the risk

be with the King," she explained to one of her staff, and on August 29th she indeed hurried to join him in London.

What should a Queen do in wartime? Like every woman, she tried to hide her agony, her trepidation for her loved ones, for her brother, David, for her own Lyon nephews and the King's family. The plans rapidly devised for her national duties, when not united with those of her husband, touched civilian life and medical care at every point. A million children had been rushed from London and other danger zones and she visited groups of these transplanted "evacuees" in Sussex. On the day after the outbreak of war, her first appearance in public with the King was on a tour of Civil Defence points and air-raid shelters in London. Then she inspected Red Cross centres, ambulance trains, government clothing factories, dockland centres and troops in training—and every evening telephoned her daughters at six o'clock.

An early personal dilemma lay in the return of the Duke and Duchess of Windsor to London. It cannot be determined what part, if any, the Queen played in the King's decision, made known shortly after the Coronation, that the Duchess of Windsor should not share the style of 'Royal Highness'. In the intimacy of brothers, the Duke of Windsor had, early in 1937, continued to telephone the King until the latter one day ended a conversation by remarking, "I'm afraid it's not going to be possible to continue these talks. It's too difficult to explain over the telephone . . . I'll tell you in my next letter." The letter was never received and, as the Duke of Windsor has said, "The Iron Curtain had gone clanging down." Was the Queen's own hand, with a woman's wisdom, on the curtain switch? If there can be an answer, it may lie in a trait of character that both brothers had in common. Both would do anything for the woman they loved.

The King received his brother on September 14th without "recriminations on either side", and we have no indication that the Queen met the Duchess at that time. The King decided that his brother's services could best be used for the time being with the Military Mission in Paris and so it was settled.

QUEEN IN THE WAR YEARS

I

AFTER-EVENTS OF CONSEQUENCE often spring like oaks from incidents too small to be remembered. The meetings with Colonel Beck of Poland at Buckingham Palace during the glittering State functions of the Coronation probably made only the slightest impression upon the Queen, and yet the reciprocal alliance with Poland signed in London at about that time was the first cause of Britain's entry into the new European war. Similarly, at the end of July, 1939, when the King and Queen visited Dartmouth Naval College with their daughters and there met Lord Louis Mountbatten's young nephew, Cadet Captain Prince Philip, the Queen perhaps remembered afterwards only a pleasant blond boy who had shown off a little and made himself agreeable, as young men should.

The King and Queen went to Balmoral—and in reality to Birkhall—as usual, though after a week the King broke his holiday to travel south to review the Reserve Fleet, a gesture that it was hoped might still check the war-like trend of events. On August 22nd, however, came the amazing and dismaying news of the German-Soviet non-aggression pact and the King hurried to London with war a virtual certainty. "I feel deeply for you," Queen Mary wrote to Queen Elizabeth, "I having gone through all this in August, 1914, when I was the wife of the Sovereign."

The Queen remained in Scotland but soon found she could contain her anxieties no longer. "If things turn out badly, I must

court curtseys. It surprised the Queen that the crowds at the World's Fair had sung "Rule, Britannia!" and "Land of Hope and Glory" and, worshipping in the President's local parish church the next day, she was surprised again. "The service is *exactly* the same as ours down to every word, and they even had the prayers for the King and the Royal Family," she wrote to Queen Mary. "I could not help thinking how curious it sounded and yet how natural." As to the Roosevelts, she found them "such a charming and united family, and living so like English people when they come to their country house". The curious *naïveté* that the Queen had retained remains implicit in these words. The truth was that neither the King nor Queen had expected such a tremendous and genial welcome in a part alien and republican land. They had faced as great an ovation—and found more demands made on their resilience—than ever before in their lives, and it was a toughening yet immeasurably reassuring experience. "That tour made us!" the Queen confided to Mr. Mackenzie King two years afterwards, "I mean it made us, the King and I. It came at just the right time, particularly for us."

The confidence was needful, for the historic oddity that saw the visit to Paris in 1914 followed by war with Germany within four months was curiously repeated with the American variation in 1939. The King and Queen returned to London on June 22nd to an exceptionally enthusiastic welcome, and the chanting crowds called and recalled them to the somewhat dizzy balcony ramp of Buckingham Palace. And on September 3rd, after every honourable alternative had failed, Britain was at war with Germany for the second time in twenty-five years.

gations and leading questions were forgotten. Perhaps each saw what they expected to see. Amid the great crowds at the Capitol a Senator grasped the King's hand and cried, "My, you're a great Queen-picker". It was estimated that the hour at the Capitol alone involved the King and Queen in over 426 handshakes. At a camp inspection, after visiting Mount Vernon, the Queen again thought it best to mention to Mrs. Roosevelt that she felt "most peculiar" and for once the King proceeded with the inspections while she sat in the car. But that night she was radiant as ever. It happened that a Cabinet Minister's eight-year-old daughter had been disappointed because the King and Queen wore ordinary dress. The Queen suggested that she should be in the hall of the White House as she left with her husband for the dinner-party at the British Embassy. There the child saw the Queen in her spangled evening gown, her jewels and diadem. "The illusion was so perfect," says Mrs. Roosevelt, "that she curtseyed to the Queen and ignored the King." After stopping to speak to her, the Queen went on, leaving a breathless little girl, who cried in rapture "Oh, Daddy, Daddy! I have seen the Fairy Queen".

After a night in a train, part blessedly spent in a siding, the visitors then faced another torrid day in New York.

A ticker-tape ride down Broadway had been mercifully overruled, but the visitors enjoyed first a cruise of the harbour in an American destroyer, and next a fantastic welcome at the Battery, extended into an hour's drive to Flushing Meadows to see what they could of the World's Fair. It was said that nearly four million people lined the route, and a popular move was the royal couple's last-minute directive to the chauffeurs to travel at no more than 15 m.p.h. which enabled the royals to see as much as possible of the city and the cheering citizens to see as much as possible of them.

After a visit to Columbia University and a ninety-mile drive down the motorway, the King and Queen were two hours late in arriving at President Roosevelt's Hyde Park home, an interlude devoted by one ardent neighbour to practising the deepest

masons talking and realized that some of them were Scots, and she made me take her and the King up to them, and they spent at least ten minutes in Scottish reminiscences, in full view of 70,000 people, who went mad! . . . We had some 10,000 veterans, she asked me if it was not possible to get a little closer to them. I suggested that we went right down among them . . . and we were simply swallowed up. But the veterans made a perfect bodyguard. It was wonderful to see old fellows weeping, and crying 'Ay, man, if Hitler could just see this . . .' " Such was the emotional fervour among the more distant—and yet tougher—peoples of a monarchy under the threat of war.

Yet the Queen found it difficult, as she told Cecil Beaton shortly afterwards, to know when *not* to smile. She winced at the rounded face exposed in the newspapers. "It is so distressing to me," she told Beaton, "that I always photograph so badly." This was not a view acceptable to Mrs. Roosevelt, who found herself marvelling after a day or two's acquaintance that the Queen "never had a crease in her dress or a hair out of place. I do not see how it is possible to remain so perfectly in character all the time." But the visit to Washington involved both the Queen and her husband in intense personal strain. The weather was unusually hot and humid; and the programme of the first day alone included two slow-moving drives under the blazing sun, a garden-party at the British Embassy and a State Dinner and concert at the White House in the evening, all with their presentations and ceremonies. The crowds were larger than any that even Mrs. Roosevelt had ever seen; the enthusiasm so intense that the Queen once again launched local fashion merely by raising a parasol, but after dinner at the White House that night the programme was interrupted when the Queen had to confess to faintness and had to rest for a time.

The next day began with that then completely unaccustomed feature for royalty, a Press reception for seventy newspaper women who were fortunately so stirred by the Queen's own smiling dignity that they kept their own, and the intended interro-

blasts of the foghorn echoed back from icebergs that had sailed unshrunken much further south than usual.

"Incredibly eerie and really very alarming," the Queen wrote home. "We very nearly hit a berg the day before yesterday. The poor Captain was nearly demented because some kind cheerful people kept on reminding him that it was about here that the *Titanic* was struck, and *just* about the same date!"

Fortunately the voyage was completed in safety, and during two days of brilliant sunshine the people of Quebec and Montreal discovered to their pleasure that their Queen could speak French and, as *The Times* said, "Many more French-speaking people saw the King and Queen today than in Paris". As in Paris, the smiling Queen was a publicist of success, smiling when she successfully sang *Alouette*, smiling at the four-year-old Dionne quintuplets, smiling at children and veterans ... "A Queen Who Smiles Like an Angel", "We will remember her Smile", "Forever may she smile", so ran the ecstatic headlines. In Ottawa, the Queen thought it would be fun to use a scheduled rest interval to explore the farming countryside. Walking in farm fields, with only two of their suite, she and the King stopped to speak to a boy. "Do you know who this gentleman is?" asked the Queen mischievously. Told that he was speaking with his King, the boy gaped incredulously but then retreated a few paces, doffed his cap, made a long bow—and so having proved himself equal to the occasion fled to the house.

The Queen indeed served to pack the tour with such newsworthy incidents. At the 'Scottish' town of Glengarry it was she who translated the Gaelic welcome on the banners—*Cead mile failte du glen garrada* "A hundred thousand welcomes to Glengarry". At Ingersoll a war veteran asked whether, to settle an argument, she was Scottish or English. "Since we reached Quebec," said the Queen, "I've been a Canadian." As the Governor-General, Lord Tweedsmuir, wrote to a friend, "She has a perfect genius for the right kind of publicity. When she laid the foundation stone of the new Judicative Building I heard the

Hartnell ultimately evolved a long flowing negligée dress touched with sable, and every problem of climate or occasion posed questions similarly only part-solved by past experience.

The Queen was unaware of the strange requirements made in her name in Washington, where a chair for her Messenger was to be provided at her bedroom door and a sprung cushion placed in the royal car to ease the Queen's continual bowing. Consulted for his experience of the State Visit to Paris, the U.S. Ambassador to France even suggested hot-water bottles for the royal beds in June and caused bewilderment by ordaining a "linen blanket" for the Queen's couch, the nearest description anyone in Paris could provide to an eiderdown. As the Queen studied her own schedules she discovered that she, too, still had much to learn. It would never do to be questioned on British parliamentary institutions, for instance, if she had to confess that she had never seen the House of Commons. This omission was made good when she paid a visit in March, 1939, and quietly took a seat in the Speaker's Gallery to watch a debate. The business was not unamusing, for A. P. Herbert was asking leave to bring in a Bill to restore L.C.C. passenger steamers to the Thames, and the Queen saw the move defeated.

There also arose the need, before the King left Britain, of appointing Counsellors of State to carry on the Royal power and functions—including much of the royal prerogative—in his absence; and the Queen was so appointed with five other Counsellors on May 5th. This procedure seemed strange, since she would also be out of the country, but the prescription was necessarily concerned with the legal possibility of the King's sudden death. According to Lord Halifax, the Admiralty even entertained fears lest Hitler should order the German battleship *Deutschland* to kidnap the King, travelling as he was on the unarmed Canadian Pacific liner *Empress of Australia*, and the Prime Minister had to take this into consideration in advising the King and Queen to undertake their journey. But as it turned out, the natural hazards provided a real danger, for the liner ran into thick fog and the

of Munich, also, that the Queen went to Clydeside to launch the great liner that was to bear her name *Queen Elizabeth*. And when she rejoined her husband, he showed her a letter from President Roosevelt containing an invitation to Washington implicit with the reaffirmation of another friendship, another royal task to be faced in the attempt to save the peace.

IV

The proposal that the King and Queen should pay a visit across the Atlantic, had first been made by Mr. Mackenzie King as Prime Minister of Canada during the Coronation festivities, seemed far more unorthodox and novel then than it does today. No reigning Sovereign had ever visited Canada, and in the United States some professed that the burning of the White House should still be weighed as an adverse factor against all the firmer bonds of a common heritage. For the Queen there was never indecision. As soon as the journey to Canada and "the State Visit of their Britannic Majesties" to the United States had been agreed, she flung herself into the multitudinous preparations which varied in this new age of mass media from the provision of advance Press photographs to a stupendous protocol of fashion.

Once again the invaluable Mr. Hartnell was summoned, and confronted with a detailed itinerary showing that from the day of arrival in Canada on May 17th till the final departure for home on June 15th the Queen would require an average six changes of costume a day with little repetition. The ever-watching eye of the movie and Press cameras seemed, at the time, to require that a dress worn in Quebec could not be worn in Montreal or Ottawa a day or two later without fear of a slight to their respective citizens. During the rail journey across America the Queen was expected, with the King, to step onto the observation platform of the royal train at smaller halts at four o'clock in the morning. Should she wear an evening gown or a simple dress for breakfast? Could something be conveniently donned over night-clothes?

monarchy again. We have taken the Queen to our hearts. She rules over two nations".

Malmaison was doubly decked for her with roses. At Bagatelle she opened a transparent lace parasol—and so resuscitated the fortunes of a hundred parasol makers. At Versailles, in the Hall of Mirrors, it was notable that there were thirteen glasses apiece for the thirteen precious wines, each bottled on the birthdays of presidents and kings. The Queen's wistful smiles must have sheltered many poignant recollections of her beloved mother who would not now hear her account of the day, but she truly enacted her royal rôle like a trouper. Many hearts were to experience a chill a little later, during a concert and service in the chapel of the Chateau, when the heavenly sound of a choir singing Monteverdi was dimmed by the roar of fighter planes, and the shadows, wave on wave, of a wretchedly timed fly-past swept menacingly across the walls and altar. The macabre interruption remained rooted in the Queen's memory, and yet the firmness of Anglo-French solidarity as a means of peace was one of the prime demonstrations of the State Visit.

The superstitious recalled that within four months of a similar visit to Paris by King George V and Queen Mary in April, 1914, Britain and France had been at war with Germany. Two months after the State Visit in 1938, Chamberlain and Daladier for Britain and France, Hitler and Mussolini for Germany and Italy signed the Munich Agreement and an Anglo-German naval agreement was signed "as symbolic of the desire of our two peoples never to go to war with one another again". On the retrospective view, Munich was well-meaning and mistaken, but the Queen had reason to suppose that the small part she and her husband had played in Anglo-French accord had helped to preserve the peace; to preserve it for the time being. Typically, when Chamberlain, sick and weary retired from the Premiership to be replaced by Churchill, she sent the stricken man her own personal letter of thanks: "during these last desperate and unhappy years you have been a great support and comfort to us both". It was on the eve

grandchildren, and it was the Queen's custom to visit the old couple at least twice a week. The date of the State Visit was set for June 28th and on the previous Tuesday evening, June 22nd, David Bowes-Lyon telephoned to break the terrible news to the Queen that their mother had suffered a dangerous heart attack. At 2 a.m. the following morning, with the King and Queen and others of her family around her, Lady Strathmore died.

Clearly the shocked thought to the Queen in the first agony of grief was that the visit was unendurable and that her husband would go alone. In the depths of sorrow she was nevertheless quick to realize the shadow that her absence would cast on the event. The King was able to reassure her that the journey had been postponed. In reality, it was delayed for only three weeks and, returning from the sad obsequies in Scotland, the Queen immediately had to summon all her self-control to discuss how the summer gaiety of her wardrobe could be diminished.

"Is not white a Royal prerogative for mourning, Your Majesty?" Mr. Hartnell suggested, and with this he instantly undertook, within the fourteen days that remained, to alter the whole collection—evening gowns, afternoon dresses—into white counterparts.

This intensive transformation trick provided an unforgettable element of success in the visit to France. Eugenie herself had never worn anything so superb as the billowing skirt composed of hundreds of yards of narrow Valenciennes lace, sprinkled with silver, that the Queen wore on the first evening, at the Elysée Palace. As Lady Diana Cooper wrote, "Each night's flourish outdid the last." At the Opera she saw the Queen "shining with stars and diadem and the Légion d'Honneur proudly worn, walk up the marble stairs preceded by *les chandeliers*", two resplendent footmen bearing twenty-branched candelabra of tall white candles. And in this glowing light glowed the Queen, the festoons of satin in her gown held by clusters of white camellias. The Parisians waited in dense crowds for every glimpse, public opinion summarized by a leading newspaper, "France is a

purchases of still lifes by William Nicholson and Matthew Smith. Privately she had also purchased a Bernini bust of Charles I, convinced that it would fill a notable gap in the royal collections. Queen Mary's passion for collecting family objects and organizing and cataloguing the furniture and other treasures of the royal palaces was well known, but the intensity of her sharply focussed interest sometimes precluded a wider view. Her successor on the other hand delighted in stealthy acts of grace and rescue, often indulged anonymously or without any public word. Hearing that Handel's harpsichord was lying neglected and in disrepair in a vault, for example, Queen Elizabeth had it brought to Buckingham Palace, where she sought the best advice and had it put into order by an outstanding craftsman, Henry Tull. Moreover, believing that so historic an instrument should be available to musicians, the Queen loaned it to a National Trust specialist collection of musical instruments, with little sign of her timely intervention.

III

The shadow of the Nazi war drew closer. In March, 1938, came the shock of the German annexation of Austria and the propaganda barrage of disruption was then turned upon Czechoslovakia. The Czechs sought reassurance from France, with whom a mutual defence pact existed; the French in turn sought assurances of support from Britain. The royal arrangements for a State Visit to France, first taken up in Coronation Year, coincided with these diplomatic undercurrents. The Queen, for her part, had determined to play her rôle with the fullest possible *eclat*: hence her piquant decision to revive the costumes of the Empress Eugenie and the accolade bestowed on Norman Hartnell of an order for no fewer than thirty gowns. Presently, in sadness, the Queen was to have cause for thankfulness that she had shown the attractive designs to her mother. In old age Lord and Lady Strathmore now spent the London season in a flat in Cumberland Mansions, Portman Square, where they were close to David and their young

that the annual sum, probably of £40,000, was more than enough after all outgoings.

Then, as one of her first definitive acts in her shadow rôle of Queen Consort it was announced that she had bought two twentieth-century British paintings for the royal collections and that other pictures would be similarly purchased from time to time. Evidently she sought the advice of Sir William Llewellyn, president of the Royal Academy, as to where her expenditure might do the most good. It was no coincidence that the Queen purchased one of Wilson Steer's studies of Chepstow Castle at a time when the artist was threatened with blindness and encroaching despondency. Llewellyn visited the ailing Steer and cheered him up with word of the thought and care bestowed in hanging his painting in the Castle. The Queen's second choice, Augustus John's study of the sleeping Bernard Shaw aroused the irony of *The Times* but was a more personal choice. Other portrait studies by John, including his *Ida Nettleship and Dorelia*, embellish the walls of Clarence House today, with Sickerts and paintings by Duncan Grant, John Piper and Edward Seago, to trace idosyncratic preferences to the present time. An easel mounted with a painting currently submitted for approval is among the accessories at Clarence House always most characteristic of its occupant.

The first John purchase produced a sequel, for the artist undertook to paint the Queen and then found that he could never capture the elusive quality that perhaps attracted him from the first. Between 1938 and 1940 some forty meetings occurred between the mercurial painter and his subject until the blitz brought the sittings to an end when both sitter and artist were exhausted. The portrait was in fact never finished, though acquired from John's family and presented to the Queen Mother after the painter's death. Graham Sutherland experienced a similar difficulty in undertaking a portrait of the Queen Mother which he later abandoned. Yet we have been tempted ahead in our narrative.

The Queen's first two essays in patronage were followed by her

by preparations for a tour of industrial Yorkshire, the approval of schedules, the mastery of presentations, the memorizing of names and careers. With his wife at his side as therapeutist and stimulus, the King also privately began the arduous rehearsals for his first Speech from the Throne, the one element that alarmed him in the State Opening of Parliament. With her husband as critic, the Queen went through some sketches that a young designer had submitted for a gown of silver tissue that she might wear at the forthcoming State Banquet to honour King Leopold III of the Belgians. The young courturier was again Norman Hartnell, and this was the first of the scores of great dresses he was ultimately to make for the Royal Family. On an early visit to the Palace at Her Majesty's direction he was taken to see the Winterhalter paintings and particularly the portraits of the Empress Eugenie in her crinoline gowns. The brilliant renaissance of the crinoline was thus achieved at the Queen's own bidding, and Hartnell's skill was a necessary component in her own ideas. In a Queen Consort there had to be supreme glamour as well as duty; a persuasive appeal to the eye as well as to the approving heart. The Consort's untiring, incessant support of her husband in private should also see every possible feminine embellishment of her supporting rôle in public.

But what else? What else especially for a Queen, other than the patronages of scores of institutions already sought and granted? For her special commemorative gift to Windsor Castle a suite of fine early Georgian gilded furniture was acquired at the Stowe auction-sale and placed to embellish one of the State Apartments that are open to the public. In making this purchase the Queen used only her own money. The new Civil List approved by Parliament did not pass into law until a month after the Coronation and followed established precedents in making no separate provision for the Queen. She remained, as any wife, subject to her husband's private allowance, and was amused to find that her bank manager at Coutt's was a Mr. George King. But she found

Accession and Coronation comes into kingship gradually, but George VI and his Queen were pitched into the rough-and-tumble of rejoicing after barely six months' preparation. The Queen told Catta Maclean that the Crown was heavy and gave her a headache, yet Sir John Reith found little sign of fatigue when he saw the King and Queen in mufti on Coronation night "in high delight that all had gone so marvellously well". In the midst of relaxation, the King had to face the ordeal of a broadcast, in which he said in quiet tones that he and the Queen would always cherish the inspiration of the day. "To the Ministry of Kingship I have in your hearing dedicated myself, with the Queen at my side, in words of deepest solemnity . . ." And the act of crowning was but the beginning. The next day the royal couple began a series of Coronation drives through London; and on successive nights a State Banquet and a Court Ball saw them called and recalled to the Palace balcony. The Queen's especial public occasion was a review of 5,000 men and nurses of the St. John Ambulance Brigade which she held in Hyde Park. Then there was the glittering never-to-be-repeated dinner-party to a representative group of the princes of India; the visit to Edinburgh when the King invested the Queen with the Order of the Thistle in St. Giles' Cathedral, and the plaudits and gaiety of similar Coronation visits to Cardiff and Belfast.

At the end of the first high-pressure month, Lady Kennett—formerly the same Lady Scott whom the Queen had shown round Glamis as a child—had an opportunity to ask if their Majesties were not tired. "Not a bit!" said the Queen. "We don't look it, do we? We are trying so hard to do it well." She swam through the enormous garden-parties, the crowded Courts, the medieval ceremonies and services. But at a house-party at Windsor Castle, she put her feet up on a couch and talked to Alfred Duff-Cooper until after midnight of the theories of kingship and, as she termed her own rôle, "the intolerable honour".

Even the respite at Balmoral—when, to be precise, they still mostly nestled in domestic privacy at Birkhall—was punctuated

By precedents and usage observed for 700 years, the Queen awaits her anointing with bare head, and her separate coronation follows that of her husband. The King is crowned while seated in the Coronation Chair, the Queen invested while kneeling before the altar. She undertakes no Coronation oath. The Queen's Crown, the jewels re-set for each Queen Consort of this century, is a framework of light platinum, based upon a diadem worn by Queen Victoria and embellished by the huge Koh-i-Noor diamond. The preliminary prayer is offered, "Defend her ever more from dangers, ghostly and bodily. Make her a great example of virtue and piety . . ." Beneath a golden canopy held by four Duchesses—Norfolk, Rutland, Buccleuch and Roxburghe—the little Queen Elizabeth was anointed with consecrated oil in token of increased honour. She received a ring, the seal of a sincere faith; she received the Crown "of glory, honour and joy . . . with all princely virtues in this life" and into her hands were placed a sceptre of Justice and an ivory wand symbolizing Mercy.

The Coronation of 1937 also held two passages of memorable and sweeping movement, the first after the King's crowning when, at the shout of "God Save the King", the peers put on their coronets; the second when the Queen was crowned and the pale, bare arms of the peeresses rose simultaneously to place their coronets. Forty-five minutes elapsed between these two high-lights of spectacle, yet to the two central figures there remained a deeper and abiding sense of religious reality. "The Queen is a person of real piety, who felt her crowning acutely," summed up the Duchess of Devonshire, her friend for twenty years. The King and Queen felt sustained by some higher power "the reality of things unseen and eternal" so the Archbishop of Canterbury testified. And he added, "They wrote to me afterwards with touching simplicity about it."

II

The monarch with an average eighteen months between

Queen Elizabeth "a tortoiseshell and diamond fan with ostrich feathers which had belonged to Mama Alix (Queen Alexandra)". In the evening a State Banquet for over 400 guests was held. No single apartment in the Palace could accommodate so large an assembly and so, while the King sat as host in the ballroom, the Queen presided in the adjoining supper-room. Nor was this her first such rôle in so glittering a scene, for only the previous week the first two Courts of the reign, with their files of curtseying débutantes and mamas, had taken place on arduous successive evenings.

On Wednesday May 12th, Coronation Day, the inconsiderate testing of loudspeakers on Constitution Hill first awoke the King and Queen at 3 a.m. and within two hours the sound of bands and marching troops made further sleep impossible. The King recorded that the hours of waiting were nerve-racking and, as always, the Palace servants, from the humblest pantry domestics to the steward and housekeeper were given a first view of the King and Queen in their robes.

The jolting ride in the lumbering Gold State Coach, swaying and dipping on its unevenly worn centuries-old iron tyres, provided one of the most uncomfortable voyages in the Queen's experience. At Westminster Abbey an embarrassing contretemps occurred just as the Queen was about to process up the nave, for one of her chaplains fainted and an agonizing delay ensued until he could be moved. When the procession began again and the Queen advanced, unflustered, one of the spectators, Lord Mersey, felt the wave of "widespread affection and admiration". Another onlooker thought her "more composed and serene than usual" and the Archbishop, awaiting her at the sanctuary, considered "her dignity enhanced rather than diminished" by the tall following figure of the Duchess of Northumberland, the Mistress of the Robes. To Queen Mary, similarly, "Bertie and E did it all too beautifully." To others the Queen seemed to move as if in a trance of consecration as the immense ritual proceeded, minute by slow minute, solemn hour by hour.

white and gold emblems for every dominion and colony of the
Empire. Twenty-six years had elapsed since the last Coronation
and it became a matter of fervent public interest that the Queen's
purple robe would be of hand-made velvet, furred with miniver
powdered with ermine tails and that the raw silk had been
gleaned from a Kentish silkworm farm. Characteristically the
King and Queen wished the ceremony to be broadcast, anxious
that its spiritual significance should be brought home to the
peoples of the Commonwealth. At Windsor Castle, at Easter, the
Archbishop of Canterbury, Dr. Lang, privately went through the
service with the King and Queen and found them, as he noted,
"most appreciative and fully conscious of its solemnity". By
April, all London was in readiness, the daffodils in the parks
squashed beneath the enormous seating stands, the 7,700 invita-
tions for Westminster Abbey sent out, the printed card a souvenir
in itself, with the Queen's new arms, with the uncrowned lion of
the Bowes-Lyon family occupying the top right corner, and
the King's arms to the top left. One new feature of the Coronation
was that the people's response to the entire festive pageantry was
charted by a band of two hundred 'mass observers' in an objective
survey, and those anxious for minuscular detail are referred to
their report.

The royal couple spent the weekend before the Coronation
quietly at Royal Lodge with their two daughters and returned to
London to receive the Archbishop of Canterbury on Sunday
evening at Buckingham Palace. It had been the venerable old
man's idea, in which they readily concurred, that there should be a
private service of spiritual preparation. "I met them in their
room," the Archbishop wrote afterwards. "After some talk on the
spiritual aspects of the Coronation . . . they knelt with me; I
prayed for them and for their realm and Empire, and I gave them
my personal blessing. I was much moved, and so were they.
Indeed, there were tears in their eyes when we rose from our
knees." This private scene was followed next day by a family
lunch at the Palace when Queen Mary felt impelled to give

functions was to protect the King from the constant blaze of crown, sceptre and orb and to maintain an invulnerable private life of his own. In an early broadcast to his peoples the King had asserted, "My wife and I dedicate ourselves for all time to your service, and we pray that God may give us guidance and strength to follow the path that lies before us." Absolute dedication was to have the counterpart of absolute repose, and in ensuring this the Queen asserted one of the first responsibilities of her supporting rôle.

Moving house into Buckingham Palace, so like moving into a curator's wing attached to a museum, taxed all her ingenuity. All the rooms of the private royal suite ran into one another; the wind sometimes moaned in the old-fashioned chimneys and, in 1937, walls and ceilings everywhere bore the scars of an earlier decor. One of the first visitors, Lady Airlie, noticed the Queen's innumerable personal touches and exclaimed. "It looks homelike already." The King, who had come in to join them at tea, smiled proudly and said, "Elizabeth could make a home anywhere."

Another visitor was a stocky young man in his twenties, his outward sleepy diffidence concealing considerable powers of concentration and drive, who set before them the revised plans for the Coronation. This was the Duke of Norfolk, who bore the responsibility as Earl Marshal of supervising all the vast ceremonial of State for the crowning of the King and Queen, though not its religious content. The date of the Coronation on May 12th, first fixed for the bachelor King, remained unchanged and the new King and Queen pleased everyone with the energy and enthusiasm with which they entered into the quickened tempo of preparation.

The firm of Handley Seymour, then the senior dressmaking establishment in London, was entrusted with the Queen's Coronation gown, while the rising Norman Hartnell was commissioned to design the dresses of the six Maids of Honour. The Royal School of Needlework undertook the task of providing the embroidery designs for the white satin gown, blending in

Victoria League, the Royal National Lifeboat Institution . . . these were but a preliminary handful of the organizations which the Queen was to sponsor, visit, inspect and foster with close and real interest.

It would have been unthinkable to have celebrated New Year— and such a New Year—without her brother David's close companionship, and it amused the King and Queen to devote the first issue of the *Court Circular* of their Coronation year solely to the announcement that "the Hon. D and Mrs. Bowes-Lyon had left Sandringham". Another private enjoyment was a visit to Newmarket to inspect the string of royal racehorses at Egerton House, which had passed to the King in the personal financial settlements with the Duke of Windsor. It is of interest that the royal couple visited Aintree that year when the Grand National favourite, Golden Miller, refused a fence and the classic steeple-chase was won by Royal Mail, a horse suitably sired by Royal Prince. The King and Queen were Lord Derby's guests at Knowsley and had the added pleasure of seeing the Molyneux Stakes won under the royal colours by the Sandringham-bred Jubilee.

There were other felicities. The first public engagement of the reign saw a drive into the East End on February 15th to open the new concert-hall and cultural centre of the People's Palace. The royal couple moved into Buckingham Palace the following day and that afternoon the Queen performed her own first solo engagement by visiting the textiles section of the British Industries Fair. There were diplomatic receptions, levees . . . so the reign slipped imperceptibly into the old traditional usages, the sturdy established rhythm. The Queen's own impress could be felt. She was not to be solely a cipher in her husband's shadow. When the first official dinner-party was held at the Palace, the names of the guests were not divulged. There was then to be more privacy, more reticence, in the new reign than the old. It is said that on their last evening actually spent at No. 145 the royal couple stole unobserved through the side gate into Hyde Park and walked there together for a time. The Queen had divined that one of her

Elizabeth felt at once that the limited power of a Queen Consort, as Mr. James Pope-Hennessy has pointed out, might best be defined as the power of doing good. The rôle would be largely as she made it: the moral strength of Queen Mary, the decorative impressement of Queen Alexandra, the charitable sweetness of Queen Adelaide, the domestic virtues of Queen Charlotte, each had achieved a different imprint. It can be seen, looking back, how admirably the new Queen was to blend them all.

King George VI told his Accession Council that he would take up his heavy task, "with my Wife and helpmeet by my side". Two days later, celebrating his forty-first birthday, he accorded his spouse the highest honour in his power by bestowing on her the Order of the Garter, the first Order of British chivalry. "He had discovered that Papa gave it to you on his, Papa's, birthday, June 3rd," the new Queen said in one of her little notes to Queen Mary, "and the coincidence was so charming that he has now followed suit and given it to me on his own birthday." Since Queen Mary also attended the family luncheon at 145 Piccadilly on the same day, this message seems to indicate the new Queen's intention to follow her mother-in-law's precept and commit everything possible to paper for the future benefit of history.

The Christmas break at Sandringham—where the King and Queen were technically Queen Mary's guests—served to soften the transition into the new reign, and powerfully reminded the country that the old traditional pattern would be resumed. Strictly, all the Queen's former patronages as Duchess of York were brought to an end at the Accession, although the majority would of course be resumed. Thus her patronage of the Silver Rose Ball to aid hospital funds was made known on December 16th, and her patronage of the Governess's Benevolent Institution on January 20th and four other patronages were announced from Sandringham the same week. The net rapidly widened. The preservation of old houses, the Red Cross, the Westminster Abbey organ fund, the Friends of York Minster, the Royal Horticultural Society, the National Council of Girls' Clubs, the

QUEEN ELIZABETH

I

THE POSITION OF QUEEN CONSORT in the British Constitution has never been officially defined. It is a rôle far more amorphous than that of the Sovereign, either a King or Queen Regnant, and yet legal authorities do not question that a Queen Consort shares to some extent in the royal prerogative. She is a subject of the Sovereign and may be guilty of treason against the Crown. At the same time she is legally entirely independent of her husband's control and can in some circumstances be regarded in law as a *femme-sole*. It is treason to compass the death of the Queen, as she is always normally known during a King's reign, but not to compass gentler designs against her except while she is the companion of the King. (This permitted the ungainly Queen Caroline her unfettered pleasures with an Italian 'Chamberlain' in Europe.) The Queen Consort shares all the protective privileges enjoyed by her royal husband, such as exemption from taxation and from the publication of her will. She is the first Lady of the land; her Solicitor General and Attorney are privileged to sit within the bar of Her Majesty's Courts; and she has her own separate officers of ceremony and legal officials: her Lord Chamberlain, Treasurer, Mistress of the Robes, her four Ladies of the Bedchamber, her four Women of the Bedchamber and so on.

Elizabeth Bowes-Lyon was the first consort Elizabeth since Elizabeth of York became the bride of Henry VII, and she was also the first British Queen Consort since Tudor times. Though interested in these historic and legal niceties, the new Queen

heard the farewell broadcast of Prince Edward, no longer monarch, from Windsor Castle. And what were her thoughts as the regretful voice sounded ... "I have found it impossible to carry the heavy burden of responsibility, and to discharge my duties as King as I would wish to do, without the help and support of the woman I love ... My brother ... has one matchless blessing, enjoyed by so many of you and not bestowed on me, a happy home with his wife and children ... "?

What were her thoughts? The next day, the new Queen wrote to Dr. Lang the Archbishop of Canterbury, "a long and delightful letter" as he called it:

"I can hardly now believe that we have been called to this tremendous task and (I am writing to you quite intimately) the curious thing is that we are not afraid. I feel that God has enabled us to face the situation calmly ..." And the letter was signed "for the first time and with great affection, Elizabeth R".

Back at No. 145, as on other occasions when her constitution was undermined by intensive nervous strain, the Duchess succumbed to influenza. The doctors forbade her to leave her room and all the pressing events of the abdication week were shaped in messages or in her husband's reassurances when he came to her bedside. Her maid, Catta Maclean, found her reading her Bible and particularly noticed afterwards that the place-mark denoted St. John, 14, the Chapter beginning "Let not your heart be troubled . . ." and ending "Arise, let us go hence".

At 10 a.m. on Thursday, December 10th, King Edward signed the instrument of abdication, witnessed by his three brothers. Technically he remained King until the Abdication Bill became law in Parliament. This occurred at 1.52 p.m. At that moment King George VI began his reign and his wife propped against her pillows in bed in London became Queen Consort and Empress of India.

Queen Mary was her first visitor. The old lady's first curtsey of State must have been a sad and intolerable moment. Waiting outside the room until Queen Mary left, Marion Crawford retained the impression that both women had wept. When the governess went in, the new Queen held out her hand. "I'm afraid there are going to be great changes in our lives, Crawfie," she said. The two talked of how the news should best be broken to the children and the effect upon their lives. "We must take what is coming to us, and make the best of it," the Queen added.

The governess did not realize that the passage into queenship had actually taken place, and her employer with typical simplicity did not tell her. It was perhaps the arrival of letters addressed to "Her Majesty the Queen" that told the story. Princess Elizabeth saw such an envelope on the hall table that afternoon when she had occasion to escort a friend to the door. "That's Mummy now," she said, in an awestruck voice.

All that day people gathered outside the house and cheered and the Queen at one time could not resist getting up to catch a glimpse of them from her window. That evening no doubt she

us. But there could be no question of my shirking my duty." Another thought had also dropped into the King's mind, that his younger brother was better fitted by traits of contentment and acceptance to be King. "I believe they would like someone more like my father," he had told Walter Monckton. "Well, there is my brother Bertie . . ."

It is surely a valid hypothesis that something like this argument was advanced in the Duchess of York's hearing and that frayed nerves caused her to speak in outraged protest utterly condemning the King's presumption. The gap in the records suggests the unconscious evasion and total repression of the one issue which the central participant could never bring himself to repeat or indeed perhaps face in quiet conscience. As one abdication commentator has pointed out, the human memory is a falible instrument, subject to promptings below the level of consciousness and never free from bias. The Duchess's words, if they were spoken, could not be admitted to the crucial flow of the King's thoughts. As Queen Mary was to write to the Duke of Windsor many months later, "You did not seem to take in any point of view but your own . . . I do not think you have ever realized the shock which the attitude you took up caused the family . . ."

And with the harsh and searing words of that one violent outcry—if one may assume that it occurred—the awful conflict was purged. The King returned to Fort Belvedere at 2 a.m. next morning. The Duke and Duchess of York went to Royal Lodge as usual that weekend, sadly realizing, as the Duke said, that they would have to do their best "to clear up the inevitable mess". The Duke, however, continually telephoned his brother at Fort Belvedere and presently drove over there at his bidding. "As he is my eldest brother I had to be there to try and help him in his hour of need," he wrote afterwards, with infinite charity. And of the Monday night the Duke wrote simply, "I went back to London that night with my wife." Two weeks were to pass before his wife next returned home to Royal Lodge and then she would no longer be Duchess of York.

record of the Duchess of York, the omissions that are so enigmatic and yet not beyond interpretation. On November 16th, for instance, the King went to dinner with Queen Mary, bent upon telling her of his irrevocable determination to marry Mrs. Simpson. With his mother that evening he found his sister, Princess Mary, and his sister-in-law, the Duchess of Gloucester. In his memoirs, the Duke of Windsor has described precisely how his sister-in-law reacted to the situation. "Never loquacious, she uttered not a word. When at last we got up to leave the table she eagerly seized upon the interruption to protest that she was extremely tired and to ask that she be excused." There is nothing here to block or restrain in the memory, no factors too hostile or unendurable to be expressed. On the more salient occasion of December 3rd Queen Mary asked the King to look in at Marlborough House "especially as I have not seen you for ten days". The King drove over and there found the Duke and Duchess of York, who had been dining with his mother. The Duke recorded in a memoranda, "David said to Queen Mary that he could not live alone as King and must marry . . ."

But was this all? The Duke of Windsor records in his memoirs that he explained to his mother, "I have no desire to bring you and the family into all this. This is something I must handle alone." In describing this same exhausting day, he recalls word for word a conversation with Mrs. Simpson's aunt and the talks with his legal advisers. Yet of the Duchess of York, there is, one might echo, "not a word". If she had made her excuses, as the Duchess of Gloucester had done, one might reasonably expect a passing mention of her presence. If she had no word to say to the brother-in-law who had become so unapproachable, it would have been explicable, though out of key with her spontaneity of character. In a necessarily personal interpretation, one can believe that the Duchess had something to say, and perhaps could no longer restrain what had to be said.

Of his conversation with Queen Mary on November 16th, the Duke of Windsor has written, "The word 'duty' fell between

But what was the constitutional difficulty, the real tension, of the crisis? It was not because Mrs. Simpson was an American or had been married before. It was simply the inflexible formula, now seen with ever more incisive clarity, that the King is the Head of the Church of England which holds that Christian marriage is indissoluble until death. He could not therefore accept the consecration of the Coronation with a marriage partner who had figured in the divorce court, regardless of her guilt or innocence.

So far the situation had been argued between the King and his Ministers, and the people were hardly aware of the existence of Mrs. Simpson, let alone the desperate inner turmoil of the Royal Family. At the end of November, the Duke and Duchess of York had to travel to Edinburgh, where the Duke was to be installed as Grand Master Mason of Scotland and the Duchess was to receive the Freedom of that ancient capital. Husband and wife by now were in an agony of apprehension and the Duchess had never sustained her husband's spirits or fulfilled her own rôle more brilliantly than when they faced the tumultous cheers of the Scots. King George VI's biographer, Sir John Wheeler-Bennett, has mentioned that a member of the Royal Family had written to Queen Mary, "Thank God that we have all got you as a central point, because without that point it (the family) might easily disintegrate". One discerns internal evidence that the writer of this letter may have been the Duchess of York. In her humility, she could not see that she and her husband, in the continuous tradition of the monarchy, were in reality themselves fast becoming the central strong point against the shock and strain. On December 3rd, as their train drew into London, they were both surprised and horrified" as they saw the newspaper placard blazoned with heavy print with the words, "The King's Marriage". So the storm had broken and the British peoples throughout the world were to shake with controversy—for or against the King.

We come now to the more significant gaps in the personal

Hardinge—that old friend whose sister, Diamond Hardinge, had been the Duchess's bridesmaid—called at 145 Piccadilly to tell the Duke of a new development. At an interview between the King and the Prime Minister, His Majesty had hinted for the first time that he might relinquish the Throne.

<center>III</center>

The bombshell had fallen, but for weeks, for a month, neither the Duke nor the Duchess of York could believe its explosive content. Fourteen years after marrying, with so many misgivings, into the Royal Family, the Duchess had come to accept that her older daughter might one day be Queen, as we have seen and she could philosophically face the prospect that, in far distant years, if anything happened to her brother-in-law, and he remained childless, her husband might first come to the Throne. These were the normal contingencies of life, of the shrouded and remote future. But the possibility the King could voluntarily relinquish his hard inheritance and in doing so thrust the burden of kingship on his younger brother, was a threat that remained inconceivable. "The Sovereign is not responsible to himself alone," Queen Mary had said, and her steadfast certainty of the obligations of a monarch at first reassured the Duchess that all might yet be well.

Her husband, in undimmed admiration for his brother, may have impressed his own undiminished conviction that King Edward would find a way out. "Look at him!" the Duke had said at a dinner-party, when the ominous reality of the constitutional crisis could have soured every course. "Look at the way he carries it off! Isn't my brother wonderful, isn't he wonderful?" Even the Duchess probably felt that the King would yield at the last to moral persuasion. But how? "I feel that we all live a life of conjecture; never knowing what will happen . . ." the Duke wrote to Queen Mary, and found himself explaining that every attempt to seek an occasion to reason with his elder brother had been in vain.

Strange to think of the destiny which may be awaiting the little Elizabeth, at present second from the Throne." But most evidential of all, on his departure, he was warmly told that he must come again "so that the links with Balmoral may not be wholly broken".

The King was in fact at Balmoral by September 18th. During the many new and often unacceptable new duties of his Accession Year he had often deputed certain ceremonies to the Duke and Duchess of York. Among these was the opening on September 23rd of the new Infirmary in Aberdeen. On the day when the Duchess and her husband performed this function, it appeared that the King was at Aberdeen railway station waiting to greet Mrs. Simpson. Whether true or false, the resulting gossip cast such a slur that the King felt bound, after his abdication, to bring a libel action. That legal dispute need not concern us. We have the authority of the historian, Professor Sencourt, however, that when the Duchess was invited to dinner at Balmoral she found that Mrs. Simpson received her, and we are told that the Duchess left as soon as she conveniently could.

Not least the Duchess's concern, was the strain and worry inflicted on her husband. The Duke was unhappy to discover that drastic changes were being made on the Balmoral estate without any question of consulting his opinion. He was constrained to write to his mother from Glamis that his brother "only told me what he had done after it was all over, which I might say made me rather sad". As the King grew more resolute in his stubborn determination to marry Mrs. Simpson, to marry her, that is, after her divorce—the prospect before the Duke of York became one of unrelieved gloom. In youth he had been subject to moods of melancholia which, his wife now sharply realized, could still bedevil his happiness. The Duchess, one remembers, was but thirty-seven and her husband four years older, and the young couple travelled back to London in October and faced a nightmare.

On October 20th the King's private secretary, Major Alexander

was the King's property, leased to the Yorks subject to His Majesty's "grace and favour". Miss Crawford certainly caught the lapse and had never admired the Duke and Duchess more. "With quiet and charming dignity they made the best of this awkward occasion," she says, "and gave no sign whatever of their feelings." Mrs. Simpson was nevertheless left with the distinct impression, as she noted, "that while the Duke of York was sold on the American station wagon, the Duchess was not sold on the King's other American interest". The knife-hard atmosphere was in fact obvious to a ten-year old child. Princess Elizabeth, who was just that age, had asked her governess uneasily "Who *is* she?" as soon as they were out of the room.

The family still followed Queen Mary's hope that the King's love would wear off, rather like the international repercussions of Mussolini's attack upon Abyssinia or Hitler's coup in the Rhineland and other unpleasant though ineffaceable facts. There had been other married women to engage the King's affections in the past, notably Thelma, Viscountess Furness, without any suggestion or whisper of morganatic marriage. *Morganatic*... One may suppose that this expedient fell into the Duchess of York's thoughts during the summer, as it did with others. It was clearly as unthinkable to the Duchess as to Queen Mary that, in the Queen's phrase, the lady "with two husbands living" could marry the King and be crowned Queen Consort. The monarchial crisis was in full momentum that autumn before the idea sank in. As late as August, when the King was cruising in the yacht *Nahlin* in the Adriatic with Mrs. Simpson and others there is evidence that the Yorks had not foreseen any problem that could not be resolved within the settled fabric of the reign.

It was unimaginable that the Throne could be shaken, or forsaken. The Duke and Duchess went to Glamis and Birkhall as usual that year and feelingly invited the Archbishop of Canterbury, Dr. Lang, to visit them at Birkhall. "A delightful visit," the Archbishop wrote. "They were kindness itself. The old house is full of charm and the Duchess has done much with the garden ...

Winston Churchill, Sir Philip Sassoon, the Countess of Oxford and Asquith, two members of the Government in Captain Margesson, the Chief Whip and Sir Samuel Hoare, First Lord of the Admiralty and, among others, Mrs. Simpson. From the list of guests in the *Court Circular* it was made clear to the world that Mr. Ernest Simpson was not present. Was this a deliberate oversight on the part of the King?

"He gives Mrs. Simpson the most beautiful jewels," Queen Mary had said. A mere man could notice those startling jewels "not only her sparkling talk but also her sparkling jewels in up-to-date Cartier settings", as Sir Samuel Hoare testified. If the presence of Mrs. Simpson of Baltimore so close to the heart of British affairs had caused speculation in America, her listing—as a married lady sans husband—in the *Court Circular* inflamed the rumours of "a royal romance". But more than those whispers dropped into the hitherto placid and now ruffled waters of Royal Lodge. Mrs. Simpson dropped in herself, though not by herself. The King brought her over one afternoon in a new American station wagon he wished to show off to his brother.

With or without malice, the Duchess of Windsor has said of this meeting with the Duchess of York, "Her justly famous charm was highly evident. Our conversation, I remember, was largely a discussion of the merits of the garden at the Fort and at the Lodge." This has an air of under-statement. The governess, Marion Crawford, brought the two Princesses in for tea "both so blonde, so beautifully mannered, so highly scrubbed", in Mrs. Simpson's impression. But Miss Crawford in the original text of her memoirs never published in England, mentioned the difficulties of the atmosphere, and noticed a "distinctly proprietary" manner in the visitor herself. It was stamped indelibly on Miss Crawford's memory that this "smart, attractive woman drew the King to the window and suggested how certain trees might be moved, and a part of a hill taken away to improve the view".

This gaucherie would have caused embarrassment in any English home, more so in Royal Lodge, which it should be recalled

She perhaps minded hearing of the King running to fetch Mrs. Simpson's nail-file, "unchanged in manners and love", as Lady Diana Cooper remarked. Irrationally she may have minded hearing of the King holding a successful "do" at Fort Belvedere, marching around the dining-table playing his bagpipes, while Court mourning still prevailed. And with her own deep religious feeling, she surely found herself sharing Queen Mary's disapproval of the "complications" of the King's private life.

On returning to London, the Duchess began helping the old Queen in the innumerable tasks of planning and arranging her move to Marlborough House. In those intimate hours, checking possessions and going through old things, Queen Mary must often have spoken of her concern, her fear even, of being asked to receive Mrs. Simpson, and no doubt confided to her daughter-in-law, as she did to her friend, Lady Airlie, her unreadiness to discuss the affair with the King, "I don't want to give the impression of interfering . . ." Concerned over Queen Mary's anxiety, unhappy that all was not going well, the Duchess may have minded even the simple defiance of old institutions testified in the King's inability or unwillingness to attend church every Sunday. And at this she had reason to ask herself if she were not being fuddy-duddy and old-fashioned. Compassionate and charitable, she could readily appreciate the crying need for adjustment, perhaps for a new approach. "It will be very good for me to pull myself together, and try to collect a little will-power," she wrote at this time.

In the planning, though as yet far off, lay the new King's Coronation and the question of whether the two Princesses should play any part in the procession. Of more immediate concern was the rôle of the Duke and Duchess of York at the King's official dinner-parties. The first was given to Mr. Baldwin as Prime Minister and the guests included Mr. and Mrs. Ernest Simpson. At the second dinner-party, besides the Duke and Duchess of York, the guests included the Marquis of Willingdon (until recently Viceroy of India) and his Marchioness, Mr.

his own Proclamation at St. James's Palace, peeping from a window in company with Mrs. Wallis Warfield Simpson. The Duchess had first met Mrs. Simpson at Fort Belvedere some two years earlier and knew of the King's growing emotion for her, although whether this were love or infatuation was then a matter of opinion. What the young Duchess could not realize was that the exemplar of her own domestic happiness was a nagging pain to the bachelor King caught up in his own predicament of love for a married woman.

The Duke and Duchess of York faced the new reign in a spirit of optimism and family co-operation. The Duchess foresaw that, since the King was unmarried, there might be new feminine duties to share with Queen Mary. It has become conventional to speak of royal duties but one might rather say 'responsibilities', for the duties of royal ladies are largely essays in service which they themselves have voluntarily created. As his brother the Duke of York's first task was to help the new King with family financial affairs and the settlement of their father's estate, and he first undertook to provide a report on how the extravagant running expenses of Sandringham might be reduced. While this took him to Norfolk, the doctors considered that East Anglia in March would be too chilly for the Duchess's convalescence and instead she went to Compton Place in the softer clime of Eastbourne, there to catch up with a heavy back-log of correspondence. Enjoying this respite, she evidently felt the need for a phase of 'retreat', a short time of withdrawal and adjustment to face the fresh trend of events.

"I am really very well now," she wrote to the royal physician, Lord Dawson of Penn, on March 9th, "and I think am now only suffering from the effects of a family break-up—which always happens when the head of a family goes. Though outwardly one's life goes on the same, yet everything is different—especially spiritually and mentally. I don't know if it is the result of being ill but I mind things that I don't like more than before..."

What was it, historians will enquire, that she *minded more*?

Scanning the front-page headlines that proclaimed the first of these visits, the average man in the street—of the older generation, at least—might have pondered what aunt-in-law and niece found to talk about for twenty-five minutes. A cartoon in *The Observer* showed the Duke and Duchess of Windsor engaged in an imaginary inquest, with the strong-chinned Duchess observing, "... and what she didn't seem to realize was that without me she wouldn't have *been* Queen". Yet this remark would have been truer still if the caller had been the Queen Mother. If we set aside the shock and distress that the abdication caused Queen Mary, or the strain of loyalties imposed on Princess Mary, the Queen Mother remains, one might say, the only other woman in the case. And her brother-in-law's abdication of the Throne for the love of a woman "with two husbands living" was undeniably the one incredible and totally unforeseen contingency that could have caused her dismay and deep-laid fear, particularly for her husband and ultimately perhaps anger beyond endurance, an anger that could not be contained.

The lacuna in the recorded facts is most noticeable wherever one might expect to find the then Duchess of York either contributing her feminine influence to events or else most deeply affected by them. We have to recognize that the true attitudes of Queen Mary and King George VI towards the family crisis were to be discovered only after their deaths. Yet in the long silence around the Queen Mother there are tracer elements that suggest neither a sensitive reticence of good feeling on the one hand, nor on the other a smokescreen imposed by the Queen Mother herself. The censorship may lie elsewhere, for in every human memory there lie truths too painful to be recalled.

II

We must return, then, to the first day of King Edward VIII's reign, when the Duchess of York, recuperating from pneumonia at Royal Lodge, learned that her brother-in-law had watched

detached retina of his left eye; and compassion in this medical emergency led to a revival in the Press of the often expressed opinion that the obvious disunity of the Royal Family should be brought to an end.

Although the Queen, Elizabeth II, had occasionally received her uncle at Buckingham Palace, she had not met the Duchess of Windsor since childhood. Since the Sovereign is the avowed Defender of the Faith, the Queen faces constant difficulty both in public and private in her relationships with divorced persons, and this may be a prime reason for what the Duchess of Windsor has called "the family-designed asbestos curtain". But as one protagonist asserted, not without a sprinkling of exaggeration, the moral issue was blunted by the presence in London of a blind old man and the woman who had been his wife for nearly thirty years.

Confined to the Palace with a chill when her uncle first arrived, the Queen had an opportunity to discuss the dilemma with her advisers. In every other sense, and especially in regard to the family, the Queen was particularly alone, for the Queen Mother was away on a visit to Jamaica, and Prince Philip and the Duke and Duchess of Gloucester were also absent on overseas tours. The Queen Mother, however, returned from the Caribbean on February 27th, and the Queen—after a delay imposed by medical advice on her uncle's condition—officially visited the London Clinic on March 15th, significantly accompanied by her private secretary, Sir Michael Adeane. This meeting with both the Duke and Duchess of Windsor was widely interpreted as an official recognition, a view on which some might demur. In the wake of the Queen, however, both Princess Marina and Princess Mary, the Princess Royal, were able to visit the Windsors, the latter only thirteen days before her tragically sudden death. The Queen also paid her uncle and aunt a second visit, this time merely accompanied by one of her assistant private secretaries, Sir Edward Ford. The Queen Mother was the only notable absentee, although her non-appearance caused neither speculation nor public comment.

Queen Elizabeth the Queen Mother on her sixtieth birthday with her three grandchildren, the Prince of Wales, Prince Andrew and Princess Anne

The Queen Mother and play producer Harold Prince leaving a performance of *The Pajama Game* at the St. James Theatre in New York, 1954

King George VI and Queen Elizabeth inspecting the bomb damage at
Buckingham Palace, 1940

Fox Photos

The moment of crowning, May 12, 1937

The Duchess of York and Princess Elizabeth, 1927

Parents and Princesses, December, 1936

The wedding of the Duke of York and Elizabeth Bowes-Lyon in Westminster
Abbey, April 26, 1923

Elizabeth and David Bowes-Lyon in minuet costume, 1909

Layfayette

Layfayette

At Glamis in costume, aged eighteen

Elizabeth Bowes-Lyon in her high chair, 1902

THE ABDICATION YEAR

I

IN ALL THE MILLIONS OF WORDS, the score of books, the serials and film-scripts that have been written about the short reign and abdication of King Edward VIII, the attitude of the present Queen Mother, the then Duchess of York, has never been discussed. The effect upon Queen Mary can be discovered from her journal and letters written at the time. The Duke and Duchess of Windsor have each published their separate narratives of events. The agonized strain upon the younger brother, King George VI, as he passed from the rôle of the Duke of York to the acceptance of the Crown, is recorded in his official biography and is implicit in his own day-to-day chronicle of the last critical week. Politicians and publishers, archbishops and statesmen, have all contributed sufficient evidence of their own interplay upon the scene. Yet in the documentation of character, motives and incidents, that have accumulated through some thirty years, the student becomes aware of a citadel of silences and secrecies still firmly walled around the Queen Mother.

There are understandable reticences and obvious omissions to be penetrated. Quickest hedges of tact or intentional taboo still confront the non-partisan who must attempt to record events without undue reserve. It will perhaps be convenient, by way of illustration, to step aside from chronological sequence and first note the minor sequel of events in 1965. At the end of February the Duke and Duchess of Windsor flew to London and the Duke entered the London Clinic to undergo a second operation for the

together, their solitude and companionship a curious foreshadowing of the future.

The Duchess made fair progress, although another and more favourable bulletin was not issued until December 30th. Her convalescence in the New Year was slow. On January 16th a message was received from Queen Mary saying that the King was unwell and that she would like Bertie to help with the houseparty. The Duchess agreed with her husband that he ought to go and on his return, three days later, he had to break it to her that the King was gravely ill and might not live. Next came an urgent message that the Duke should return to Sandringham and he hastily had to leave her again, and flew down to Norfolk with the Prince of Wales. Alone and anxious at Royal Lodge with Lady Helen Graham, the Duchess of York heard the continual knell of the radio bulletins solemnly intoning that the King's life was drawing peacefully to its close. Shortly after midnight the telephone rang. It was her husband to tell her the final news and, in her grief for "Papa" the Duchess perhaps forgot that her own husband was now only a heart-beat from the Throne.

know of the increasing devotion of the Prince of Wales to a Mrs.
Wallis Simpson.

v

On May 6th, 1935, King George V and Queen Mary celebrated
the Jubilee of the twenty-five years of their reign. With London
crowded with royalties and Commonwealth representatives, it
was a phase particularly busy with responsibility and entertain-
ment for the Duchess of York. Themselves tangible recipients of
the tremendous upsurge of loyalty, the Duke and Duchess repre-
sented the King at the Jubilee celebrations in Edinburgh, and the
Duchess and Princess Elizabeth shared in the state drives to the
outer regions of London. At the Court balls and the Ascot festivi-
ties that year, the Duchess was, one might say, the Queen's right
hand.

The summer brought the engagement of the Duke of Glou-
cester to Lady Alice Montague-Douglas-Scott, a daughter of the
seventh Duke of Buccleuch, a romance that the Yorks had done
their utmost to foster. In December, in the contrast of events,
the King's sister, Princess Victoria died, and the Duchess sorrowed
greatly for the old lady, who had been Princess Margaret's god-
mother.

Her deep sympathy for the King, coupled with the fog and
chill of the funeral at Windsor, alike reduced her own spirits
to a low ebb. On December 16th it was announced that she was
suffering from a chill. Three days later, the bulletins declared that
she was making satisfactory progress towards recovery from an
attack of influenza; and the children went to Sandringham
with their grandparents. In reality, the influenza developed
into pneumonia and the Duchess was seriously ill at Royal
Lodge.

Her Christmas dinner was an invalid meal on a tray in a clinical
atmosphere of doctors and nurses, but fortunately she had turned
the corner and her husband could keep her company in the sick-
room. It was the first Christmas they had ever spent alone

Lodge—the Duchess perhaps with a book, sometimes at the piano, occasionally playing patience. If the business of tickets were arranged, they could sometimes stroll under darkness through the park and slip unrecognized into the cinema at Marble Arch. Even dinner parties were comparatively rare.

The Duchess was worried about her mother's health. With her own larger domestic staff—Alah, Bobo and Crawfie for the children alone—the summer visits to Glamis Castle tended to shorten, and summer holidays were spent mainly at Birkhall on the Balmoral estate. Birkhall is a stone-built stuccoed Scottish house of 1715. Hospitably extended, it is still the Queen Mother's Balmoral home, with guests constantly coming and going under the broad pine-log porch. In the nineteen-thirties it was a paradise of superb Deeside views, and moorland air tinged with woodsmoke, of Landseers and pinewood furniture, oil lamps and candlelight. Royal Lodge, too, was a haven of quiet comfort, improving each year in domestic perfection. The Duke and Duchess had kept two of the old bedrooms on the ground floor, while the children and guests had their rooms upstairs. Edging the terrace, the Duchess caused an elaborate ornamental screen fence to be erected, ensuring perfect privacy. She did not mind taking the children along with her on suitable public engagements and trained them for their public role at an early age. But the terrace fence of Royal Lodge, later replaced by stonework, was a symbol of the absolute reticence of her own private life.

The Yorks' ideal family life, however, became widely known to the public. "The home at the heart of the Empire" was one journalistic phrase attaching to No. 145, and a little knot of sightseers usually clustered on the pavement, as if waiting would evoke some magic at the shrine. As the red London buses rumbled past Hamilton Gardens, passengers craned for a glimpse of "the Little Princesses" at play in the sooty laurels and rhododendrons. The popularity of that phrase "the Little Princesses" was itself an evocation of the special virtue and domestic example of royalty. Focusing a devoted attention on the Yorks, the public did not

games of rummy and racing demon every evening with her
daughters from five till six, the hilarious splashing of bath-time,
and the winter afternoons when the children were learning to
dance reels and the Duke and Duchess if they had a free hour
would join in. It was as if the Duchess were trying to repeat her
own care-free and affectionate childhood, and even, if that were
possible, to heighten it. As with her own mother, she taught
Princess Elizabeth to read, taught her the psalms and collects of the
old Scottish paraphrased version and seemed resolved that rules
and discipline should be left to others. If Lady Strathmore had
been unable to relinquish authority to governesses, the Duchess
evidently made good this failing. "No one had ever had employers
who interfered so little," Miss Crawford tells us. The Duchess,
she found, left much to her judgment and seemed not over-
concerned with higher education. The heightened responsibility
indeed worried the young governess so much that she was driven
sometimes to seek Queen Mary's advice and suggestions.

The Duchess spent those fleeting years of her early thirties in a
placid dream. In royal duties she never faltered, in the incessant
correspondence with her patronages, her charities and societies
and the resulting engagements, in the visits with her husband to
Wales and Plymouth, Southwold (for his annual boys' camp) and
the Midlands. The Duchess flew for the first time on a visit to
Brussels with her husband in 1935. At No. 145, the morning inter-
lude with the children was followed by the office hours with
Helen Graham or Mrs. Bowlby, Harold Campbell, who was
technically the Duke's private secretary, or Jimmy Cole, who
managed the household business and accounts. A sea of photo-
graphs, yellowing in the files, enshrines the Duchess's public
afternoon activities, but many of the negatives are already lost,
and the more informal day-to-day records are shrinking fast. In
the evenings, journalists reported, the Duke and Duchess some-
times went out, to Ciro's or the Mayfair Club. But more often
they sat at home, on either side of the fireplace, the Duke plying a
needle—he made a dozen chair covers in petit point for Royal

that Princess Elizabeth was rising six. From Rosyth, where she was stationed with her husband, Lady Rose Leveson-Gower recommended a young Dunfermline governess, Marion Crawford, who had been taking her own daughter for a short session every day. The Yorks were impressed because they heard that Miss Crawford performed prodigies of walking, and they wished to have someone young and active who could enjoy playing and exercising with their children. They drove down from Glamis to meet her and for the first time, as Miss Crawford said "I met that long cool stare. The little Duchess, she thought, had the nicest, easiest, most friendly of manners. My whole impression was of someone small and quite perfect." Two weeks later, Miss Crawford's acceptance of the post was discussed through Lady Rose as intermediary. "Why not come for a month," the Duchess wrote, "and see how you like us and we like you?"

Long afterwards, when she had married and concluded her services, Miss Crawford wrote—or collaborated in writing—an account of her fifteen years with the Royal Family, and the sheen of feminine journalism imposed on her memoirs created the adjective 'Crawfie-ism' for saccharine, over-sweet and perhaps over-intimate accounts of royalty. If it seemed overly sentimental to state with precise truth that the Duke and Duchess were "devoted to each other and very much in love" after ten years of marriage, then Miss Crawford might be held guilty. One powerful and patriotic inducement in writing her reminiscences was that Britain at that time was direly short of dollars, and she readily earned thousands of dollars for world rights from an American magazine. It was an unforeseen and unexpected flaw that the Americans sold back the British rights to an English magazine for almost precisely the sum of dollars she had earned. The fact remains that 'Crawfie', as she became known to her pupils, has given us a valuable picture of royal domesticity.

To Miss Crawford we chiefly owe the authentic record of the children's high jinks every morning in their parents' bedroom "no matter how busy the day, how early the start"; the Duchess's

time interest. The clearance of weeds and scrub of Fort Belvedere was repeated though with different subtlety. In the house the saloon was cleared of its partition walls and the original proportions restored. With the conservatory newly painted in white and the drab stucco of the house freshly washed in a shade of pink rose, Royal Lodge immediately assumed a pristine air. To the Duchess the presence of a small chapel near the entrance gates was also particularly welcoming. Although the family practice of morning prayers was long since discontinued, there have been few days in her life when she has missed Sunday morning services, and it was like old times to have a family chapel of her own.

It was pleasant, too, to pop over to the Fort, without strain on her brother-in-law's hospitality. One wintry afternoon when the lake in Windsor Great Park, Virginia Water, was frozen over, the three royal brothers, David, Bertie and George, suggested skating. The Duchess had never skated before but boots were unceremoniously thrust on her feet, kitchen chairs was provided for support and the Duchess and David's current lady, Thelma Furness, were off on their awkward glides and swoops in gales of laughter. "The lovely face of the Duchess, her superb colouring heightened by the cold, her eyes wrinkled with the sense of fun never far below the surface, made a picture I shall never forget," Lady Furness wrote.

Queen Mary also enjoyed paying visits to Royal Lodge—when the old Waterloo Bridge was being demolished she bought a stone pedestal to grace the Lodge gardens—and Prince George, Princess Mary and the Mountbattens came. If the staff sometimes suffered from an embarrassment of visitors, the Duchess for her part delighted in glowing hospitality.

IV

Early in 1932 the Duchess of York was concerned with the emerging problem of the education of her elder daughter. Probably Queen Mary had dropped the smallest of judicial hints

an extremely secluded house within a fenced enclosure of oak coppice and dense yew hedges. King George IV had used the Lodge as a private bower for his probably platonic friendship with Lady Conyngham. At his command Nash had embellished it with an octagonal conservatory, and Jeffry Wyattville with a lofty Gothic saloon. Within this thatch-roofed folly, King William and Queen Adelaide subsequently enjoyed picnics and Queen Adelaide draped the conservatory with chintz to form a shady marquee. Various tenants had made alterations and additions. The house had been single-storeyed until Sir Arthur Ellis, chief equerry to Edward VII, added an upper floor of four bedrooms and a bathroom to the four bedrooms and two bathrooms already existing on the ground floor.

The ultimate result was unsightly. The Duke and Duchess of York had to traverse a long glass greenhouse to reach the front door and they were faced on every side with gaping lavatory-pans and old-fashioned bath-tubs. The best room in the house, the Wyattville saloon, had been divided into three small rooms; the ceilings and skirtings showed dampness and the dilapidated exterior was of a dingy and undistinguished hue. But the Duchess envied the privacy and solitude of the grounds and saw the possibilities of restoring and improving the house itself. "I think it will suit us admirably," the Duke reported guardedly to the King. Whereupon the King promptly replied, "I am so pleased to hear that both you and Elizabeth liked the Royal Lodge and would like to live there . . ."

Royal Lodge, as it became known, was to become the Yorks' true family home, and it is still the Queen Mother's chief home today. The alterations and improvements that she desired could not be set in hand immediately. The 1931 financial crisis of economy and restriction fell on the nation; the King drastically pruned his Civil List with similar cuts imposed on every member of his family, and the Duke had to sell the six horses of his hunting stable. But the rehabilitation of the grounds of Royal Lodge thus became the young couple's unextravagant and principal spare-

Wales, Princess Victoria, Princess Ingrid of Sweden, the baby's aunt, Lady Rose Leveson-Gower, and David Bowes-Lyon. The Duchess also heard with amusement of the phenomenal number of girl babies registered by their surnames only during late August and early September while parents awaited an announcement of the names of the royal baby to be used for their own.

III

The royal couple were far from aware that the six most settled years of their lives were heralded by Princess Margaret's arrival. A serious plan developed indeed for the Duke of York to go to Ottawa as the next 'G.G.' or Governor-General. In retrospect, one realises that it would have been a highly popular move if the Duke and Duchess had resided in Canada with their two little girls. The King's advisers, Sir Clive Wigram and Lord Stamfordham, both approved the prospect but it was disallowed by Mr. J. H. Thomas, the Dominions Secretary of State in the Labour Cabinet, much to the Duke and Duchess's ultimate relief. With a sense of reprieve the Duke resumed his hunting with the Pytchley that winter and the Duchess could preside happily in her own nursery world with Alah and Bobo (Miss Margaret Macdonald, then an under-nursemaid in the household). The Prince of Wales had begun to plan his garden at Fort Belvedere and Saturday afternoons were spent in his company hacking at a jungle of saplings and brambles. The sharp billhooks and hatchets caused the Duchess great misgivings and she was apt to embarrass the toilers with cries of 'Do be careful! Darling, do mind!'

The 'grace-and-favour' enjoyed by one of the King's sons could not long be withheld from another. The Duke and Duchess of York visited Paris in July, 1931 primarily to see the Colonial Exhibition, and on returning they began house-hunting in the neighbourhood of Windsor and Ascot. It happened that Mrs. Fetherstonehaugh, the widow of King George V's racing manager, had but recently vacated the Royal Lodge in Windsor Great Park,

splutter on the telephone, "You haven't given us much time!"
The Home Office couple set out for Glamis munching sandwiches,
motoring towards a sunset so stormy and splendid that Mr.
Clynes began rapturously quoting poetry.

The two arrived at the Castle at nine o'clock with time to
spare, and at 9.30 a baby girl was born. The anticipated Prince
was a Princess, not to be less loved for that. As Mr. Clynes
recalled, somewhat in disappointment, "in an ante-room where a
few privileged persons were waiting, I was shown a baby girl".
The event found the fond parents so unprepared that they had
no girl's name in readiness. There could be no question of
switching 'Charles' to 'Caroline' or 'Robert' to 'Roberta'. After
several days of discussion, it was August 27th before the Duchess
of York wrote to Queen Mary at Balmoral, explaining her choice
of Ann Margaret. "Ann of York sounds pretty, and Elizabeth
and Ann go so well together. I wonder what you think? Lots of
people have suggested Margaret, but it has no family links really
on either side."

The historical argument favouring 'Margaret' was that there
had been three Scottish queens of that name, and a larger quota
of princesses. If Margaret were declined, the Duchess decided that
the name Rose would honour her sister. On August 30th, how-
ever, Queen Mary visited Glamis—"E looking very well and the
baby a darling"—and broke the surprising news that the King
thought the name Ann would not do.

The parents, intensely disappointed, had no option but to
observe the King's wishes. It is evident that the Duchess decided
to give her father-in-law less opportunity of renewed disapproval,
for on September 6th she wrote to Queen Mary, "Bertie and I
have decided now to call our little daughter 'Margaret Rose' ...
as Papa does not like Ann. I hope that you like it. I think that it is
very pretty together."

The King raised no further objection and the Archbishop of
Canterbury christened the baby in the private chapel of Bucking-
ham Palace on October 30th. The sponsors included the Prince of

fairy tales. The Duke of York once had occasion to write to his elder brother, "There's a lovely story from the East End that in the event of anything happening to Papa I am going to bag the Throne in your absence ! ! ! " But bagging the Throne was the very last contingency the Yorks desired in the pleasant pattern of their lives.

The Duchess passed the time of her retirement very happily with weekends at St. Paul's Walden Bury, with a visit to old Princess Victoria at Coppins, and sociable occasions with her brother, "the other David", and her sister-in-law Rachel in their new house in Bryanston Square. Installed in readiness at Glamis Castle in July, it became obvious that the doctors had miscalculated and a new estimate anticipated that the baby would be born between August 6th and 12th. The Home Secretary, Mr. J. R. Clynes, and the worried and over-imaginative Mr. Boyd came to lunch at Glamis on the 6th, but the tranquil Duchess was clearly certain in her own mind that the doctors were not quite right again. It had been arranged that Mr. Clynes and Mr. Boyd, the heavenly twins, both small in stature, should stay at Airlie Castle, with a direct telephone line to Glamis and a motor-cycle dispatch rider in readiness day and night in case the wire broke down.

No word came. On the 10th the two consulted with Sir Henry Simpson, the obstetrician, at the Glamis gates but declined to enter the Castle for fear of embarrassing the Duchess. The waiting husband and wife felt sorry for Mr. Clynes. "I always wanted him to come up when he was sent for, which would have been much simpler," the Duke wrote to Queen Mary. On the 14th, Mr. Boyd refused to leave the telephone but another week passed and on the morning of August 21st Lady Airlie found him "wild-eyed and haggard after sitting up all night". Mr. Clynes took things more calmly, enjoying his prolonged experience of Scotland's stately homes. That evening, just before dinner, the Glamis household was thrown into a flurry at suddenly learning that the baby might be born within an hour. Admiral Brooke, the Duke's comptroller, telephoned Mr. Boyd and heard a

have stumbled at once into the rash supposition that the infant would be a boy. On simple averages it was a reasonable expectation, and boys preponderated in both the Windsor and Strathmore families. Any psychologist can detect the unconscious wish for a son to lift the burden of future sovereignty from their delectably pretty daughter.

Despite inconvenience for officials and accoucheurs, the Duchess was moreover stubbornly determined that the boy should be born under her father's roof at Glamis Castle. It could be her woman's privilege to embellish the family home and its history with the birth of a future king. With every year it seemed less likely that the Prince of Wales would settle down, although he was now shaping a bachelor country home of his own at Fort Belvedere. Something that the Prince of Wales had said eight years before was perhaps beginning to echo in insistent whispers in the Duchess's mind. When she had been wondering whether she should marry the Duke of York, the Prince had remarked "You had better take him, and go in the end to Buck House."

The thought had so daunted her that she had repeated the phrase to her father. And in 1930, once the Yorks began to take it for granted that David, the Prince of Wales, might never wed, so it became a viable prospect that after forty or fifty years, however brief their own sojourn in Buckingham Palace, their son might inherit the Crown. Others had come to the same conclusion. In particular, the romantic Ceremonial Secretary at the Home Office, Mr. Harry Boyd, was particularly anxious that no shadow of a Bedchamber Plot at Glamis—or, indeed, anything untoward—should raise any question affecting the legal succession to the Throne. So concerned was he, in fact, that he even underscored in red ink, ready to show the Duchess, a passage in a book giving an account of the birth of the son of James II and his Queen and the rumours that a changeling prince had been substituted concealed in a warming-pan. It effectively demonstrated, thought Mr. Boyd, how careful one had to be. The creeping industrial depression of the 'thirties enhanced the popularity of such glossy

for, during the Yorks' residence in Holyroodhouse, the King's
health again caused medical concern. The ancient Scottish royal
palace must also have seemed gloomy and chill to the Yorks
after the amenities of Glamis or Birkhall, that small and sunny
house near Balmoral that they enjoyed every summer. Whiffs of
malt drifted from a nearby brewery and it became apparent that
the Holyroodhouse kitchens were somewhat short of glass and
linen. But the Duke and Duchess made light of these difficulties.
The Duchess spent a little time alone in the Long Gallery studying
the alleged royal portraits by Jacob de Wet, the Dutchman whose
paintings were also hung in the Glamis Chapel. She was at her
best at a children's garden-party and the *Scotsman* poetically
proclaimed of her beauty and grace that she might make the
ghost of Mary, Queen of Scots feel jealous. So the little Duchess
added to her laurels, and was hardly aware of her own personal
enhancement, so concerned was she with the pleasure and pride
of her husband's success in the Scottish ceremonies of the General
Assembly.

<center>II</center>

When the nineteen-thirties dawned, the Duchess of York may
well have wondered—like her mother thirty years earlier—what
the new decade would bring. The prime item on the engagement
book was a visit to Rome in January for the wedding of the
Crown Prince Umberto of Italy to Princess Marie José of Bel-
gium. The Duchess had eagerly looked forward to renewing
her acquaintance with Italy and unluckily was laid up with
bronchitis, her old susceptibility, and the Duke had to go alone.
In her company he might have found the confusion at the
wedding a glorious rag. Without her he could hardly contain
his irritability. But when he returned his wife was able to impart
the wonderful news that she was expecting another baby.

Just as Princess Elizabeth had so nearly arrived on her parents'
wedding anniversary, so it seemed that the newcomer might be
on time for his mother's thirtieth birthday. The parents appear to

grave illness with an infected lung brought anxious reminders for the first time that the Prince of Wales might not marry and might ascend the throne a bachelor, and the Yorks suddenly visualized a distinct prospect on which their daughter might be heiress presumptive to the Crown. By March, 1929, the King was convalescing from an operation and the Duke and Duchess of York were able to go to Oslo with untroubled minds for the wedding of Crown Prince Olav to Princess Martha of Sweden. Another happy event had been the wedding at St. George's, Hanover Square, of Michael Bowes-Lyon to Elizabeth Cator, a match between her brother and her school friend that the Duchess of York had long fostered. That Spring, David Bowes-Lyon also married Rachel Spender-Clay, and so was sealed the last wedding of the immediate family circle.

An equally agreeable event both to the romantic and the religious facets of the Duchess of York's personality was the decision that her husband should serve as Lord High Commissioner to the General Assembly of the Church of Scotland later that year. Since the year 1561 the monarch had always appointed a representative to the General Assembly but for nearly three centuries, no member of the Royal Family had been appointed to that office. The year 1929 moreover was to see the union of the Church of Scotland with the Union Free Church of Scotland after nearly a hundred years of division, and the Duke of York's role as the Sovereign's deputy implied that he would twice take up residence in royal state with his wife in the Palace of Holyroodhouse.

The citizens of Edinburgh were delighted to welcome "the girl from Glamis" and her husband and regretted only that they had not brought the three-year-old Princess. "Not that they would have seen her but they would have liked to feel that she was here," the Duchess wrote to Queen Mary. "It almost frightens me that the people should love her so much . . . I hope she will be worthy of it, poor little darling."

She had renewed cause to fear the lurking shadows of the future

THE YEARS OF CALM

I

ON THEIR HOMECOMING IN 1927, the Duke and Duchess of York moved at once into No. 145 Piccadilly and several days were spent tugging and moving around furniture that had proved not quite in position. The tusks of the elephants that the Duke had shot in Uganda found a place on either side of the hall and an acceptable Office of Works carpet mushroomed towards the stairs, into the house that the Duchess regarded as the first home of her own. Her wedding gifts and furnishings basked in a far more congenial environment than at Richmond. The décor typified its period, with the brocade or chintz slip-covered arm-chairs, the fringed lamps and bronzes and gilt-framed mirrors, the sofa tables, lacquered cabinets and Persian carpets. In the draw-ing-room an immense chandelier hung from the gilded pattern of the ceiling, and the mouldings of the white painted double doors were picked out Palace style in gold. But the Duchess made the atmosphere one of home; the double-glazed windows had hushed the traffic and it was a house of pleasant sound, Australian canaries singing near a garden door, a croaking parrot, a Georgian clock with a serene carillon of sixteen bells and, especially later on, children's voices drifting down from the nursery floor, echoing and magnified beneath the glass dome.

Number 145 remained the Yorks' London home for nearly ten years. They could not conceive circumstances in which they might find it necessary to leave, although the latent possibilities of the future crept frighteningly nearer in 1928. King George V's

by nightfall. The delay curtailed their stay at their next port of call when, by a printer's error, it was officially announced that the Royal visitors could not stand more than two days in Mauritius. In Malta Lord Louis Mountbatten had arranged for a Sunday afternoon cruise on his yacht *Shrimp* and his guests long remembered with glee that the anchor fouled and they could not get clear. At Gibraltar the Duke and Duchess were equally delighted to discover that the *Renown* was to be played out of harbour with 'Now thank we all our God'.

The Duke and Duchess of York returned to London on June 27th to face an unexpected loyal demonstration by Londoners agog to show that they considered the Royal Embassy had "done it well". The cheering crowds still called for them outside Buckingham Palace and the radiant Duchess, unable to part for a moment with her new-found baby daughter, stepped out on to the balcony with her fourteen-month-old Princess in her arms.

so many inquisitive fingers had touched the Duchess's frock that it was unfit for further use. By the time Adelaide was reached, curiosity had turned to more friendly acceptance, so that two children were able to walk through the grown-ups and hand the Duchess two threepenny bits "for Baby Betty's money box". The whole continent also blossomed with "Duchess hats" until every other woman wore a hat with a turned-up brim and feathers to one side.

But the climax of the tour lay, as the Duchess had foreseen, in the ceremonies and speeches for the opening of Parliament in Canberra on May 9th. She rigorously made sure that practice sessions were set aside every day when she could help her husband with his speech exercises and in the eventual reading of his two long speeches and the message from the King, the Duke did not hesitate once. It may be apocryphal that his wife was overheard to say, "Darling, how splendid. I am so proud of you!" But the broadcast speeches emotionally stirred Australia and the Duchess shared in the reflected glory. "The Duchess has had a tremendous ovation," the Governor of South Australia, Sir Tom Bridges, wrote to King George. "She leaves us with the responsibility of having a continent in love with her."

The tour had put the final polish of graduation on the Duchess's royal training. She had experienced the full range of public events, met every kind and condition of man and encountered nearly every occupational hazard of the royal profession, from the physical pressure of crowds after the cordons had broken to the unexpected peril of fire at sea. On the homeward voyage to Mauritius, flames broke out in a stokehold aboard *Renown* and an inferno of fire and gas fumes was fought for ten hours, with every risk of the main oil supply catching alight and exploding. The heat was so intense that, among other casualties, a sailor had his feet scalded on deck.

In the fog of oily steam that shrouded the ship, the Duchess seemed unperturbed at the prospect of transfer to a lifeboat in the middle of the Indian Ocean. Happily, the fire was extinguished

Australia similarly enhanced the popularity of the tour by providing a heaven-sent opportunity at the very moment when it seemed that the news interest might collapse from sheer fatigue of enthusiasm. The Duchess had kept watch without result for other invalids from Glamis. Then as they were approaching Melbourne from Hobart, Pat Hodgson, the secretary, triumphantly produced a letter from a young Tasman ex-engineers officer, living in Melbourne, who said how happily he remembered his war leaves spent at Glamis Castle and mentioned diffidently that he hoped to catch a glimpse of Her Royal Highness at the official ceremonies. The Duchess remembered him well and the wartime letters they had exchanged, and so he was telephoned and invited to Government House to meet her. It was a stroke of good public relations and for the Duchess, an hour of genuine pleasure, so far from home, recalling the old days, the singsongs around the piano, the fun of raiding the hothouse for grapes when the gardener was engaged elsewhere, the parting gifts at breakfast-time on those drear wartime mornings. It was arranged that the young man should attend the State Ball at Government House with his wife that evening. And so it came about that the Duchess opened the ball first by dancing with the Governor-General and next with the Prime Minister and then with an ordinary civilian "with no signs of glory", a gesture superbly acceptable to the Australians, so prone to regard the royals as would-be idols who needed debunking and all the more delighted to find they were human.

Princess Elizabeth's first birthday was observed in Melbourne with a salute of naval guns but the Duchess was touched at the interest everywhere displayed in her baby daughter. "It is extraordinary," the Duke wrote home, "her arrival is so popular out here. Wherever we go, cheers are given for her as well, and the children write to us about her." Pat Hodgson, Lady Cavan and Mrs. Little-Gilmour jointly coped with the letters, the requests for photographs of "Princess Betty", and the constant inflow of gifts that had to be acknowledged. At a garden-party in brash Sydney

individuals in the crowd and really looking at them. People would then say with delight "She looked at me!", infecting the whole throng with pleasure. By chance the Duchess singled out in this way in Auckland a notorious local Communist agitator.

"I've done with Communism!" he told the Prime Minister, Mr. Coates, the next day. "I was in the crowd with the wife, and one of the children waved, and I'm blest if the Duchess didn't wave back and smile right into my face. I'll never say a word against them again. I've done with it for good and all."

It pleased the New Zealanders that she drew the Duke's attention to twins, and played up to the children—it was widely thought that she inspired the Duke's phrase, "Take care of the children and the country will take care of itself"—and in addition proved herself, as soon as she had the free time, a proficient angler. Trout-fishing in Lake Taupo she landed a seven-pounder and, trying for schnapper in the Bay of Islands, she caught seventeen out of the twenty landed in her boat. In Wellington it was perhaps a matter of equal luck that she walked towards a familiar face in the crowd and it proved, of course, to be one of the wounded soldiers whom she had known at Glamis. "She glows and warms like sunshine," one of her excited admirers wrote at this time. But the unaccustomed strain of the tour told upon her and, just as the South Island was reached, the Duchess succumbed to tonsilitis and the doctors insisted she should return to Government House, Wellington, and rest.

This verdict was a blow to the Duke who had modestly thought all along that the crowds were cheering his wife rather than himself. Continuing the programme alone, he gained confidence from finding that the crowds still welcomed him sympathetically. It was ten days before husband and wife again met and then the Duchess was on the *Renown* in stormy seas near the port of Bluff, watching the perils of the Duke's transfer from a harbour tug. "I was glad to be on board," she wrote, "when I saw my husband being thrown—literally—from the bridge of the tug onto our quarter-deck."

of the Caribbean or was proffered the ceremonial kava bowl of
Fiji, her parents were there first. Long before Elizabeth II began
her hand-shaking marathons, her parents greeted two thousand
guests, mainly coloured, at Jamaica's Government House, and the
Duke and Duchess of York were the first royal couple to pass
through the Panama Canal. In the initial phase the journey was,
however, clouded by sadness. The *Renown* sailed outwards via Las
Palmas and, in mid-Atlantic, word was brought to the Duchess
of the death of her dear friend and former bridesmaid, Diamond
Hardinge. It was a comfort that, of the two ladies in attendance
with the Duchess, Lady Cavan and Mrs. John Little-Gilmour, the
last was nearly as old a friend and could share her sorrow. This
mournful news edged with irony the jubilation of the first land-
fall at Kingston, Jamaica, and the Duchess felt she could not dance
at a ball on the second night and made her excuses.

This sombre *leitmotiv* of the overture was repeated in muted
pattern in the Pacific. The party visited the Marquesas, where the
Duchess was crowned with a chaplet of red coral and a day or two
later, south of Samoa on February 13th, she awoke to be told that
the bandmaster of the Marines had died during the night and
was to be buried at sea that day. The strains of Chopin's Funeral
March thudded mournfully through the ship: twenty-five years
to the day before another band of the Marines would rehearse
that dirge in preparation for the funeral of a king. If a message
was written in the surf, it could not be discerned. A week later a
private telegram arrived from King George and Queen Mary,
"We know that both of you will do everything to secure the
success which has already attended your efforts" and within two
days the *Renown* steamed into Auckland Harbour in a blinding
rainstorm.

In every royal progress there comes, early on, some small
emblematic incident that seems to set the tenor of the whole. On
the first afternoon in Auckland as they moved through the crowds,
the Duchess practised a technique of her own which she described
to Mrs. Eleanor Roosevelt, the simple method of picking out

to undertake the tour duly recognized, the itinerary then lay open to question. As originally proposed, the Duke and Duchess would have been plunged into the heavy formalities of Canberra at the outset, and a more leisurely tour of Australia and New Zealand was to follow. It upset a few pundits to have this plan reversed but the Duchess saw that the opening of Parliament should form the proper logical climax of the tour, and she had her way. It was the first time that a royal lady had taken part in such a tour since the visit of Queen Mary as Duchess or Cornwall and York in 1901. As the autumn of 1926 deepened into winter, the Duchess became immersed in preparations and realized with greater clarity what was involved.

She had known from the outset that it would mean long heart-wrenching separation from her baby daughter. We have a glimpse of her kneeling on the floor in the morning-room at No. 145 playing with her baby on a couch, the infant's hair "very fair and beginning to curl charmingly". During the tour, the little Princess Elizabeth was to spend her time alternately with her Strathmore and Windsor grandparents while her young mother made do with messages and photographs. The royal travellers were to sail from Portsmouth on the battle-cruiser *Renown* on January 6th, 1927, and when taking leave of her baby at last the Duchess was almost in tears. "I felt very much leaving," she wrote. "The baby was so sweet playing with the buttons on Bertie's uniform that it quite broke me up."

v

The pattern of a royal tour, the exotic ceremonies of welcome, the civic festivities, the intensive impossible sightseeing in the midst of massive crowds, has become over-familiar from repetition. In 1927 the Yorks's journey was still so novel that two books were written about it and a slick but significant descriptive phrase 'The Royal Embassy' gained world-wide currency. Long before the present Queen Elizabeth II discovered the gaiety and colour

in a prolongation of successful treatment that removed all but a trace of his impediment in ordinary life and mitigated it, except when the Duke was very tired or ill, on official occasions. His persuasive wife was thus instrumental in alleviating one of his heaviest psychological handicaps in royal duty.

"No one has ever taught you how to breathe," Mr. Logue would tell patients. And he would add with his immense Australian assurance, "I can tell you what to do but only you can do it. There is only one person who can cure you and that is yourself." The Duke of York began the system of exercises with hope and then growing confidence. The Duchess often accompanied him to the consulting room in order that she could understand the treatment and help with it at home. Within two months her husband was able to write to his consultant, "I really do think you have given me a real good start in the way of getting over it . . . I am full of confidence . . ."

The remedy was applied at the eleventh hour, for the Duke and Duchess were about to embark on their greatest adventure to date. The Prince of Wales's successful tour of Australia in 1920 had reopened a long disused road of royal enterprise. A remark on the part of the Duke that he did not want his elder brother to be the only member of the family to gain first-hand knowledge of the Commonwealth had been widely quoted, and the opening of the new Parliament buildings in Canberra brought from Mr. Bruce, the Australian Prime Minister, a meaningful invitation to the King that one of his elder sons should perform the ceremony.

If the young Duchess was determined that her husband should not be passed over, on account of the difficulty of his speech defect, she could see "a way round things" and above all she could always talk to the King. "He never spoke one unkind or abrupt word to me," she was to confide later to Lord Dawson of Penn. "He was always ready to listen and give advice." Any advice she may have sought from the King and any imperceptible womanly artifice was not in vain. With her husband's ability

lent their names as patrons but were inclined to creak and fluster at public functions. This the little Duchess changed: her interest in an organization was of almost flattering intensity. Visiting the Black Country and the North-East in 1925 she was cheered and subjected to "endearing epithets" by industrial crowds who could feel that somehow, magically, she was one of themselves, a Cinderella who had pulled it off. A cry was raised that had not been heard for many years—"Oh, isn't she lovely!"—a cry that has echoed ever since for one or other of the ladies of the Royal Family. The little Duchess had learned to smile freely and the cliches about radiating charm, grace, dignity, began to recur. But it was the Duchess of York who made them cliches by her air of constant investment in these now-standard royal properties.

What the crowds and the beaming officials did not see, though readily apparent to the Royal Family, was her wifely power to stimulate her husband's courage and resolution, her serene ability to calm his nervous eruptions of quick temper with a word, her effortless and complementary ingenuity in easing the nervous tension that his stammer inflicted in public life. In pondering the stony problem of a suitable wife—a future Queen—for the Prince of Wales, Queen Mary must have anxiously realized that it would have to be someone like Elizabeth, the pioneer who had shown the way.

The King found it difficult even to listen to his stammering second son. As soon as the symptom of tightened facial muscles appeared, he closed his ears to the struggle so that the wretched young man had to repeat every word over again. The Duke had found it not a scrap of use consulting speech therapists, and he was sinking into the secret dread of a lifelong defeat when his wife persuaded him to make 'just one more try'.

This last-hope among the specialists was of course Mr. Lionel Logue, a young Australian who had won fame for the demon-strated efficacy of his methods in London. On the Duchess's "ingenuous insistence" the Duke kept an appointment with Mr. Logue in Harley Street. This consultation was to prove the first

their lives afresh in the light of three years' marriage, but the lull also enabled the King and Queen and their advisers—and indeed the British nation—to assess the young couple as new components of the Royal Family, new supporting players of the monarchy. To an extraordinary extent the Duchess of York had herself fashioned and moulded her own position, creating royal duties where none existed, formulating a pattern based on the advice of the Queen and Princess Mary though distinctly her own. From that first presidency of a minor hospital group and the first trivial patronage of a maternity hostel fête, she had enmeshed herself in a complex network of philanthropy and good-doing that ranged from Highland crafts to dockland settlements, mothercraft training and women's leagues, children's charities and the arts, Commonwealth and other overseas groups, youth clubs and educational organizations. The list was far-ranging. When the Duchess first married, Lady Katherine Meade readily coped with business as a part-time lady in waiting. Before many months, Lady Helen Graham was appointed on a permanent and full-time basis. The Duchess knew what she wanted to achieve, and some early resignations from the Duke of York's official Household suggest a measure of disagreement with the new feminine power behind the scenes. By 1926 Mr. Patrick Hodgson was serving as private secretary, Captain Basil Brooke handled household and financial affairs as comptroller, Colin Buist was the Duke's equerry—and occasional aide to the Duchess—while Lady Annaly, Lady Helen Graham and the Hon. Mrs. J. Little-Gilmour were all on call as an effective rota of ladies in waiting. Such was the public façade, behind which duties and disciplines were built up at ever-increasing pressure.

To turn back to the records of royal activities in the nineteen-twenties is to realize the gap that the Duchess of York decisively filled in public life. As we have noted, the monarchy had been dulled for a quarter-century by a dearth of youthful and pretty princesses. Apart from Princess Mary and Princess Pat, there remained only elderly but well-meaning ladies who agreeably

"a tremendous joy", as her husband wrote. "It seems so wonderful and strange. I am so proud of Elizabeth at this moment after all that she has gone through during the last few days." Whatever the hazards the medical bulletins spoke of normal and satisfactory progress. Four days later, the Duke of York could write to his father, "Elizabeth and I have been thinking over names for our little girl and we should like to call her Elizabeth Alexandra Mary."

One may speculate that if the infant had been a boy, the name David would have been in store, "such a nice name", the Duchess had said, and one full of subtle compliments. The young parents were worried lest the name 'Elizabeth' should be disqualified. "Such a nice name," the Duke reiterated to his father, "and there has been no one of that name in your family for a long time. Elizabeth of York sounds so nice, too."

How could the King raise any objection? The choice of names seemed to include his mother and his wife. The name 'Mary' was also in compliment to his daughter. Princess Mary had in fact been the first visitor at Bruton Street when the guns were still booming their salute to the newcomer, on the morning of the 21st, proving herself, as ever, a staunch and true friend.

Princess Mary was one of the six sponsors at the christening in the private chapel of Buckingham Palace on May 29th. The Duchess similarly sought to compliment the King and Queen and Lord Strathmore as grandparents, Lady Elphinstone as aunt, and a survivor of the older generation, Queen Victoria's third son, the old Duke of Connaught. "Of course poor baby cried," Queen Mary noted. The new baby was third in succession to the Throne *for the time being*, as all the newspapers were at pains to stress. But to the new mother the intangible distant dream of Princess Elizabeth had become realized with a sweetness at last beyond her highest hopes.

IV

The quiet summer of 1926 allowed the Yorks to take stock of

to be nanny to the new baby. Queen Mary who, like the King, had become devoted to her daughter-in-law, also recorded with renewed satisfaction the private comings and goings of 'Bertie & E'.

April began to pass in an incessant rainfall, and on the 19th the Duke and Duchess drove through the showers to lunch with the King and Queen at Windsor Castle. Next day, the doctors were hastily summoned to 17 Bruton Street and the Home Secretary, Sir William Joynson-Hicks, also hurried there to fulfil his statutory obligation of being present in the house for a royal birth. His intended precise timing was nonetheless out of gear. There were complications as all the world realized when the obstetric surgeon, Sir Henry Simson, was summoned. A day of anxiety passed into night. In the small hours of the morning of the 21st, the three gynaecologists—Sir Henry Simson, Sir George Blacker and Mr. Walter Jagger—consulted together once more and "a certain line of treatment was successfully adopted". The baby, a Princess, was probably brought into the world feet first by a Caesarean section.

Ninety minutes later the duty equerry at Windsor sent in a message to the King and Queen. "We were awakened at 4 a.m. by Reggie Seymour who informed us that darling Elizabeth had got a daughter at 2.40. Such a relief and joy," the Queen recorded in her diary. The first bulletin missed the early editions of the newspapers and so the "wireless"—still a novelty—was fittingly the medium to give the news in millions of homes: "Her Royal Highness the Duchess of York was safety delivered of a Princess at 2.40 a.m. this morning". The implication of danger is obvious. That afternoon, after the Mountbatten sisters, like the three fates, had lunched at Windsor Castle, Queen Mary and King George arrived at Bruton Street to be told that the young mother was asleep. "We found Celia Strathmore," Queen Mary wrote, and the Queen was delighted with her first grand-daughter, "a little darling with a lovely complexion and fair hair".

To the new mother, soon taking her baby in her arms, it was

of York was able to confide to her own mother, Lady Strathmore, at Glamis that August. They had "always wanted a child to make our happiness complete", the Duke of York was presently to write jubilantly to Queen Mary. He deftly sidestepped the word "son" and the Duchess herself avowedly wanted a daughter. But her pregnancy now enhanced the urgency of finding somewhere to live and after the autumn days at Glamis and Balmoral the Duke arranged to lease 40 Grosvenor Square from a Mrs. Hoffman. The Duchess firmly intended to risk no contingency that her baby would be born at White Lodge. Was there some confused nightmare prospect of doctors lost in the fog in Richmond Park in an emergency? Or was there the daunting circumstance, unhappily lodged in her mother's remembrance, that her own eldest sister had died in Richmond at Forbes House not a mile from the White Lodge itself?

Although this dark distress had occurred years before the Duchess was born, it perhaps still coloured her mother's persuasions. Lady Strathmore sensibly suggested that the Duke and Duchess should move into 17 Bruton Street and this was effected when they returned from Sandringham at the end of January. Great changes were looming over the King's Norfolk home, for Queen Alexandra had died shortly before Christmas; and Queen Mary strolled round the big house with the little Duchess, making the necessary transformation plans for a new régime. Neither woman dreamed that when the time came for another change Elizabeth herself would be the next châtelaine.

The return to Bruton Street brought relief from the sightseers who constantly picketed White Lodge. For those few blissful weeks of early Spring, the Duchess returned to anonymity, enjoying tête-à-têtes with her friends, Elizabeth Cator and Dorothé Plunket, with the Pagets and the Spender-Clays, Viscountess Massereene and Ferrard and so many more. With her husband, she slipped out of town to enjoy the old family weekends at St. Paul's Walden Bury, and it was arranged that Alah (Mrs. Knight) should transfer from the Elphinstone menage

III

It was probably through a nursemaid that the Duchess of York first heard in 1924 that the mansion of 145 Piccadilly was to be vacated, and she "put her name down" with the Commissioners of Crown Lands as promptly as any would-be tenant spotting the right house on a building estate. Remembered only by older Londoners, No. 145 stood two doors from Apsley House where the traffic of Hyde Park Corner now sweeps into the park; it boasted a narrow cobbled forecourt and above all it was backed by a fenced and shrubby enclosure known as Hamilton Gardens. Into this secluded pleasance backing on Hyde Park the nanny of Princess Mary's household sometimes took the Lascelles baby, there to meet the Allendale and other Piccadilly nursemaids, and the gossipy news that the Bass family had vacated 145 was probably passed by Princess Mary to her sister-in-law. The Duchess of York, with her father's eye for an imposing building, saw at once that the house would be just right. Into its four floors were stowed just sufficient accommodation, with the reception rooms supplemented by a small two-storey wing at the side. Evidently Queen Mary was finally brought round with deft tact to the view that White Lodge was a little too far out for the crowded engagement book of the Duke of York's life. As president of the British Empire Exhibition at Wembley that year he had to entertain a great deal and Curzon House was rented for convenience. But this was an unexpected expense from his gross Civil List allowance of £25,000 a year, "with no ready cash for your own", as his father sometimes reminded him. The leases and sub-leases of Baron Albert Rothschild and Sir William Bass on No. 145 had not yet terminated and three years of protracted negotiations were still to elapse before the Duchess and her husband could at last move in.

Princess Mary was anticipating her second baby that summer and one may trace an emotional link between the arrival of her son, Gerald Lascelles, and the sudden fond hopes that the Duchess

Buganda and then they were off again in quest of elephant in the Semiliki Valley. It was not a good time of year, the Duke had to write home, the natives were burning the elephant grass and the ash settled everywhere. But his aides were startled at the aplomb and resilience of the little Duchess. Returning to comparative civilization, "she would appear in a quarter of an hour," wrote one, "looking as though she had never been motoring miles in a Ford over roads which in England would be considered impassable, or creeping through thorn bush and wading waist-high in a swamp".

After being sorely tried by mosquitoes on the White Nile steamer *Samuel Baker*, the travellers began the last leg of their journey in a leisurely four-weeks cruise down the Nile on the more comfortable *Nasir*. They paused and camped wherever good sport or good photography was promised; the weather was hot and the river offered the only coolness. At Tonga they were in time for the annual tribal gathering of the Nubas and motored into the mountains to see the march past and wrestling games of twelve thousand Nubian tribesmen.

At Khartoum, however, the familiar formality of triumphal arches awaited them. It was six months since the Governor-General of the Sudan, Sir Lee Stack, had been murdered in Cairo, and the crowds found in the young Duke and Duchess an opportunity to affirm their own potent blend of nationalism and loyalty. With the massive guard and the night illuminations of this welcome, the Duchess must have felt that she had seen nearly everything. Even so, floods and bush-fires were capped by a blinding sandstorm stinging from the banks of the Suez Canal before a restful ten-day cruise was completed on the liner *Majola* back to Marseilles.

In the watery sunshine in London on April 19th the royal couple found crowds awaiting them at Victoria Station but the M.C.C. cricketers were returning on the same train and it was a matter of humorous dispute whether the throngs were greeting the Yorks or the cricket team. There remained, too, the intractable problem of that residential white elephant, White Lodge.

swollen rivers and lurch through the forest tracks in a leaking car in driving rain.

One car became so waterlogged that it had to be left behind and the entire party of seven crowded into one small Buick. This had the merit that some of the pressmen who were trying to cover the trip from Nairobi were left behind. But these were the days when safari was a byword in smooth organization and opulent comfort and Anderson, the white hunter, rapidly reported everything under control. In the tent used as a bathroom even the canvas tubs were dry when unrolled. Early in January the Duke and Duchess were shooting in the clear, dry weather they had expected. The bush teemed with game and in those days, in a different climate of opinion, sport was unimpeded by the conscientious dictums of animal preservation. The Duchess herself shot a rhinoceros, water-hog, buffalo, oryx, waterbuck, Grant gazelle, dik-dik, hartebeeste, steinbuck and jackal but, having demonstrated her proficiency, one gathers she was then more than relieved to exchange her 0.275 Rigby rifle for her camera.

One night the camp was disturbed by a stampede of zebras fleeing from lions and hyenas. Another time a sudden storm of wind and rain brought down the tents and left everyone drenched and confused in the darkness. Yet these adventures did not diminish the pleasure of the 5.50 a.m. start for the morning shoot in the cool early freshness, the return to camp on mule-back, the glowing days and the velvety nights. The Duke and Duchess were staying with Lord and Lady Francis Scott at Rongai when the tragic news was brought of the sudden death of their Nairobi host, Sir Robert Coryndon, and the Duke of York had to return to Nairobi for the funeral. The safari was abandoned but in mid-February the party moved on into Uganda, where the Duchess had the carefree sport of shooting crocodiles, the only beasts, as she said, she could never regret killing.

They crossed the Victoria Nyanza and saw the source of the White Nile at the Ripon Falls. They were entertained at Government House, Entebbe. In Kampala they visited the Kabaka of

have sat down two minutes too early." Less susceptible to femi-
nine persuasiveness, Queen Mary, delighted in having the young
people at White Lodge, "to keep it in the family", but Elizabeth
could point out that Bertie needed a rest and recuperation after a
strenuous year. There had been his steady round of industrial
visits, including a visit to the Rhondda Valley, as well as his boys'
camp, his share in the State Visits, the triumph in Northern Ireland
and a series of unrelenting public engagements around London.
And so the Duchess had her way and on December 1st, 1924, the
young couple left London en route for a winter holiday in Kenya,
Uganda and the Sudan.

Travelling overland through France, they joined the P & O
liner *Mulbera* at Marseilles to find that the capricious Mediter-
ranean was colder than Richmond Park; and the Duchess was not
a good sailor. In the warmth between Aden and Mombasa they
enjoyed the traditional shipboard merriment of Crossing the
Line, and they landed in Mombasa on December 22nd. A great
native dance gathering was held in their honour and five thousand
men and women who had already been dancing for three days
when they arrived, so that Africa welcomed its guests in its gayest
and most flamboyant mood. And then came the journey through
jungle and plain to Nairobi, and from the windows of the
Governor's train they excitedly catalogued their first glimpse of
wild life. "Zebra, hartebeeste, ostrich, baboons, wildebeeste,"
the Duke pencilled in his diary a reference list of species sighted
near the line.

The travellers spent Christmas in Nairobi at Government
House, the first Christmas separated from all family ties that the
Duchess had ever known. Her closest link with home was
with Lady Annaly (formerly Lavinia Spencer) to whom she had
been bridesmaid and who now shared the trip as lady in waiting.
Captain Basil Brooke and Lieut.-Commander Colin Buist made
up the small travelling party. The New Year of 1925 was greeted
up country near Meru and instead of the cool, dry weather that
they had expected the heavens opened and they had to ford

It was April before the Duke could report the boiler "actually finished", a special event to write to Queen Mary about. With the house absurdly warmer in time for the warmer weather, there remained the problem of the journey to or from any evening engagement. The Duchess was expected to play her pristine part at every royal function, her gowns uncrushed by travel, and her mother's home in Bruton Street had to provide a dressing-room. In July, 1924 the Duke and Duchess of York were required to entertain the then heir to the throne of Ethiopia (Haile Selassie) and Princess Mary was able to loan them her London home, Chesterfield House. Since the same month also saw an official visit to Northern Ireland and a week of official activities, the Yorks already felt hardened to the curious royal necessity of living in and out of suitcases. They thought their reception in Ulster astounding, the cheering "quite deafening" the loyalty and enthusiasm genuine and wonderful. "Elizabeth has been marvellous as usual," the Duke reported to the King. "She knows exactly what to do and say to all the people we meet." The Yorks however still hardly grasped the idea that they had so readily won personal popularity.

II

The new heating at White Lodge was installed too late. The young Duchess had clearly made up her mind not to spend the miasmic depths of another winter there. This determination required the utmost finesse of beguiling diplomacy if Queen Mary's sensibilities were not to be abraded nor the King's authority infringed. The King was readily won over: he admired her courage, her stubborn ability to stick to her guns and, as Sir John Wheeler-Bennett has pointed out, even his stern insistence on punctuality was not proof against her charms. In his orderly stop-watched household his daughter-in-law arrived two minutes late for dinner full of blushing apologies, but the King was unperturbed, "You are not late, my dear," he said. "I think we must

was in an equal flurry, for a large new palace was hardly completed in time. During the festivities, the plumbing failed and there was no hot water, while the cold supply was clouded with cement. At the christening, the royal infant, one day destined to pass into exile as King Peter of Yugoslavia, was all but drowned when the ancient Patriarch allowed him to slip into the font, and saved by his godfather's quick presence of mind in scooping him up.

The great assemblage who watched this performance included practically every royal personage still to be found east of Trieste. Of these, the Duchess of York had previously met only Prince Paul and Princess Olga but her husband proudly reported home, "They were all enchanted with Elizabeth, especially Cousin Missy (Queen Marie of Rumania). She was wonderful with all of them and they were all strangers, except two . . ." It was his wife's first experience of the pageantry and formality of a Balkan court, her first ordeal under the cross-fire of critical and questioning eyes, and she emerged successfully. Yet the embarrassments had not excluded the farcical sight of her bashful husband carrying the naked and screaming babe three times around the altar on a cushion, and a traditional gift of hand-embroidered underwear from the parents.

The discomforts of the unfinished royal palace in Belgrade were next to be eclipsed by the deprivations of White Lodge in a frigid and foggy winter. A promised new boiler failed to arrive, and the couple had to take refuge in a house at Guilsborough, Northamptonshire. Convenient for the Duke's hunting with the Pytchley and Whaddon Chase, and close to several of the Duchess's friends an engagement in town nevertheless entailed a bleak round journey of 160 miles. The Duchess attended a school prize-giving in London and, since her official address was still Richmond, no one realized the effort required. A chilly overnight at White Lodge scarcely solved the difficulty. On one occasion, the chauffeur lost his way in the fog and they wandered round the park for an hour, passing and repassing the Lodge on the unposted roads.

at dinner and bluffly described her as "a perfect little duck, one of the nicest little ladies I have met for years".

The incisive eye of Lady Diana Cooper also detected the Duke and Duchess at a theatre "such a sweet little couple, so fond of one another . . . sitting together in the box having private jokes. In the interval, I found them standing together in a dark corner of the passage talking happily as we might. She affects no shadow of airs or graces . . ."

In the heat of July the newly-weds engaged in their first round of duties with a visit to Liverpool. That this involved an afternoon at Aintree Races was incidental, for the baked ground made jockeys cautious and the racing was voted remarkably dull. This smooth trial run of royal duty prompted the Duke to hint that a Commonwealth tour would not come amiss. The Prince of Wales' successful overseas mission the previous year had fired the young couple's imagination, but for the present the King took the view that they "had just married and must settle down". Then, just as the Yorks were recovering from this disappointment, they were suddenly summoned to attend both a royal wedding and a royal christening.

The infant son of King Alexander of Yugoslavia was to be christened on October 21st and, late in September, Lord Curzon as Foreign Minister precipitately decided that the Duke and Duchess of York should take up invitations to act as godparents. The following day was also to see the marriage of King Alexander's cousin, Prince Paul, to Princess Olga of Greece, elder sister of Princess Marina, at which the Duke and Duchess could represent King George and Queen Mary.

The Duchess was indignant at such short notice. The Duke wrote to his secretary, and Comptroller, Wing Commander Louis Greig, "Curzon should be drowned . . . He must know things are different now." His wife had less than three weeks to prepare her wardrobe and had reason to joke that her trousseau would have to do. The Yugoslav Royal Family, on the other hand

good plain cook but lacked finesse in other directions. The King and Queen came to lunch on the Thursday of Ascot week, June 28th, and the Duke felt it best to write to his mother, "I had better warn you that our cook is not very good." Queen Mary however was delighted to be entertained in the home of her girlhood and pleased with her daughter-in-law's proven good sense. "They have made the house so nice with all their presents," she noted that night in her journal.

Apart from the Strathmores, the Prince of Wales was an early guest and duly recorded that Elizabeth "had brought into the family a lively and refreshing spirit". She had indeed brought far more: an eagerness and willingness to serve that pleased the older generation, and a fresh and radiant youth that captivated the public. The Royal Family of 1923 was not over-endowed with glamorous princesses; no other English prince had married for love in the course of the century and an extraordinary upsurge of public affection and approval enveloped "the little Duchess", as she almost immediately came to be known.

The private honeymoon had not ended before the business of this wider public honeymoon surged into White Lodge. On June 2nd there appeared the announcement of her first presidency: the Duchess of York was to head the Scottish Women's Hospital Association which avowed as a prime purpose the endowment of beds in the Royal Free Hospital. She successively became president of the Royal School of Art Needlework and of the North Islington Infant Welfare Centre, causes which have a familiar ring in connection with the Queen Mother to this day. It was equally characteristic that she early gave her partonage to the Contemporary Art Society, and her first "royal engagement" was to an art exhibition on June 18th to inspect the modish portraiture of Savely Sorin. Her own portrait by Lander was the *success fou* of the Royal Academy, and the June weddings of two of her bridesmaids, Lady Mary Cambridge and Miss Diamond Hardinge, alike heightened the warmth of public interest. Admiral Earl Beatty found himself seated next to the new Duchess one night

had come true. After his gloomy forebodings about daughters-in-law in general, King George V could particularly voice his satisfaction. "You are indeed a lucky man to have such a charming and delightful wife as Elizabeth," he wrote to his son. "I trust you both will have many many years of happiness before you and that you will be as happy as Mama and I are after you have been married for thirty years . . . I am quite certain that Elizabeth will be a splendid partner in your work and share with you and help you in all you have to do . . ."

The young Duchess of York's only regret, indeed, could have been that her honeymoon clashed with David's coming-of-age celebrations on May 2nd, and this difficulty was probably over-come in private. In adding his signature to the enormous vellum marriage certificate in the Abbey, among the scrawls of empresses and princes and statesmen, David had reason to report with glee that he had signed very small in the corner. On May 9th the newly-wed couple arrived at Glamis, where ten days later the Duchess contracted whooping cough. "So unromantic to catch whooping-cough on your honeymoon," the Duke wrote in comicality to his mother. Later, they spent a night or two at Frog-more, in the shadow of Windsor Castle, where an old-fashioned residential suite remained forlornly isolated among rooms stuffed with surplus furniture. Whether or not the couple discovered extra pieces for White Lodge we cannot tell but the Duke found the house charged with memories of his schooldays as if to encourage him to reminisce to his wife of his boyhood.

The rambling mansion of White Lodge in Richmond Park was ready for its new occupants early in June and the Duchess learned to her dismay that she could not stir out of doors without the hazard of sightseers. Redecorated and freshly carpeted, the house effectively set off their wedding gifts but had otherwise little improved in domestic amenities since the Duke and Duchess of Teck were in residence at the turn of the century. The bride had cause to apologize for the quality of the food. The cook was a

CHAPTER SIX

THE LITTLE DUCHESS

I

To Mrs. Greville's gratification, the Duke and Duchess of York spent the first two weeks of their honeymoon at Polesden Lacey In setting the house at their disposal, Mrs. Greville had considerately installed the novelty of a "wireless receiver" and so the honeymooners perhaps heard their wedding anthem again that evening when the Westminster Abbey choir visited the broadcasting studios at Savoy Hill. Polesden Lacey is a Regency mansion built on four sides of a patio so that the reception suite at the south-east corner was particularly sequestered from the service quarters to the north-east. The upper windows command a sweeping view of the soft Surrey hills and woods, and in April the air is fragrant with the blossom of *Clematis armandii*, trained for fifty yards across the south front of the house. The young couple played a little tennis and lethargic golf. In the garden they strolled in the concealment of the long terrace walk, that walk laid out by no less a romantic than Sheridan when he owned the house. They sat about lazily in the wicker armchairs in the sunroom and no doubt they giggled at having the glories of Mrs Greville's drawing-room to themselves, the gilded panelling transported from an Italian palazzo, the sportive puttis of the painted ceiling.

The world came bursting in on the third day, when a Press photographers' session had been arranged. It was also announced that day, to clear any doubts, that the bride took the rank of a princess, and so the old childish daydream of a Princess Elizabeth

after leaving the Abbey, said others. It was a gesture at all events that touched millions. The bride also happened to forget her gloves, an oversight that established a fashion for marrying without gloves for months afterwards.

The Archbishop of Canterbury conducted the service, and the then Archbishop of York, Dr. Lang, gave the address. "Your separate lives are now, till death, made one," he told the bride and bridegroom. "You cannot resolve that your wedded life shall be happy. But you can and will resolve that it shall be noble. You will think not so much of joy as of achievement. You will have a great ambition to make this one life now given to you something rich and true and beautiful . . .

"The warm and generous heart of this people takes you today into itself. Will you not in response take that heart, with all its joys and sorrows, into your own?"

To the devout Elizabeth these words were a briefing. They mingled with the wedding bells and the cheers and some on-lookers found the bride more serious than smiling as the wedding coach passed through the tapestry of humanity back along the Mall, through Marlborough Gate to Piccadilly and down Constitution Hill to Buckingham Palace.

the gown was described as being in old medieval style and sure enough a panel of silver lace threaded with ribbon straight from neck to hem brings before us once again the favourite 'Princess Elizabeth' theme.

The wedding-day of April 26th, 1923, found central London *en fête* and massed with eager crowds. Some of the onlookers were so well-informed that they could debate the propriety of a wedding-ring made with Welsh gold rather than Scottish and whether the bride alone merited an escort of Life Guards when it had been decided she did not. King George noted that the day began with rain. The showers soaked the streamers with their slogan 'T.R.H. The Bride and Bridegroom'; the raindrops twinkled on aluminium-painted bells and cascaded across the entwined initials A and E on the painted frames around the lampposts. But the downpour ceased at 9.30 and did not daunt the enthusiasm of the waiting throngs. There was the King and Queen's procession, the sight of Queen Alexandra and her sister, the Empress of All the Russias, those two old ladies bobbing together in their own gilt coach; and the bridegroom 'a little pale', as bridegrooms should be. In Bruton Street, onlookers had cause for anxiety lest footmen and police should mask the bride. She had been given an ermine cloak against the rain, and very characteristically wore it pushed back, so that the crowds could see her wedding-dress. And King George V noted afterwards in his journal the auspicious sign that 'the sun actually came out as the Bride entered the Abbey'.

Indeed, the sun spread a sudden flood of light into that then extremely dark and dingy building, a heavenly arc-light illuminating uniforms and costumes. The Duke of York wore blue Royal Air Force uniform. The bride came slowly into the Abbey and against the anthem of the choir one heard a little gasp, a rustle of approval, a sigh, as she paused at the flat tombstone of the Unknown Warrior and laid there her bouquet of roses. It was a remembrance for Fergus, said some, and a brilliant improvement on Princess Mary, who had laid her bouquet at the Cenotaph

Elizabeth could not of course see in herself the injection of youthful simplicity, the 'common touch', that the public immediately acclaimed as her peculiar gift to the institution of royalty.

The wedding gifts poured in from institutions as varied as the Civil Service Sports Council (pepperpots) and the Needlemakers' Company (one thousand gold-eyed needles), and the bride soon found herself suffering from a superfluity of clocks and oriental lacquered cabinets. Installed for the delectation of guests in the Picture Gallery at Buckingham Palace, the gifts nevertheless made a welcome and impressive display. A gift from Prince Paul of Serbia requested a sitting to John Sargent for a pastel sketch. This most fashionable of portrait painters found Elizabeth "the only completely unselfconscious sitter" he had ever known, although this enabled him to achieve no better than a chocolate-box sketch with brimming blue eyes.

The problem of a future home was solved by the grace-and-favour allocation of White Lodge in Richmond Park, where the 'ga-ga' Lord Farquhar had relinquished his tenancy. The Duke was attracted by the tennis-court and his future Duchess by the expansive open view. The newspapers were immediately full of reminders that the heir to the Throne, the Prince of Wales, had been born at White Lodge, although they missed the point. Strangely closer to the mark was an ancient throat specialist in Wimpole Street on whom Lady Elizabeth had occasion to call. "Did you see that girl?" he said excitedly to a medical friend who must have passed her on the stairs. "That pretty little girl in blue?" his friend replied. "Pretty little girl be blowed"—was the rejoinder "that's the future Queen of England."

The select dressmakers of the 1920's were seldom publicized and the intense limelight shared by modern couturiers was not cast upon the wedding-gown. Its chief motif was around the bridal veil of old Pont de Flandres lace which Queen Mary inflexibly produced from her store, a somewhat embarrassing infliction since the chiffon mousmé of the dress had to tone with its faded ivory tint. Yet Lady Elizabeth's choice also prevailed:

couple regretted the verdict. The public meantime snapped up every morsel of news about the royal wedding. They read happily, for instance, that a veteran clerk of the Archbishop of Canterbury's Faculty Office had been engrossing marriage licences for fifty years and the Royal licence put him to extra trouble: "For three days he will stoop over a roll of parchment nearly a yard square in a locked room. He will use twenty quill pens of various thicknesses and will write the licence in old English lettering with black ink." A four-tier wedding-cake, the public learned, would weigh 900 pounds and was to be made in Scotland.

This wedding-cake was to feature in Lady Elizabeth's day of royal initiation on March 17th. One senses the imaginative touch of Major Hardinge, who was one of the King's secretaries and Diamond's brother. The Duke had been staying at Glamis and they publicly went to Edinburgh to inspect the plaster model of the cake and then visited a factory known as the "Blighty Works" where disabled ex-Servicemen were receiving training in cloth manufacture. The cameras clicked at the Duke's spats and at Elizabeth's feathered velvet hat. In the afternoon their attendance at the England-Scotland rugger match was inevitably headlined as the "Battle of the Rose and the Thistle".

The old photographs show Lady Elizabeth in those velour fashions, plump, demure, but unsmiling, and tautly nervous. The limited publicity accorded the bridegrooms who had married brides of the family at the two previous royal weddings found her ill prepared for the approval and ready affection she now met on all sides, and she was taken aback at the warmth of welcoming popularity. The Duke merited it for his work in industrial relations and other fields. In these days when the activities of the Duke of Edinburgh no longer surprise us, we forget that the Duke of York once addressed an Academy dinner, and was president of an international congress on aeronautics, a presidential speaker for the Royal Agricultural Society and a speechmaker—despite the agony of his stammer—on topics as varied as trade revival, the Washington Conference and the police force. But Lady

pattern: three close personal friends and three of royal affiliation who had been bridesmaids to Princess Mary. The invitations went to Diamond Hardinge and Betty Cator, that old school friend, to Lady Katherine Hamilton, youngest daughter of the Duke of Abercorn and Lady Mary Thynne, youngest daughter of the Marquess of Bath, to Lady May Cambridge, Queen Mary's niece and daughter of the Earl of Athlone, and Lady Mary Cambridge, another of the Queen's nieces, daughter of the Marquess of Cambridge (now Duchess of Beaufort). The list implied considerable social tact, and Cecilia Bowes-Lyon, daughter of the bride's eldest brother Pat, and Mary Elphinstone, daughter of her eldest sister, completed it as attendants.

Meanwhile the nation—and indeed that wider unit still then known as the British Empire—received the news of the engagement with unreserved rapture. A Scottish Lass was marrying an English Prince, regardless of the bride's long line of English grandmothers or the Danish-Germanic strains of the bridegroom's parents. "A princely marriage is the brilliant edition of a universal fact," Bagehot had said, although his mid-Victorian traditions lacked the adhesive merit of such discoveries as that bride and bridegroom were both descended from King Robert I, the Bruce, of Scotland. Headlining a double page spread of Glamis photographs, a weekly magazine contrived the slogan, "Linked again with Royalty as When a Lyon Wedded Robert II's Daughter."

The decision to hold the wedding in the Abbey was equally popular, producing evocative reminders that the last prince of the Royal House to marry in the Abbey had been the young King Richard II in 1383, which was also during the reign of Robert II of Scotland. The proposal of the British Broadcasting Company to broadcast the service was greatly acceptable to the man in the street, the first broadcasts of "Grand Opera" from Covent Garden having "demonstrated the technical possibilities," and the Dean of Westminster was in favour but the Abbey Chapter declined. The objection was that "the Service might be received by persons in Public Houses with their hats on" and it seemed that the young

papers, and Chinese jars perched upon bookcases from Maples. To Lady Elizabeth the King was a bluff hoarse-voiced man whom she had seen in tears at his daughter's wedding. "I was never afraid of him," she confessed years later to Lord Dawson of Penn. "He was so kind and so dependable. And when he was in the mood, he could be deliciously funny, too! Don't you think so?"

The Strathmores were chiefly entertained, however, in the huge ornately plastered rooms of Sandringham House itself. At Princess Mary's wedding old Queen Alexandra had perhaps seemed a tiny unapproachable figure in violet velvet and many jewels. Now, in close-up, Elizabeth compassionately found her deaf, half-blind, her auburn wig too large, and yet there was still, as T. E. Lawrence said, "the ghosts of all her loving airs, the little graces ... the famous smile, all angular and heart-rending ..." There was poignancy in the meeting (an occasion I have endeavoured to describe in my book *Sandringham*) and the tender-hearted young newcomer was unaware of the impression she was herself creating on others, "Elizabeth is charming, so pretty and engaging and natural", Queen Mary confided to her journal that night, while the King completely shared his wife's opinion, "A pretty and charming girl".

"Perfectly charming ... so well brought up ... a great addition to the family," were the further views Queen Mary expressed to her brother, the Marquess of Cambridge. Some delay transpired in fixing the date of the wedding, for the King and Queen were due to undertake an official visit to Rome, and were awaiting a date from the Italian Government. The King's consent to the marriage, required under the Royal Marriages Act of 1772, was formally given, however, at a special meeting of the Privy Council on February 12th, "Now know ye that we have consented and by these Presents signify Our consent to the contracting of Matrimony between His Royal Highness Albert Frederick Arthur George, Duke of York, and the Lady Elizabeth Angela Marguerite Bowes-Lyon ..."

Elizabeth drew up her list of bridesmaids with a sense of

young couple had planned to defer an announcement but it was decided that the betrothal should formally appear in the Court Circular of Tuesday January 16th. "We hoped we were going to have a few days peace first," Elizabeth wrote to a friend. "But the cat is now completely out of the bag and there is no possibility of stuffing him back. I feel very happy, but quite dazed."

She had expected excitement, but the inundation of cables and letters completely astonished her. The crowd of reporters thickened on the doorstep in Bruton Street until one bold spirit, Harry Cozens-Hardy of *The Star*, asked to see her. His pertinancity circumvented the butler, and the request reached Lady Strathmore. "Leave this gentleman to *me*," Lady Elizabeth was heard saying.

She set the stage quite mischievously, discovered—Act Two, Scene One—at a little writing desk, pen in hand, answering letters. "I suppose you have come to congratulate me? How very kind of you. I hadn't the remotest idea everybody would be so interested . . ."

Mr. Cozens-Hardy asked if it were true that the Duke had proposed three times before being accepted. Lady Elizabeth answered, with the greatest composure, "Now look at me. Do you think I am the sort of person Bertie would have to ask twice?" One recognizes the endearing tactical persuasion over the years. Next day a royal secretary hinted that it would be better for no more interviews to be given, and the curtain closed.

III

Lord and Lady Strathmore went to Sandringham with their daughter on Saturday January 20th and first set eyes with astonishment on the crowded little drawing-room of York Cottage, which the King and Queen still occupied while Queen Alexandra lived on at the big house. To Lady Strathmore it must have been remindful of a room in her father-in-law's old flat in Belgrave Mansions, with its poorish water-colours hung upon flock wall-

Greek Orthodox priest crossing Berkeley Square and the contest collapsed in helpless laughter.

So it went on, and beneath the superficial fun and gaiety lay the inner ferment of decision. One friend has told of the pleasure of "the much-used piano" at the Bury, while outside was "a garden ready to be enjoyed and work always waiting to be done in it". A courtship photograph shows the young Duke of York deep in an excavation, coping with tree-roots, while Elizabeth watches with demure encouragement. But when the Duke had departed, Lady Strathmore noticed her daughter's perturbed and abstracted air. "That winter was the first time I have ever known Elizabeth really worried," she wrote afterwards. "I think she was torn between her longing to make Bertie happy and her reluctance to take on the big responsibilities which this marriage must bring."

With the New Year of 1923, the Duke was fired with new resolve, so much so that he arranged a code with his parents at Sandringham for a telegram to signal success or failure. On Saturday January 13th the expected message arrived, "ALL RIGHT BERTIE".

Elizabeth was finally won over during a walk together in the Bury woodland that morning, and the next day saw one of the rare occasions when she absented herself from Sunday morning service. With everyone else at church, she and her future husband spent a few hours together before he dashed off to Sandringham. When he arrived after tea, Queen Mary noted, "We are delighted and he looks beaming." A final suggestion of Elizabeth's hesitancies can be detected, however, in a letter he wrote to his parents the following day. "I am very happy and I can only hope that Elizabeth feels the same . . . I know I am very lucky to have won her over at last." Then his pen was fired with deeper fervour in a letter to Lady Airlie. "My dream has at last been realized. It seems so marvellous to me to know that my darling Elizabeth will one day be my wife."

On the Monday, public conjecture was already rife, for Lady Elizabeth's absence from church had not passed unnoticed. The

instantly responded, and in which his own personality throve and blossomed. He was deeply in love . . ."

The matchmakers were also both contriving and insistent. Lady Airlie never ceased to plead the Duke's cause whenever Lady Elizabeth visited her. A more effervescent hostess of the period, Mrs. Ronald Greville, very deliberately included them in dinner parties and theatre parties and planned for results. Mrs. Greville—"Maggie" to her friends—resembled "a small Chinese idol with eyes that blinked". The only daughter of a Scottish whisky millionaire, she "liked to fill her house with celebrated and handsome people", as one of her younger followers, Osbert Sitwell, has said. She had, however, great acumen and "a word, a look, a glance would indicate a complete grasp of any situation". But above all Mrs. Greville had just brought off the coup of bringing together and, so to speak, matching and marrying Edwina Ashley and Lord Louis Mountbatten (later Earl and Countess Mountbatten of Burma) and now was ardently eager to play a Scottish-burred Cupid to all the King's sons. "My dear," she used to say, "I'm not an educated woman, but—" and some new fun, usually in pin-pricking the complacent and pretentious, would emerge.

This particularly suited "Bertie" and Elizabeth who shared above all the same sense of humour. It was surely a joke more than a grief when their earlier mentor, Lord Farquhar, died, leaving all his richly extravagant but completely hollow bequests. Making official visits to Rumania in June and again in August, the Duke of York returned from both these trips with gay and amusing accounts of a Balkan royal wedding and a Balkan coronation, particularly his popularity in the ritual of scattering silver coins to throngs of children. From the windows of 17 Bruton Street, when the Beaver craze of beard-spotting was at its height, the two young people staged an hilarious match with their Pakenham neighbours across the street. Violent waves and gestures indicated scores for every beard until one of the Pakenhams, with a wild shout, noticed a bushily camouflaged

handsome young attachés eager to squire her to the cafés in the brilliant sunshine, with drives to Fontainbleau and Malmaison, and a ball at which, as one guest noted, "Lady Elizabeth Lyon was the most charming sight . . . a bewitching little figure in rose".

It appears probable that one of her Embassy admirers proposed to her later in the summer and she is said to have received five proposals in the course of the year. Perhaps among these the Duke of York again voiced his hopes, for there are indications that a decision was promised but deferred. Marriage indeed was put out of court by the strain of another domestic crisis, Lady Strathmore's health again broke down and she became more than ever dependent on Elizabeth as she prepared to face another operation.

Now both the King and Queen felt concern for the future. King George V's first impressions of Lady Elizabeth shortly before Princess Mary's wedding had been highly favourable, but if she were not to marry his son, then the horizon was clouded with new perplexities. "I hope we shall be as lucky with our daughters in law as Lady Holford has," the King wrote, apropos one of his friends, in August, 1922. "I must say I dread the idea and always have."

In September, with Elizabeth once more acting as her father's hostess, the Duke of York revisited Glamis Castle for the shooting. The arduous, casual and utterly informal recreation that Lord Strathmore offered gave him an exhilarating and meaningful new vista of sportsmanship; and in the evening, a friend has recalled, "the drawing-room would be dimly lit, except for the pool of light made by the candles on the piano . . . We would all sing and topical songs could be adapted to some person present . . ." The family fun seemed like a steel cord pulling him from the morass of stultifying formality. As Sir John Wheeler-Bennett was to comment in his official biography of King George VI, "The relations of Lord and Lady Strathmore with their children and the happy badinage and affection of a large and closely knit family were a revelation to him, providing a climate of ideas to which he

delighted with her ensemble that she invited the staff and tenants' wives of St. Paul's Walden Bury to a party to see it and so began a pleasant custom of previews continued long afterwards for the staff at Buckingham Palace.

The other bridesmaids included Lady Mary Cambridge and Lady May Cambridge, Lady Mary Thynne and Miss Diamond Hardinge, all of whom were to fill a similar rôle at her own wedding. Thus on February 28th, 1922, Elizabeth first rode in a State procession through central London and saw "from the front" the crowded street scenes she would one day find so familiar. In tracing the story of a Queen one can hardly fail to note the introductory codas of events, and it was now that she first moved in procession up the Abbey nave which within fifteen months she was herself to tread as bride, and as a Queen to her coronation fifteen years later.

At the Palace, at the family luncheon in the state dining-room, she briefly met or renewed acquaintance with every member of the Royal Family, except that "odd man out" of the future, the Prince of Wales, who was absent on his tour of South America. The Duke of York wrote to his brother that the bride "looked lovely" but he prudently omitted to mention the bridesmaids. Posed for the first time in a Palace photograph, Elizabeth is seen in the back row of the bridal group, unusually pensive, not to say anxious, in expression. The full view of the family and all the heavy pomp of the wedding brought home more vividly than ever the difficulties involved in marrying royalty.

The Lady Elizabeth's fuller friendship with the Duke was not immediately resumed. Early that spring she visited—and in effect sought refuge with—her friend Diamond Hardinge in Paris. As daughter of the widowed Lord Hardinge, Diamond was châtelaine of the British Embassy and so it was from that lovely—and some say haunted—mansion in its verdant garden in the Rue de Faubourg St. Honore that Elizabeth gained her first independent view of the splendours and pleasures of the capital of France. The holiday could hardly have been more auspicious, with a variety of

dressers, two chauffeurs, a detective, a footman, a gentleman in waiting and his valet.

Lord Strathmore for his part invited the Duke of York to Glamis for some shooting. When the royal guest arrived, Lady Strathmore had fallen ill and was in bed. She was to undergo an operation shortly afterwards but Elizabeth of course capably took charge and proved herself a perfect hostess. "It is delightful here and Elizabeth is very kind to me," the Duke sent a note to his mother a day or two before Queen Mary came to tea. He added a restrained afterthought, "The more I see her the more I like her." He spent four days enjoying the physically arduous shooting with Michael and David, plodding across the rough backstrip bogs and moors, and the Queen studied Elizabeth anew over the baps and scones and was more than ever convinced that she would have been just right for her son.

<div align="center">II</div>

Romance was increasingly in the air in 1921 as the family began looking forward to Christmas. While Lady Strathmore slowly recovered from her illness, her daughter, now aged twenty-one, was the moving spirit in planning the festivities. Late in November Princess Mary announced her engagement to Lord Lascelles and invited Elizabeth to be one of her eight bridesmaids in Westminster Abbey. The wedding was accorded the status of State ceremonial. The original plan was, indeed, that ladies should wear full Court evening dress, with feathers and veil, until the Archbishop of Canterbury pronounced this attire unsuitable for a religious ceremony. The rush of Christmas was followed by the conferences and dress fittings of the bridesmaids. Their dresses were of straight-cut cloth of silver, with an under-robe of ivory satin *broderie anglaise* showing through open panels, and in addition, true to the period, a large silver rose was worn at the hip with a true lover's knot of blue. The head-dresses were of veils within a wreath of silver rose leaves. The Lady Elizabeth was so

in-law," Lady Airlie wrote afterwards. In the Spring of 1921, friendship had progressed to the pitch where the Duke of York felt obliged to consult his father. "You will be a lucky fellow if she accepts you," the King said, in his characteristically offhand way. There is no evidence that he had met Elizabeth at the time, but his opinion of his son's fortunes was confirmed. The Duke proposed and was refused.

Lady Strathmore had to say she felt sorry for him: he looked so disconsolate. It was an intense setback to the Duke, suffering as he was from a sense of loneliness and of a lack of understanding and appreciation in his home circle. Sad though she was at having to refuse him, Elizabeth felt at the time that her decision was irrevocable. "I do hope he will find a nice wife who will make him happy," she wrote to Lady Airlie. "I like him so much and he is a man who will be made or marred by his wife."

Happily, they continued to meet, at first less often and then again with the old recurring frequency. Their seniors still hoped to bring them together and found it touching to note that, with disappointed humility, the Duke was still in love. On Elizabeth's brow, too, a friend noted a "thoughtful look ... though super-ficially it would appear all sparkle and girlish fun". Hostesses found her "the best dancer in any ballroom" but closer friends knew that "she was a girl who would find real happiness only in marriage and motherhood ... a born homemaker". Queen Mary, too, felt sorry for her son. Few other eligibles were in sight and indeed she told a close friend that she considered Lady Elizabeth was "the one girl who could make Bertie happy".

Quite early in the summer the Queen tactfully hinted to Lady Airlie how pleasant it would be to have a real holiday at Airlie Castle. As a good lady in waiting and a better friend, Lady Airlie immediately acquiesced and diplomatically also included Princess Mary in the invitation, thus repeating the circumstantial pattern of the previous year. Airlie is the smallest inhabited castle in Britain but Queen Mary arrived for her few quiet days with two

did not appear, perhaps because she was yielding family precedence to her sister-in-law, Mrs. John Bowes-Lyon, who was presented that year. In 1923, when the Courts were next held, Elizabeth was already a member of the Royal Family. She may have quietly attended, on the other hand, one of the crowded royal garden-parties of 1919 which "constituted a presentation".

She continued to meet the Duke in the autumn and winter of 1920 when Princess Mary was clearly her willing accomplice in arranging opportunities and invitations. Lady Elizabeth first visited Buckingham Palace with Princess Mary shortly before Christmas and was taken up in the lift to the Princess's apartments. Perhaps Queen Mary strolled in and she faced for the first time the Queen's intent, questioning gaze. Queen Mary was more concerned at that time with conning over the Greek and Danish Royal Families for a possible wife for the Prince of Wales than with the matrimonial prospects of her second son. The matter was raised one day with Mr. Lloyd George, who took the view as Prime Minister that the days of continental alliances were over and that both the King's elder sons had better seek a bride among the British aristocracy.

"I don't think Bertie will be sorry to hear that," the Queen told Lady Airlie. "I have discovered that he is very attracted to Lady Elizabeth Bowes-Lyon. He's always talking about her. She seems a charming girl. But I don't know her very well."

Lady Airlie responded that she had known Elizabeth all her life and "could say nothing but good of her". Convinced that mothers should never meddle in their children's love-affairs, Queen Mary said nothing more. Lady Airlie was thus not surprised when Elizabeth began dropping into her flat in Ashley Gardens and talked of "Bertie", and yet it became obvious that her confidences were heavy with doubt. Elizabeth had now seen enough of the Royal Family to realize how constrained and restricted life could become if she married into that circle. "She was frankly doubtful, uncertain of her feelings, and afraid of the public life which would lie ahead of her as the King's daughter-

The lease of the establishment in St. James's Square was relinquished in 1920, although Lord Strathmore leased an equally opulent and remarkably similar London house at 17 Bruton Street, a dignified double-fronted Adam mansion, a few doors east of Berkeley Square. With its redecoration set in progress, the family made the customary August move to Glamis Castle. And here again a stepping-stone of future happiness was reached unaware when, at Lady Airlie's neighbourly instigation, the Duke of York paid a visit from Balmoral.

As we have seen, Mabell, Lady Airlie, a lady in waiting to Queen Mary, was one of Lady Strathmore's oldest friends. She had Princess Mary staying with her that summer at Cortachy Castle and Lord Strathmore arranged a large party to meet the Duke and welcome the Princess. As if to supply the Duke with naval interest, Rose and her husband were home from Malta. The young people danced in the evening and, for dressing up, we are told that Lady Elizabeth wore "a rose brocade Vandyck dress with pearls in her hair". One has no difficulty in recognizing her Princess Elizabeth costume.

Apart from suiting her, its merit no doubt lay in its namesake association rather than flimsy royal overtones. Her father had long since forgotten his old objections to the Court but Elizabeth was fully capable of seeing the funny side of royalty. On a hot London afternoon she and a friend were motoring up to St. Paul's Walden Bury for the weekend but the family car assigned to them was a stately and high-roofed Daimler comically resembling the cars used by Queen Mary. Elizabeth could not resist raising her umbrella above her like a parasol while, sitting bolt upright, she and her escort bowed and waved at the astonished citizens of Edgware Road.

It remains an oddity that the then future Queen of England was never presented at Court. Although those feathery parades of débutantes and mamas were revived in 1920, her name does not appear on the presentation lists and in 1921 no Courts were held When the ceremonial was resumed in 1922, Lady Elizabeth again

children's party at Montagu House when she had given him the cherries from her cake. He was slim and highly strung and he still stammered badly but this impediment diminished to the merest hesitation in pleasant company.

One can imagine that Elizabeth brought him out, talking of their mutual enthusiasms, dancing and tennis, teasing him with argument as she liked to do. Neither attached undue importance to the meeting. Two weeks later she read that the King had created him Duke of York, and yet there is no sign that her dance partner of an evening was an acquaintance sufficiently tangible to warrant a letter of congratulation. As wise old Lady Airlie said, "Her radiant vitality and a blending of gaiety, kindness and sincerity made her irresistible to men." Not merely young men, one notices, for older ones, also, had lost their hearts to her. One handsome man, in the age group of her elder brothers, admired her fervently and never married, evidently because he could find no one to equal her, and whether she declined his hand or not he remained content to spend life through as her helpful and chivalrous knight errant.

Another friend attempted to analyse his "intense desire to please her". On the credit side were listed her "unruffled serenity", despite her ability to "express opinions very trenchantly" and "a great love of argument". "Those she is with feel themselves all they would wish to be. If to be witty, they become scintillating. In companies of the shy and silent, she will launch one of those inexhaustible topics on which everyone wishes to talk . . . When discussions become exasperating she can interject a remark to distract immediately."

The impromptu deftness, however, was demonstrated not to be without forethought. Before a luncheon party with some rather pompous guests, she entered into a conspiracy with a friend across the table to laugh whenever she raised an eyebrow. The signal flashed at the first dullish remark, while Elizabeth laughed with charming naturalness. The friend followed suit and the solemn atmosphere of the luncheon was quickly dispersed.

THE RELUCTANT BRIDE

I

LADY ELIZABETH BOWES-LYON met Prince Albert, King George V's second son, in May, 1920, at a small dance given by Lord and Lady Farquhar at 6 Grosvenor Square. Lord and Lady Annaly, newly-weds of one year status, were also guests and were probably responsible for Elizabeth's introduction to the Farquhar circle. So events led on in their pleasant progression. Lord Farquhar was an eccentric figure, a man of seventy-six with a fierce expression, a firm chin and a military moustache, "so gaga", as Bonar Law said, that one did "not know what to make of him". He had once been Master of the King's Household at the Court of Edward VII and treasurer of the Conservative Party, and he was thought immensely rich. He was in fact to leave a grandiose will leaving personal mementoes or large sums of money to nearly every member of the Royal Family but he in fact died heavily in debt, the legacies could not be paid and the disappearance of certain funds that he had managed for Princess Arthur of Connaught was never satisfactorily explained. He sounds an unlikely sponsor of romance, and yet Prince Albert—the future King George VI—fell in love with Lady Elizabeth that night, a transcendent fact which the young man did not realize until later.

Studying at Cambridge, after transferring from naval service and learning to fly in the R.A.F., the Prince was now twenty-four to Elizabeth's twentieth year, and age no longer set a gulf between them. If he had danced with her as a thirteen-year-old girl, as her governess said, neither could recall it but he remembered the

In 1919, as in 1945, everyone had a sense of battling for the climate of peace against headstrong winds. The wounded still returned, or were transferred from one hospital to another, and the Glamis ward did not close until nearly the end of the year. Nor did Lady Elizabeth's interest in the domestic affairs of the boys in blue end with the Armistice. She found herself still sympathetically concerned with the problems of work and homes for returned heroes and indeed jobs were found on the estates for some men who had first met the Strathmores as hospital patients. With all the enthusiasm and energies of her eighteen years, however, Elizabeth enjoyed what could be made of the revived London season.

Peace was signed in June and the searchlights shone through the night sky in a cascade of jubilation. In July Elizabeth saw the Victory March and long remembered the tremendous ovation given to Marshal Foch at the head of his procession. The brilliant sunshine of Royal Ascot saw her in a white lace frock and a hat akin to a poke bonnet. The young racegoer could claim that she was within a few weeks of her nineteenth birthday, and her daughter was to attend a race-meeting for the first time at nearly the same age.

Then once again the weekends lengthened at St. Paul's Walden Bury. "It's so perfect here," Elizabeth sighed to a friend. "But it's so perfect at Glamis, too." And yet when settled once more within that rose-pink castle she appears to have felt the sense, so prevalent in the atmosphere of 1919, of being at a dead end, of being indeed at the end of a chapter. The old park merged with the woods, the new plantations with the heathlands and moors, and so to the mountains. And then? Lady Elizabeth could, and did revive the picnic camp-fires of her childhood, with the local Girl Guides. She could, and did help to revive her mother's garden-parties for charity and local philanthropy. And there were of course fish to be caught in the Dean, and perhaps fish to be caught, and thrown back, elsewhere.

when he could have been repatriated in an exchange through Holland he had given up his place in favour of another badly wounded brother officer.

The coming of peace thus alleviated anxiety without immediately changing the lives of the Strathmores. But with Pat and Jock both safely home a great fancy-dress party marked the Christmas festivities. It was in another world, her pre-war childhood world, that Elizabeth had worn her 'Princess Elizabeth' gown, and now curiously enough, she had it copied in her new adult size, the style, the high waist, the gathered sleeves the epaulettes, the embroidery, buttons and neckline precisely the same.

In February, 1919, the family gathered in London for the wedding of Princess Patricia of Connaught to Commander Alexander Ramsay, which the newspapers applauded as contributing to "the democratization of the Throne". The bridegroom was a kinsman of Forfarshire neighbours, and the Strathmores and Elphinstones were prominent in Westminster Abbey for this, the first of a popular chain of post-war royal weddings. It was just as well they were all in town, for word of Michael's return came at such short notice that there was only just time to dash to the station to meet him. Amid this family happiness, Elizabeth was fitted for her dress as bridesmaid to her close friend, Lady Lavinia Spencer, who was to marry Lord Annaly. The two girls had both been bridesmaids at Rose's wedding and in April Elizabeth went to stay with the Spencers at Althorp, Northamptonshire, in readiness for the ceremony. Lavinia's brother had married a Hamilton, whose family had always been so welcome at 20 St. James's Square in pre-war days, and so we see another link drawn in the mesh of social consequences that steadily enveloped Lady Elizabeth in the next three years. Meanwhile, as "demobbed" servants returned, the Bury was reopened and New Zealand and Australian officers came to spend their leaves there as well as at Glamis. Sheep still grazed on the lawns, but to the visitors still so far from home this was a sight for sore eyes.

marry one of the New Zealanders about the house. The prophecy was not fulfilled but, if she had been an only child, unaccustomed to the company of older brothers, it is possible that she might indeed have lost her heart to one of the handsome officers who came to Glamis and then British history would have been different.

Too young to take part in the war, she was not too young to impart to her father's guests the tonic qualities of companionship and sympathy that restored their confidence before they again faced Armageddon. Whenever the postman came, it was always sure that there would be letters for Elizabeth who, always readily promising to write, continued to maintain her extraordinarily wide correspondence with skill and persuasion. Her father's chief amenuensis, she also wrote constantly to all three of her fighting brothers and her letter to Captain Michael Bowes-Lyon was one of the last before he was reported killed.

This notification was a further terrible blow to Lord and Lady Strathmore, only eighteen months after the death of Fergus and when they were just beginning to recover from the constant reminders of his loss. In spite of her own grief, it is said that Elizabeth arranged for David to come home from Eton so that his company might help her parents, but his boyish consolation took a strange line. He persisted in saying that Michael was not dead, and indeed he soon refused to wear either the conventional black arm-band or a black tie. On his way back to school, an elderly friend who lunched with him in London took him to task for this lack of mourning. "But Michael is not dead," David maintained. "I have seen him twice. He is in a big house surrounded with fir trees. He is not dead, though I think he is very ill—his head is tied up in a cloth." The friend argued in vain that the War Office was unlikely to make a mistake, but whether David's circumstantial picture was a coincidence or a paranormal example, it was proved to be right. Three months later the news came that Michael, shot through the head and too ill to communicate, was a prisoner in Germany. The family discovered afterwards that

was also Charlotte Grimstead's aunt, a strong reason for supposing that the consanguinity had produced a pairing of recessive genes that resulted in the defective infant.

The lurid gossip of a monster and the legend of the secret room could be strung together thereafter as a tale for the servants' hall. Although it is faintly possible that the unpresentable child lived in concealment for a short time, it is more likely he could not have survived. The shock to the parents was transient, for their new heir, the twelfth Earl, was born only eleven months later. When he arrived at manhood the story of his unpresentable—and probably long dead—elder brother may have presented itself as a vengeance in the blood which caused him to refrain from parenthood. His wife is said to have heard the story of the monster and to have pined away. In fact she died of peritonitis which could have arisen from an infection arising from contraception or even abortion. The story was indeed gloomy enough to have given the thirteenth Earl his "ever sad look" and his wish never to have the subject mentioned. Five of his eleven healthy children were born before he knew the secret. Every successive fresh pregnancy in his family must have brought the old haunting shadow to his mind. The Glamis monster is indeed monstrous and it is wretched to have to examine this old unhappy tale.

The gentle Lady Elizabeth would have had the best of reasons for not discussing so indelicate a subject. And, besides, was there not enough tragedy in the world in 1917?

IV

In the residue of Glamis folklore, the belief persisted that the Lyons had a gift of second sight. Under the dire food shortages of 1917, Lord Strathmore sought to improve his young daughter's proficiency with rod and line—and as a markswoman, too—and some old wives no doubt attributed her success in the Dean Water to inherent powers of divination. There were gossips, also, who could claim with conviction that Lady Elizabeth would

In the midst of his large and charming family, it seems then that
the Queen Mother's grandfather, the thirteenth Earl, thus knew of
something. The Queen Mother's father, on his own coming of
age in 1876, however, valued his peace of mind and refused to
allow the dreadful secret to be revealed to him in turn. He may
have known it already and was aware that it sufficiently belonged
to the past. He perhaps hoped by discontinuing the custom to
stamp out the appalling mid-Victorian floodtide of rumour that
had gushed in full spate since his uncle's death. His refusal slammed
the door on the gruesome mystery that Strathmore husbands
necessarily had to keep from their wives.

But what was the secret? Much additional spadework of
research had been undertaken only recently by Mr. Paul Bloom-
field, with results that appear both logical and credible to the
modern mind. When the young Walter Scott visited Glamis in
1793, an enthusiastic collector of "the queerness and the fun" of
Scottish folklore, he knew of the room "the secret of its entrance
imparted to three people" and he expected ghosts but of such a
super-mystery as the monster he gives no hint. There were no
rumours, then, of that unhappy creature in 1793, and if he came
into existence subsequently there is nothing to arouse either our
suspicion or our pity until October, 1821, when a male heir to the
Strathmores was *born and died* on the same day. The authorities,
Douglas's *Scots Peerage* and Cockayne's *Complete Peerage*, are
agreed on this event, although the notice is absent elsewhere. The
parents were Thomas, Lord Glamis, and his wife, née Charlotte
Grimstead. They had married ten months earlier and they had
another son, destined to be the twelfth Earl, in September, 1822.
Since the existence for a day of the elder son is missing from many
reference books, Mr. Bloomfield may refer to him with reason
as the Unpresentable Heir.

The circumstances around the birth and death of this child
evidently had to be hushed up. The parents probably did not
understand the true extent of their tragedy themselves. They were,
however, first cousins once removed. Lord Glamis's grandmother

Glamis, and we must confront the thing ourselves as a lurking familiar long known to or guessed at by the Queen Mother.

The story, then, is of a secret room within the fifteen-foot-thick Castle walls and, within the room, a dreadful secret known only to three people, the Earl of Strathmore, his heir and the factor or manager of the estate. In the more preposterous versions, the heir is told on his coming-of-age of a nameless horror, a shambling unhuman creature kept in hiding through the years and through the generations. The theme is, of course, a recognized favourite of Victorian fiction, the immortal monster stems from *Frankenstein* and the hidden family secret is akin to the insane wife in *Jane Eyre*. On collating the various Glamis stories there are a few accounts that assume reasonable credibility. Thus the wife of the thirteenth Earl of Strathmore (grandmother of Queen Elizabeth the Queen Mother) is said to have tried to wheedle the secret out of the factor, Mr. Ralston, whereupon he had told her very soberly, "Lady Strathmore, it is fortunate that you do not know it and can never know it, for if you did you would not be a happy woman". In similar vein, Augustus Hare has told how the Bishop of Brechin, oppressed by the habitual "ever sad look" of the thirteenth Earl was bold enough to offer to help in any way he could "in case the services of an ecclesiastic could be of any use in his secret affairs". Lord Strathmore thanked him, but said that in his unfortunate position no one could ever help.

Again, there is the testimony of a witness as reputable as the wife of an Archbishop of York, a Mrs. Maclagan, who was in fact the sister-in-law of the twelfth Earl. This twelfth Earl died childless in 1846 and his brother then inherited the title at the age of forty-one. The secret was thus divulged to him unexpectedly in middle life—by the factor and a family solicitor—and, according to Mrs. Maclagan, his wife then inquisitively asked to be initiated in turn. "My dearest," the new Earl replied, "you know we have joked about the secret room and the family mystery. I have been into the room, I have heard the secret, and if you wish to please me you will never mention the subject to me again."

attracted by the sound of the fire-engines, the splendid sight of the dashing horses and the glow of the flames, and the young châtelaine arranged some thirty people in line to pass pictures and furniture hand to hand to greater safety. The Dundee brigade with its fuller equipment succeeded in getting the fire under control. Unaccustomed to Glamis faces, a very young reporter from Dundee plied Elizabeth with questions, "How had the fire started? What damage had been done? Which member of the family slept in which room?" She cut short his flow and moved away.

"I've no time to make conversation!" she said.

"Who's yon prood lassie?" the discomfited boy enquired. The next issue of the local paper, however, devoted a page to the fire and brother and sister read no doubt with mingled delight and scorn of the 'indefatigable energy' and 'defiance of discomfort' with which they had faced the flames, their first accolade in print.

III

"The legend of the Glamis monster is based on a very strange and secret occurrence," Kathie Kuebler has written. "Lady Elizabeth surmised what it was all about and told me what she knew, but in strict confidence." In 1917 the German governess had of course long since disappeared behind the curtains of war. After she and her pupil had exchanged "short, inadequate letters" for a time through a British Consulate in Holland, communication petered out. The "monster" nevertheless was always recurring in questions that Elizabeth grew adept at parrying. It has been recorded that, besides the singsongs and whist-drives, the soldiers liked to tell ghost stories, perhaps because they were young and had seen one face of death, and the firelight flickering at Glamis on suits of armour provided favourable atmosphere. The family knew that the monster was a subject of world-wide notoriety, though he hardly ranked as a ghost and remained less than a legend. An officer from the remote outback of Australia might prove to be as acquainted with the old tale as anyone in

in memorizing the wounded men as individuals. "We want you to feel this is your home from home ... you are our guest," she would say, so that old soldiers talked long afterwards of "Dear old Glamis" and "little Lady Elizabeth". This gift of acquaintance deepened in 1917 when Lord Strathmore began entertaining parties of Australian and New Zealand officers who were on leave. Fate had already given her working practice in the technique of a royal memory and now, unconsciously, she was being rehearsed in "the ties of Empire ... the connecting link of a Commonwealth".

As Elizabeth bourgeoned into womanhood, tougher strains were also evident in her character. To the unaccustomed she appeared to have that slight hauteur of caste and breeding that made initiated Tommies say she had "no swank at all". The friendly charm masked self-reliance, and the sweetness was edged by cool appraisal. One Saturday evening in September, 1916, two soldiers opened the door of the roof to meet smoke and flames, and then came clattering back down the stairs with shouts of 'Fire!' There were no bed cases in the ward and nearly all the patients had been taken, with the nurses, to a cinema. Lady Strathmore and David were somewhere in the house, but Elizabeth first telephoned for the fire brigades from Glamis, Forfar and Dundee before she called David and domestic help, raised the general alarm and organized her panicky platoon into a chain with pails and jugs from the nearest bathroom tap.

A strong wind was blowing and the roof of the central keep was well alight before the local Glamis brigade arrived. Their hoses were too short to raise water from the river Dean to the required height and the Forfar brigade came on the scene but little better equipped. Before long a lead water tank in the roof burst under pressure of the heat and the needed water flooded in a deluge down the staircase where Elizabeth and David redeployed their force with brooms and mops to sweep it away from the doors of the drawing-room and other apartments to a less harmful flow down the stairs. By now villagers had been

eldest sister-in-law, brought her own five-year-old son, who
was forever commanding his "Aunt Elizabuff" to be "funny".
Thus the old family life was revived in the upper rooms of the
Castle, while from the hospital quarters the gramophone strains
of *If You were the Only Girl in the World* or the mouth-organ
plaint of *There's a Long Long Trail* came drifting as usual up the
staircase.

As Elizabeth was to do many years later, Lady Strathmore
found solace in a domestic routine which her daughter was quick
to encourage. Every morning, the two women went to the chapel,
their heads mantled with lace, for private prayers. The soldiers
having discovered this custom, some had expressed a wish to
attend and so a bell was briefly rung. Elizabeth and her English
governess would then shut themselves away for lessons, either in a
room high above the courtyard or, in the summer, in an eyrie on
the topmost roof-leads where stout old railings formed a balcony
among the turrets. Here one would not miss seeing an aeroplane
if one of these still interesting machines should come buzzing
above the Grampians. The sound of the Union Jack flapping on
its flagstaff supplied cheerful punctuation to one's studies and,
when the Western Front was active, it was a practical considera-
tion that one could always see the telegraph boy whenever that
menacing and undesirable figure appeared upon the drive. Once
or twice governess and pupil were disturbed when a chimney-
stack caught fire, and then the more mobile soldiers came hurrying
up with saucepans and soup-plates full of salt to throw down the
chimney to quench the flames.

The late afternoon was reserved for the ward visits and the
questions that Lady Elizabeth seemed to make ever fresh and
pleasantly personal. "How is your arm? . . . Are you sleeping
well? . . . Have you heard from home? Why are you not smok-
ing? Have you plenty of tobacco?" Throughout the war some
1,500 men passed through Glamis Hospital. In invalid blue or
regulation issue pyjamas and dressing-gowns, each group must
have looked very much alike, and yet Elizabeth rarely faltered

Dundas, Lady Kinloch, Lady Victoria Russell, the Hon. Mrs. Bethell, the Hon. Mrs. Ruthven, the Hon. Margaret Wyndham, Mrs. George Forbes ... the Cazalets, the Bowden-Smiths, Carmichaels and Drummonds and Eyres-Monsells ... Such was the social strata in which Lady Strathmore's last unmarried daughter might be expected one day to find a husband and we can notice in the guest-list names destined still to loom in the loyalties of the Queen Mother's kith and kin twenty, forty and even fifty years later, so steadfast is her adherence to old friends. No doubt people gaily reminded the bride's unmarried sister that she would be next, and probably no one heeded the augury of the naval emblems that auspiciously decorated Rose's wedding-cake. Yet one hopes that at least some nautical fragment may have been represented in the sugar-icing of Lady Elizabeth's slice, for her future husband had just rejoined his ship *Collingwood* as a young lieutenant and was about to face the action in the Battle of Jutland which he regarded as the most conspicuous of his naval career.

In the complex embroidery of events Elizabeth passed through Windsor only the following week on her way to enjoy the Fourth of June celebrations with David at Eton. It may be noted that Prince Henry (now the Duke of Gloucester) had also attended Wellesley House School at Broadstairs and was David's contemporary at Eton. But other links were to further her own way to the altar, including her friendships with Lady Mary Cambridge, Lady Mary Thynne and Diamond Hardinge, all of whom were to be bridesmaids with her at Princess Mary's wedding six years later.

For the present, Elizabeth returned to Glamis Castle, with the added difference that in her sister's absence the responsibilities of that enormous house rested more heavily on her own youthful shoulders. Her mother had not shaken off the shock of Fergus's death and, under the depressing fear of another telegram, was often unwell and listless. Mary Elphinstone came to stay, bringing her own two-year-old toddler, and Dorothy Glamis, Elizabeth's

sling, but this created an effect she had not foreseen. When he sent
the photograph home, his parents feared that the missing arm had
been amputated. Hearing this, Elizabeth wrote not only to assure
them that all was well and express her sorrow that they were
worried unnecessarily but also to set all fears at rest another
photograph clearly showing both arms was enclosed.

Although no one, as yet, could dream of future events, it was
all excellent training for queenship.

<p style="text-align:center">II</p>

Elizabeth's sister, Rose, was married to Commander William
Spencer Leveson-Gower, R.N., heir to Earl Granville, on May
24th, 1916. The Archbishop of York officiated and it was a
wedding flecked with naval pageantry, with Elizabeth one of the
three bridesmaids in the London church she knew best, the family
parish church of St. James, Piccadilly. A lull had occurred in the
air-raids on London and no warning police whistles or wailing
maroons disenchanted the congregation. The bridesmaids wore
frocks of white chiffon with coatees of rose-painted chiffon and
little Dutch bonnets of pink silk ribbon, and the charming trio
carried bouquets of pink roses. It was a bridal picture much to the
taste of the wedding guests, so predominantly feminine. The
reception was held at 20 St. James's Square and, as at every func-
tion in this second year of the war, men were markedly in a
minority.

Apart from this absence, the guest-list merits interest as a clue
to the social milieu of Lady Elizabeth at this time. The Duchess of
Devonshire and Lady Dorothy Bentinck, Viscountess St. Cyres,
the Countess of Dysart, the Countess of Selkirk, the Earl of
Camperdown, Lord and Lady Sudley, Lady Newton and the
Hon. Phyllis Legh, the Dowager Countess Beauchamp, Lady
Delia Peel, Lady Blanche Conyngham, Lady Cicely Vesey, Lady
Mackenzie of Gairloch, Lady Alice Egerton, Lady Westbury,
Lady Trevelyan, Hugh and Lady Ada Fitzwilliam, Lady Alice

to be a better cyclist than David, who now assumed the airs appropriate to a young man commencing his first term at Eton. Then Fergus came home to spend a few hours' leave at Glamis. He left as darkness fell on the Monday and on the Friday a telegram arrived. Once more disaster swept unheralded on the Strathmores. The day after returning to France—ten days after his wedding anniversary—Fergus had been killed at Loos in the storming of the Hohenzollern Redoubt. It was all the more tragic that he left his wife with a two-months-old daughter.

The hospital patients all signed a letter of sympathy which was sent up to Lady Strathmore. It was not until a day or two later that, emerging from the initial trance of bereavement, she and her youngest daughter noticed the curious silence of the ward and found that none of the men were to be seen around the grounds. As a mark of condolence, they had agreed among themselves not to play the gramophone or the piano, not to use the billiards-room—which was nearer the family quarters—not to use the lawn for games and to use only a side door of the Castle to avoid intrusion on the family. Touched by the gesture, Lord and Lady Strathmore sent a message asking them to continue with their recreations in the usual way "for you are our guests", but for a time it was Elizabeth alone who punctiliously said goodbye to each departing soldier.

There are old photographs that show a little figure in black, skirts flapping nearly to her buttoned boots but with that open smile that had made every man feel she was his special friend. She knew them all by Christian names, she knew about their parents and their civilian lives; she made a point of discovering these salient details of every newcomer. She remembered them years later when she saw them again, though many went back to France and never returned. It was one of the elements of friendship that she took a snapshot photograph of each man to send to his family, and became proud of her ever-lengthening list of correspondents.

By a mischance, one of her photographs of a man with a shoulder wound was posed so that it would not show his right arm in a

who had been exchanged as prisoners of war, maimed and dis-
figured, so deeply affected her tender heart that Lady Strathmore
decided the old routine of lessons should be resumed. Rose
returned from her London training course and assumed a strange
authority as the Glamis hospital sister. Elizabeth promptly wished
to emulate her as a hospital nurse but was obviously too young.
For a time, adult guidance diverted her attention to a flock of
perverse red hens who were supposed to yield eggs in untold
quantities in return for being warmly housed in one of the disused
castle towers, but despite immense quantities of wartime food
their output remained unresponsive. Another small duty was the
sorting of the hospital mail before lessons. Many of the men,
wistfully recalling their Glamis days, were to remember her
waiting for the post or hurrying down the drive with her black
cocker spaniel, and running up the staircase, eagerly calling her
mother, when there were B.E.F. envelopes from her brothers.

Whenever the ambulances brought new arrivals, the routine
was for Lady Strathmore to visit the ward with her daughter to
be introduced. But usually, before then, always quick to greet a
shy stranger with a smile, Elizabeth had already met the newcom-
ers. She had her stock of questions in readiness to break the ice,
"Where do you come from? Does your shoulder—your arm—
your foot—your leg—hurt you? I hope you like Glamis—"

"She had the loveliest pair of blue eyes," one of the patients
has recalled, "expressive, eloquent eyes. She had a very taking
habit of knitting her forehead now and then when speaking . . .
that sweet, quiet voice, that hesitating yet open manner of talking.
For her fifteen years she was very womanly, kind-hearted and
sympathetic." She was trying to look older; she had put her hair
up early, with a bun, and a fringe on her forehead, in the style
that became a hallmark for years, yet she was still a child. A
feverish rat-hunt in the Crypt terrified her, and she claimed to be
afraid of mice. She had acquired a bicycle and would sometimes
ride it "with eyes tight shut", falling off, jumping on and enjoy-
ing the soldiers' alarm for her safety. Evidently her ambition was

Crypt, and the boys in blue, some in slippers, some with their heavy black boots brightly shining, to share the fun of opening gifts.

At the last moment, that Christmas, Elizabeth decided she would like to give a personal present to each man, a decision that led to a rush to the village to buy fountain-pens, pencils, books and playing cards. David, on holiday from school, joined in the immense lark of being dressed up as a lady visitor, complete with skirt, buttoned boots, cloak, furs, veil and feathery hat, whom Elizabeth escorted around the ward and introduced as her cousin. David brightly asked the questions that ladies were supposed to put to wounded soldiers, and whether the men were deceived or not, they played up nobly and feigned utter astonishment when the real David was produced the following day.

Although there were gaps at the family table, Lady Strathmore decreed that the first—and surely the last?—war Christmas should be as happy for the two children as possible. So they went to see the pantomime in Dundee and rode into Forfar to giggle together at Charlie Chaplin. The men themselves gave concerts and blackened their faces for a minstrel show. Whist drives were arranged, with nurses and family and servants to add extra players; and Lady Elizabeth was a popular partner—and sometimes, it is said, a cause of jealousy and recriminations of Tommies who seemed too 'pushing' to get to her table. Illusions comforted these men so far from home. A corporal in his late twenties constantly assured her she was just like his fiancée. The young girl made friends too readily and with such genuine warmth that it was a constant source of sorrow to her to hear of 'discharges' leaving to make way for a fresh group of wounded men. It became a custom of the house for the soldiers to have a farewell supper in Christmas style with crackers and caps and mottoes, speeches and flashlight photographs and little packages of "gifts from Glamis Castle" (which meant, invariably, gifts from Elizabeth).

Early in 1915, however, the arrival of the badly wounded men

his leave was cancelled. Abruptly Glamis seemed empty of family and full of strangers, for helpers of the Forfar and Angus Red Cross arrived, with their iron bedsteads and schoolroom chairs and tables, and began to prepare part of the Castle space for hospital use.

The supervision of household treasures became a responsibility that Lady Strathmore and Elizabeth shared but it was decided to move as little family furniture as possible in order not to spoil the homely and welcoming aspect of the rooms. In the dining-room the family portraits stared down at sixteen white hospital beds. The Crypt, which is in reality a former banqueting hall slightly above ground level, was arranged as a mess-hall with trestle tables and bentwood chairs beneath the medieval shields and armour on the walls. In the billiards-room Nebuchadnezzar looked down from his tapestry on a green baize table stacked with "comforts". The bookshelves were stored with socks and shirts and body-belts, while on other tables sheepskin coats were piled waiting to be waterproofed with varnish.

"My chief occupation was crumpling up tissue paper," the Queen Mother has recalled, "until it was so soft it no longer crackled" and her tenderized handiwork was used for the lining of sleeping-bags. Except for sparetime reading, lessons were neglected. When no more tissue remained to be softened, endless knitting awaited the young volunteer, with for variety, the task of sewing khaki shirts for Jock's local battalion of the 5th Black Watch. Shortly before Christmas, the first 'boys in blue'—as the wounded men were known from their blue flannel hospital suits. —arrived at Glamis Castle from Dundee Royal Infirmary. They were, in fact, convalescents, doomed to be returned to the trenches as soon as possible. But to the young girl it added spice and excitement to go to the village and buy unfamiliar brands of cigarettes and tobacco, Gold Flake and Navy Cut, and it was added fun to disguise the "comforts" as Christmas parcels. Spending Christmas at Glamis was in itself an immense novelty, with a dark Christmas tree brushing its topmost spurs against the roof of the

A GIRLHOOD IN WARTIME

I

"IT WILL ALL BE over by Christmas . . ." The fourteen-year-old Lady Elizabeth's first view of the war was inevitably optimistic and romantic. Her two eldest bachelor brothers, John and Fergus, immediately proposed to the ladies of their choice and announced their engagements, and the family was flung into the ferment both of mobilization and marriage. Lady Rose took up nursing training in a hospital in London. Of the brothers, thirty-year-old Pat was immediately called up with the officer's reserve of the Black Watch; John and Fergus were soon serving with that regiment, though in different battalions and Michael enlisted in the Royal Scots.

Elizabeth found herself engaged in running errands and vividly remembered years afterwards, as she said, "the bustle of hurried visits to chemists for outfits of every sort of medicine, and to gunsmiths to buy all the things that people thought they wanted for a war, and found they didn't". Fergus, who was twenty-five, was married on September 17th to Lady Christian Dawson-Damer, a daughter of the Earl of Portarlington, in the thirteenth-century parish church at Buxted, Sussex, and the bride to Elizabeth's admiration compromised with wartime by wearing "a white travelling dress" with an old Brussels lace veil. Michael acted as best man, and the Bury was lent for the brief honeymoon while the family rushed to Scotland ready for Jock's marriage to Fenella Hepburn-Stuart-Forbes-Trefusis on the 29th. Michael's coming-of-age was to have been celebrated that same week, but

the stage to present them with one each. "A man who knows how to behave!" said Lord Strathmore, with a twinkle.

The hospitality that the adults of the family had enjoyed in London would be returned once or twice during the season when the Earl and Countess of Strathmore gave a reception. The music of the hired orchestra drifted up to the third floor and Elizabeth leaned over the banisters to admire the toilettes of the ladies, just as her own daughters were to do at Buckingham Palace twenty-five years later. And then one morning at the end of June Lord Strathmore handed the *Morning Post* across the breakfast table. "Here, read it," he said to Fräulein Kuebler, pointing to the news of the assassinations at Sarajevo. "This means war."

For all that, war seemed so incredible that when Fräulein Kuebler went to Germany for her holiday two weeks later, Lady Strathmore, embracing her, made her promise to return. Rose and Elizabeth would walk in Hyde Park, glancing critically at the riders in the Row, and the thought of the summer ahead at Glamis seemed untarnished by the wild rumours. On August 4th, Lady Elizabeth awoke to the gifts and greetings of her fourteenth birthday and as a birthday treat that evening Lady Strathmore had taken a box at the Coliseum. The car had to crawl to the theatre through the crowds, and then Elizabeth and her brothers looked down on a packed and excited audience. The vaudeville programme featured sketches with Charles Hawtrey and G. P. Huntley and a singer of curious ability who was styled 'The Man with the Tetrazzini Voice'. Every chance topical allusion was cheered, and a ballerina named Fedorowna received the ovation of her life-time . . . for were not the Russians our potential allies? When Britain's ultimatum to Germany expired at midnight, Elizabeth was no doubt already at home in bed, and the distant cheers of the crowds at Buckingham Palace were like the soft wash of surf on an empty shore.

excuse of historical entertainment to which every governess could conscientiously conduct her pupil. But above all Herbert Ponting's film *With Captain Scott in the Antarctic* was undoubtedly seen by both David and Elizabeth at the Philharmonic Hall.

Meanwhile, the Junior Oxford examination was attempted that April and "passed with distinction". The delighted Lady Strathmore drew up more elaborate future plans for her daughter's fuller education. The German governess was to remain another four years, while Elizabeth's gift for languages, music and art were to be more particularly cultivated. Lady Strathmore's plans embraced a visit abroad at least once a year, to Germany for the Bayreuth Festival, to Austria and Vienna, to Italy and Rome ... But none of this was to be.

Instead, a more tangible and remarkable release from routine occurred in a visit to the White City at Earl's Court, not merely for the exhibition palaces within their gleaming white domes and towers but also the orchestras, the pleasant promenades among the lawns and flowers, the floating charm of the swan-launch on the lake and the giddy headlong ascents and dips of the scenic railway, which Elizabeth "enjoyed greatly, screaming loudly" as the cars rushed through a tunnel.

When David returned home for the Easter holidays, the two could escape together into new and companionable explorations of London. "We used to go to theatres as often as we were allowed," David Bowes-Lyon once said, "usually in the cheaper seats, as our purses never bulged." Shakespeare, he cautiously added, "was by no means slighted". But it was Cyril Maude in *The Headmaster* and *Grumpy*, *The Lights of London* at Drury Lane, *Eliza Comes to Stay* and the like that chiefly sent the two hurrying expectantly into the pit or the back of the circle to be lost in the intense rapture of a world of illusion. One evening, Elizabeth and Miss Kuebler went to Maskelyne's, the hall of magic, and next morning at breakfast they told excitedly how the conjuror had produced real red roses from thin air and then descended from

still in the vigour of their power. Lord Rosebery and Lord Lansdowne were luncheon guests at No. 20 when they were summoned as elder statesmen to advise King George V on the thorny Irish problem of Home Rule. We need not suppose that this was mentioned in Elizabeth's presence, and yet the King's dilemma subjected the royal prerogative to controversy at the table of every great house in the land.

Lord Rosebery was apt to observe that it was a symptom of twentieth-century monarchy that every word of the King's was as treasured in England "as if it were God's . . . he cannot speak without the chance of his words being noted and carried", and the Queen Mother has always conducted herself as if she bore this precept in mind. In fact, Lord Rosebery had submitted to the King a statement of desirable royal qualities, still preserved in the Royal Archives. "Besides devotion to duty and reticence," he wrote, "there is something else . . . and that is the instinct of striking the imagination." It is not improbable that he repeated this in some form to Lady Elizabeth, when he sensed her interest in royalty, and that she remembered . . .

The table talk, alas, was not noted. Yet there were times when Fräulein Kuebler sat next to Elizabeth and Lord Strathmore's eminent guests tried to make the young German governess feel at ease by talking pleasantly of her native land. "Lady Elizabeth was glad for my sake, and secretly pressed my hand under the table," she says. It is a typical sidelight on her pupil.

With her penchant for namesakes, Elizabeth would not have failed to persuade some friendly grown-up to take her to see the film, *Queen Elizabeth*, with Sarah Bernhardt in the title-role, which created a sensation wherever it was shown shortly before the war. Kathie Kuebler was allowed to take her to cinemas in 1913 and 1914. The opening by Sir George Alexander of the New Gallery Cinema on the site of a famous London picture gallery made the moving picture industry socially acceptable, and soon afterwards selections from stage musical comedies were being shown. The mammoth production of *Quo Vadis?* offered the

be served at the schoolroom table for supper. Unfortunately the two youngsters went out visiting with their mother that day. When they returned rather late, Miss Kuebler had already dined satisfactorily and well on the hare, and instead of the splendidly dressed dish of game little remained but the head.

IV

Assiduous in her studies, Elizabeth was removed a shade further from the purdah of childhood by promotion to her parents' luncheon table throughout the London season. In the greater formality of the dining-room at 20 St. James's Square, so strangely dubbed the Eating Room, this exacted a grown-up responsibility more circumspect than at Glamis or the Bury; but her parents, her father especially, no doubt realized the asset of her peculiarly sympathetic and unselfconscious charm in conversation. The Strathmores kept a table of elegant and quiet perfection, circled always by attentive silent footmen though lacking the ostentation practised elsewhere in that last opulent year before the first world war. Lord Strathmore might be said to specialize, in his goodness of heart, in collecting elderly widowers and the more prominent lonely statesmen of the House of Lords. He could have claimed, though he would have been the last to utter such a boast, that his table had seated four ex-Viceroys of India; Lord Lansdowne, Lord Elgin, Lord Curzon and Lord Minto. This foregathering had occurred while Elizabeth was still in the nursery but now she turned her serene and confident smile upon Viscount Goschen, a Viceroy of the future. And, indeed, she met at her father's table senior statesmen who seem today like full-dress characters of another age, peopling a vanished Imperial past.

Thus it is strange to realize that the present Queen Mother, so essentially a figure of our own day, should have met Lord George Hamilton, who had served under Disraeli, and Lord Rosebery, who had accepted the premiership from Queen Victoria in succession to Gladstone, and met them, moreover, when both were

Occasionally Elizabeth now "followed the guns", her sociability at last outweighing distaste of the slaughter. In any case, David was now learning to shoot, and sisterhood demanded that she should share his target practice. More to her taste was to watch the expertise of fly-fishing for trout in the Glamis burn or to be included in a tennis tournament. One day it was suggested that the best player should be partnered by the worst. This led to certain asperities until Miss Kuebler, blandly innocent, was selected to partner the family champion.

Meanwhile, the separate withdrawn life of the schoolroom continued; and when the moors fell silent the stay at Glamis was prolonged, as if ebbing time had suddenly become precious, until at last only Lord and Lady Strathmore, Rose and Elizabeth and the governess sat at the huge table in the panelled dining-room. There was talk of war but the opening of the Palace of Peace at The Hague had seemed auspicious, and there was talk of friendship, too. A few language students in Forfar had formed a German club and one of the members, a local churchman, asked Fräulein Kuebler and Lady Elizabeth whether they would care to attend. Practice in speaking German was the principal object, and so we find the supreme oddity of the future Queen of England conversing in German with her loyal Scottish subjects.

Elizabeth and the family returned to St. Paul's Walden Bury for Christmas but immediately hurried back to Glamis for the New Year of 1914. The hills were covered with snow and tobogganing was the order of the day, Scottish ski-ing then being unknown. The chief New Year resolution was obviously directed to passing the Junior Oxford exam. Lady Strathmore noticed her daughter's thinness and pallor and thought that she was sometimes kept too hard at her school-books. "Good health is more important than exams," she once reminded the strict though amiable governess. David also found objection in the stern régime, particularly after he went out with a gun with his father for the first time and returned in triumph carrying a hare. This notable first trophy of his sportsmanship, it was decided, should

little man in apple-green frockcoat who was supposed to parade
at midnight carrying a boxful of cabbages. Ghost-hunting was
Curzon's little-known preoccupation; he claimed to believe
firmly in ghosts and slept in every well-attested haunted house
that his friends could offer, but never with a glimpse of a mani-
festation. Glamis was no better than the rest. It is perhaps notable
that the spooks were silent, for this was the last great pre-war
season at the Castle. Each of the twenty-eight guest-rooms were
occupied and there were, besides valets and lady's maids innumer-
able who had lodgment elsewhere.

In the laundry six women coped with the bundles of rumpled
linen that another platoon of servants carried unseen each morning
down the service stairways. In the kitchen a French chef ruled
over a staff prepared to provide family luncheon for fifty, includ-
ing the plum pudding that the Earl of Strathmore had for lunch
every day of his life, and in addition to the enormous quantities
of food for the servants. The unexpected arrival of ten officers
of the Black Watch to luncheon caused no disarray in the day's
events. At thirteen Elizabeth was increasingly initiated by her
mother into the hostess's responsibilities of such an establishment,
from the orders every morning for the chef to the occasional
inspection of the snowy table-cloths, napkins, sheets and towels
stacked in the linen-room. Approaching young ladyhood, she
would have shared in the conferences in the greenhouses on the
promise of the melons, pineapples and figs required to be in
perfection by the time of stipulated crosses marked on the
calendar. In that last pre-war Scottish summer, the new formal
gardens which Lady Strathmore had been developing for four or
five years were in their first full maturing flower, the sunken Dutch
Garden, the Italian Garden, each within its pleached trees or yew
hedges. Lady Strathmore eyed the alcoves among the trimmed
yews and declared they would one day each house a statue of one
of her children, one for Pat and one for Jock, one for Mary, and
one for Rose, perhaps "one for you, too, Elizabeth". There is no
need to regret that the plan was never carried out.

Kuebler's word for it that at one of the dances Elizabeth "met the children of the King" and was seen dancing with her future husband, Prince Albert. Though written in the light of after events, we cannot afford to disregard this romantic but possibly illusory trimming. That otherwise forgotten dance provides an overlooked link of continuity between the first acquaintance at the children's party at Montague House in 1905 and a meeting at a dance given by Lord Farquhar in the summer of 1920.

In July, 1913, Prince Albert was a naval cadet of seventeen, just back from all the excitements of his first transatlantic cruise aboard the *Cumberland*. It is possible that he may have attended a dance with his sister or younger brother, aged respectively sixteen and thirteen. It is on record that among the Canadian girls at Quebec nothing would tempt him onto the dance floor, though he was seen to dance every dance at a ball for the Fleet in Alexandria only four months later. It is just possible—and amusing to suppose—that as his unrecorded partner in the interim, pretty Elizabeth Bowes-Lyon may have contributed to his self-confidence.

It was Lady Rose Bowes-Lyon, in the outstanding beauty of her early twenties, who however enjoyed to the full the whirling excitements of the 1913 season. She found it nothing to attend three or four balls in one night and then to be fresh at the piano next morning practising the Symphonic Studies of Schumann. The Countess of Strathmore and Lady Rose made themselves largely responsible for sponsoring the coming-out of the widowed Lord Curzon's daughter, Cimmie. If she happened to see the bills, Lady Strathmore may have been shaken at the cost of decorating the ballroom of Curzon House with orchids at a cost of £2,000 but the former Lord Viceroy of India could never resist such princely gestures.

Claiming that he wished to meet the ghosts, Lord Curzon was a guest at Glamis that September. Each night for eight nights he slept in a different haunted room, prepared to encounter anything from the swearing spectre of Earl Beardie to the harmless

sary, but the boy was too ill to be moved and surgeons and nurses were summoned from London.

The disconsolate memories of Alec's death were suddenly revived with terrible apprehension. The operation on King Edward VII eleven years earlier had made the removal of the appendix a familiar and even fashionable operation but there remained the considerable natural hazard to a child of eleven years. Every unspoken thought deepened the anxiety and, on her knees, in the privacy of her own room, Elizabeth must have prayed desperately and repeatedly that David would not die.

Kathie Kuebler was able to comfort her with a sign. It was a coincidence that she too had a brother twelve years old. He, too, had been ill with appendicitis only four weeks before; the surgeons had operated, and a letter fresh in the post from Germany announced that he was now fully well. This could not have lessened the fervency of Elizabeth's supplications. So far as one may interpret, her faith was, as it is today, both simple and personal: one sought to do one's best, and to love one another, in the life that God had given. One believed in the direct link of prayer, of petitions that might be answered if such was His will.

The operation was performed and, as Miss Kuebler wrote, "We lived through anxious hours before we knew that the outcome would be a happy one. How happy we all were then!" The prayers had been answered, and to Elizabeth it was a happiness deep as a dedication when, a day or two later, she was allowed to see her brother and sit beside him.

III

Lady Elizabeth celebrated her thirteenth birthday in London on the eve of the usual massive household migration to Scotland. In the few weeks of the London season availing her before this, she had attended some of the junior dances given for teen-age groups among the families of friends. It was customary for governesses to chaperone their charges to these functions, and we have Miss

family. "With her discerning heart," said the governess, long afterwards, "it was an act of charity."

The Strathmore family was now closer knit than of old, with Lady Strathmore, Rose and Elizabeth, forming the nucleus that flowered at weekends when Jock came home from the city and nineteen-year-old Michael occasionally appeared from Oxford, and there a jubilant reunion occurred when Fergus returned on home leave from India. Lord and Lady Glamis arrived, bringing with them their two babies, an adored niece and nephew to Elizabeth. Tennis tournaments and a family form of golf spread over the emerald lawns. But it was 1913, with time closing in faster than anyone knew, and it was the mid-week serenity that Kathie Kuebler was to cherish in recollection, the walks in the woods and the sight of blue lakes that proved to be meadows of bluebells, the return home and Elizabeth's immediate rush for her mother . . . "How often I heard her clear voice calling, 'Mother darling, where are you?' in tones that rang through the house" . . .

II

David came home for his Whitsun holidays to demonstrate that he was now a full inch taller than Elizabeth, even when pressing down his tight fair curls, and a snapshot taken that summer bears a slight and amusing suggestion of male arrogance. "I am catching up with you," he seems to claim. Elizabeth evinced a liability to snuffle and catch cold, so that she was compelled to carry scarves about to ward off every chill. Avoiding the vigilant eye of the head gardener, Mr. Keeling, the two may have feasted one afternoon on illicit early fruits in the glasshouses, and Lady Strathmore was not surprised when her son complained of a tummy-ache.

The sufferer was sent to bed and no doubt missed his dinner. Next morning, however, the local physician was summoned and gravely announced acute appendicitis. An operation was neces-

than her years warranted". Within two weeks Elizabeth had stage-managed everything so admirably that the Fräulein had agreed to stay as her permanent governess, taking over her entire teaching. As Fräulein Kuebler recorded, "She had gone to school for only a short time, and the systematic German time-table was quite strange to her". With relief at escaping from school, and being always near Mother, Elizabeth swung happily into piano lessons at 8 a.m. for an hour before breakfast and fell with a new will into a clocked curriculum from 9.30 a.m. to 4 p.m. that included French, German, history, geography, mathematics, drawing, nature study, needlework and gymnastics.

Miss Kuebler had indeed drawn up the time-table with what she called "true German thoroughness", and Elizabeth's adolescent enthusiasm and model application was soon a cause of delight in teaching "such a willing pupil". Nature study and drawing lessons were readily shifted to the garden and Elizabeth skilfully devised excuses for transferring other studies out of doors. English was spoken during lessons but the governess insisted on German during their ordinary conversations and noted with pride that her pupil soon spoke fluent German. The relationship developed rapidly into affectionate and almost equal companionship, and a photograph shows the two trudging the lanes with their walking-sticks, the Fräulein in her grey and shapeless serge and Elizabeth with modish, flower-trimmed and beribboned hat.

They must have looked an odd couple, particularly when a pony was harnessed to the wagonette, the butler handed in a basket with cakes and sandwiches, and they drove off together, looking for a spot for a picnic tea. At a clearing in the woods, with the pony hitched to a tree, they would collect brushwood and build a camp-fire to boil the kettle. Kathie Kuebler, who had never been in an alien land nor so far from her own home before, at first suffered from homesickness, a fact Elizabeth quickly noticed. "Tell me about Germany" she would say comfortingly and encouraged the Fräulein to talk of her homeland and her

beseiged every morning, as it was, by young ladies brought by electric Brougham and limousine.

Miss Wolff provided a sound classical education, and her examination papers were set by Oxford examiners, an asset possibly in the eyes of Lord Strathmore, whose sons went to Balliol. Miss Wolff's school was well staffed and it is said of one teacher that "Mr. Ford's excellent lectures on history" were of exceptional merit. Tempting though it is to picture the future Queen as his attentive pupil, it should be recorded as a curiosity that the Queen Mother "cannot remember the name of the school", although she attended for some eight months and had the satisfaction of winning a prize for literature given for an essay.

Was it then so traumatic an experience, an unhappiness firmly to be consigned to oblivion? Teachers are familiar with the distress of the lonely child, accustomed to the constant company of adults, who experienced great difficulties in adjustment when flung into the mêlée of his or her contemporaries. Painful as her school initiation may have been, the young Elizabeth endured her misfortune for two terms, while preparing for the Oxford Junior Examination. Her youthful ordeal was not without a credit side, for it was at school apparently that she met her namesake, Elizabeth Margaret Cator, daughter of a Unionist M.P. who lived in Pont Street. Betty Cator was to become her lifelong friend, her bridesmaid and future sister-in-law—wife of Michael Bowes-Lyon—and thus an aunt to Queen Elizabeth II and Princess Margaret.

The necessary release mechanism from school was triggered in April, 1913, when Kathie Kuebler, the daughter of a Prussian official, arrived at St. Paul's Walden Bury as a temporary governess to teach a little German during the Easter holiday. Elizabeth saw a tall and pudding-like blonde of about twenty-one, Kathie found her "charming to look at . . . she had a small delicate figure, a sensitive somewhat pale little face, dark hair and very beautiful violet-blue eyes . . . a child far more mature and understanding

BEFORE THE WAR

I

IN SEPTEMBER, 1912, Lady Strathmore returned to London earlier than usual, first to get David off to school and then to launch the youthful Lady Elizabeth in a new phase of her education. The affectionate mother foresaw that her daughter would feel lonely without the young brother who had been an inseparable companion for so long. Elizabeth had grown "taller and paler and darker", a friend noted, although "her charm was the same . . . the delicious gurgle of laughter", but she was no longer the roseate pippin who had so enchanted Gorell Barnes. The time had come when it seemed she might benefit from the company of other girls of her own age, and it was settled that she should attend a private day-school for girls in central London.

This was an "advanced" and "modern" decision on Lady Strathmore's part, and wisps of reticence still enfold its outcome. Evidently friends recommended a school of the most select and irreproachable character but failing a reference from its foremost pupil, its identity is now open to doubt. One or two of the élite and fashionable day schools available to the daughters of upper-crust St. James's, Mayfair and Belgravia, were so select and discreet that their records have disappeared without trace. The researchist draws blank on such promising archives as the Francis Holland School, then one of the leading private girls' schools in London. On the other hand, there were few establishments as impeccable or reticent as Miss Wolff's in South Audley Street,

September, 1912, just after his mother's fiftieth birthday. Elizabeth no doubt supervised Catta Maclean in packing his trunks, installing surprises as well as the official school requisites, but little could alleviate the mournful courage of parting. "David went to school for the first time on Friday. I miss him horribly," she wrote to a friend.

youthful tennis. "You will find them", enquirers were told, "either on the tennis courts or near the stables". After the big grouse shoots of September, Fergus, Michael and Lord Strathmore went on more casual forays for partridges and rabbits, while the ladies supervised the picnic baskets. Alec, who had been ill earlier in the summer and had undergone an operation, was still convalescent and liked to sit about in the garden. On October 19th Elizabeth probably heard almost casually that he had felt unwell and had gone to bed. And suddenly the light chatter of summer was a century away and Glamis was silent in incredulous grief that Alec was dead.

The effect of this tragedy as a psychological factor on the Queen Mother's personality has never been discussed. Clearly it caused a radical flowering of the selfless sympathy and compassion that has always seemed foremost among her attributes. She was "old enough to understand". She insisted on buying her own wreath for Alec, but her thought was for her mother with a perceptiveness beyond her years. Perhaps Rose suggested it would be best to keep Mother occupied, and Elizabeth beguiled her into Italian practice or suggested that David should not miss his lessons. Some such threads of persuasion drew Lady Strathmore from her sorrow and were drawn stronger with daily solicitude until, back again at the Bury, the pain of bereavement slowly dulled and she became involved and immersed once again in the education of her two Benjamins.

The question of a governess was postponed until after the return to Glamis for Hogmanay, and then further delayed because David would soon be going to prep school. Lady Strathmore was thus especially comforted by her youngest daughter, and perhaps both drew ultimate strength from the family motto carved in Latin on one of the great fireplaces of Glamis Castle. Elizabeth had already asked its meaning, long before, and was one day to find solace in it herself, in her own private sorrows of future years, "In thou, my God, I place my trust without change to the end".

David went away to a preparatory school at Broadstairs in

the Abbey. Lady Elizabeth saw her mother and father in their robes and watched their departure under the overcast sky. With David and Rose, and perhaps Michael, Fergus and Alec, also, she watched the spectacle of the Coronation procession from the windows of a family friend whose London home overlooked the route. It was one of those seasons of monarchist fervour when every child lived in a daze of kings and queens, crowns and sceptres, and Elizabeth could not have been an exception. The make-believe figment of Princess Elizabeth was not yet banished to limbo. At the age of eleven, less time was devoted to brushing the lustrous hair of her immaculate dolls or polishing and preening the superb dolls house that the Glamis gardeners had made, but childish things were not yet put away. To be sure, Alah had become a more distant figure, transferred to the charge of Lord and Lady Glamis's new nursery. A Scottish nursery-maid, Clara (Catta) Maclean, remained behind as children's maid and Elizabeth's devoted slave. Yet change was in the air.

To the astonishment of her pupils, Madé revealed an unsuspected side of her private life and announced that she would be leaving to marry a young man named Edmund Guèrin, with whom she would live in France. After the first dismay, the children went into huddled discussions on the choice of a wedding gift. The stringencies of pocket-money were not relaxed; to share in Mother's gift did not suffice, and Elizabeth was determined to give a wedding present of her very own. Eventually, by a contribution of tenpence-halfpenny, David was permitted to join in this personal offering and a silver spoon for infusing tea was jointly purchased "because you like tea" and Madé had once chanced to explain the difficulty of making good tea in France. The presentation card, however, carried an anxious postscript, "We hope Edmont will be kind to you".

Consideration of a new governess was deferred until after the usual Glamis holiday, and the house-party was merry as ever, unaware of an impending family calamity. Freed from lessons, Elizabeth and David devoted hours to enthusiastic frenzies of

typifies her own environment that the splendour which the young girl found there was echoed in the smaller pictures hung upon red damask walls in the chapel of the Villa Capponi.

This chapel was the relic of some former occupant, for Mrs. Scott's devotions ran to plainer pattern, and yet we trace from her the deep inward religious faith that Lady Strathmore passed in turn to her youngest daughter. A gift greater than pearls, it never was, and never has been, a mere lip-service to the Church. With the boys away, the custom of morning prayers at the Bury gradually faltered, but Elizabeth's first steps every morning were directed to her mother's bedroom where, so a governess has affirmed, they read a chapter of the Bible together.

Church attendance was regarded as an acknowledging duty to God, and evidently is still so regarded by the Queen Mother today. Lady Strathmore was fond of recalling an occasion when, with a heavy cold, she was unable to attend morning service at St. Paul's Walden and so sent ten-year-old Elizabeth and David to go to church alone. Arriving a little late, they reached the church door to hear the first hymn already being sung. Rather than steal in guiltily and undergo the stares of the congregation, Elizabeth felt that they should not go in at all. Yet the duties of the sabbath were still to be performed and so the two children sat down unseen behind a hedge and read steadfastly through the service in their prayer-book, the prayers, the responses, the collect, the psalms. Before the young worshippers had finished, the people came streaming from the church, but the two persisted in their service to the end and then returned home care-free and content.

V

The glowing Edwardian era ended, and the tide of gilded summers that had flooded childhood began to ebb now in turn. The new King George V and Queen Mary were crowned on June 22nd, 1911, and the Earl and Countess of Strathmore left 20 St. James's Square early that morning to gain their places in

David in tow. The younger Miss Verne confessed, innocent of
any Freudian motives, "I used to lift her on and off the piano
stool oftener than was necessary just because she was so nice to
take hold of." It was a difficulty that Elizabeth's hand was too
small to span an octave, but she showed talent. At home Elizabeth
so quickly played by ear that she was heard fingering through old
Scottish songs when she was supposed to be practising exercises,
and at Verne's she was able to play in the children's concert, in a
programme including Bach and Beethoven, after only six months'
studies.

Her place at the end of the programme was moreover that
reserved for the best players, a feat not to be achieved without
extra practice. One day Miss Verne felt that a difficult exercise
had gone on too long and thought it best to enter the torture
chamber. "We have only just begun," said her assistant teacher,
firmly, but her beguiling pupil took instant advantage of the
interruption to slide from the music stool. "Thank you so much.
That was wonderful," she said politely, and held out a hand in
farewell. Miss Verne told the story long after to illustrate Eliza-
beth's quick tact and perfect manners. The deft opportunist was
coaxed back to the piano and the lesson ended happily.

An element in the artistic aspect of Lady Elizabeth's education
was that her maternal grandmother, the twice-widowed Mrs.
Scott, now lived in Florence with her unmarried daughter, Anne
Violet, and two or three visits were paid to Italy. A serene and
beautiful old lady, Mrs. Scott owned an untouched Italian Medici
villa, the Villa Capponi, on the hills above the towers and domes
of the city, and a friend remembers the garden, tier upon tier of
terraces and rose-covered walls, "with magnificent cypresses
standing out against the blue distant mountains". More remark-
able the house possessed an organ, inset against the dark panelled
walls of the great living-room, and no doubt Elizabeth was
allowed to try to play it, an experiment that led to her organ-
playing at St. Paul's Walden parish church, apparently, some years
later. There were visits to the Pitti and Uffizi galleries and it

strange lady whom she met on the stairs, a lady who smiled but passed without speaking. They were imaginative youngsters, and Elizabeth, especially, read omnivorously. When the sociability of adults or her brother's willing company failed her, she was usually to be found lying full-length on the floor, propped over a book, a habit, Alah testified, that made her elbows red and raw.

IV

The migration of the family to 20 St. James's Square for the London season occurred in May every year, less to follow fashion than for family convenience. The junior world was, of course, in the attics, with views of treetops and chimney-pots, but constant forays were made to the park and to friends, to music and dancing classes and indeed to art exhibitions and concerts, though visits to public museums and art galleries were considered at that time not quite correct. The dancing classes at Madame d'Egville's establishment were suitably exclusive: the accompanying governesses sat in a long and whispering line, while their pupils glided over the polished floor to the one-two-three of an elderly French ballet-master. The waltz, the polka and the Highland schottische were still dominant requirements for the groups of silk-sashed girls and Eton-jacketed small boys. These attainments, however, qualified for the junior dances in the pale-plastered drawing-rooms of Lansdowne House, that enormous mansion then occupying the massive terrain between Berkeley Square and Piccadilly. "Come and talk to this little girl; she is called Elizabeth Lyon," the hostess would say, in introducing her into the juvenile coteries. Some of the boys remained her love-lorn if precocious swains for years. It was Elizabeth's own idea, on hearing that one boy was ill, that she should visit him with her governess to cheer him up on the gloomiest of November days, though she had not seen him for two or three years.

Tuition in singing and music took her at about the age of eight to the school of the Verne sisters, always of course with

original was inconveniently rough and uneven. The ghosts of Glamis were busiest in the late 1860's and 1890's, dates coinciding in each generation with the number of mischievous boys in the family. In 1910, there occurred a minor recrudescence of scampering, giggling phantoms who looked remarkably like David and Elizabeth draped in sheets and towels.

Yet these pranks in themselves had a scaring quality and, as the only unmarried sister left at home, Lady Rose recalled a wild autumn night when the two children came to say goodnight to their mother before going to bed and David remembered a storybook he had left in the crypt, where the pair had been playing that afternoon. With a timid look, David asked if he could ring for a footman to fetch it or go with him. "Certainly not," said Lady Strathmore. "There is nothing to be afraid of. You are eight years old and you don't need anyone to take care of you."

Nervously the boy set out, but Elizabeth skipped after him a moment later. "Mother said you weren't to ring for someone," she reminded him, "but she didn't say you couldn't have me." With the wind whistling and battering at every window, it was an eerie journey, past the watching eyes of the portraits in the drawing-room, down the broad stone staircase to the stone spaces of Duncan's Room and the huge stuffed bear that stood sentinel there, and so to the silent suits of armour shimmering in the light of the crypt. Glamis, with its endless rooms and passages, was a wonderful place for hide-and-seek, but only for hide-and-seek in daylight.

The incident was remembered as typical of Elizabeth's gentle protective tact and unselfishness. "Elizabeth was an ideal younger sister," Lady Rose once said, "always original and amusing and full of fun or sympathy, whichever you happened to need."

Later on, David claimed occasionally to see shadowy 'grey people' in the rooms of Glamis. His elders discounted this 'second sight' as showing-off, just as they did his water-divining, and the grey people were such that they never caused him alarm. Elizabeth readily supported her brother with a chilling account of the

Mary, to Lord Elphinstone, a match destined to spread happy enmeshments of cousinhood through three generations. David wore Highland dress and the bridesmaids, with Elizabeth in attendance, were dressed in blue-sashed white Romney dresses with large black picture hats, carrying fans instead of bouquets.

Probably Elizabeth was ten before she heard very much of the ghosts of Glamis. The horrific tale of Earl Beardie dicing with the Devil in a topmost tower or the whisper of a monster locked in a secret room were not for childish ears. Although a bedroom admittedly had an unpleasant atmosphere, perhaps due to dry-rot, the sense of evil disappeared when the room was converted into a bathroom. A chair in an adjoining sitting-room was supposed to be occupied by a black boy, the ghost of a negro page, but nobody ever saw him, his dark presence was more sensed than seen. Any scurry of wind in the drive, any whirlwind of leaves, might be due to the spectral Jock the Runner or again it might not. The ghostly appearances of the reputed Grey Lady were evasive and unsatisfactory. Rose and Michael Bowes-Lyon could, however, tell truthfully of sleeping guests disturbed when bed-clothes were twitched away by unseen hands. There had been many such pranks before Elizabeth was born, when her brothers were young.

The best of the sightings was recited at second hand by an aunt who remembered when an old man with a flowing beard had been seen—by hazy nightlight—seated at the fireplace of the blue room and had turned towards the terrified witness a mask-like dead face. The haunting was completely explicable to anyone who knew of the masks, wigs, beards and costumes stored in the dressing-up chests downstairs, and the family took all these strange tales with a grain of salt. Visitors might be left with their illusions, but no one really believed that the sleepwalking Lady Macbeth had stalked through the passages or that King Malcolm had died in King Malcolm's room. (Indeed, he probably died four centuries before that tower was built.) If Lady Strathmore really had boarded over a blood-stained floor, it was merely because the

both at Glamis and the Bury, especially for Lady Strathmore's tea-party entertainments at which her "two Benjamins" unwillingly though effectively danced the minuet. The children enjoyed the dancing lessons with old Mr. Neal from Forfar, a gay yet formal figure in his gleaming shirtcuffs and black frockcoat, and they vastly enjoyed dressing up. The annual visit to the Drury Lane pantomime would see scenes re-enacted in costume for weeks afterward and a visit to *Peter Pan* proved unforgettable. The dog was astonishingly like Juno, and Lady Strathmore would have carefully stressed the lesson that the author had been born at Kirremuir not twelve miles from Glamis. But the minuet performed at the tea-parties was at best a grudging accomplishment. As Lady Cynthia Asquith has said, it was "their only grievance against their mother. The publicity of so large an audience was not to their taste".

The Glamis visit was a focus, too, for garden-parties, tenants' balls and other diversions, and Mdlle Lang has recorded a curious incident that probably occurred in 1910. A garden fête was being held in aid of charity, Elizabeth patronized the amateur lady palmist in her tent, and Madé enquired, "What did she say?"

"She was silly. She said I'm going to be a Queen when I grow up."

"That is not possible unless they change the laws of England for you," said Madé incautiously.

"Who wants to be a Queen anyway?" Elizabeth retorted, and danced around the room singing one of Madé's French nursery rhymes, 'S'il fleurisse je serai reine'. ('If it blossoms, I shall be Queen.') The prophecy was curious, yet nothing more. The amateur seer may have caught some telepathic wisp of 'Princess Elizabeth', but it was the accession year of King George V and Queen Mary, and queens were in every mind. Like a similar story of the child Queen Victoria, the incident has been exaggerated into folklore, strewn with caravans of gypsies and old crones muttering at Epsom. Certainly a more impressive event to Elizabeth in 1910 was the wedding in July of her eldest sister,

was already twenty-four and his engagement to Lady Dorothy Osborne brought an atmosphere of new excitement, the eight-year-old Elizabeth wrote "Me and Dorothy's little brother are going to be bridesmaids". It was in fact as the youngest of six bridesmaids that she made her first appearance in public cere-monial at the wedding in the Guards' Chapel at Wellington Barracks on November 21st, 1908, wearing a frock of white muslin and satin, and gravely concerned with the good behaviour of David and the bride's younger brother as fidgety trainbearers in suits of pale blue silk. At the Chapel doors the spectacle was enhanced by arched swords of the guard-of-honour, and the Strathmore pipers. None could have guessed that a future Queen was among the bridesmaids or that Buckingham Palace and Clarence House, just across the park, were both to be her future homes.

Lady Strathmore at about this time made her daughter the party frock of rose brocade, high-waisted, full-skirted, satin-buttoned from neck to floor, trimmed with silver ribbon, which she copied from a painting by Van Dyck. No doubt efficient little ears overheard adult admiration, "Like one of the children of Charles the First", but the resemblance was more to the Stuart Princess Mary than Princess Elizabeth, and the costume had been copied from that of another Elizabeth, daughter of James I. Nearly all children play games of royal make-believe—in the Edwardian era perhaps more than now—and Elizabeth knew more of royalty, especially Scottish royalty, than most children. She probably knew that the obliging artist Jacob de Wet who had painted the sixteen Biblical pictures in the Glamis chapel had also painted the portraits of the Kings of Scotland at Holyrood House. Calling at the manse to inspect Mr. Stirton's family curios, she displayed an unusual knowledge of such things for a child and always gazed with fascination, as he noticed, at his portrait of Prince Charles Edward Stuart.

The princess's gown, then, remained in use longer than most fancy costumes. It was packed in the travelling luggage and worn

III

It was one of Lord Strathmore's quirks that he kept a strict rein on pocket-money for his youngest children, happily ignorant that Elizabeth at the age of six cajoled pennies from Madé and the servants and was remembered by Mrs. Thompson, the house-keeper, pleading "May I have silver pennies this time?" David was capable of rolling his eyes at susceptible guests and remarking, "We haven't had no presents lately, Elizabuff!" This brought the conjecture, "No, but I expect we shall have soon . . ." and the victim obliged with the expected donation. When the purchasing power of money, especially for presents, was better understood, two or three years later, Mrs. Thompson devised small services, such as shelling peas or hulling gooseberries, for which payment could be honourably received. Borrowing was strictly prohibited and the official provision of ninepence a week was not increased, apparently, until Elizabeth reached her teens. Then the improve-ment seems to have been precipitated by the device of spending nearly a full week's pocket money on a telegram to her father: "SOS LSD RSVP ELIZABETH." This proved completely successful, though the ingenious investor was made to understand that the ruse could not be repeated.

The chronology of childhood is measured less in time than in the flowering of the personality. The moppet who begged in the kitchen, "Please may I have a cream?" was followed within a year or two by the more dignified maid who enquired, "May I come in and eat more—*much more*—of that nice chocolate cake than I liked to eat upstairs?" The two junior Redskins who burst into the dairy at Glamis demanding milk and a biscuit under threats of scalping were to be followed by the more domesticated eight-year-old girl who demurely remarked, as if the thought were her very own, "If you could make the pats of butter a little smaller it would be better. Persons waste the big pats on their plates".

The memories are trivial, like thistledown fragments, with tangible weight. When her eldest brother, Patrick, Lord Glamis,

Glamis stables for a quiet end. His rider was determined, however, that he should still enjoy life and this caused her accompanying slaves of the outing to run breathlessly at her stirrup, ultimately exerting their tired muscles in a final frenzied struggle to prevent both donkey and joyously shrieking rider plunging down a steep bank into a stream. Elizabeth's favourite pastime, it was noted, was simply "making friends". Visitors and family sometimes conspired to miscount thirteen at a luncheon party, so that she should be called down to make a fourteenth. She had the gift even then not of merely insinuating herself into good graces but of commanding captivation by instinctively knowing the right thing to say. A family group was once discussing the entertainment of an anticipated guest who was known to be difficult. "Let's ask Elizabeth," one proposed. "She can talk to *anyone*."

Analysing her conquest of his own affections, Lord Gorell has told of a game of changing words to opposites when his name, Gorell Barnes, became Borell Garnes and so declined to "Mr. Abominable", whereupon Elizabeth impetuously advanced it from "Mr. Nice" to "Mr. Remarkable" and remembered this triumph, as he did, for years. Once, when he was lamenting that the hour of his departure was drawing near, she cried vehemently, "But why don't you *beg* to stay?" One grown-up friend, twelve years her senior, chanced to send her a birthday letter. She plunged at once into correspondence and maintained it so steadily that it matured into a friendship lasting for life.

Not that everyone was enslaved by "the drowsy caressing voice, the slow sweet smile, the delicious laughter". When a crisis at home delayed Madé in France after a holiday a temporary governess was engaged. This deputy ordained that her pupil should write an essay on 'The Sea', by no means a familiar or welcome subject, and years later the result came to light in an old copy-book, the Queen Mother's earliest literary fragment. "Some governess are nice," it began, "and some *are not*." And that was all.

family team played the Dundee Drapers and Lord Strathmore, bowling his leg-breaks, secured a hat-trick of three wickets in three balls. To celebrate the achievement—none would dare say fluke—his friends decided to buy him a panama hat and, after dinner with appropriate speeches, a selection were solemnly presented for trying on. "I always loved that cricket up there," Michael Bowes-Lyon once wrote. "Do you remember one special umpire, Mr. Arthur Fossett, short, round, red-faced and fat, who was perfectly trained never to no-ball Father and always give his appeals out?" One afternoon, a match depended solely on the ability of Fergus, who was no cricketer, to achieve the unusual and make a run, and amidst cheers he managed to pull it off. On another occasion the family team had eight runs to win with six wickets in hand but Lord Strathmore's brother, Uncle Pat, a confirmed pessimist by reputation, refused even then to wax confident and with an appalling reversal the Castle team was actually defeated by four runs.

These intensive matches were followed by less serious evening sessions with Madé and others, with Elizabeth and David in perpetual rivalry for the right to bat. Rather earlier, when Elizabeth was about five years old and a Glamis footman was bowling, every falling wicket evoked her wildest demonstration of partisan glee. "Who is the man bowling?" asked one of the visiting team. "That's James," his young supporter revealed. "I'm going to marry him when I grow up."

At eight years old, Elizabeth was allowed to remain up for birthday parties and, increasingly, for the joyous fun of dressing up for charades. Two great chests of old fancy dresses, masks and wigs, supplied unequalled costumes and Elizabeth proved "a born comedienne". Sometimes the guessing side became too old for her, as when her elder brother, Alec, convulsed the adults by portraying the 'great gulf' fixed between Heaven and Hell. Then there were tea-parties with the Ogilvys, embodying the novelty of a drive in a 'motor-car' to Cortachy. For picnics Elizabeth occasionally bestrode an ancient donkey, reputedly housed in the

Then there was Bob, the tiny Shetland pony, who merits this ultimate paragraph. So amenable that he would delicately pick his way anywhere, up the stairways in the grounds and occasionally into the house, and so dearly loved that he was transported each year between the Bury and Glamis. His owner never looked more delectable than when mounted upon him side-saddle in her full-skirted red riding outfit.

II

The annual move to Glamis in August was never undertaken without a junior maelstrom. All Alah's firm management was required throughout a fever of decision on which books and toys and even pets should be taken or which livestock confided to friendly domestic care and left. Nursemaids, footmen, lady's maid, valet, butler, governess, all were transported in the great migration. The journey north of five hundred miles, usually made by the "Flying Scotsman", was an adventure of roaring speed and swirling fields that delighted the children until, heavy with sleep, they at last reached the Castle when all its turrets and towers were a shadow against the afterglow of the sunset.

Schoolroom curriculum, never strict, was all but abandoned for eight or nine weeks while the entire family devoted themselves to what Lord Gorell has called, "the best of company, fun and games that the war-free world had to offer". A friend of Jock (John) Bowes-Lyon, whom he had met at Oxford, Gorell Barnes, as he was then, was studying for the Bar, and through his precise eyes we momentarily see the delectable Elizabeth as "the most enchanting child ever dreamed of". Part of Lord Gorell's own sympathetic attraction to the child was his ability to make up stories on demand, and twenty years later his young disciple could still retell his saga of the man in the inflated suit who fell off the roof "and bounced and bounced till they strewed the courtyard with tintacks to puncture him". Another guest recalls a merry group of the Bowes-Lyon brothers at teatime creating a fantasy of tall stories until the tears ran down her cheeks.

old barn with a loft reached by a ricketty ladder, where was kept
"a regular store of forbidden delicacies, acquired by devious
devices . . . apples, oranges, sugar, sweets, slabs of chocolate
Meunier, matches and packets of Woodbines . . ." The cigarettes
were preserved for a future attempt at smoking which, in the
event, was forever postponed. A romantic idea that the store
might be used for a runaway exploit was also forgotten, for a
suitable excuse for running away never materialized. The Bowes-
Lyon children were rarely punished. When Elizabeth was given
her first pair of scissors and practised by cutting a pair of new
sheets to ribbons, mischievously aware that this combined
heinous sin with the perfect excuse, her mother merely sighed,
"Oh, Elizabeth!" David was once sufficiently naughty to be
chastised with mock severity with a hunting-whip. Although the
victim screamed with laughter, his tender-hearted sister sat up in
bed and sobbed.

Besides the 'flea-house' there were the attractions of the harness
room, where the dog Juno usually had her puppies, and there were
the bantams' nests nearby where one could find "eggs that were
good for tea". Mdlle Lang has testified to the range of the
children's pets: Persian kittens and tortoises, rabbits, frogs, newts
and caterpillars—the terror of Alah—injured birds, rescued until
they died or flew away, and two black pigs. Lord Strathmore
tamed a bullfinch, called Bobby, which became his daughter's pet,
pecking from her plate at meals. When poor Bobby was ulti-
mately murdered by a cat, the ruffled corpse was tearfully placed
in the finest coffin the schoolroom could supply, a cedar-wood
pencil box, and laid to rest in a deep grave while Elizabeth intoned
her own improvised funeral service. The end of the highly
intelligent pigs, Lucifer and Emma, was more uncertain. They
grew to such a size that it was decided they should furnish a prize
in a village raffle. The horrified children broke open their money-
boxes, cajoled their relatives for sixpences and are credited with
buying half the raffle tickets. Alas, the pigs were won by strangers
and left the Bury, their ultimate fate cloaked in mystery.

six or seven, she detached Lord Gorell from the family group after luncheon and led him to the small library with the confidential whisper, "Shall us sit and talk?" and for more than half an hour she effectively managed her share in the conversation. At eight, she confided in Lord Gorell that, at six, she was sure she "had bothered him most awfully".

Lady Strathmore later pleaded inability to remember many tales of Elizabeth's girlhood, a defence intended to prevent distortion when a story was told yet again but she considered one anecdote characteristic. The affairs of a young man who though rich was not personable were being discussed by the grown-ups unaware that the little daughter of the house was still in the room. "How sad to think," said one, "that the poor man will be married only for his position and money." A faintly reproachful small voice chimed in from the back of the sofa. "Perhaps," said Elizabeth, "perhaps someone will marry him 'cos she loves him."

The stories linger and, happily, that bygone childhood is not irretrievably lost. When she had just come into the public eye, in her twenties, and when her memories of infancy were still vividly fresh, the present Queen Mother jotted down notes unseen these many years, which I venture to quote, "At the bottom of the garden . . . is the WOOD—the haunt of fairies, with its anemones and ponds, and moss-grown statues, and the BIG OAK where the two ring-doves, Caroline-Curly-Love and Rhode Wrigley-Worm contentedly coo in their wicker work Ideal Home . . . Whenever—and this is often—a dead bird is found in this enchanted wood it is often given solemn burial in a small box lined with rose-leaves . . .

"Now it is time to go haymaking, which means getting very hot in a delicious smell. Very often she gets up wonderfully early —about six o'clock—to feed her chickens and make sure they are safe. The hens stubbornly insist on laying their eggs in a place called the FLEA HOUSE, and this is where she and her brother go and hide from Nurse . . ."

Sir David Bowes-Lyon similarly recollected the flea-house, an

Mdlle Lang found that her two pupils could already read and write. Their mother, as we have seen, taught all her children their first lessons. Elizabeth knew psalms by heart as well as poetry; her mind was stocked with Bible stories; she could read the simpler stories of *Little Folks* and her mother had given her elementary music, dancing and drawing lessons. Lady Strathmore admired the Froebel precepts, although it was still an advanced view in the nineteen-hundreds to teach by play. Family charades served to instil the kindlier stories of Scottish history as well as deportment, and sing-songs around the table inculcated musical discipline. All the older generation of Lyons were particularly musical. An elderly uncle is remembered for producing a tuning-fork at the dining-table. "Madrigal, Spring is Come", he would say, sounding the note, and the highly imitative Elizabeth was occasionally allowed to stay up and join in. On one occasion, she was inspired by her elder sister, Rose, to have her hair pinned up; in long skirts she held her frock up a little, duplicating her sister's gesture to the life.

Being urged forward by Rose and constantly in adult company stimulated a not unattractive precocity. Mdlle Lang has told of an incident when visitors called and Lady Strathmore, probably engaged in planning some distant recess of the garden, could not be found. Elizabeth greeted the visitors in the drawing-room and rang for tea. When Lady Strathmore arrived, the child was successfully wielding the teapot and making conversation as she had seen her mother do. She was then six years old. Still earlier there is a story of her imitative ability at the age of only three when she greeted the old factor of the Glamis estate. "How do you do, Mr. . . ."

The Bowes-Lyon children were often heard, in fact, and not often unseen behind their green baize door. Their mother included them at the family lunch-table as soon as they were old enough to behave reasonably well. Lord Gorell remembered David being imperiously enjoined by his sister not to bother him, "the unconcealed object being to bother me by herself". Aged

Discobolus, whom the family had long nicknamed 'The Running Footman' or 'The Bounding Butler'.

Nearing her mid-forties, the Countess of Strathmore herself found in 1904 that her own change of name and title gave her the sense of being a bride again, an illusion heightened by the new town house, the smell of fresh paint at the Bury and the planning of a new garden at Glamis Castle. Seldom at a loss for a Biblical simile, she called her two youngest children her 'two Benjamins', and comically protested that they were mistaken for her grand-children.

Early in 1905 a new governess joined the family in the person of Mdlle Lang, who still has a vivid recollection of Elizabeth greeting her in the hall, "an enchanting child with tiny hands and feet and rose-petal colouring, like a Dresden china figure", murmuring with perfect politeness, "I do hope you'll be happy here". Just as the complications of Clara Knight's name became "Alah" to little tongues, so Mademoiselle was abbreviated to "Madé" and in this beloved guise she remained another focus of juvenile affection for the next seven years.

Lady Strathmore's choice of a French, rather than English, governess was characteristic. As a young girl she had been taught French, Latin and a little German; we are told that she was widely read, a talented painter and a brilliant pianist. Certainly she was versed in the womanly arts so admired in her generation. Her patchwork quilts and embroideries embellish the bedrooms at Glamis, among them a copy of a Jacobean coverlet which she found in shreds and tatters and painstakingly reproduced with, as her own distinctive contribution, the names and birthdates of all her ten children embroidered beneath the valance. In the garden she was an early disciple of William Robinson and Gertrude Jekyll, those advocates of art in the guise of natural simplicity. It has been said that she knew more about flowers than her gardeners, and she managed her outdoor and indoor staff with a peculiarly individual tactful persuasiveness, a velvet glove that rarely tightened in sternness.

THE TWO BENJAMINS

I

THE POPULARITY OF THE monarchy in the past half-century has largely rested upon the projection of happy and united family life. With the era of George VI and his consort, who were inseparable, this appearance became a reality. King George V and Queen Mary, though a fond married couple, had both complained that they found communication with their children difficult; but in measuring the immediate recovery of the status of kingship from the crisis of Edward VIII's abdication, historians must assess the strength derived from the Queen Mother's entirely happy family upbringing at St. Paul's Walden Bury.

The Queen Mother can look back at a childhood of golden Edwardian summers, golden in retrospect if less in climatal reality, when as she has said the sun seemed always to be shining and there were "carpets of primroses and anemones to sit on". In the lucent haze of remembrance, the two children, brother and sister, run down the slope of the lawn in their smocked pinafores and floppy sun-hats, down the lawn and up the hill beyond to fall panting into the scent of new-mown grass. There is rarely an hour without young David's cries of "Elizabuff! Elizabuff!" Whispering together or searching for wild strawberries, the girl's dark tresses against the boy's golden curls, the two pretty children are almost figures from a Riviere print. For an eternity of June afternoons the white cloth was spread for tea with Alah and Mother and perhaps Rose in the shadow of the statue of Diana or the

Strathmore's sumptuous requirements by taking in the house next
door. No plaque marks it as the scene of much of the Queen
Mother's girlhood. Lord Strathmore drily found his house
"handy to the Carlton Club" and another asset was of course
that a key to the square gardens accompanied the lease, a constant
amenity for the nursemaids and children of families in town. It is
pleasing to think of the Queen Mother as a little girl playing with
her brother around the equestrian statues of William III, behind
the square railings now edged in by commerce, clubs and the Arts
Council.

It was from No. 20, when she was five years old, that little
Elizabeth Bowes-Lyon was driven to a children's party given by
the Duchess of Buccleuch at Montagu House. (Then one of the
last private houses in Whitehall, it occupied part of the site of the
present Air Ministry offices.) The Duchess had grandchildren
ranging in age from one to twelve years and it was natural for
girls aged five and boys aged nine to be brought together in
childhood equality. At table, free of her Nanny's watchful eye,
little Elizabeth prised the cherries from her cake and gave them
to the thin, stammering little boy next to her. Prince Albert, the
future King George VI, was unaccustomed to being given any-
thing so small and sweet and illicit, and he never forgot it.

like Fergus and Michael, this settled an old playroom argument: the daughters of lords were not ladies, not always, but the daughters of earls . . . well, now, even little Elizabeth was Lady Elizabeth, and it was droll to see letters to Mother addressed to "The Countess of Strathmore".

The thirteenth Earl, long before taking his Grosvenor Gardens flat, had economically solved the metropolitan needs of his large family with his stuccoed mansion in Queen's Gate Gardens in the less remote recesses of the Cromwell Road. The new fourteenth Earl, after much house-hunting with Celia, finally settled upon the sumptuous mansion, No. 20 St. James's Square. The Duke of Norfolk, premier duke and earl of England, still had his town mansion at the north-east angle of the square, and it served Lord Strathmore's quirkish humour for a Scottish Earl, by no means premier nor in the first ten, to be more comfortably housed in the south-west corner. Norfolk House was antique and decrepit, the Strathmore mansion unquestionably finer.

Built by Robert Adam, with a palatial stone façade of giant pilasters and pedimented windows, it still outshines its neighbours today. From the impressive entrance hall a large staircase with handsome iron balusters ascends to two drawing-rooms where the Countess of Strathmore was delighted to find superb decorative ceilings enriched by paintings by Angelica Kauffman The mansion was of course arrogantly wasteful of space: one could have fed a battalion in the so-called Eating Room, but the house was graced by characteristic Adam alcoves and fireplaces and, across the back courtyard, even the stables boasted a handsome Adam façade. It must have annoyed Lord Strathmore that this opulent residence was not ready for him when he rode to Buckingham Palace to receive his credentials as Lord-Lieutenant of Forfarshire. His future duties in the county in which Glamis is situated were sufficiently nominal not to aggravate the qualms with which he still regarded the Court.

No. 20 St. James's Square is now the London headquarters of the Distillers' Company and has been enlarged even beyond Lord

Strathmore's flat in Belgrave Mansions, Grosvenor Gardens, whither he had moved, those alert for portents might note, from Queen's Gate Gardens. Lord Glamis was now concerned with finding a town house; it was becoming clear that it would not be long before he succeeded to the earldom. Perhaps the opulent and lavish display of the new Edwardian era freshly impressed him with the importance to his family of amply maintaining his aristocratic stature and dignity. Placed in fuller charge of family affairs as his father aged, he had become aware of the untapped reserves of family wealth. Unexpectedly heavy dividends were beginning to flow from the Bowes chemical and industrial interests around Durham and Newcastle upon Tyne. With his own eldest son about to embark on an Army career, Lord Glamis may have examined his family status with a freshly quizzical and paternal eye. Maturity had enhanced his taste and judgment, and many improvements at the Bury and Glamis date from about this time.

"We must do something about that ceiling," he said, playing billiards at Glamis beneath cracked and flaking plaster, and experts on Tudor work were deceived by the ceiling of baronial distinction that he installed. Plans for selling a family property at Gibside were discussed, though not without weighing the worth, sentimental and otherwise, of a fine fireplace with heraldic shields and arms which was retained and subsequently transferred to enhance the feudal atmosphere of Glamis billiards.

The thirteenth Earl of Strathmore died in Bordighera in 1904 and his son discovered not without astonishment that he had left a fortune of a quarter-million pounds (which we may estimate at above two million at today's values). Grief for his old father did not diminish the new fourteenth Earl of Strathmore and Kinghorne's satisfaction that his own son and heir would now be serving in the Army as Lord Glamis. He had forgotten his own fretting dislike of Army restraints, and the repetition of old family ways and traditions had an increasing appeal. The servants were told that they still had to address him as "My Lord" but should say "Yes . . ." or "No, Lord Strathmore". For the younger boys,

to the coronation of King Edward VII. It was very doubtful whether the old Earl of Strathmore, in his seventy-ninth year, could endure the fatigue of attendance. If the family debated whether Lord Glamis would go to Westminster Abbey in his stead, the unexpected illness of the King caused the event to be postponed until August and it is probable that Lord Glamis no longer deferred his visit to Scotland.

The social events of Coronation Year made it desirable for the family to be present in force or, rather, in bulk at Glamis Castle. Moreover, their close neighbour, Lady Airlie at Cortachy, was still wearing mourning for the loss of her husband in the Boer War; and Lady Glamis, always a generously sympathetic and thoughtful friend, would have anxiously travelled north to be near her. Lord Glamis probably heard unmoved the news that Lady Airlie had been appointed lady in waiting to the new Princess of Wales. The thought of royalty still slightly rankled, unaware as he was that one of his nursery cots harboured a future Queen. The King, when Prince of Wales, had once undertaken to visit Glamis. Elaborate preparations were made and at the last moment the royal visit was called off on account of toothache. Lord Glamis must have thought the excuse quite unforgivable. At about this time Aunt Hyacinth also appeared briefly to take farewell of the babies, for she had married her American, Augustus Jessup, and was going to live in Philadelphia. One face among so many was not missed in the timeless world of the nursery and between Glamis and the Bury one nursery was very like another.

Yet the fuller future was gradually emerging. In London, in 1903, Katharine, Duchess of Atholl, called on Lady Glamis and a minor event can be noticed. "I was very impressed by the charm and dignity of a little daughter, two or three years old, who came into the room", wrote the Duchess ". . . as if a little princess had stepped out of an eighteenth-century picture." It is the first we reliably hear of the attributes of regality in the little Elizabeth that were to stamp her indelibly in the minds and hearts of millions.

The family's activities were then chiefly centred in old Lord

August 4th had not then been stained by the grim remembrances of war. During the next three weeks the grown-ups clucked and hovered and Clara Cooper Knight, the daughter of an estate farmer, took up her duties as nursemaid. Then twenty years old, she had acquired her skill as the sixth of twelve children, was ultimately to become nannie to Princess Elizabeth and Princess Margaret and was to become known to the Royal Family as 'Alah'. On September 23rd the new baby was christened with the names Elizabeth Angela Marguerite in the parish church of St. Paul's Walden.

It hardly matters whether, not to feed the old argument, the present Queen Mother was born in the nineteenth century or the twentieth. When the new baby's first cry rang through the Bury, Queen Victoria still had six months to reign, the Wright brothers had not flown, Marconi had not received the first tremor of radio signals across the Atlantic and the ubiquitous horse had yielded hardly a hoofmark to the horseless carriage. The moon still sailed untouched through the sky; the atom was undisturbed in its small universe; and the words vitamin, insulin, penicillin, nylon, chrome and Cellophane had not been coined: such are the changes in the lifetime of a woman still only middle-aged. But the world was still more static in the nursery, with its high fender, its small pieces of laundry always airing on the fire-guard, its soft oil-lamp. Estate gas-light was considered too dangerous to introduce and electricity evidently had not reached that part of the house.

We have Clara Knight's testimony that her little Elizabeth was "an exceptionally happy, easy baby: crawling early, running at thirteen months and speaking very young". And the infant was barely launched in this Olympian feat of running when Lady Glamis had a further surprise for her husband, and had to confess as a woman in her fortieth year that another baby was on the way. The newcomer, her tenth child, was born on May 2nd, 1902, and named David, by way of blessing and sanction among the giant Goliaths of his five elder brothers.

The date of his christening had perhaps to be fixed with regard

expected with so youthful and ebullient a household. The Bury, indeed, fell silent only twice a year; in late summer when they all usually invaded Glamis, and for two weeks when an uncle and aunt were visited at Streatlam Castle, the principal estate of the Bowes in County Durham. As the nineteenth century drew nearer its close, the parents no doubt noticed that life was indefinably quieter. The four elder boys were all at school. Mary Frances had coiled up her hair and was leaving the schoolroom. Only Rose, aged nine, and Michael, aged six, still inhabited the separate nursery rooms, with their rocking-horses and Marcus Stone pictures. As the year 1900 dawned, people wondered what the new century had in store. Considerable controversy centred on whether the twentieth century was beginning at all—or should one properly wait until 1901?—and *The Times* carried a correspondence for days on the topic. "I begin today a New Year and a New Century", Queen Victoria firmly settled the argument for herself on January 1st, 1900. Perhaps the anticipations of a new century were a little previous after all, but in any event, in a year of such novel date as 1900, one expected surprises. And after her long quiescence it was a very surprised Lady Glamis indeed who told her husband in January that she was expecting another baby.

IV

Elizabeth Bowes-Lyon was born at St. Paul's Walden Bury on August 4th, 1900, when the vigorous briar rose, Paul's Carmine Pillar, was in full flame about the porch. Her elder brothers were no doubt packed off to Glamis beforehand with strict instructions not to worry their ailing grandfather; and the two sisters, Mary Frances and Rose, were among the first to see the chubby, blue-eyed baby. Celia's younger sisters, too, must have been early on the scene: Hyacinth, who was being ardently courted by an American, and her quieter twin, Violet, who seemed to be courted by none. The Saturday child perhaps seemed a good omen, full of grace, and the propitious rose blossoms and fruitfulness of

that the arc of domestic fruitfulness was accomplished, and from this moment they regarded their family as complete. Their garden, constantly dappled for so long with babies and nursemaids was passing to a phase of schoolboys and tutors; the parents apparently considered a tutor advisable for Patrick, who so missed his eldest sister. It has often been remarked that the children fell into convenient social age-groups, first the trio of Violet, Mary Frances and Patrick, then the three boys, John, Alexander and Fergus, then Rose and her brother Michael. After the arrival of John, the fourth child, in 1886, the whole house had been re-planned and enlarged for the tumultuously growing family, and a new frontage in neo-Elizabethan red brick soon flanked the road-side. Packed with children and stacked to the attics with servants, this new wing constantly echoed to the clatter of junior comings-and-goings behind a stout set of green-baize padded doors.

The elder children were taught always to be considerate to the younger; the smaller were always sociably involved in the ener-getic concerns of their seniors. Lady Glamis taught all her children in turn to read and write, and trained them herself in the rudi-ments of drawing, dancing and music. Each group in turn were told the familiar Bible stories as they reached an age of under-standing. In her thirties, still surprisingly slender, Lady Glamis was never at odds with her nannies and nursemaids. The first governess engaged for Mary Frances seems however to have packed her bags before long: there could not be two instructors in the schoolroom. Lady Glamis, people said, had a genius for family life. Boys and girls alike, it was generally agreed that the Bowes-Lyons added good looks and curious powers of charm to the junior social life of the neighbourhood. Benevolent uncles were forever appearing in wide variety and household cricket matches of the Bury versus the Villagers, with Mary Frances knowledgeably keeping score, were highlights of the long summer weekends.

After the loss and sadness of their first-born, Lord and Lady Glamis enjoyed six tranquil years as calm and settled as could be

remained sober. Perhaps the housekeeper and butler jointly ush-
ered their lady through her reception rooms for the first time:
the drawing-room in the north-east wing, the music-room in the
west wing, the dining-room, the smoking-room, the library and
little library. Such was the ample, well-staffed and friendly but
infinitely graduated domestic world into which the new genera-
tion of Bowes-Lyons were to be born.

The first child, a girl, punctually made her advent in April,
1882, and was named Violet Hyacinth, after Celia's twin sisters.
Nine months later, Lady Glamis was able to intimate to her hus-
band that another baby was on the way and another daughter,
Mary Frances, duly arrived in August. Throughout the next ten
years the fond parents improved their happiness with a fecundity
as regular and dependable as the espalier pears and peaches that
ripened on the red brick walls of their fruit garden. On her own
twenty-second birthday, Lady Glamis had hopes of presenting
her husband with the gift of a son, and to the immense satisfaction
of the family she achieved this only eleven days behind time. The
boy, Patrick, received a brother, John, eighteen months later and,
more surprising, another son, Alexander, was born within thirteen
months. Then a fourth son, Fergus, made his appearance two years
later almost to the day, and another daughter, Rose Constance,
arrived the following May. A lull then ensued until October 1st,
1893, when a son, Michael, was born. (A brief table shows the
remarkable timing of this late-Victorian family: (1) Violet
Hyacinth, April, 1882; (2) Mary Frances, August, 1883; (3)
Patrick, September, 1884; (4) John, April, 1886; (5) Alexander,
April, 1887; (6) Fergus, April, 1889; (7) Rose Constance, May,
1890. (8) Michael, October, 1893.) Lord Glamis could cheerfully
boast that he would soon have a family cricket team. But the new
baby was only seventeen days old when the oldest daughter,
eleven-year-old Violet Hyacinth, who had been sent to stay with
her Aunt Violet at Forbes House, died of diphtheria. Her funeral
had to precede Michael's christening.

This tragedy may have seemed a sign to Lord and Lady Glamis

lawns and pleached arbours, they were all somewhat out of fashion in 1881, rather forlorn and even neglected, when the new Lady Glamis first came to St. Paul's Walden Bury.

Probably the nineteen-year-old wife had never seen the house until she arrived there, imperceptibly pregnant, with her husband. As the horses toiled up the hill, the first view, chiefly of the Bury kitchen quarters, was hardly impressive. The graceful proportions of the former Georgian entrance front are hidden away even now on the garden side. The balanced style was familiar to Celia from many houses she already knew at Richmond and Kew, but dark concealing ivy rampaged nearly three floors high towards the classic pediment of brick that masked the roof.

The mansion of St. Paul's Walden Bury dates from the first quarter of the eighteenth century and is enhanced by two wings designed in rococo taste as polygonal pavilions; and at about the same time as the building of the house the grounds had been laid out with a cultivated observance of the teachings of Le Notre. There are avenues of trim beech hedges stretching through coppices of beech and oak, the glades enhanced by statuary reputed to have been sculptured by John Nost. An atmosphere of spacious and elegant seclusion has marked the Bury these many years but the house must have been alive with bustling excitement on that day in 1881 when the new young occupants first moved in.

Under the watchful eyes of the housekeeper and butler, the assembled servants, housemaids and scullerymaids and footmen, curtseyed and bowed to their new mistress. The presentation of the keys to 'Her Ladyship' would have been followed by the introduction of the outdoor staff, coachmen and gardeners and gardeners' boys and woodsmen, shuffling their feet and touching their forelocks in an outside yard. Lady Glamis would have turned an interested eye on the faithful head gardener who was receiving an annuity under Charlotte Bowes-Lyon's will, although the bequest could be withdrawn at any time without notice, and a coachman who was similarly privileged, provided he always

bridesmaids, the Duke of Portland gave her away and the congregation was enlivened by the presence of the bridegroom's six sturdy brothers. Claud George was living at the time in Hyde Park Barracks and after the honeymoon Cecilia perhaps went home to her mother and stepfather at Forbes House for a week or two. Within six months, however, Lord Glamis had resigned from the 2nd Life Guards, and was already jubilant with the happy knowledge that his marriage was to be blessed with a child.

<div style="text-align:center">III</div>

If nothing is more Scottish than Glamis Castle, with its dark though unreliable traditions of Macbeth, nothing could be more English than the Waldens, some thirty miles north of London and scarcely ninety miles in any direction from the sea. Even now they are strangely sequestered, a series of chalk uplands carved by placid streamlets into three-hunt valleys, though clasped within a circlet of five towns, westward Luton, eastward Stevenage, northward Hitchin, and to the south Harpenden and Welwyn. When the recently-wed Lord and Lady Glamis eagerly came to their new home, travelling perhaps first by train to one of the sleepy railway stations and thence pleasantly by carriage, the Waldens were still the drowsy essence of rural England.

At King's Walden, the Saxon king Ethelred had been eagerly ready to hunt red deer. At Abbot's Walden, given by a certain Wulfgar in the year 888 to St. Alban's Abbey, all the cheese produced on the farms and many hundred eggs were reserved to the abbot's kitchen. At the dissolution of the monasteries the manor was exchanged by Henry VIII for other lands with the Dean and Chapter of St. Paul's Cathedral, and so the name became St. Paul's Walden. Hereabouts the tradition lingers that a manor house is styled a Bury, being a hide or retreat, thus Aston Bury, Ayot Bury, Bayford Bury, King's Walden Bury and so many more. Houses of mellowed Tudor brick or with serene Georgian façades, set in their gardens with flagged walks and

Paul's Walden, the beerhouse known as the Woodman at Whit-well with the paddock adjoining and all my other real estate in the parish of St. Paul's Walden or any adjoining parish referred to as my Walden property . . ." Lord Glamis discovered with astonishment that his grandmother had left him a couple of pubs. It must then have dawned on him that the 'other real estate' comprised the Georgian mansion and park of St. Paul's Walden Bury and hundreds of acres of the finest farming land in Hertfordshire, the bulk of a £40,000 estate that we should today value nearer £300,000.

As the solicitor's voice droned on through clauses and sub-clauses, the young Lord Glamis must have experienced a roseate vision of release. In those few minutes he blithely resigned from the army and married his lass of Richmond and was the happy master of all he surveyed. Then, the next instant, his grand-mother's joke turned decisively sour, for there was a codicil, made after fifteen months of anxious thought. In a few brief sentences, Grandmama changed her mind and the estates were left to his father, the thirteenth Earl of Strathmore, for life, while Claud George's interest was reduced to an annuity of £400.

Rarely can dreams have been shattered so swiftly. Fortunately, Lord Strathmore was a shrewd and sensible parent, and though proud of owning 24,700 acres—a claim to fame he entered in the first edition of Who's Who—he was equally aware that another large estate could only add to the burden of his problems, a yeast to corrode rather than gild the gingerbread. There was happily a way through the difficulty. The grandmother's will could be observed in the letter, if not in the deed. Claude could receive not only his annuity but also the tenancy and income of St. Paul's Walden Bury which would more than equal having his cake and improving it.

The result of this arrangement between father and son was that Lord Glamis married his Cecilia Nina Cavendish-Bentinck by special licence at Petersham parish church no July 16th, 1881. The charm of the bride was enhanced by her twin sisters as

and broad acres of Glamis. In 1880 his time out of barracks was more frequently spent at the home of a Mr. and Mrs. Henry Wareen Scott who lived at Forbes House near Richmond. This congenial and warm-hearted pair had remarried as widow and widower and the house on the edge of Ham Common was enlivened by Mrs. Scott's three young daughters by her former marriage, Cecilia, Violet and Hyacinth Cavendish-Bentinck.

Claude George fell in love with the eldest girl, dark-eyed slender 'Celia', who was just eighteen. Her father, a younger son of the fourth Duke of Portland, had taken Holy Orders, though never under the necessity of finding a living, and had died when Celia was only three. A warmth of sincerity and kindness welcomed Lord Glamis at the Scotts' threshold and in Celia he found a love of the simple domestic pleasures and an underlying seriousness, especially in religious faith, that matched his own. The bright thought of her no doubt solaced him in his gloomiest duty hours at Windsor Castle. Then amid the January rainfalls of 1881 he was saddened by the news of the death of his grandmother and a broader road suddenly opened in his affairs.

Claud George had been her first and favourite grandchild. Her portrait, in lace cap and shawl, shows a woman of anxious and even sad disposition, but it suggests too a twinkling sense of fun implicit in a last grand joke that she attempted to play on her grandson in her will. Born Charlotte Grimstead of a substantial Hertfordshire landowning family, she had married an earlier Lord Glamis in 1820 and it was a sorrow, known to few, that her first child had been born and died on the same day; and a second son had died childless at the early age of forty-three. Old grandmother Charlotte lived to the age of eighty-three and early in February, 1881, Claud George was summoned to the reading of her will.

No doubt the family solicitor apologized for its length, its complexity and its codicils. In an opening phrase the testator disposed of her furnishings, pictures and personal chattels and then came to the nub of her posthumous jest, ". . . and to my grandson Claud George my public-house known as the Strathmore Arms at St.

Durham, and so the rich Bowes estates ultimately passed into the newly united Bowes-Lyon family.

This inkling of history provides an understanding of the ancient and aristocratic lineage of Queen Elizabeth the Queen Mother. Those unfamiliar with the puzzling customs of English precedence should perhaps know that the eldest son of an heir may use his father's secondary title until succeeding to the earldom, hence Lord Glamis, that other children use the ancestral name, hence Bowes-Lyon and that the daughter of an earl may be styled 'Lady' rather than the spinster 'Miss'. Lady Elizabeth Bowes-Lyon was thus a noblewoman and also a commoner. And with this imperative digression one must still explain her father's stubborn contempt of the Court, the massive irony that rendered her regal childish imaginings the merest make-believe. It made the possibility of a marriage into the royal house appear in her girlhood utterly non-sensical and it was an obstinacy that had congealed in his character twenty years before his youngest daughter was born.

Simple-hearted, kindly, unsophisticated, even naïve, Claud George Bowes-Lyon, Lord Glamis, had seen his father, the thirteenth Earl, at hard-drinking dinner parties at which a pageboy was kept under the table to loosen the gentlemen's collars as they fell from their chairs. Peering from the castle as a small boy he had seen guests, roaring drunk or insensible, carried out on stretchers to their carriages: he was therefore no prude. Yet as a twenty-five-year-old subaltern in the Life Guards at Windsor in 1880, he was shaken at the disclosures of military drunkenness, horrified at the heavy gambling into the small hours at Windsor Barracks and, above all, shocked at the first-hand gossip in the officer's mess of the easy morals of the heir to the Throne.

Serving in his father's old regiment and managing as his father had done, on his army pay plus a paternal allowance, the young man gloomily faced the prospect that he might be immured for years in the Guards. He chafed daily and hourly at what he considered an unwholesome and inadequate way of life. Neither the Draghounds nor other diversions compensated for the lost sport

condemned to death. In fact, she was innocent, as the deathbed confession of one of her accusers was to prove, but she was burned alive on the castle hill "with great commiseration of the people, being in the prime of the years, of a singular beauty, and suffering all, though a woman, with a manlike courage". The estates of Glamis were forfeited and the castle ransacked of furnishings and silver.

When restored to his possessions, the seventh Lord Glamis returned to a draughty, broken shell. His grandson, ninth of his name, was created Earl of Kinghorne in 1606, three years after James VI of Scotland succeeded as James I to the united kingdom of Great Britain and Ireland. The first Earl began to beautify Glamis; the second Earl came to his inheritance as the wealthiest peer in Scotland but made the costly mistake of first raising an army to follow Montrose and then of supporting an army against him, and the third Earl of Kinghorne inherited estates £400,000 in debt. It can have been only a partial recompense in 1677 to be created Earl of Strathmore and Kinghorne by King Charles II. The new Lord Strathmore began to pay his way by 'prudence and frugality' but there remained ample ready money for carved coats-of-arms and a plentitude of sundials, and within twelve years the date of 1689 was placed on the Castle door-knocker in token of completed works.

Such were the Strathmores. They had entertained Mary Queen of Scots, complete with elegant menus in French, on her progress to Huntley. They were ardent Jacobites and in the 'Fifteen' they entertained the Chevalier de St. George (the Old Pretender), with hospitality so lavish that beds were made up for eighty-eight gentlemen. But they were prudent, too, and when Bonnie Prince Charles sought refuge in Glamis and was threatened with discovery he necessarily left the Castle in such haste that he left behind his watch and spare suit of clothes. A generation later, the ninth Earl of Strathmore married the impulsive Mary Eleanor Bowes, only daughter and heiress to George Bowes, whose wealth comprised two-thirds of the half-million acres of County

Queen Mother as a young married woman read and approved. The origins of the game were forgotten, and perhaps too much can be made of the make-believe of an imaginative and lonely younger child. Yet the curious element is that her father, the fourteenth Earl of Strathmore, though a Scottish patrician with uncomplicated ideals of loyalty to King and Country, was hardly a man to instil his family with monarchist thought. "If there's one thing I have determined for my children," he used to say, "it is that they shall never have any sort of post about the Court."

II

The Earls of Strathmore had been close to kings, in every sense, ever since the dim medieval fighting days that came to documented reality in 1372 when their ancestor, Sir John Lyon, married Dame Joanna, daughter of the newly acclaimed King Robert II of the House of Stewart. Dubbed the White Lyon for his fair complexion, Sir John by way of dowry gained the estates of Glamis (pronounced 'Glahms') in return for the moderate rent of 'one red falcon to be delivered yearly on the Feast of Pentecost'. His grandson was created the first Lord Glamis in 1445, probably in return for loyalty to the youthful Scottish King James II during the violent civil wars. Seven other lords of Glamis succeeded in direct line in the next 130 years, fighting at Sauchieburn, falling with the flower of Scottish nobility on Flodden Field, warring and dying, until in 1578 the ninth Lord Glamis succeeded in the fierce procession as a child of three.

The only hiatus to shadow the chivalrous records had been forty years earlier when the widow of the sixth Lord Glamis was accused of witchcraft and indeed of seeking to cause the death of King James V of Scotland with her spells and potions. Born a Douglas and thus reared in the camp of the king's enemies, she was imprisoned in Edinburgh Castle with her young son, the seventh Lord Glamis, found guilty after a shabby trial and

and the spell was broken and the laughing children had clapped their hands and skipped with joy at the applause. Taking the chubby, warm little hand of the daughter of the house, he had enquired, "And who are you supposed to be, my dear?" And she had drawn herself up "with great *empressement*" and replied, "I call myself the Princess Elizabeth."

The incident gleamed in the memory like a polished jewel, for the child was of course Elizabeth Bowes-Lyon, destined to become one of the most popular women in the world, the lady whom we know today as Her Majesty Queen Elizabeth the Queen Mother. The echo of the distant drums of futurity sounded their soft whisper until the grown girl had married into the royal family and perhaps her benign influence had gained Mr. Stirton an appointment as domestic chaplain at Balmoral. But the child was telling the playful truth rather than foreshadowing the future, for her mother had copied the dance costume from a Van Dyck portrait of one of the daughters of King James I, and she was indeed Princess Elizabeth.

James Stirton did not live to see the little Elizabeth of Glamis Castle crowned as Elizabeth, Queen Consort. He knew her daughter as Princess Elizabeth but did not dream that she in turn would one day be crowned as Elizabeth II, Queen Regnant. He might otherwise have been more attentive to the historical quirk that King James's daughter, Princess Elizabeth, became Queen of Bohemia by marriage and was mother to the Electress Sophia of Hanover from whom the House of Windsor is descended.

And yet the tremble of the distant drums was noticed elsewhere. An old friend of the family, less connected with Glamis Castle than with the Bowes-Lyon home in Hertfordshire, recalled some twenty years later that he had always addressed the little girl as 'Princess Elizabeth', almost from infancy, kissing her hand and invariably making a low bow "which she acknowledged haughtily but courteously" in a sustained pretence of princesses-and-courtiers. The story was authorised—one might almost say, certified—in a manuscript by Lady Cynthia Asquith which the

THE LATE COMER

I

IN THE VAULTED DRAWING-ROOM of an ancient Scottish castle on an afternoon of late summer in the year 1909, two children gravely danced a minuet. The girl, nine years old, a blue-eyed brunette, wore a long gown of soft rose brocade, ribboned and buttoned in the style of the seventeenth century, and daintily lifted her skirts to show her steps. Her partner, her younger brother, was decked in the striped motley of a jester, with cap and bells and sagging cotton stockings, and she guided him through the dance with serene composure.

The occasion was a tea-party chiefly to reward the philanthropic ladies of the neighbourhood of Glamis. The tinkle of teacups and conversation had diminished; the children's mother had seated herself at the piano; their music master, old Mr. Neal, nestled his violin into his silvery beard, and the two little creatures had appeared "as if by a magician's touch, seeming to rise from the floor", as the local minister romantically recorded.

In that setting, under the bland ancestral portraits, their miniature dance was charming, and yet slightly absurd, droll and yet touching, to many of the quiet, watching audience. More than twenty years later, the Rev. James Stirton found that a vagrant whiff of beeswax and sweet peas could still evoke the scene: the graceful girl, her dark hair falling to half-conceal the rose and silver epaulettes of her shoulders, the fair young boy—nearly as tall—following her moves with rapt concentration. But perhaps the minister best remembered the moment after the music ceased

ILLUSTRATIONS

Following page 128

Elizabeth Bowes-Lyon, 1902

Elizabeth and David Bowes-Lyon, 1909

At Glamis

The wedding, April 26, 1923

The Duchess of York and Princess Elizabeth, 1927

Parents and Princesses, 1936

The coronation, May 12, 1937

Bomb damage at Buckingham Palace, 1940

The Queen Mother in New York, 1954

The Queen Mother with her three grandchildren

CONTENTS

A full source of my quotations, etc., will be found in an appended Bibliography and I have to make it clear that the copyright in material from royal journals and letters is reserved.

HELEN CATHCART

First published in the United States 1966

Printed in the United States of America

The Queen Mother

THE STORY OF ELIZABETH, THE
COMMONER WHO BECAME QUEEN

BY HELEN CATHCART

Illustrated with photographs

DODD, MEAD & COMPANY · NEW YORK

Also by Helen Cathcart

HER MAJESTY THE QUEEN: THE STORY OF ELIZABETH II

The Queen Mother

THE STORY OF ELIZABETH, THE COMMONER WHO BECAME QUEEN

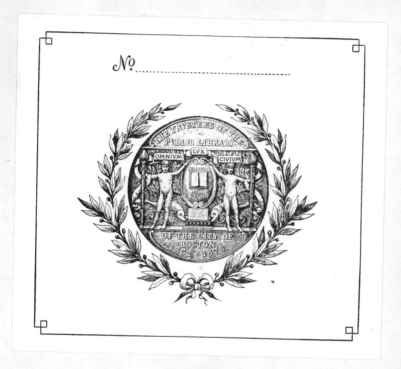